m.s.

The Boston Raphael

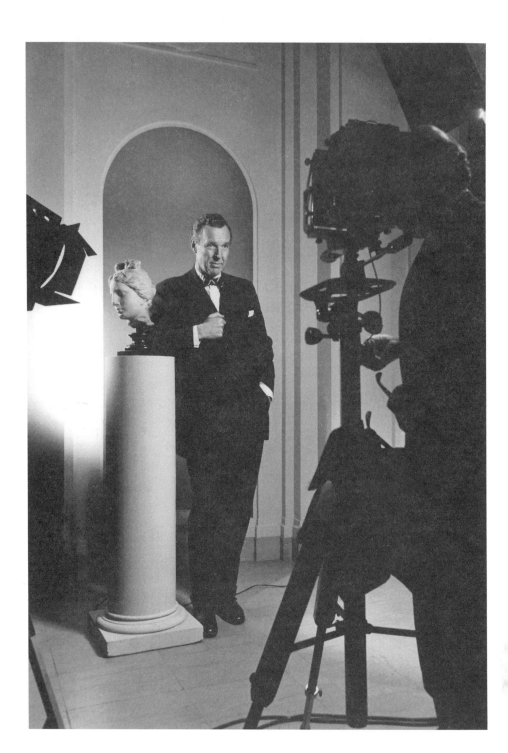

The Boston Raphael

A Mysterious Painting,
an Embattled Museum
in an Era of Change
 &
A Daughter's Search
for the Truth

Belinda Rathbone

David R. Godine · *Publisher*
Boston

First published in 2014 by
DAVID R. GODINE · *Publisher*
Post Office Box 450
Jaffrey, New Hampshire 03452
www.godine.com

Frontispiece: Perry T. Rathbone being photographed by Yousuf Karsh, MFA, Boston, 1966. Photograph: Ivan Dmitri.

LIBRARY OF CONGRESS CATALOGING-IN-PUBLICATION DATA

Rathbone, Belinda.
The Boston Raphael : a mysterious painting, an embattled museum in an era of change & a daughter's search for the truth / Belinda Rathbone.
 pages cm
 Includes bibliographical references and index.
ISBN 978-1-56792-522-7 (alk. paper)
1. Rathbone, Perry Townsend, 1911–2000. 2. Museum of Fine Arts, Boston—History—20th century. 3. Art museums—Social aspects. 4. Raphael, 1483–1520—Authorship. I. Title.
N520.R38 2014
708.144'61—dc23
2014020036

FIRST EDITION
Printed in the United States

CONTENTS

To my father's grandchildren
Claudia, Sarah, Emma, Vanessa, James, Elliot, and Dylan

Part I

The Greatest Adventure of All

IT WAS THE EVE of the Feast of San Giovanni, and Florence was thronged with tourists. My sister Eliza, my cousin Cecilia, and I had arrived the night before, booked into a room at a small hotel in the heart of town, and spent the morning visiting favorite sights. The Bargello, with its quiet courtyard and timeless treasures, including Donatello's bronze sculpture of the triumphant David in a feathered hat; the tiny chapel of the Palazzo Medici Riccardi, where Benozzo Gozzoli's frescoes envelope the visitor in a rich landscape through which the Magi make their journey to Bethlehem; and the Medici Chapel, where Michelangelo's monuments to the great patrons of the Renaissance preside over his brooding allegories of Dawn and Dusk, Day and Night. We stopped for lunch at a local restaurant, practiced our Italian (Cecilia's fluent, Eliza's passable, mine nonexistent) on a cheerful waiter, ordered the *spaghetti del giorno*, and drained a carafe of *vino della casa*. But now it was time to make our only scheduled appointment. We threaded our way through the crowds of sightseers, street performers, and peddlers on the Piazza della Signoria and bypassed the line of visitors at the entrance to the Uffizi Gallery, all waiting their turn to stand before some of the greatest treasures of Western art in the world. Through a door at

the far end of the East Wing, we entered the quiet seclusion of the staff entranceway.

Our appointment was with one small painting, at one time attributed to Raphael, that was not on view to the public. A receptionist at the desk called for Giovanna Giusti, the curator with whom I had been corresponding by e-mail since March. From her I had learned that the picture – which had dropped out of sight more than twenty years before – was, in fact, at the Uffizi, that it was in storage, and that it would require special permission to see it. The date was set: three o'clock, June 23. There we were.

On a midsummer day thirty-six years earlier, about 150 miles north of where we stood, another party had gathered around the very same painting. My father, Perry T. Rathbone, was considering its acquisition for the Museum of Fine Arts, in Boston, where he was then director. This would be a coup for the MFA, which was about to celebrate its centennial year, 1970. Nothing could adorn the centennial celebrations more than a previously unknown work by one of the greatest artists who had ever lived. Nothing could crown my father's fifteen-year directorship of the MFA more gloriously than such a treasure.

The party had converged from various points: from Boston, Perry Rathbone and Hanns Swarzenski, the MFA's curator of decorative arts, who was the first to have seen the picture and to urge Rathbone to consider it for the MFA; from Paris, John Goelet, a young museum trustee with deep pockets; and from London, John Shearman, a professor of art history at the Courtauld Institute of Art, generally regarded at the time as the foremost expert in the work of Raphael. Their appointment was with Ildebrando Bossi, a Genoese art dealer from whom Swarzenski had already bought a number of Renaissance works of art for the MFA.

They were full of excitement at the prospect. "In Genoa," my father wrote to my mother on July 15, "we made our rendezvous with John Shearman on the dot and thus commenced the greatest of all adventures – negotiations for the Raphael," to which he added in big block letters "(CONFIDENTIALLY)."[1]

It was indeed the greatest of all adventures. In fact, it was the beginning of an art-world *cause célèbre* of international scope, a

milestone in the history of art collecting, and also the unraveling of my father's thirty-two-year career as a museum director.

We waited in the dusky entranceway for Signora Giusti to appear. Greetings in both languages came eagerly to the fore as a sturdy middle-aged woman arrived at the desk. She guided us out the staff door and across the piazza, through another giant door into the West Wing, and up a wide stone staircase. Upstairs the walls were lined with metal racks upon which old master paintings were hung floor to ceiling. A white-smocked preparator led us farther into a small, windowless room. Standing at a worktable, he folded back the white tissue paper around a small portrait on a panel – just 10½ by 8½ inches – unframed, as starkly naked as a patient on an operating table.

I remembered her well – a young girl of about twelve or thirteen, impeccably dressed in rich velvet and lace, decorated from headdress to belt in exquisite Renaissance finery. Her name was Eleonora Gonzaga – at least it was the last time I had seen her – and she was of noble lineage, the daughter of the Duke and Duchess of Mantua. If there was a difference in my fresh impression, it was that she looked somewhat colder and cleaner, as if nothing beneath her impeccable jewel-like surface was left to be penetrated. Her trace of a smile and her steady gaze – poised and confident, but with the innocence of adolescence – betrayed little of her life to date and nothing of her travels since. She was as mysterious as ever.

The painting had been sent to a conservation lab in Rome following its return from Boston some years earlier, where it was cleaned and closely studied by various experts. At that time, said Giusti, choosing her words carefully, "the consensus was that it is not by Raphael."

Expert opinions just a few years earlier than that had been quite different. "Before lunch the verdict was delivered," my father wrote to my mother on July 15, 1969. "A genuine early Raphael."[2]

From being quite sure that it was an early work of Raphael, to being quite sure that it was not, the trend of expert opinion rode the waves during the painting's brief thirteen-month period of public exposure in Boston. At the same time, another struggle, equally if not more diverting, was over the manner of its exportation from Italy and arrival in Boston.

The little portrait had become the object of a contest, which usually means that only one side can win. While its acquisition was designed to serve one purpose – as a centennial prize for the MFA and the crowning acquisition of my father's tenure – its return to Italy served another – as a trophy for Italy's top art sleuth, Rodolfo Siviero. For the purposes of both parties, it was imperative to believe in its attribution to Raphael. But once the struggle for ownership was settled, in favor of Italy, the debate over its attribution left the international arena. The last time the picture was publicly exhibited was at the Palazzo Vecchio, in Florence, in a memorial exhibition to Siviero after he died in 1984. The wall label accompanying it stated noncommittally, "Attributed to Raphael." Many visitors saw it there for the first time, and some remembered the controversy surrounding it. The label begged the question, and they came to their own conclusions, or not. While the picture still represented one of the most celebrated of Siviero's repatriation efforts, it was no longer officially considered a Raphael. All that fuss, and it wasn't a Raphael after all?

What had been a widely aired embarrassment to Boston had become a somewhat lesser and soon forgotten embarrassment to Italy. Perhaps this is what I sensed behind the manner of Signora Giusti. While its ownership was by now apparently beyond dispute, the picture was still tainted with the struggle over its cultural patrimony, which now seemed even more ironic given its consignment to storage. For all intents and purposes, it had been successfully buried. Our little pilgrimage and its brief resurrection had ruffled her feathers.

"If not by Raphael," asked Cecilia, "then who?"

"Emilian School," pronounced Giusti.

"What about the girl," I pressed, "her identity?"

"Unknown," she answered without a pause.

After we had stared at the painting as long as we politely could, I made a snapshot, and the man in the smock wordlessly folded it away. We groped for more information about the intervening years and the expert opinions that had been visited upon it. Obligingly, Giusti led us away to her small office, where she operated from a crowded desk surrounded by stacks of books and piles of papers, and

shared with us articles from the Italian press on the subject of the "Rafaello di Boston." She hurried in and out of the office to the photocopier down the hall and returned with piles of copies for each of us. The longer we spent in her company, the more her tone became defensive and hurried. The more questions we asked, the shorter her answers. She performed with the patience and armor of a carefully instructed civil servant, but her act was under strain. Finally, she summarized. Any research we might carry forward from there, she assured us, would only lead to the same conclusion. There was nothing left to say, and there was nothing left to do. The painting had left Italy illegally, and it was no longer considered a Raphael. She politely reminded us that the holiday weekend was upon her. We bade our bilingual good-byes and thanked her for her time, and with that she led us through a back door into the early Renaissance galleries for what was left of the afternoon.

What had we come in search of anyway? To revisit the object that led to my father's downfall, as if gazing upon it might deliver some kind of resolution? Was it a ritual we needed to perform to achieve what we now call closure? Or was it simply, at long last, to answer the question that occasionally arose at the family dinner table when the subject of the Raphael came up for review? What had they done to it in the laboratory? What had they discovered, and how definitive were their conclusions? And where was it now? After a protracted and bitter struggle over getting it back, the Italians had done exactly what my father had most feared: they had made it their hostage. They had buried the story, along with the deposed work of art. The case was closed, and the trail was cold. Confirming this reality in person felt somewhat anticlimactic, like visiting the grave of someone you were already quite certain was dead.

But a few months later, the reaction of certain experts gave the story an unexpected lift. "I felt the picture had been swept under the carpet," [3] said Nicholas Penny when I visited him in March 2006 at the National Gallery of Art, in Washington, where he was then head of European paintings.[4] For Penny, a deeply knowledgeable and refreshingly outspoken Englishman, his firsthand encounter with the little painting had been a formative experience. He had first seen the painting when it was unveiled in Boston, in 1970. At the time a

graduate student in art history at the Courtauld Institute of Art in London, Penny was on a visit to Boston with his American bride. Fascinated, he had carried home a small color reproduction of the painting he had bought in the museum shop. After following the story of its demise, he later published the image in his 1983 book, *Raphael*, with Roger Jones, identifying the artist as "perhaps Raphael."[5]

"My intention was to bring it back to light," said Penny. "Even if it's not by Raphael, it's still a very interesting picture." But Penny remained puzzled by the fact that my father had approached just one Raphael scholar for an opinion – John Shearman, who had been Penny's professor at the Courtauld. Had Rathbone consulted others, he might have been on firmer ground. Was it his commitment to confidentiality that made him play his cards so close to his chest? Was it Shearman's well-known tendency to isolate himself from his fellow scholars? Either way, would a second opinion have strengthened, or weakened, the case? No matter what, Penny surmised, in a case of a precious and rare picture believed to be the work of a great Renaissance artist, it had been "fatal to go the lone path.... What you underestimate are the weapons that are being sharpened with envy."[6]

Not long afterward I spoke with another Raphael scholar, Paul Joannides, at the University of Cambridge, who saw the picture for the first time at the exhibition at the Palazzo Vecchio in 1984. "I would tend to think that Shearman was probably right," he told me. The picture, he observed, possessed qualities much like other early works of Raphael – the moon face, the small almond eyes. "It's not a very penetrating portrait," he admitted, and if it were, in fact, by Raphael, "it would not do him a great deal of credit." On the other hand, he suggested, "there are people around Raphael not yet defined, and the picture could be the work of another artist of the period we have yet to discover."[7]

By the time I embarked on my research, it was too late to meet John Shearman, who died in August 2003. A few months later, simply out of curiosity, I attended his scholarly memorial service at Harvard. In the bright and businesslike Faculty Room at University Hall in the middle of Harvard Yard, his loyal students and colleagues gathered to remember his contribution to the field. I listened for

signs of the Boston Raphael story. But it quickly became clear that, while Shearman had continued to work extensively on Raphael at his various posts – as professor at the Courtauld, then Princeton, and finally Harvard – he had successfully buried the Boston Raphael in his past, surely embarrassed by the storm of publicity surrounding it, the challenges to his scholarship, and perhaps not least, the disaster his attribution had caused the Boston museum.

My parents staunchly believed in the injustice of the episode for the rest of their lives. They moved on, but it was like a cloud that had never completely blown away, a permanent blot on my father's otherwise fine reputation, a heartache that every so often acted up again and required soothing. They would review the details and recastigate the characters they blamed for the fiasco. Most of all, my father blamed the Italian government for reclaiming a work of art that they ultimately had so little use for. "It was absurdly handled," my father told an interviewer in 1981, "and someday, if I live long enough, I hope to have the strength to write about it."[8] To another interviewer he went as far as to say that he believed that someday the picture might return to Boston.

My father did not live long enough, nor perhaps would he have ever had the strength to write about it. Instead, the press version of "the Boston Raphael" trailed him for thirty years, all the way to his obituaries when he died in January 2000. For all his many successes, this fiasco remained, as he himself had called it, the greatest adventure of all.

But while the superficial press version of the story bothered me, so did my father's obviously subjective account. Furthermore, the story was incomplete; there were many aspects of its outcome that remained mysterious, even to him. Meanwhile, the carapace of family myth hung stubbornly around it, obscuring further details, a web of ethical issues too delicate to untangle, discouraging further questions too painful to raise or to investigate. While I understood his motives implicitly, I could not help but wonder: Where had his judgment gone wrong? If character is destiny, what aspects of his character had brought him into the crosshairs of this life-changing event? Was the Raphael the only reason for his abrupt departure from museum work? To what extent was he the victim of circumstance,

of changing times, and of a cluster of conflicting personalities closely involved in the case? How could the ground have shifted under him so suddenly? Or had it been shifting, imperceptibly to him, for years?

In his prime, Perry Rathbone was one of the most influential museum directors in America – a connoisseur of great breadth as well as a brilliant showman. Over the course of thirty-two years he played a crucial role in the modernization of the American art museum, transforming them from quiet repositories of art into palaces for the people. As director of the City Art Museum of Saint Louis (now known as the Saint Louis Art Museum) from 1940 to 1955 and the Boston Museum of Fine Arts from 1955 to 1972, he ambitiously moved both museums forward into the postwar era. He staged unprecedented loan exhibitions, and with his flair for publicity, he attracted record crowds. He brought light and life into the galleries and expanded and improved auditoriums, restaurants, and gift shops. He established committees of women volunteers and with their help invigorated museum programs with films, lectures, and special tours both local and abroad. Under his leadership, attendance and membership increased exponentially, and consequently so did revenue. In Boston his staff tripled, the budget quadrupled, and the annual sale of publications increased more than 1,000 percent. These were achievements of which my father was justly proud, but he knew that numbers were not the only measure of success. More than anything, he was proud of the acquisitions he had made for the museums' permanent collections. His career had been ascendant in every way, until the end. To this day many observers continue to wonder how the dean of American museum directors could have made such a fateful and avoidable error of judgment. More than one person has reflected that, in the manner of Icarus, Perry flew too close to the sun. Still others have called the behind-the-scenes drama at the MFA Shakespearean in the scope of its moral struggle. Some viewed Rathbone as a tragic hero, a martyr to the museum cause. As one former colleague said of his fall, "Perry had to take it for the whole rest of the art world."[9]

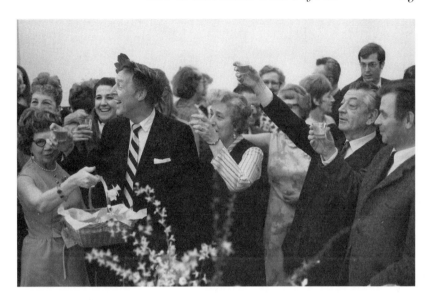

Perry T. Rathbone celebrating fifteen years as director of the MFA with staff members (left to right) Lydia Calamara, Mary Jo Hayes, Virginia Nichols, Hanns Swarzenski, Jan Fontein.

A born optimist, Rathbone's enthusiasm for art was infectious, and his powers of persuasion seemed almost limitless. His tall, impeccably dressed figure matched his commanding voice and ready eloquence. His democratic air exuded the spirit of his motto, "Art is for everyone." With his youthful good humor and his genuine interest in people, he conveyed this belief naturally and effortlessly, surrounding wherever he stood with an aura of excitement and festivity. In addition to his formidable day job, he accepted invitations to boards of trustees, professional associations, and panels of experts, as well as invitations to lecture, write, and jury. He not only enjoyed these roles but also felt an obligation to be a part of the urgent, ongoing discussion, to speak out for what he believed in, and to take the heat when it came. On top of this was his nonstop social life, which he regarded as an essential part of his job and, fortunately for him, on which he personally thrived. In retrospect, how he fit all these activities into an average day remains hard to imagine. He lived life as if to defy the natural limits of one man.

Rettles de Cosson, #13,
Murren, Switzerland, 1937.

Of course, there was a woman behind the man – his wife and our mother, Euretta "Rettles" de Cosson. Born in Cairo to an English father and American mother, Rettles spent her childhood in Egypt and later attended schools in England and finally Switzerland, where she became a passionate skier. Soon afterward she started training as a downhill racer. After winning several races in Switzerland and Austria, Rettles was made captain of the British women's team in 1938 and then again in 1939, and she looked forward to entering the Winter Olympics for the 1939–40 season, to be held in Germany. But this would not come to pass. When Germany invaded Poland in September 1939, the Olympics were canceled, and Rettles found herself stranded in the United States for the duration of the war. By a fortunate piece of timing Averell Harriman had just opened a ski resort in Sun Valley, Idaho, earlier that year. Rettles signed up to race against the American women's team and spent the winter of 1940 in Sun Valley. Hailed as "Britain's most fearless skier,"[10] she lived up to her reputation for daring and perserverence. Despite taking a bad spill in the 1940 races for the Sun Valley Ski Club, she nosed out her American competitors and a year later earned the prestigious Diamond Ski.

It was in the wake of this triumph that Rettles first visited Saint Louis and met Perry Rathbone, the young director of the City Art Museum. Then and there she set her sights. Their wartime courtship began in earnest when they were both stationed in Washington, Rettles working for the British Information Services and Perry for the United States Navy Publicity Office. Over the course of several months, Perry fell in love with Rettles's quiet worldliness, her fascinating background, and the independent and competitive spirit that rumbled beneath her shy demeanor. They were engaged on the eve

of his departure for the South Pacific in May 1943. Thus, at the relatively advanced age of thirty-four, Rettles de Cosson won another race against the American competition: landing the most eligible bachelor in Saint Louis.

From a child's point of view, my father towered over us, both physically and as an example of how to live passionately for one's vocation and give it one's fullest potential. There was no question that he was a figure we were supposed to live up to, and my mother reinforced this perception subtly but unwaveringly. We were his entourage and his cheering section. We walked in his glow, shaded and also sheltered by his fame. Like the family of any public figure, we were expected to understand and support his side, for we were a part of his identity. Wherever he went, he showed us how the individuals he encountered played an important role in his life, hailing the florist in Harvard Square, the chemist, and the gas station attendant like old friends.

It was exciting to be treated as insiders in his castle of work. I remember visiting him in his office, a huge high-ceilinged square where he operated behind a spacious desk, face-to-face with his latest object of desire on the opposite wall – Tiepolo's terrifying *Time Unveiling Truth*; Monet's delightful *La Japonaise*; the riveting, anonymous *Martyrdom of St. Hippolytus*; ter Borch's soulful *Horse and Rider*. Occasionally, at the end of his day, I might be invited to trail after him on his rounds through the galleries, his brisk pace matching his omnivorous, critical eye. I practically ran to keep up, often losing track of how we got to where we were and in which end of the enormous building we found ourselves. Always he wanted to know what I thought and seemed to take my opinion to heart. And always he ventured to point out what was new in the way of an acquisition or fresh installation – his latest achievement. So I grew up with an uncommon sense that the art museum was in a continuous state of renewal and change. Things happened there for a reason, not by chance. Someone was at the helm, and that person made all the difference.

He was constantly guiding us on how to see a work of art and what made it wonderful. He preached a discriminating eye for quality but also openness to every kind of creative effort. At home as well as in

the Museum, every object, every work of art or piece of furniture, had a background, its own story to tell; each was an emblem of our parents' mythical past. The vulgarities of mass culture were held at bay. Comic books, junk food, chewing gum, and Coca-Cola were not allowed in the house, and television viewing was strictly limited. We were the upholders of high culture and hallowed tradition in a crass and commercial world, and we were clearly outnumbered.

Then there were the parties he and my mother hosted at our home on Coolidge Hill in Cambridge before the important evening events at the Museum. From the arrival of the help in starched uniforms (William Swinerton, a former butler from Ham House in England, and his wife made an incomparable team), to their invasion of the family kitchen, the bustle of dinner plates and glasses through the swinging pantry doors, to the animated banter, laughter, wafts of Guerlain, Chanel, and cigarette smoke mingling and rising to the upstairs landing, where we huddled, fascinated, to the gentle roar of guests bidding their good-byes in the front hall – that this was a glamorous and exciting world they inhabited we had no doubt.

Every July we welcomed my father home from Europe at Logan

Rathbone family group passport photo. Clockwise: Rettles Rathbone, Belinda, Eliza, Peter, 1954.

Airport, an event we looked forward to with great excitement. He would have a little something in his suitcase for each of us – a hand-made souvenir from one of the countries he had visited – and we knew there were other surprises in store that he would keep in the bottom drawer of his dresser for later occasions. Over dinner we would beg him to tell us stories of his adventures abroad – the wonders of art he had seen, the interesting or odd people he had met, the mishaps and the chance encounters of his hectic travels. On our own occasional long summers abroad, between our mother's carefully planned visits with friends and relatives all over the map, we joined him here and there for a bout of intense sightseeing, with varying degrees of enthusiasm, depending on our age, as he attempted to teach us patience in the presence of greatness.

At Christmastime one of the great thrills of the season was to accompany him to Bonwit Teller, the most elegant women's clothing store on Newbury Street. Straight to the second floor my sister and I would follow him to the designer dresses, where saleswomen in suits and lacquered hairdos circled around my father as if he were royalty, presenting him with the latest evening dresses as if they were one of a kind, inquiring would this one or that one most become Mrs. Rathbone? My father sized them up like works of art, engaging the ladies in animated conversation. He loved to shop as much as my mother hated it. She allowed him the pleasure of choosing, of enhancing her trim, athletic figure and her classic beauty, and, for the sake of his vanity perhaps more than her own, she always saved the biggest surprise under the Christmas tree for last.

As a member of the first generation of Harvard-trained museum professionals, my father was part of a postwar revision of the very concept of the American art museum. In his time, his achievements were clear to see and widely known. But by now they are nearly invisible, folded into the many layers of change since his heyday, forgotten amid their endless subsequent iterations and installations. Before setting out on the long path of his career, his mentor at Harvard, Paul Sachs, offered these cautionary words: a museum director's life is written in sand.

In his retirement from professional life, which he accepted grace-
fully but reluctantly at seventy-five, my father continued to ply his
folders and file cabinets with an unanswerable yearning to turn
their contents into something meaningful and readable, to tell his
story. But he was wary of the enterprise. He looked on, skeptically,
as other museum directors of his time wrote their memoirs, which,
while valuable, were also inevitably as self-serving as they were polit-
ically handcuffed. Of one thing he could be sure – that his life and
times were carefully preserved in the archives of the museums he
had served, as well as in the boxes and file cabinets and trunks at
home full of personal letters, journals, press scrapbooks, and photo
albums that he had kept faithfully throughout his life. In addition,
two lengthy interviews were conducted after he retired from the
MFA: one for the Archives of American Art in 1977, the other for
the Columbia University Center for Oral History in 1981. It may
have been too late for him to write his memoirs, but he left us – my
brother, Peter; my sister, Eliza; and me – with a minutely documented

Classical Galleries before renovation, Museum of Fine Arts, Boston, 1960s.

trail. He had done his utmost to show us – and anyone else who might care – the way back to his true story, to make of it what we would for ourselves. As I stepped into the mass of evidence of his success, I was also freshly alerted to his many challenges. And as I began to investigate other individuals close to the scene, his point of view was countered by those of others. What emerged beyond my own impression of a benign and beloved leader was a figure in the constant heat of the spotlight, and one who was far more embattled and controversial than I had imagined.

How could it be otherwise? As a public servant, a museum director is fair game, inevitably the object of criticism for the museum's shortcomings as much as the object of praise for its success. A new generation of museum directors continues to redefine the profession – to confront the latest demands of the public, improve on the physical plant, expand public programs, refine connoisseurship, conserve and build the collections, all the while and ever in search of a path to financial stability. Today's museum directors face many of the

New Classical Galleries reinstallation, 1967.

same challenges as those of the past, but no matter what, as Paul Sachs warned his museum studies students at Harvard, their work will be written in sand. Other castles have been built where my father's once stood, and other people have claimed responsibility for the innovations he stood for, as if for the first time, but in retrospect only in a new way, on a new scale, for a new age. In understanding the story that follows, it is essential to consider its many ramifications within the context of its times.

Meanwhile, among the dwindling fellowship that remembers it at all, mystery, rumor, and misunderstanding still surround the story of the Boston Raphael, as well as a crust of inevitability that was only formed in hindsight. Our visit to the Uffizi was the first step backward into a matrix of circumstances that paved the way to this landmark series of events. If it was the story my father least wanted to be remembered for, it was also the one he most wanted fully told.

This is not the book my father would have written, though his words have been a constant guide in the writing of my own. If he were still with us, I would have perhaps gained further insight into the workings of his mind at that time and access to a few pertinent facts that still remain mysterious. At the same time, it would have been impossible to attain the degree of objectivity necessary to tell the story in its many facets. I embarked on my research with some trepidation, not knowing what I would find, and in the face of my siblings' grave concerns about the enterprise. From their point of view (and that of many other friends), the less remembered – much less written – about this unfortunate incident, the better. But since returning to live in Boston, I was perhaps more aware than they how inaccurately it was recalled and how generally misunderstood it was in the first place. There was nothing that mattered more to my father than historical accuracy in fact and context, and there was nothing that bothered him more than uninformed and casually drawn conclusions.

In my research into primary and secondary sources, I have sought to understand the circumstances surrounding the story of the Raphael with an open mind. While some mysteries remain, I have not knowingly left anything significant out of the story. I have sat with the enemy and absorbed the shock of learning that there were other ways of looking at the same events and the same personalities

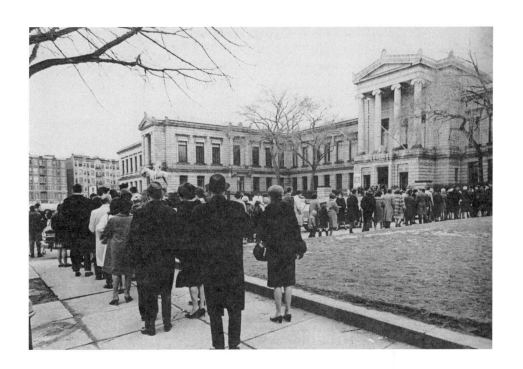

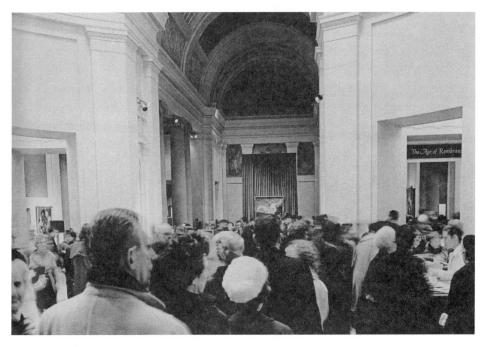

TOP: Crowd in line for *The Age of Rembrandt* exhibition at the Museum of Fine Arts, Boston, January 22–March 5, 1967.

BOTTOM: Crowds at *The Age of Rembrandt* exhibition at the Museum of Fine Arts, Boston, January 22–March 5, 1967.

than the ones I was raised to believe. At the same time, I have carefully weighed each personal account for its degree of truth against accounts of the same events – both conflicting and corroborating – and endeavored to size up each witness for his or her inclinations and sympathies. Even in my father's absence I have had to fight the natural reflex to defend him from criticism. For all my striving for objectivity, there is no escaping that I have come to this work with a point of view about the politics of the art world, and one that was clearly honed by the subject himself. But in reliving those years we lived together, as both biographer and witness, I have come to understand them as if for the first time. My point of view by now comes with a background of evidence, and now I understand in all its fullness what before I had simply taken on faith.

The story of the Boston Raphael is inseparable from another story. No small part of this event was the political turmoil brewing within the institution itself in the late 1960s – a museum in the flux of change, in the throes of ideological conflict, as its size, its scale of operations, and the value of its collections reached a tipping point, the point at which the modern art museum was becoming the postmodern art museum. The philosophical questions of that bygone era are still urgently with us today, even as the landscape has vastly changed. The conventions of exporting works of art, the methods of research and authentication, the ways that museums are managed and the priorities that have recently overtaken them – all three of these issues turned a decisive corner during and in the immediate aftermath of the Raphael affair, just as they played out as elements in its outcome.

"How well did you know him?" a former member of the MFA's Ladies Committee asked me not long ago. The question took me aback. Did she mean that no one could know a father who was always on the job? Did she mean that she knew him better than I did? Had she forgotten for a moment whom she was talking to? Or was it a provocative question, the one I was constantly asking myself as I reviewed the archives of his life, seeking to understand him differently, objectively, while also knowing him, as a close witness to those troubled times, and as only a daughter can?

1965

In 1965 the Boston Museum of Fine Arts was enjoying a revival that was long overdue. During the previous decade attendance figures had tripled; membership had multiplied six times; publications had grown from a trickle of drab little booklets into a steady flow of tempting full-color catalogs, calendars, and postcards; and fifty exhibition galleries had been completely renovated, their treasures brought to life in the glow of new lighting and fresh installations. Collaborating with the local educational station WGBH, the MFA was the first museum in America to be wired for television, hosting on-site programs for both adults and children several times a week, and thereby expanding its public outreach exponentially. Not least, the collections had grown by hundreds of artworks, bringing new strength to every department, including the promise earlier that year of the entire collection of eighteenth-century French art belonging to the late Forsyth Wickes. On the evening of December 10, 1965, the Museum's volunteer Ladies Committee staged a surprise tenth anniversary party for the man who was responsible for instigating these dramatic developments: director Perry T. Rathbone.

In an elaborate ruse in which his wife, Rettles, was a key conspirator, Rathbone arrived in his black tie and dinner jacket at the Huntington Avenue entrance, where he was greeted by a throng of two hundred friends. Amid a chorus of congratulations he was led up the grand staircase – red-carpeted for the occasion – to shake hands with beaming well-wishers every step of the way. He was genuinely

flabbergasted. "I, the unsuspecting victim," he wrote in his journal that week, "was led to the 'slaughter' by Rettles, who turned out to be the most subtle actress of them all in this colossal conspiracy."[1] Rettles, shy and demure, was every bit the woman behind her man, following him up the stairs, smiling and embracing the guests, radiant in her newest Bonwit Teller evening dress.

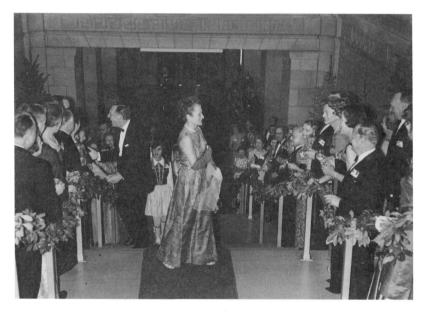

Perry and Rettles Rathbone greeting guests at party honoring PTR's 10th anniversary as director, December 1965.

At the top of the stairs Ralph Lowell, the MFA's president of the board, crowned Rathbone with a laurel wreath. There followed general cocktail hubbub in the rotunda and then a dinner dance in the spacious Tapestry Hall just beyond. It was well known that the director had lately been taken by an insatiable love affair with Greece – both modern and ancient – and the theme was custom-made to his taste: a Greek menu of lamb, steeped in the Mediterranean flavors of lemon and garlic, washed down with the pinesap-flavored white wine retsina, and the cloudy, licorice-flavored aperitif ouzo, while a

lively Greek band serenaded them all. Unprepared as he was to be the object of celebration that evening, Rathbone mustered his best modern Greek to express his thanks and amazement, which amused everyone, including the Greek musicians. Later, with typical spontaneity and joie de vivre, he led anyone willing in a Greek line dance. "The evening had a genius hard to define," he fondly recalled, attributing it most of all to "the spirit, personality, the imagination of Frannie Hallowell."[2]

Frances Weeks Hallowell was the first woman to join the MFA board of trustees. From the start, Frannie and Perry were natural allies. At a welcoming dinner for the new director ten years earlier, they were seated next to each other, and Perry could see immediately that this bright, attractive, and socially connected woman could be a major asset to the cause, and not just as a trustee. To that old boy network she brought her feminine talent for social entertaining as well as the tactical mind of a politician. In another age she might well have been running for public office. Her father, Sinclair Weeks, was onetime Republican senator for Massachusetts and secretary of commerce under President Eisenhower in the 1950s. As his eldest child, Frannie learned firsthand from his example and inherited his political acumen, as well as his ambition. It came naturally to her to be a step ahead of the game, and her mind teemed with ideas. Over dinner on the evening when they first met, Perry asked Frannie if she would be willing to organize a group of women volunteers for the MFA. "Will I?" she replied with a big smile. "I can't wait!"[3] Unbeknownst to Perry, Frannie had conjured up the notion of a women's committee of volunteers almost as soon as she was elected to the board just a few months before. With Rathbone in charge, her idea took flight.

The tenth anniversary party was typical of Hallowell's genius, and Rathbone was right in awarding her the lion's share of credit in the creation of that magical evening. But perhaps what was harder for him to define – the real magic – was the spirit of festivity and celebration that he himself had inspired. By now his skeptics had taken a backseat, and the old guard had laid down their arms. He was loved by his staff, and also by his public. His energy and

optimism had pervaded every corner of the Museum. He had galvanized his team to the cause, and the cause was never far from his thoughts.

Rathbone understood, as well as anyone, that the party served more purposes than to flatter and entertain the MFA's inner circle.

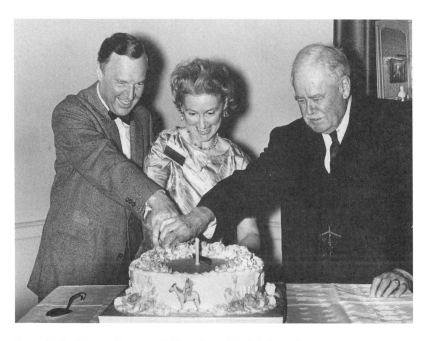

Perry T. Rathbone, Frannie Hallowell, and Ralph Lowell cutting cake at the tenth anniversary of Ladies Committee, 1966.

Nothing works like marking an occasion to remind people of their good fortune, and also their debt. The major donors were there, and Rathbone was especially pleased to see Alvan Fuller, the heir to his family's collection of old master paintings, who had come in specially for the occasion from his winter home in Palm Beach. In the midst of the noisy celebration Fuller took Rathbone aside to mention his promise of a gift to the Museum of a late Rembrandt. "No doubt the spirit of the moment inspired the resolution," observed Rathbone. "One cannot underestimate the importance of such events."[4]

While there was much to be proud of, Rathbone was in no position

to rest on his crown of laurels. For with the tangible achievements of the past ten years behind him, he now faced his most challenging years as a museum director. For those were challenging times in every way. Looming in the background of the Museum's cultural renaissance in the 1960s was the moody aftermath of the assassination of President Kennedy and the sudden escalation of the Vietnam War. For America, 1965 had been one hell of a year. On February 6 President Johnson ordered the bombing of a North Vietnamese army camp near Dong Hoi in retaliation for their attack on a US military outpost. In March he increased the pressure with continuous air assaults and soon afterward sent in the first round of American troops while the Vietcong tenaciously stood their ground. On February 21 Malcolm X was assassinated in the midst of his speech at the Audubon Ballroom in New York City. In March Martin Luther King Jr. led a civil rights march in Alabama from Selma to Montgomery. In August President Johnson secured the passage of the Voting Rights Act, giving all African Americans the right to vote. But just five days later, race riots erupted in the black ghetto of Watts in Los Angeles. A confrontation between a black resident and a white policeman escalated into a five-day urban nightmare. More than thirty people died in the melee, and more than two hundred buildings were completely destroyed by fire. From the point of view of many African Americans, among others, the Voting Rights Act was too little, too late.

They were not the only segment of the population that was dissatisfied. A generation of baby boomers was coming of age, and they were not necessarily inclined to model themselves on their parents' example. Suspicious of their central government, disenchanted with the American class system, and sympathetic to the underdogs of society, they railed against materialism, hypocrisy, and the apparent complacency of the older generation. "I can't get no satisfaction," ranted Mick Jagger to the angry twang of electric guitars. The song was a number one hit in 1965, its rage touching a hot spot in the American psyche and charging the airwaves with a menacing undercurrent. Everyone had something to complain about, and everyone had the right to be heard. It was all part of a rapidly changing social landscape.

One of the greatest personal thrills of Rathbone's directorship had been to forge the MFA's connection with the Kennedy White House. The Kennedy years made Boston a star on the political and cultural map, and its former senator elected president put Massachusetts in the spotlight. With Boston as his hometown and Harvard as his alma mater, John F. Kennedy drew from the Harvard faculty many of his closest advisors, including Arthur Schlesinger, Jr., John Kenneth Galbraith, and McGeorge Bundy. At the inauguration ceremonies Boston's own Cardinal Cushing gave the invocation for the first Irish Catholic president in US history. Many notables of Boston's political and cultural scene were invited to the inaugural celebrations, including Mr. and Mrs. Perry T. Rathbone.[5]

For the first time in Rathbone's working life, there was a First Lady in the White House with a genuine interest and background in the arts. Rathbone immediately grasped how powerful a message this could be for every museum in the land, and for Boston in particular. "It means a great deal in our country, where art hasn't had the sort of inborn respect it has had for generations in Europe," he told the *Christian Science Monitor* of Jacqueline Kennedy's impact on

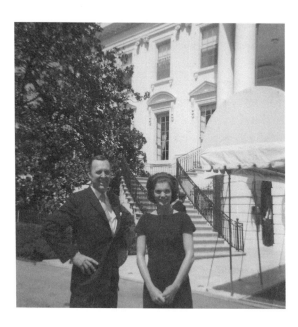

Perry T. Rathbone and Jacqueline Kennedy, the White House, April 1961.

the arts, "to have someone take it so seriously and recognize its importance. I think it will be a great boon to American culture in general."[6] He seized the moment to make the connection right away, for all too often Boston stood in the shadow of New York and Washington. When he learned that Mrs. Kennedy was redecorating the White House, searching for appropriate pieces of American furniture, decorative arts, and paintings, Rathbone made it known through John Walker, director of the National Gallery, in Washington, that the MFA would gladly lend works of art to the cause. With her famous soft-spoken charm, the First Lady responded enthusiastically, and Rathbone had the distinct pleasure of selecting two dozen works of art from the MFA for her to choose from.

She chose eleven – for the State Dining Room, George Healy's portrait of Daniel Webster (to be hung directly across from the full-length portrait of Abraham Lincoln by the same artist), and for the family's private quarters, watercolors by American masters with special ties to Boston: Winslow Homer, Edward Hopper, Maurice Prendergast, and John Singer Sargent, "helping to add a New England flavor"[7] to their domestic scene. The story made for a glamorous piece of publicity – to make known the genuine interest of the White House in what Boston had to offer – and Rathbone took full advantage of it.

Besides restoring the White House to its former glory, a top priority on the First Lady's agenda was to personally embrace and celebrate America's cultural leaders. In November 1961 she invited the Spanish expatriate cellist Pablo Casals to perform for a private evening at the White House. For the first time since he had left Fascist Spain for Puerto Rico, Casals consented to play for an audience. For this special event the Kennedys invited the cream of American cultural society, including the MFA's director and his wife, for a black-tie dinner before the concert. Hardly a detail of this legendary evening was lost on Rathbone. He noted the flowers, the dinner service, the choice of wine, the fish mousse and the *filet de bœuf*, the First Lady's evening dress ("a green chartreuse column of silk"), and the decoration of every room they passed through. When Pablo Casals performed after dinner in the East Room, he savored every note: "a glittering company all around absorbing great sonorous

music from a great artist, I was conscious of my privilege every moment."[8]

A few months later, the French minister of culture, André Malraux, sent the *Mona Lisa* to Washington to honor the Kennedys' embrace of the arts in America. The most famous picture in the world hung in the National Gallery for three weeks, attracting some five hundred thousand visitors before traveling to the Metropolitan Museum, in New York, where an estimated one million lined up to pay homage. With typical can-do spirit, Rathbone asked the French Ministry if they could extend the loan to the MFA, not only because it was one of the three most important museums in America but also because Boston, with its vast college student population, was in many ways, he asserted, "the intellectual capital of the United States."[9] The *Mona Lisa* did not travel to Boston, but it was typical of Rathbone's tireless efforts to draw national attention to his institution.

But with the abrupt end to the Kennedy years, Washington's spirit of support for the arts withered. That bright shining moment was but a brief promise and in retrospect shone all the brighter for it. The country entered a period of mourning, not only for the president but also for its shattered identity. At the same time, there perhaps was never a time to equal the 1960s in its ravenous appetite for change. Every kind of belief or value system was up for review; nothing was standing on solid ground. While this was a time of idealism and liberalism, when a postwar prosperity was supposed to be within everyone's grasp, it was also a time of accelerated forward movement without a clear sense of consequences or of what might be lost in the transition to a new age.

Commercial movies such as *Bonnie and Clyde*, *The Pawnbroker*, and *Blow-Up* were reaching unprecedented levels of explicit sex and violence, bursting through the boundaries of acceptability like a runaway car chase. At the same time, horrendous images of the war in Vietnam came home to everyone with a TV set, increasingly in "living color" – which only added to the confusion of what was right and what was real, which black-and-white film had somehow made clearer – stirring up even more anger at the administration and confusion about America's role in Southeast Asia. In the face of LBJ's vision of The Great Society, and with the success of his con-

siderable legislation to further that end, frustration and anger were nevertheless widespread, unmitigated by a new and seemingly unquenchable sense of entitlement. Violent crime was on the rise, a fact that many attributed to racial tension and the conditions of poverty in the cities. In Boston, the 1960s was a decade of enormous growth in terms of its black population, which nearly doubled, while many of the Jewish communities left Roxbury and Jamaica Plain for the wealthier neighborhoods of Newton and Brookline, and the working-class Irish of Charlestown and South Boston now competed with African Americans for jobs and resources in the decreasing domain for small industry. Ethnic neighborhoods drew their battle lines and lived in precarious hostility.

The city Rathbone served as a museum director was giving way to upheavals of every kind. With the rise in violent crime, he feared for the Museum's safety, given its proximity to the poor neighborhoods of Roxbury. City politicians struggled with a growing population of the needy, while the well-to-do fled to the suburbs. New interest groups – blacks, women, local artists – began to make themselves felt in the cultural scene and were not shy about making their demands widely known.

There were changes in the physical landscape as well. An ongoing building boom surged recklessly over town and country, devastating old neighborhoods and historic monuments. The 1960s was a time of rampant new building projects, thanks to a zealous and often misguided group of second-generation modernist architects, and also the destruction of sacred monuments of American culture, many an architectural treasure, old neighborhood, and park landscape. In 1960 the historic West End of Boston was demolished, the old neighborhood replaced by anonymous high-rise apartment buildings with billboard signs advertising "If you lived here, you'd be home now" to the drivers of gas-guzzling American cars stuck in rush hour traffic on their way home to the northern suburbs. It took charismatic cultural leaders to stem the tide where they could. Jackie Kennedy's preservationist mission and high standards of taste left their indelible impression. Lady Bird Johnson followed with a campaign to limit the spread of billboard advertising that was spoiling the view from the highways. In the same way that these women

served a key role in Washington in the way of enlightened resto-
ration programs, Rathbone took on the struggle in Boston.

America's increasing dependence on the automobile had made
the development of the interstate highway system under Eisenhower
a priority since the 1950s. In the early 1960s the plan for the con-
struction of the so-called Inner Belt in Boston threatened to cut an
eight-lane superhighway through working-class neighborhoods of
Cambridge, Somerville, and Jamaica Plain and through the heart of
Boston, including the parkland along the Fens just across from the
Museum. City politicians perceived the Inner Belt as a way of bring-
ing life and commerce to their dying inner city, but underestimated
the devastating effect it would have on the city itself as a livable
option. As the Inner Belt plans were gradually revealed to the public,
a storm of angry protests from local residents followed. By 1965
these had reached their peak. As director of the MFA, Rathbone was
a key spokesman for the opposition, addressing business and civic
leaders at meetings, and leading the loudest and angriest interest
groups at the public hearings in Boston. The highway's presence
would isolate the Museum, he argued, and sever its connection with
the city's thousands of university students. One proposed route would
take over the Museum's parking lot, another its museum school.
First its construction, and later its constant activity, might also
endanger the Museum's collections. A study group, including seis-
mologists, worked for months on the possible effects of the highway
on the Museum's structure and contents. Most of all, stated Rath-
bone at one such hearing, it would ruin the fabric of the city and
everything that was unique about Boston, turning it "into a precinct
of no more distinction than downtown Tulsa or Wichita." The whole
idea, he argued, was an unmitigated disaster, a product of "bull-
dozer psychology."[10] After a ten-year struggle lasting through the
1960s, the opposition won their case in one of the first successful
grassroots preservation campaigns in America, but not without a
titanic effort.

In a similar spirit of misguided urban improvement favoring the
car, the city of Cambridge made plans to widen Memorial Drive
along the Charles River, which would mean destroying the stately
avenue of sycamore trees that had been there as long as anyone

could remember. Civic-minded Cantabrigians raised an organized protest, with Isabella Halsted, secretary of the MFA Ladies Committee and a resident of Memorial Drive, among its most ardent participants. Known as "the Battle of the Sycamores," it waged on until the plan was defeated and the sycamores left standing. This was an early and therefore significant victory in the ongoing battle between city residents and politicians for the highway, and it bolstered the Inner Belt opposition.

As much as these issues were an unwanted distraction from his day job, Rathbone was a cultural figurehead in Boston, if not in all of New England, and there was no getting out of it. His journal of the mid-1960s is rife with complaints about the calls on his time and the distractions from the Museum. It dampened his spirits and drained his energy, but he rose to the challenge, for it was in his nature to be wary of any enterprise that threatened to destroy the heart of an old city. Truth and Beauty were on trial, and it was up to a museum director to set them right. "Inner Belt, BRA,[11] Fund-raising problems give me sleepless nights," [12] Rathbone admitted in his journal on October 19, 1965.

Rathbone was especially sensitive to what was going up and what was coming down, in Cambridge and Boston. As much as he was devoted to Harvard, his alma mater, by the 1960s he deplored how the university was changing the physical fabric of Cambridge, which was now his permanent home. In 1965, at the first sight of the completed Peabody Terrace, a new residence for married students at Harvard, he was dismayed at the way these buildings permanently marred the river view of his beloved undergraduate years. Much of the responsibility for this lay with Josep Lluís Sert, the Catalan architect who was the dean of Harvard's Graduate School of Design. Rathbone liked the Serts personally – Josep and his wife, Mancha, were small and slight, urbane and intelligent – and particularly enjoyed the modern European element they brought to Cambridge. He also admired Sert's architecture – in theory – but context had everything to do with it. He strenuously objected to Sert's guiding principle that "Cambridge must rise!" As he mused somewhat bitterly, "the smaller the man the bigger his ambition to impose himself."[13]

Sert's Holyoke Center now towered ten stories over Harvard Square. And with the erection two years earlier of the first and only Le Corbusier building in America, the Carpenter Center (also thanks to Sert's strenuous advocacy), Rathbone was outraged. He especially resented that the Carpenter Center, which eventually became the home of Harvard's studio arts, had taken up the only available space on Quincy Street long designated for the Fogg Museum's inevitable expansion. The new building destroyed the unity of Quincy Street, "having no relationship whatsoever to its surroundings. Nor has this tortured pile of concrete designed by Corbusier have any apparent logic within or without."[14]

While he bemoaned the erection of new buildings around the Harvard campus, Rathbone also witnessed the University's neglect or misuse of hallowed historic houses, especially Elmwood, the federal mansion at the far west end of Cambridge that is now the official residence of the University's president. In the 1960s the Harvard Corporation seriously considered the idea of tearing the house down rather than admitting to the need and expense of restoring and maintaining it. In the midst of this debate, the dean of faculty, Franklin Ford, lived at Elmwood in its somewhat-neglected state of repair. After going for drinks one evening with the dean and his wife, Rathbone was shocked at the state of its interior. "The heart of Elmwood has been carved out and thrown away," he mourned. "Elmwood, home of Lt. Gov. Oliver, of Eldridge Gerry, of James Russell Lowell, of Kingsley Porter,[15] has been 'suburbanized,' brought to a level of mediocrity that is scarcely believable ... as Elmwood stands today it is a sort of 'Harvard ruin.' It exists but I cannot say it is alive."[16]

Not quite yet a ruin was Memorial Hall, the grand old Victorian Gothic memorial to Harvard's own Civil War Union dead. The imposing cathedral-shaped building had lost the top of its clock tower in a 1954 fire. Its soaring spire had been reduced to a squared-off stump, and ten years later Harvard showed no signs of interest in restoring it. Across the river the prosaic Prudential Tower rose fifty-two stories out of its element, the first skyscraper to challenge the coherent skyline of Boston's Victorian Back Bay. Soon the little streets of downtown Boston would give way to a host of tall office buildings towering over the historic old State House and the

Old South Meeting House. And so the mania for modernism and change raged through the decade, inexorably changing the face of old Boston.

In his youth Rathbone had championed modernism, but by the mid-1960s he no longer necessarily embraced the latest contemporary art. While he admired the abstract expressionists with some reservation, he now looked downright warily upon the emerging pop artists who were overtaking them – Jasper Johns, Roy Lichtenstein, and especially Andy Warhol. He dutifully kept abreast of the art magazines of the day, such as *Art in America* and *Artforum*, but felt impatience with the obfuscation of art critics. He resented an approach that seemed to relegate connoisseurship to a lower position on the scale. Was theory overtaking the direct appreciation of the physical object? Was the new intellectualism doing its best to mystify rather than clarify? Was the new art drowning out the sacred values of beauty, craft, and technical innovation? Perhaps most of all, he saw his role as a champion of modern art being usurped and no longer urgent. The world had caught up with him – in fact, it was streaking past – and that particular adventure was no longer quite fresh.

Rathbone continued to be his socially adventurous self, eager for new experiences and new contacts, excited by the liberalism of the younger generation. The sexual revolution found him perhaps somewhat regretful that he had not been a youth in such a frankly liberated age while at the same time concerned for his teenage daughters' virtue. Harvard still required a coat and tie in the dining halls, but soon these rules would give way to the pressures of antibourgeois proletarianism. Now it seemed that educated young men dressed like workmen in jeans and T-shirts, young women exposed more skin with every passing year, and instead of dancing to the steps of the fox-trot or the waltz, young people improvised and gyrated to the beat and twang of ear-splitting electric guitars. Yet while he bemoaned the demise of ballroom dancing, he leapt into the fray with a room full of the younger generation doing the Mashed Potato and the Twist, ever ready to experiment, to taste and engage in the curiosities of his time.

Alert to every nuance of a shifting culture, Rathbone was equivocal about the waning of the class system, which to him simply meant a lessening of certain standards. Without such standards, what would become of the beautiful traditions of his youth? Along with the class system seemed to go table manners, dress codes, and the English language. Returning from a big coming-out party in the mid-1960s, he lamented, "Somehow these debutante parties lack the glamour, the beauty, the "occasion" that they certainly possessed when I was a youth. I suppose the basic reason is that their social meaning is dwindling."[17] It was not only the class system that was weakening but also the subordinate role of women in society. A revolution was brewing, its first signs in how a young woman of the next generation dressed. She wore a bikini on the beach and not much more on the street. Hemlines were on the rise; so were tight leather boots up to the knee and hot pants. Betty Friedan's *The Feminine Mystique*, published in 1963, sparked the beginning of the women's movement and coincided with the introduction and growing popularity of the oral contraceptive, which opened the way to women's sexual freedom. And who would have believed that to the next generation "coming out" in society would mean declaring yourself a homosexual rather than the carefully programmed activities of the debutante, the well-bred girl whose well-off parents were officially announcing her eligibility to be married? Was it imaginable that the word "elite" was on its way from being a word of status to something to be reviled, and soon to become a degrading -ism?

At the time Rathbone's personality split along the lines of his dual instincts – equally strong – between his conservative and adventurous selves, between his love of tradition and his need for the vibrancy of the new and the experimental. His mind was still open, but the issues had changed color. He was at midlife, a point when many a modernist favoring change meets the inner preservationist. The older generation was dying off, passing on the mantle of responsibility and tradition. Now his mind reached as far backward in his memory as it did forward into the unknown. His mother died in 1960, and the death of Rettles's aunt, Mary Peckitt, a grand dame of Washington, D.C., came soon afterward. She left a welcome trust fund, a house packed to the rafters with Renaissance Revival furni-

ture, and an empty space in the family topography that signaled the end of an era.

Now in his midfifties, Rathbone had three children who were in their awkward teens. Peter, the eldest, not appearing to be ready for college after graduating from Brooks School, had enlisted in the army, signing on for an additional year with an assignment in Europe[18] in a tactical move to avoid being drafted and sent to Vietnam. Peter, once pictured in the *St. Louis Post-Dispatch* at age six as the "youngest collector" with his little Calder stabile of a giraffe, groomed from an early age to appreciate the finer things in life, was home for the holidays from basic training in Fort Dix with his head shaven, soon to be stationed in Germany for three years, an army private with a safe but soul-crushing office job.

They say that siblings are like leaves on a branch, with each leaf turning the opposite direction from the last to better catch the light. Eliza had laid claim to the front seat of our father's tutelage. She would be graduating from the ultratraditional Miss Porter's School in Farmington, Connecticut, with a class that might with some accuracy be called the last of the debutantes. As his third child and second daughter, I escaped a certain degree of scrutiny and grooming for the role my sister inherited. It seemed less effort was made to direct me, or was it that I was less inclined to take direction, or both? A year later I would attend an educational experiment called Simon's Rock in the Berkshires as a member of its first graduating class. My sister and I were only two years apart, but the changes taking place in those years meant that we almost belonged to different generations. She had a coming-out party; two years later I could see no point in doing the same.

The magic years were over. No one believed in Santa Claus anymore. Life had marched on at its steady pace, and then suddenly, it seemed to have gone by in a flash. "This was perhaps our last Christmas with all three children," my father noted in his diary in 1965, although as a parent of three teenagers, he was also gratified to have maintained their respect and affection in the era of the so-called generation gap. "That they like us and our company and that of our friends means everything."[19]

The years of his generation's ascendancy had peaked. From now

on it would be a struggle to stay one step ahead of the trends. And still, there was so much work to do. His former battle cry, "Art is for everyone," was no longer new. What had become of the young man famous for ushering in change? For the first time in his life Rathbone felt that he might be behind the curve instead of in his customary place: ahead of it.

Having kept a journal faithfully since the early 1950s, in 1966 his writing trailed off, with hardly an entry between January and September. Confronting the blank pages on September 30, 1966, he wrote, "Months of neglect stare me in the face. The ever increasing pressure of life puts writing a journal almost beyond endurance."[20]

The Making of a Museum Director

I N 1921 HARVARD INTRODUCED a yearlong graduate course led by Professor Paul Sachs called Museum Work and Museum Problems. Better known as simply "the Museum Course," it has since become legendary, the first and by far the most influential of its kind in America.

The idea for the museum course came to Sachs in consultation with the secretary of the Metropolitan Museum, Henry Watson Kent, a high-flying innovator who routinely transcended his nominally administrative role. Kent perceived the urgent need to educate a new generation of museum professionals. Art museums in America were growing rapidly, and new museums were opening all over the map. Searching for a younger generation of properly trained "museum men" (in those days, they were assumed to be men) ready to address the challenges of the day, Kent found they were nonexistent, and he urged Sachs to do something about it. "I find I know no one who seems to meet the demands," wrote Kent to Sachs, "which are that he be understanding in how to organize, popularize, and advertise a museum; that he should be a gentleman of some presence and force; that he should be very sympathetic with the situation as regards the creation of the right kind of spirit and sentiment; that he should be thoroughly qualified also along the lines of collecting, with a knowledge of values; that he should have knowledge of the possibilities of borrowing."[1]

Kent had decided that Harvard, with its first-class art faculty,

libraries, and a burgeoning teaching museum, was the natural place to lead the way.

In the formation of his course, Sachs endeavored to train the scholar-connoisseur, adding to this essential quality hands-on instruction on a museum's day-to-day management. The course began experimentally and informally in 1921 with a few students and proved an instant success. Early graduates of the course included Alfred Barr, the first director of the Museum of Modern Art; James Rorimer, director of the Metropolitan Museum; John Walker, director of the National Gallery in Washington; and John Coolidge, director of the Fogg Museum. For nearly thirty years Sachs single-handedly trained a generation of museum professionals, including Perry Rathbone, who entered in the largest class to date in 1933.

By the time the museum course had begun, Edward Waldo Forbes had paved the way. Forbes was from an old Boston family, the grandson of Ralph Waldo Emerson on his mother's side, while his paternal grandfather was the China trade capitalist John Murray Forbes. Spending his summers on the island of Naushon in Buzzards Bay, Edward developed an enduring respect for nature and a lifelong hobby of painting *en plein air*. As the first director of the new Fogg Museum,[2] Forbes placed an unprecedented value on connoisseurship and conservation. He emphasized the importance of the students' firsthand acquaintance with authentic works of art, a privilege he himself had not enjoyed as a Harvard undergraduate, when art history classes relied primarily on black-and-white reproductions.

At Harvard, Forbes had studied under Charles Eliot Norton, the first professor of art history at the college, who emphasized the relationship between fine arts and literature. Norton's course, like that of his close friend John Ruskin at Oxford, was largely theoretical, as much about society, literature, and ethics as about visual art. But being a child of the industrial age, Forbes, like many of his contemporaries, was also drawn to the "aura of the original." After graduating from Harvard, he traveled in Europe, absorbing as much as he could of the real thing. In Rome he struck up a friendship with Norton's son Richard, who was teaching at the American Academy. Norton persuaded Forbes to assemble a collection of Renaissance

paintings to put on loan to the Fogg for display. With this advice, his lifelong relationship with the Fogg began.

Forbes thus set an example, which led to gifts of important works of art to the Fogg's collection from other wealthy Harvard alumni, welcome additions to the fledgling collection of plaster casts and a small group of traditional paintings gathered by the Museum's original donors, Mr. and Mrs. William Hayes Fogg. New gifts from Forbes and others were so numerous by 1912 that plans were made for a new museum adjacent to Harvard Yard on Quincy Street. As director, Forbes conceived of the new Fogg as a laboratory of learning, accommodating galleries, lecture halls, curatorial offices, conservation, and a research library all under the same roof. He closely oversaw the architectural plans by Charles Coolidge – from the outside, a simple brick neocolonial; inside, a spacious, skylit courtyard modeled, down to the last detail, on a High Renaissance facade in Montepulciano, in Tuscany, creating a sanctuary from the day-to-day bustle of Cambridge. Forbes insisted that this be finished, like the original, in travertine, at the then-extraordinary cost of $56,085. Harvard president Abbott Lawrence Lowell balked. A simple plaster finish would cost about $8,500. The travertine was not only expensive, Lowell asserted, it was ostentatious. But Forbes was adamant. How can you educate young people in the language of materials, he asked, if they are exposed only to cheap imitations? The debate dragged on for several months while Forbes sought financial support from other benefactors and eventually, with typical single-mindedness and patience, won his case.

Someone once described Forbes as a man of few ideas, all of them excellent. Among these was the idea to recruit Paul Sachs, Harvard class of 1900, to teach and to be codirector of the Fogg. Sachs was a New Yorker and a partner in the family investment-banking firm of Goldman Sachs. He came from a long line of German-Jewish patrons of the arts and was himself a passionate collector of prints and drawings. Having plied the family trade for a few years, he was more than willing to leave the financial world behind and join the fine arts faculty at Harvard. Forbes perceived how Sachs – already a generous benefactor of the Museum – could complement his own

interests and inclinations, bringing his business know-how, as well as his extensive contacts among rich art collectors from New York and beyond. Their partnership began with Sachs's appointment to the visiting committee in 1911. "My foot is in the door,"[3] Sachs excitedly told his wife, Meta. The door opened in 1915, when Sachs was made associate director of the Fogg. This unlikely duo – one a patrician Boston Brahmin, the other from the Jewish-German financial world of New York – formed the vision and foundation for Harvard's art department in the twentieth century, a combination with far-reaching consequences.

How did it come to pass that Perry Rathbone would fall into this exclusive lap of learning, and where had the seeds of his interest in art been sown? It was his father, Howard Rathbone, who first inspired his artistic inclinations. From infancy to age six, Perry grew up in New York City, where his father worked as a salesman for a wallpaper firm and then as a furrier, and his mother, Beatrice, was a public school nurse. Among Perry's formative memories were family visits to the Metropolitan Museum. One unforgettable day in the American period rooms, his father told Perry and his only brother, Westcott, that the antique desk on display was certain to contain a secret drawer. To prove his point, he slipped under the guard rope, gestured to the boys to follow him, and unlatched the desktop wherein, like a magic trick, the secret drawer was revealed.

Why was this little vignette, which Rathbone fondly related to an interviewer decades later in 1982, so significant? On the surface, it tells of his first visits to an art museum, but more than that, it shows a combination of paternal traits he would cherish and inherit: a curiosity and keen interest in the arts, the audacity to break rules to get closer to a sacred object to better understand it, and the personal charm to talk his way out of trouble when necessary.

Though he did not have the benefit of a higher education, Howard Rathbone had an eye. An avid photographer, he was alive to his physical environment in its every form – from antique furniture to the scenic beauty of the countryside to the distinction of a pedigreed dog. A spry little man, he knew how to strike a pose and what to

Howard Betts
Rathbone, self-
portrait, undated.

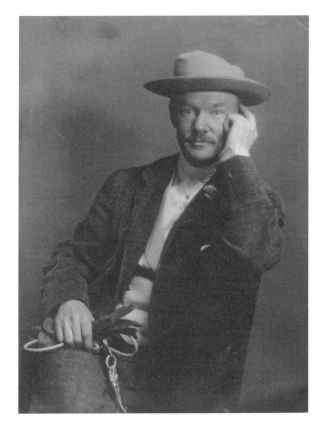

wear for every occasion. He understood the quality of materials, the subtleties of color, and the value of the little details – how to stuff the handkerchief in his breast pocket just so and how to keep the carnation fresh in his buttonhole. He was also a charmer par excellence, not just with the ladies but also with children, the elderly, or anyone who appeared to be in need of a little boost. In contrast to his practical, steadfast, long-suffering wife, Beatrice, Howard had a gift for making everyone in his orbit feel like the most important person in the world.

If his father inspired Perry's artistic eye, natural charm, and sartorial savoir faire, it was his Uncle Jamie who drew out his more intellectual side, and it is he who should be credited for planting the idea of Harvard so firmly in Perry's mind. His mother's younger

brother by ten years, James Willard Connely was a dashing figure in Perry's childhood. A graduate of Dartmouth College, he worked for some time as a journalist in New York for *McClure's Magazine* and *Harper's Weekly*. A handsome young man with a mop of dark brown hair, Jamie was worldly, articulate, and intimate with writers and artists, which meant that he frequented the colorful bohemian circles of Greenwich Village. As a bachelor living in a rented room, he was also happy to accept the occasional home-cooked meal (even under the critical eye of his sister, Beatrice) and to entertain his rowdy, redheaded nephews. At the time the Rathbones lived in a small apartment on 141st Street in Washington Heights.

Years later Jamie recalled the fine spring day in 1928 when the question of Perry's academic future was more or less settled. By this time the Rathbones had moved from the city to New Rochelle, where Perry was enrolled in the public high school. It should be mentioned here that the family's hopes had now been transferred to their younger son, after their firstborn, Westcott, had been expelled from every school in town for failing grades and misbehavior of one kind or another, winding up his high school years in a strict Catholic seminary. Weck, as he was known, had always been an antic, hyperactive child whose severe case of dyslexia, not yet widely known, went undiagnosed and whose penchant for entertaining his friends with clowning served only to aggravate his weak academic performance. Perry, conversely, had quietly worked hard at his studies and had shown signs of a higher ambition, a willingness and an ability to go the distance to reach his goals. Though somewhat shy compared with Weck, slight in build, and less talented at sports, Perry now towered over his older brother in height and in stature. For years Weck had hogged the limelight, but once in his teens it was Perry's turn to shine.

Sharing a picnic with the Rathbones on the rocks of Long Island Sound one spring day, Uncle Jamie (as he himself recalled) was wearing his brand-new bowler hat from Bond Street, which he felt sure "heightened [his] avuncular mien." The question of Perry's future came up for discussion. While his performance in mathematics and science left something to be desired, he showed a keen interest in literature and a talent for acting and public speaking as well.

Most of all Perry showed a talent for art, consistently contributing his pen and ink drawings to various student high school publications. But there were considerable doubts in both Perry's and his parents' minds that his artistic talent was "firm enough to build upon a career as an artist." His uncle set out to strategize. He should study fine arts. At Harvard. Where else? And then seek a post in a museum. "On that path," Jamie argued, "he could move for life in the well-remunerated circles of art, enjoying all the atmosphere and congeniality of it without being required to produce it."[4] Jamie felt quite sure that he had made an impression on the whole family. In hindsight, it seems that he had.

While in academic terms Perry's high school record was unspectacular (he graduated 178th in his class of 235), his sixteen-year-old heart was thus set on Harvard. "I wish to go to Harvard," he wrote in his application, "because, from what I have seen and learned of the

Perry, Beatrice, and
Westcott Rathbone,
c. 1929.

college ... I know that the Fine Arts course is exceptionally good."[5]

The Rathbones would be stretched to meet the costs of a Harvard education – in 1929 tuition was $400, and residence costs added another $350. Westcott had already laid claim to $800 of the family's resources for studying music (an interest that did not last), while their parents' combined income was a modest $7,000 a year. Perry applied for financial aid with letters of support from his high school teachers. Perry was "a manly, well-bred, and splendid fellow," said one, "who has a real capacity for exerting the right kind of influence among his fellows." Perry came from a family of "old reliable New England stock – the kind who do the right thing."[6] His English teacher added that he was a boy of the highest moral qualities. "I notice it in particular in English class in our discussions in which he always supports the right side," she wrote, and she made the point that this took courage in the face of "possible ridicule from the other boys."[7] Despite financial needs and fine moral character, Perry's application for financial aid was denied, but the show of support for his case might have also been exactly the degree of extra weight his application needed to succeed. In July the letter arrived. Perry was accepted into the Harvard class of 1933. Somehow his parents pulled together the necessary funds, and he entered his freshman year in September 1929.

Once he was admitted, his father offered a candid appraisal of Perry's strengths as well as frankly admitting his shortcomings. "[Perry] is a splendid worker in channels he is interested in," he wrote, "but a very rank procrastinator in the things that do not interest him." What interested him was art; he exhibited a gift for drawing and "a great craving for knowledge of both the old and new artistic worlds."[8]

It was only a matter of weeks after Perry arrived in Cambridge before the stock market crashed in October 1929. But Harvard was a safe haven during those early years of what was to become the Great Depression, a highly civilized way of life and a sanctuary of learning far removed from the concerns of making a living. President Lowell, in charge since 1909, had recently completed his most far-reaching accomplishment: the house plan. New housing had been badly needed to accommodate the growing student population, which had doubled in the late nineteenth century, and Lowell had seized the chance to design an inner structure for the much larger college into which Har-

vard had suddenly evolved. The idea was to create smaller communities in the form of newly built residential houses, each with its own cultural, social, and athletic activities. In a fresh democratic spirit, an effort was made to diversify members of the student body in terms of their social and economic backgrounds. The house plan greatly improved the quality of life among the undergraduates, particularly for those, like Perry Rathbone, who were not rich enough to rent their own private digs along the so-called Gold Coast of Mount Auburn Street and who formerly would have been relegated to rented rooms in working-class neighborhoods far from the center of the campus.

Dunster House, the farthest east of the newly completed neo-Georgian houses along the Charles River, would be Perry's home and community for his final two years at Harvard. With his roommate Collis "Cog" Hardenbergh, an aspiring architect from Minneapolis, Perry enjoyed a comfortable suite with a fireplace and three windows overlooking the river, altogether a pleasant retreat for study and a decent place to entertain their girlfriends (in those days of Prohibition, this usually meant bathtub gin) before a football game. Together Cog and Perry bought a brand-new sofa; mother made curtains, and a few other pieces came from home, including a blue-and-white tea set. Perry began his art collection with a Japanese print, for which he paid six dollars.

Meals were served in the Dunster House dining hall, where students ordered from a menu and were waited on by maids in black-and-white uniforms. No Harvard man in those days would have thought of going to a meal without a coat and tie. Nor would he have gone anywhere in public without a hat. At last Perry found himself in the kind of company he had been yearning to keep for many years. "Ever since a young child," his father wrote, "[Perry] has gradually developed a discriminating taste as to the selection of his companions." He admitted that his younger son's discriminating taste was "at times almost too much so, for among certain classes he is not considered a good mixer."[9] Now among his Harvard classmates, Perry was in his element. And while during his high school years he had shown little interest in the opposite sex, the young women of Wellesley and Radcliffe Colleges were a breed apart from the small-town girls of New Rochelle.

Perry was right in anticipating that the fine arts courses at Harvard were exceptionally good, and they were only getting better. The new Fogg Museum had recently been completed on Quincy Street in 1927, and "it still had this delicious odor of fresh wax on its floors," Perry recalled years later. Genuine objects of antiquity were replacing the reproductions of classical statuary that had filled the old Fogg, and a gift of seventeenth-century Jacobean furnishings established the Naumberg period room on the second floor. Picture collections, including Italian art of the fourteenth and fifteenth centuries and a group of nineteenth-century European paintings given by Annie Swan Coburn, were also growing. Forbes's efforts to make the building itself of the highest quality were not lost on young Rathbone, who recalled years later his first impressions of the new Fogg building: "You could see that it was beautifully designed, beautifully built, and with a great care for the materials."[10]

In his freshman year Perry took a survey course taught by Chandler Post, which provided the art historical framework he would rely on for the rest of his life. "[Post] was a model art historian," Perry recalled, "with a marvelously organized mind."[11] Post memorized his lectures and delivered them with splendid clarity. His course was well complemented by another kind of survey taught by Arthur Pope, who provided a more experimental approach to art history in the language of drawing and painting. Pope addressed the broad spectrum of visual expression across the centuries – from Indian miniatures to Greek vase painting to the revolutionary style of Giotto – providing a sense and framework for aesthetics that lifted art and its appreciation out of the purely chronological format Post supplied.

While his classmates schooled at Groton or Middlesex might have visited the great museums and monuments of Europe, Perry had never traveled beyond the mid-Atlantic states. As much as he enjoyed Post's classes, he found himself woefully out of his depth, earning a C- in his first term. His art history courses were not the only ones Perry found challenging. German A was a bugbear, Geometry I was even worse, and Botany was a disaster. His first report came in with three Cs and two Es. Perry was put on probation and would be asked to leave if his grades didn't improve by the end of his freshman year. His worried mother assured Dean Hindmarsh that

her son was "worth educating,"[12] confidently adding that by another year, when he got into his stride, he would do worthwhile work.

As his mother promised, Perry did get into his stride, eventually raising his grade level to a B average when he began to major in fine arts in his final two years. Art history courses with Charles Kuhn, George Harold Edgell, Langdon Warner, and Helmut von Erffa were complemented by a studio art class with Martin Mower, "an old-fashioned small-time painter who was a friend of Mrs. Jack Gardner," as Perry later remembered him, and "a real aesthete."[13] In those days, the art history courses included drawing as a way of training the eye and memorizing the details, especially in the study of architecture and objects, and at these exercises he excelled.

The Fogg collection was not the only one available to the art history majors at Harvard. The Boston Museum of Fine Arts – housing one of the greatest collections in America – was just across the river, and students were encouraged to go there. The history of Asian art was just beginning to be taught at Harvard (Norton had not considered it worthy of serious study in his day), and the Asiatic collections at the MFA were world-renowned. But unlike the Metropolitan Museum, which he had enjoyed so much as a boy, Perry found the Boston museum somewhat forbidding. No one on the curatorial staff came forward to welcome the Harvard students, and certainly not the director, Edward Jackson Holmes (a direct descendant of Oliver Wendell Holmes), who was regarded as a remote and intimidating figure. Isabella Stewart Gardner's museum, Fenway Court, was just a stone's throw from the MFA and had a far more welcoming and fascinating atmosphere. Mrs. Gardner had been a personal friend of most of the Harvard fine arts faculty, and her museum, with its world-class collection of European paintings and its dazzling Venetian garden courtyard, was for the art-minded student "an absolute wonderland."[14]

There were other outlets for Perry's art interests in his undergraduate years. His talent for drawing or, as he put it, "my modest ability with a pen,"[15] won him membership to the Lampoon. This unique club of undergraduates produced a humor magazine four or five times a year, and because wit and talent were more desirable commodities in this context than a listing in the Social Register,

membership in the Lampoon was within his reach, while exclusive final clubs such as the Porcellian (sometimes called "the Piggy Bank," referring to the exceptional wealth of its members) were not. But the Lampoon had perhaps more interesting distinctions to its credit in the long run. For starters it was housed in the most eccentric building in Cambridge – a flatiron mock-Flemish fortress at the division of Mount Auburn and Bow streets. Only members were allowed within its fabled interior, which was furnished with antiques donated by wealthy patrons, including Isabella Stewart Gardner, and finished in dark paneled walls, its vestibule inlaid with no fewer than 7,000 Delft tiles. Members enjoyed dinner there once a week in the trapezoidal Great Hall, lit from above by sixteenth-century Spanish chandeliers while gargoyle-like creatures supported lamps along the walls. Thus the Lampoon provided another inspiring interior in which to bask, as well as another social outlet, albeit, as Perry put it, "in a clubby sort of way."[16]

In his junior year Perry also became involved with another kind of club – the Harvard Society for Contemporary Art. This was an experimental art gallery started by Lincoln Kirstein, Eddie Warburg, and John Walker, all seniors when Perry was a freshman. In 1928, with the support of both Forbes and Sachs, this adventurous trio claimed a couple of rooms on the second floor of the Harvard Coop in the heart of Harvard Square in order "to exhibit to the public works of living contemporary art whose qualities are still frankly debatable."[17] From the point of view of Sachs and Forbes, this undergraduate enterprise let them off the hook when it came to the untested art of the early twentieth century. They could be supportive in both spirit and funding, along with other members of the board, while maintaining their own high standards at the Fogg. Membership in the Society cost a student from Harvard or Radcliffe two dollars a year. For this they were introduced to modern art by the likes of Léger, Miró, Braque, and Picasso, whose qualities, in just a few years, would be hardly debatable at all. The Society even staged a piece of what we would now call performance art, inviting Alexander Calder to construct his circus of wire figures on the spot and then make them perform. It was a daring and audacious enterprise, true to the spirit of the times. Soon afterward, in 1929, the Museum

of Modern Art opened in New York, with both Kirstein and War-
burg deeply involved in its formation.

By the time Rathbone joined the staff of the Society, Kirstein and
the rest had graduated and left Cambridge. They passed the leader-
ship to fine arts major Otto Wittman, who in turn urged Rathbone
and Robert Evans, an English major, to become codirectors, main-
taining the original triumvirate form to the organizations. Already
it had attracted a loyal group of followers, including several New
York collectors and dealers willing to lend work for exhibitions.
During Rathbone's tenure the society organized an exhibition of
surrealist art – the latest "group movement" – which included works
by Dalí, Ernst, Picasso, and Miró. They also organized shows of con-
temporary American artists, including recent works by Charles
Sheeler, Mark Tobey, and Stuart Davis, stressing that these Ameri-
cans showed an independence from European influences. Venturing
into the politically charged, they exhibited a series of prints by Ben
Shahn on the controversial Sacco-Vanzetti trial. The show inspired
various groups to call for the expulsion of the undergraduates
responsible for it and required President Lowell to compose a public
statement in their defense, making the whole event something of a
sensation. At peak times the Society's visitors numbered more than
one hundred a day, and by 1933 it had become a vibrant part of the
cultural life of Greater Boston.

When he graduated in 1933, Rathbone already had his eye on Paul
Sachs's highly recommended museum course. Various ideas he had
once entertained – of becoming a writer, a set designer, or a land-
scape architect – had by now faded. Ever since taking his course in
French painting in his sophomore year, he had warmed to the idea
of studying further with Sachs, for whom he felt a special affection.
While Sachs treated undergraduates with a certain formality, his
graduate students enjoyed a more intimate relationship. Although
his lectures could be somewhat pedantic – he read them aloud from
a script – he was known to be at his best in the more relaxed format
of the seminar.

Paul Sachs hardly looked the part of a museum man. In contrast

to the rather rumpled figure of Edward Forbes, Sachs dressed like a banker, as Rathbone observed with interest, in stiff collars and dark suits. He was abnormally short – about five foot two – and when he was seated on a high Renaissance chair, his feet didn't quite touch the floor. He had very dark, bushy eyebrows and piercing eyes, which appeared even larger behind his thick spectacles. He had a rich voice and a "very pleasant New York accent,"[18] and best of all, it seemed to Rathbone, a warm heart. Everyone who took Sachs's museum course also came to know Mrs. Sachs, whom Rathbone remembered as "rather broad in the beam, with an old-fashioned sort of chignon hairdo and a smile that stretched all the way from ear to ear."[19] Meta Sachs took a real interest in her husband's students, and she also had the wit and confidence it took to poke fun at her husband when he acted a bit pompous.

As his students grew in number – Perry Rathbone entered the largest class to date of twenty-eight in the fall of 1933 – Sachs maintained the informality of the course's fledgling years. On Monday afternoons he held seminars at his own home, an old federal mansion called Shady Hill just a short walk from Harvard Yard and the Fogg. Appropriately enough this was the former home of Charles Eliot Norton, the figurehead and first professor of Harvard's art history department. In the library, which ran the length of the house in the back, Sachs arranged his books as well as various artifacts and drawers full of prints and drawings. He invited his students to appraise his private collection, identify objects, and hold them in their hands. His notion was that the student should get to feel, literally, at home with art. "There you would sit," remembered Agnes Mongan, another museum course graduate, "with some incredibly rare object in your own two hands, looking at it closely … a small bronze Assyrian animal, a Persian miniature … a Trecento ivory … a small Khmer bronze head."[20]

While he encouraged them to develop expertise in one particular area, Sachs declared, "Every self-respecting museum man must have a bowing acquaintance with the whole field of Fine Arts."[21] He taught his students to be curious about everything they saw and to develop an eye for the authentic. One exercise was to identify within four minutes which of a selection of objects on the table – a piece of

brocade, a bronze object, a Buddha, a handle, a pestle – was actually made within the last fifty years. He asked them to select an object and make a case for its acquisition to an imaginary board of trustees. He trained them to develop their visual memories by asking them to list all the pictures on the second-floor galleries of the Fogg in the order of their appearance, adding to this their provenance, condition, and aesthetic value.

Sachs's students also needed to understand what went into the running of a museum from inside out and from top to bottom. He asked them to make architectural renderings of the Fogg's floor plans to better understand the particular logic of a museum building. He taught them how to catalog collections, organize exhibitions, and write press releases. He assigned research papers on a variety of topics and added to this bibliographies, class presentations, and gallery talks. He taught them to compare collections from all over the world, to have a working knowledge of what was where. One assignment was to list every single French painting in America. It was "a hothouse treatment,"[22] remembered Rathbone, one that made the students realize at once how little they had learned of the real world as Harvard undergraduates.

A museum is as good as its staff, Sachs used to say, and he meant this to apply to every level of its management. Perry observed that Sachs considered "some of our number rather too privileged,"[23] and that it wouldn't hurt them to get a taste of the less glamorous side of museum work. Sachs introduced them to janitorial duties, stressing the importance of keeping "a tidy ship."[24] Students were asked to take turns arriving early in the morning with the maintenance staff and then follow the superintendent around, dusting the cabinets and sweeping the floors.

Sachs also insisted that students be closely acquainted with artistic techniques. To that end Edward Forbes conducted a laboratory course in Methods and Processes of Italian Painting, more familiarly known as "egg and plaster." Forbes taught them how to paint in egg tempera and how to prepare a gesso panel, how to handle the esoteric materials and how to use the tools of the old masters such as the wolf's tooth. He introduced them to the technique of gilding, of painting on parchment, and the methods of fresco – both fresh and

secco – using the walls of his classroom at the Fogg Museum as their practice ground.

They visited and reported on neighboring museums such as the Worcester Art Museum and the Museum of the Rhode Island School of Design. And during the Christmas and spring breaks Sachs led his students on field trips to New York, Philadelphia, and Washington to meet dealers, collectors, and museum curators, including some of his former students who by now were well and highly placed.

Edward Forbes's *Methods and Processes of Painting* class, 1933–1934. LEFT TO RIGHT: James S. Plaut, Perry T. Rathbone, Henry P. McIlhenny, Katrina Van Hook, Elizabeth Dow, Charles C. Cunningham, Professor Edward W. Forbes, Mr. Depinna, John Murray.

They visited the collection of the Widener family at Lynnewood Hall outside Philadelphia, where the entire class of twenty-eight was given lunch and waited on by footmen in livery. They were served tea at Grenville Winthrop's townhouse in New York City, where they viewed his unrivaled collection of nineteenth-century French paint-

ings and sixth-century Chinese sculptures and jades. Sachs assured his students that the collector would be more than happy to tell them how he came upon this jade or that picture. "Look around," Sachs would say. "Ask any questions you like."[25] They were welcomed at Abby Rockefeller's townhouse on West Fifty-Fourth Street, the first home of the Museum of Modern Art. They called on Joseph Duveen, the premier dealer in old master pictures, at his stone palace at the corner of Fifty-Sixth and Fifth. Duveen would appear in his morning coat, surrounded by his faithful assistants. "The great Lord Duveen would crack a few jokes and show us a few treasures,"[26] remembered Rathbone, and he could easily see the magic this dealer worked on his wealthy clients, especially the legendary superrich of the older generation such as Frick, Morgan, Widener, and Huntington. In Washington they were personally welcomed by the curators of the National Gallery and of Dumbarton Oaks, and the collectors Duncan and Marjorie Phillips. These were the kind of receptions Paul Sachs had come to expect – and his students to enjoy – from the extensive network he had developed over decades.

A scholar may work in solitude, but a museum professional needs to be out working in the world, and Sachs never ceased to stress the importance of personal contacts. He shared his long list of leading art world figures with his students, including his careful instructions on how European nobility should be addressed, as in "My dear Contesse Beausillon" or "My dear Lord Crawford." While it was easy to recognize the great collectors, Sachs also taught them to never condescend to the lesser known, never to "high-hat"[27] the amateur, for they might very well know more than you assume, and their resources and potential for support were inestimable.

Likewise Sachs told his students to become familiar with their trustees and to visit them in their own homes. Equally important, it was essential to know how to entertain them. When an important out-of-town visitor came to Cambridge, Sachs hosted black-tie dinners at Shady Hill, inviting his students to these lavish affairs to show them both how to dress properly and how to create the right atmosphere for cultivating the rich. Last but not least, he encouraged them to become collectors themselves at whatever level they could afford. Rathbone's classmate Henry McIlhenny, coming from

a family of considerable means in Philadelphia, had already pur-
chased a major still life by Chardin, which he hung over the fire-
place in his suite at Dunster House. Rathbone's budget could
accommodate only the odd Japanese block print to be found in sec-
ondhand bookshops, but those thrilled him just as much. It was not
until his senior year that he acquired his first oil painting – a primi-
tive American portrait of a dark-haired gentleman dressed in black.
For this stern Yankee – later attributed to Sheldon Peck and today
valued at five thousand times what he bought it for in 1932 – he
paid five dollars to a roadside antique dealer in upstate New York.

Sachs embraced his students as if they were his own children.
As in any family there were inevitably some children who were eas-
ier to manage than others. It was difficult for Sachs to assert his
superiority over the three students who had started the Harvard
Society for Contemporary Art – Kirstein, Warburg, and Walker –
partly because they belonged to the same close-knit New York (and
largely Jewish) society that Sachs did. Warburg considered Sachs "a
humorless little cannonball of energy,"[28] Walker called him a
"stocky, strutting little man,"[29] and Kirstein said he was "a small and
nervous man, who hated being a Jew."[30] Some considered Sachs a
reverse snob and observed that he tended to favor students not as
privileged as he was. This made for a naturally congenial relation-
ship between Sachs and Perry Rathbone – who was neither privi-
leged nor Jewish – that lasted well into Sachs's retirement. "If he
liked you, he would never desert you"[31] was the impression he made
on Rathbone, and this proved to be true, far beyond the course of his
Harvard years. Sachs wrote letters of recommendation for Rath-
bone at the drop of a hat, letters that were the gold standard in the
field. This opened many doors as he made his way west after Har-
vard in search of a professional life, landing his first job in the depths
of the Depression at the Detroit Institute of Arts under its legend-
ary director William Valentiner. When Rathbone eventually
returned to Boston in 1955 to take over the MFA, Sachs was there to
greet him and to counsel him.

By World War II Sachs had trained hundreds of young men and
women as museum professionals. He had, almost single-handedly,
created a nationwide network of the ruling elite. This network would

continue to work together for years to come, trading opinions and personnel, collaborating on loan exhibitions, and meeting annually at the American Association of Art Museum Directors, an invaluable sharing of experience and ideas, for which Rathbone served as president for two years. The museum course was the bedrock of Rathbone's approach to museum problems and leadership as he set out into the real world, along with his museum course classmates James Plaut, Charles Cunningham, Henry McIlhenny, Thomas Howe, and Otto Wittmann. All would go on to play leading roles in the American museum world. Together these men would create a fraternity of professionals sharing the same high standards of museum management they learned from Sachs at Harvard. By the mid-1960s they had come of age, and so had their achievements.

But Sachs could take Perry Rathbone only so far. Now he was about to enter the wilderness without a map. For it was not only the social and urban landscapes that were changing but the American museum as well. The problems Rathbone faced were in large part those of the monster he and his colleagues had helped to create – a much larger and more diverse audience, with much higher expectations, a public hungry for blockbuster exhibitions and ambitious building programs. By the 1960s these pressures had reached a new peak, and it was during this same restless period of change that Harvard's Museum course was finally dissolved.

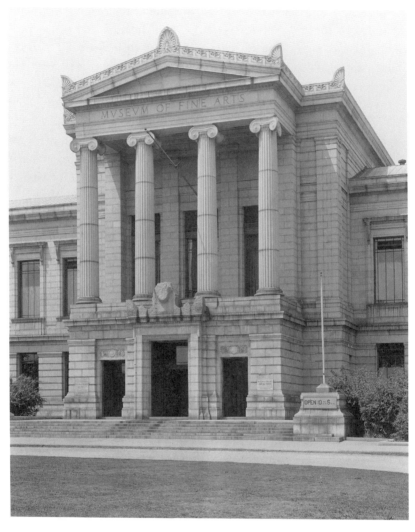

Museum of Fine Arts, Boston, Huntington Avenue façade, 1920.

The Centennial Looms

IN THE MID-1960S the Boston Museum of Fine Arts approached
its 100th birthday. Like many great cultural and educational institu-
tions in America, the Museum was an offspring of the Gilded Age,
an age of enormous wealth enjoyed by a very few that was the bedrock
of its formation. In 1870 the Museum was conceived by a group of
high-minded Boston Brahmins and incorporated as "a gallery for
the collecting and exhibiting of paintings, statuary, and other
objects of virtue and art." Six years later its first dedicated building
opened on Copley Square with its fledgling collections of paintings,
plaster casts of classical statuary, and real Egyptian mummies. Well-
to-do Bostonians were inspired to give generously to their new
Museum, and the collection quadrupled over the next decade, lead-
ing to the concept of a new building site on the parkland of the Fens.
Over the years it consistently surpassed the ambitious goals of its
founding fathers, but by the 1960s it faced an ongoing financial
struggle to maintain the high standards it had achieved. Therefore,
it was essential to make the most of its forthcoming landmark year,
to publicize and celebrate its greatness, and also to make known its
pressing needs. Meanwhile, in New York, the Metropolitan Museum
had a brand-new director, the youthful and dashing Thomas P. F.
Hoving, and the Met was gearing up for its centennial celebrations
the very same year.

The rivalry between New York and Boston, and between the MFA
and the Met in particular, was age-old. Born just two months apart,

they were from quite different backgrounds, and each had strengths the other envied. The MFA, as historian Nathaniel Burt wrote, "inherited a collection, prestige, the backing of Boston's Best and its best institutions, everything but public assistance and cash." From the beginning, Boston, compared with New York, was "scholarly, intense, serious, but poor … a long thread of complaint weaves through the rivalry of the two sister institutions, the Met always jealous of Boston's reputation, and Boston always jealous of the Met's money."[1] Boston's collection of Japanese art was unrivaled anywhere in the world (including Japan), and those of ancient Egyptian and classical art second only to the Met's, and in some areas even greater. But the Met had the noticeable edge in old master paintings, and in the eyes of the general public, that was what mattered.

These comparisons were in high relief as their centennials approached, especially with Hoving and Rathbone at the helms, both known for their bold outreach and flair for publicity. While Rathbone was a seasoned museum director now in his midfifties, Hoving was twenty years his junior and in 1967 new to the directorship of the Met, immediately following a brief stint as parks commissioner under Mayor John Lindsay and, earlier in his career, a curatorial assistantship at the Cloisters, a medieval branch museum in Fort Tryon Park. Rorimer, another medievalist and Hoving's immediate predecessor as director of the Met, had guided the Met for the previous eleven years. He was distinguished by his connoisseur's eye for quality and his expert hand at installations. But he was socially insecure, secretive by nature, and remained aloof to most of his staff as well as the general public. "Rorimer had a passion for professional anonymity and secrecy," wrote John McPhee. "He had an air of cloaked movements and quiet transactions, of indisclosable sources and whispered information – a necessity surely in the museum world, and something that Rorimer had refined beyond the wildest dreams of espionage."[2] He was also not very collegial, and Rathbone had never warmed to him.

In their choice of Hoving as Rorimer's successor, the Met trustees sought to embrace a larger public, a museum more committed to education and outreach. The Rorimer years were ones of "consolidation and careful management," according to museum historian

Calvin Tomkins, but now it was time for a leader more inclined to innovation, someone more like Rorimer's predecessor, Francis Henry Taylor, who had boldly moved the Met out of its postwar doldrums. "The pendulum had swung once again," wrote Tomkins of Hoving's appointment. "Youth and energy and fresh ideas were at a premium, and the soundest policy might well lie in the calculated risk."[3]

Hoving and Rathbone were both native New Yorkers, but from different parts of town. Hoving was born to privilege – his father was chairman of Tiffany & Co. – and young Tom grew up in a spacious apartment on Park Avenue, attended private schools, and summered in fashionable Edgartown. Rathbone was the penurious son of a wallpaper salesman from Washington Heights, attended public schools, and spent his summers at his grandmother's house in the sleepy upstate village of Greene, New York. But while there were differences in their backgrounds, their personalities shared the essential traits of the modern museum director: a natural instinct to popularize and to publicize, and a readiness to perform for the crowd, the camera, and the microphone. "A foe of stuffiness,"[4] as the press described Rathbone when he arrived in Boston in 1955, was a term that could equally have applied to the young Tom Hoving twelve years later. As historian Karl Meyer put it, Rathbone was "an older and tweedier version of Hoving."[5]

Rathbone was older, but tweedy would hardly describe the image he projected in his portrait by photographer Yousuf Karsh in 1966, which shows him as he typically presented himself – perfectly groomed and meticulously dressed, with a flair that walked the line between conservative and sporty, a casual, colorful elegance that is the museum man's special turf. Six foot two and weighing in at an approximately maintained 180 pounds, he understood the language of clothes, the quality of materials, and how to strike a pose. Stylish as he was, Perry Rathbone did not give off an air of privilege as much as pride in his role in serving the public. Despite, or perhaps because of, his privileged upbringing, "Hoving didn't have the class that Perry had, or the elegance,"[6] according to the art dealer Warren Adelson, who knew them both.

Hoving was something of a bad boy, capricious and unpredictable, a natural show-off. Rathbone strove to make people feel comfortable,

while Hoving rather enjoyed making them squirm. Both Rathbone and Hoving had an appetite for challenge and a high tolerance for risk. But Rathbone was also a stickler for accuracy, while Hoving was perfectly comfortable with the occasional white lie or colorful embellishment of the truth. He brought to the director's job a dash of the high-end salesman, with that hint of condescension, along with the savvy of a city politician. These were interesting ingredients, and perhaps just the ones needed to dodge the bullets that would certainly come flying before he was through with the Metropolitan Museum, and it with him. In retrospect, Hoving was perhaps better prepared than Rathbone for the changes that were then taking place in the museum world, and more adept at directing them to his advantage. As the directors lined up for their banner year, it was going to be an interesting dance to watch.

In 1965 Rathbone began the monumental task before him, to "lay pipe" for 1970. A centennial, as some wise person told him as he entered the planning stages, is a fate worse than death. By the time it was over, he would come to understand the full weight of those words.

For the first time in its history, the Boston Museum embarked on a capital campaign drive. Looking forward to its second century, securing the funding was a foremost priority in achieving its goals. In the 1960s inflation was changing the economic outlook in ways that no one could have predicted, and in ways that made everything going forward unpredictable. The museum's endowment went down, while the pressures on its financial resources went up. The cost of mounting exhibitions was suddenly many times what it had been just a few years before, with insurance, travel, and construction costs rising exponentially. At the same time it also began to be clear that professional curators could no longer afford to live on the modest "gentlemen's" salaries that used to be par for the course. There was the high cost of living, and there was the high cost of running a museum. Until recently the Museum's endowment had paid for 90 percent of its operating expenses. Just as the public's expectations climbed, inflation outpaced the endowment revenue. Just as the American public was becoming accustomed to the idea of improvements in every sector of public life as an inalienable right, the postwar economy began sputtering for the first time.

Architectural rendering, George Robert White Wing, Museum of Fine Arts, Boston, 1969.

The biggest challenge was the need for space; with its increased staff and operations developed under Rathbone's direction, the Museum had outgrown its building. A whole new wing was conceived to expand and improve its activities. At a projected 45,000 square feet, this new wing would increase exhibition space and relocate the administrative offices, library, restaurant, and education department. Physically it would join the two extensions at the west end of the building to form an outdoor courtyard for the display of modern sculpture.[7] Phase one of the program was to add additional space to the decorative arts wing at the East end to house the Forsyth Wickes collection in meticulously reproduced interiors of the benefactor's home in Newport, as specified by his will.[8]

Beginning with the urgent need to publicize the campaign, Rathbone moved the versatile and affable Diggory Venn over from the education department to direct the production of fund-raising materials and generally field all publicity efforts. *The Challenge of Greatness*, a lavishly illustrated booklet, detailed the Museum's needs, breaking them down into their various categories: bricks and mortar,

staff salaries, operations, and last but not least, acquisitions. After a long trustees' meeting in October 1965 to discuss fund-raising tactics ahead, Rathbone recorded in his journal the reluctance he faced in introducing the bold facts of raising money to the Yankee old guard. Clearly, they had come to take their museum's financial health for granted, to believe that they were well set up for the future, thanks to the generous and farsighted founders of the pregraduated income tax days. As Rathbone discovered to his dismay, "There was a conspicuous dislike of the direct appraisal of what our trustees *must* give."[9]

A few days later Rathbone's mood was more optimistic, following the first "cultivation" meeting for the Centennial Development Fund Drive in the ballroom of the Sheraton Hotel in Copley Square. Helen Bernat, a new trustee with fresh energy, had arranged a luncheon party for a group of prospective donors and guests of honor, including Senator Edward Kennedy, Boston mayor John Collins, and William Paley, chairman of CBS. "A bit of a strain for all concerned," recorded Rathbone, "but anxiety melted with the success of the proceedings. Mrs. B. spoke beautifully and president Ralph Lowell was at his best. Then a slide presentation with a tape recording followed by my speech which went over very well. We are encouraged. For the first time outside the Museum family I pronounced our need – $20,000,000."[10,11] In 1965, when a first-class postage stamp cost five cents, the Eastern shuttle between New York and Boston was fifteen dollars, and an average family income was less than $6,000 a year, this was a breathtaking figure indeed.

When Rathbone took the helm in 1955, the MFA was widely known as the Old Lady of Huntington Avenue – respected, staid, rich, but old-fashioned. The trustees knew full well that the Old Lady had fallen behind the times, and she required a major fix. Arriving straight from his conspicuous success as director of the City Art Museum of Saint Louis,[12] Rathbone appeared to be the kind of man the Museum was looking for to charge the place with new energy and fresh ideas.

Since 1935 George Harold Edgell, who was also one of Rathbone's professors at Harvard, had been director, but his instincts for

running the Museum remained stalled in a Depression-era attitude. "Charming and cavalier,"[13] as Rathbone described him, Edgell arrived at the MFA every day with a pet spaniel that slept under his desk and checked out early on Fridays to head for his shooting estate in New Hampshire. About once a week he made the rounds of the curatorial departments to inquire if there were any letters that needed writing. Otherwise it seemed to him there was little left for him to do and no conceivable way for him to improve on the peaceful status quo. Legend had it that museum attendance was so low that Edgell and William Dooley, head of education, used to stand at the Huntington Avenue entrance and wave their arms in front of the sensor to raise the figures. Special events, such as the afternoon tea parties that quietly honored the installation of a corridor of drawings, were attended by a loyal and mostly elderly few. MFA trustee Richard Paine, an innovative investment advisor, told Rathbone in all candor that he hoped under his directorship there would be no more of those parties that no one turned up for except "some old ladies in funny hats."[14]

The job Rathbone was taking was on an entirely different scale from the one he had left behind. The Boston Museum was considerably older than the City Art Museum of Saint Louis, and its collections far more extensive. While the Saint Louis museum had just one curator to cover all departments,[15] every department at the MFA was led by an aging curator, each one internationally revered and firmly entrenched, each in charge of his or her own little hill town. Furthermore, in contrast to the Saint Louis museum, whose operating costs were entirely supported by city funds, Boston had the only major museum in the country entirely dependent on private donations – not a single tax dollar headed its way. In the mid-1950s there was no admission charge, and Rathbone was appalled to learn that the Museum had only fifteen hundred members, nearly half of whom paid less than five dollars a year for the privilege. Meanwhile, the staff of the Museum operated a little like a men's club, in which its curators, as well as its patrons, carried on their work with virtually no accountability to their public. The collections were priceless, but the Museum was nearly bankrupt, and the galleries were dim and lifeless. It was, as Rathbone described it, "a slumbering giant."[16]

Boston's challenges were clearly visible in the mid-1950s, but

there was at least one factor making the job more attractive to Rath-
bone than Saint Louis had been at first.[17] The Museum had a conge-
nial and gentlemanly president of the board, the white-whiskered
Ralph Lowell. Lowell was the quintessential Boston Brahmin. "Mr.
Boston," as he came to be known, sat on many boards in the city,
where he performed the duties of the civic-minded philanthropist.
Lowell was the opposite of a social climber, sitting with his wife,
Charlotte, at the top of the social ladder and, in typical Boston style,
dressing the part down. Personally he seemed to see no reason to
change his habits as progress crept up around him – he never
learned to drive, and he never flew in a plane. He summered in Nah-
ant, a quiet spit of oceanfront a few miles north of Boston, and not
once in his life had he set foot in Newport, that ostentatious getaway
of rich New Yorkers. But while firmly habit-bound, Lowell was not
so conservative when it came to the evolving needs of the cultural
institutions he served in Boston. Practical and to the point, he
instinctively understood the pressing goals and needs of the MFA at
midcentury. By the time Rathbone came to the helm, Lowell, like
other members of the MFA board, was ready for change. For his part,
Rathbone understood that enlisting and maintaining the support of
the old guard was implicit in his appointment as museum director.
He would have to go about his job with a sense of respect for tradi-
tion while remaining alert to the challenge of delivering the changes
everyone understood were necessary for the MFA.

Indeed, the careful investigation of Rathbone's suitability had
been going on for months, if not years. MFA trustee John Coolidge
had visited Saint Louis two years earlier and had returned with a
very positive impression of the art museum – a grand neoclassical
edifice designed by Cass Gilbert for the 1904 World's Fair as a Hall
of Fine Arts, situated at the highest point in the city's sprawling
Forest Park. Coolidge, then director of Harvard's Fogg Museum,
found the Saint Louis museum "full of stimulating surprises, no
duds with big names ... but always fresh, unpretentious, and truly
wonderful." He credited the director with its extraordinary growth
and winning style. "Rathbone's showmanship is exemplified by his
placing of sculpture and tapestries. He has adapted an intractable
building, a monument to diverse uses, and he has expressed the

Perry T. Rathbone watches visitors' reactions to medieval limestone sculpture of the Madonna and Child in sculpture hall, City Art Museum, Saint Louis, 1952.

highest connoisseurship and taste."[18] The trustees of the MFA were at the time beginning to wonder when their aging director Edgell, now in his seventies, would retire and could hardly wait to move forward with the search for his replacement. Several other candidates were considered, including Rathbone's Harvard classmates Charles Cunningham, who would soon take on the Wadsworth Athenaeum, in Hartford, and James Plaut, director of Boston's Institute of Contemporary Art. Also under serious consideration was Richard McLanathan, already curator of decorative arts at the MFA. But while all were equally Harvard men (imperative) and graduates of Sachs's museum course (desirable), Rathbone had the edge.

In their selection of Perry Rathbone for Boston, some trustees may have been impressed by his circus-act publicity stunts, which were certainly notable (it was said he had more in common with P. T. Barnum than his first two initials). Exuberant – irrepressible, even – he never failed to dream up some colorful surprise to draw the

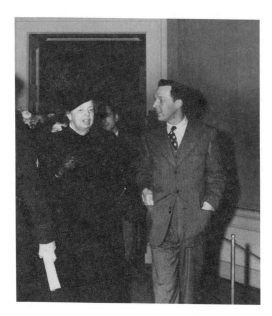

Perry T. Rathbone escorts
Eleanor Roosevelt into
Treasures from Berlin,
City Art Museum, Saint
Louis, January, 1949.

public's attention to the latest museum event. But even more to the
point, Ralph Lowell cited the number of special exhibitions he had
organized that were indeed worthy of the fanfare. The era of ambi-
tious loan shows was just beginning, and Rathbone was a clear
leader in the movement, with the extraordinary success of his exhi-
bitions from postwar Europe that, although the term had not yet
been applied to the art museum, were *blockbuster* events. In January
1949 searchlights spanned the dark midwinter skies from the top of
Saint Louis's Museum Hill to announce the exhibition of *Treasures
from Berlin,* a spectacular display of old master paintings that had
been buried in the Merkers salt mine during the war. The crowds
came in droves – some from hundreds of miles away – with lines of
automobiles clogging the roads through Forest Park to the entrance
of the Museum. To accommodate the unprecedented crowds in a
limited schedule, Rathbone pressed the city to provide special bus
service and kept the doors open twelve hours a day, from 10:00 a.m.
to 10:00 p.m. When the one hundred thousandth visitor passed
through the entrance gate, the director was there to greet the aston-
ished young woman with a gift. To this day no exhibition in the his-

tory of the Saint Louis Art Museum has topped the attendance record set by the Berlin show – an average of 12,634 people per day.

Just two years later Saint Louis would host another blockbuster. The Kunsthistorisches Museum in Vienna sent 279 works of art from their collection on a tour of American museums. Many of the works of art, including the famous Gobelin tapestries, were on a spectacular scale, and twenty-one galleries on the ground floor were cleared to accommodate them. *Treasures from Vienna* also included a number of pieces from the Hapsburgs' world-class collection of arms and armor, and Rathbone's publicity plan drew special attention to this feature, arranging for a knight on horseback to parade through the streets of downtown Saint Louis to advertise the show and later entertaining visitors when they arrived at the Museum. Again attendance hit record highs, altogether 289,546 over a six-week period, which, according to one report, was 90 percent higher than the crowds for the same show when it traveled to Chicago.

In addition to this exotic fare, Rathbone conceived and created exhibitions of American art that spoke to the regional interests of the southern Midwest, such as the popular *Mississippi Panorama* and *Westward the Way*. Consistently, he also championed modern art and local collectors, most notably the newspaper heir Joseph Pulitzer, Jr., the department store mogul Morton May, and the symphony orchestra conductor Vladimir Golschmann, thereby encouraging many other Saint Louisans to join in the excitement of collecting art of their own time. Perhaps Rathbone's greatest personal achievement was to mount the first retrospective of the art of Max Beckmann in America in 1948.

Rathbone had landed in Saint Louis right at the cusp of an era of change, and he had succeeded in transforming the museum from a quiet repository of art into a vibrant center of culture, attracting people from every walk of life. With a broad mind and boundless energy, he seemed capable of anything. News got around the country that there was a man in Saint Louis who could, and did, make the difference. With his instinct for publicity and his eye for quality, he seemed a person who could lead Boston into the future. "He'd made quite a splash in Saint Louis," recalled one MFA trustee. "He was clearly a man who had a high level of ambition. He also had a

great success at breaking some of the original boundaries of what a museum might be. It was very exciting."[19]

For Rathbone's part, it was a tortured decision to pull up stakes in Saint Louis, where his career had taken off, where he had formed enduring friendships, and where his happy family life had begun. But it was obvious that Boston's offer meant an advancement to his career, and so with excitement and resolve he accepted their offer in 1954. Francis Henry Taylor, the then recently retired director of the Metropolitan Museum,[20] sent a telegram to the MFA's board of trustees congratulating them "on securing the best man in the country."[21]

Ten years later, Taylor's description was borne out – the MFA had rallied from its slumber, and from all appearances, Rathbone, its first professional museum director, was living up to the board's highest expectations in every way. If some of the older guard had been wary of this young man from the Midwest, they could by now hardly deny his positive effect. He had instilled logic and clarity into the organization of the collections on view, and excitement into their display. To the MFA's "stifling" and "airless" galleries Rathbone had brought a "fresh breeze," said many a press review of the new director. He had "ventilated" the place with new energy and a new kind of economic prosperity, one that relied on the engagement of a broader public and the stimulation of a declining urban population. In his centennial history of the Museum, Walter Whitehill called Rathbone's initiatives "The New Deal." He cited Rathbone's combination of "rare artistic perception and knowledge with the instincts of a showman,"[22] the qualities that made this "New Deal" a reality.

Under Rathbone the MFA immediately took on a distinctly festive spirit. While the director set forth to make the museum building and collections more attractive to visitors, the Ladies Committee, under Frannie Hallowell, fanned out all over Boston and environs to drum up new members, from Newburyport to the north, New Bedford to the south, and Framingham to the west. Long gone were the days when everyone who might have cared for the Museum lived in the Back Bay or Beacon Hill; like most American cities after the war, Boston had fled to its suburbs. Furthermore, ethnic pockets of Greek, Italian, Irish, Jewish, Polish, Armenian, and Chinese needed

to be actively sought out and convinced that the MFA was not for Brahmins only. As the old saying goes, Boston was a city where "the Lowells speak only to the Cabots, and the Cabots speak only to God," but it was time for those conversations to broaden and for those barriers to break down. The Ladies Committee went about the task of ensuring they would.

Opening receptions at the Museum under Rathbone were among the most sought-after social events of the season and always well covered by the press. Hallowell and her band of ladies made every affair a memorable one, showing the same playful passion for surprise tactics for which the director had become famous. They decorated the grand staircase, designed the dinner menu, and created party favors according to the theme of each new exhibition. A fife and drum corps of men and boys led the guests into dinner for the opening of paintings by John Singleton Copley. For *The Age of Rembrandt*, the Ladies arranged Dutch floral still lifes complete with real birds' nests and bugs in formaldehyde. For *Chinese National Treasures*, they created twin dragons – a spectacle of wire mesh and evergreen clippings writhing their way down the main staircase. Rathbone could now rest assured that with the Ladies in charge, there would be plenty of drama and excitement without the need to conjure up the circus acts of his past (and which had sometimes run away with him).[23] No more "old ladies in funny hats." The MFA had become the place to see and be seen.

It was also a place where the staff loved their work, where they felt appreciated at the top, no matter what their position in the hierarchy, for the director conveyed a sincere interest in each one of them personally. "Just the way he said hello in the morning made me feel good for the rest of the day," remembered long-time staff member Carol Farmer of Rathbone's leadership. On the job, Rathbone was never one to hole up in his office; he was all over the Museum, moving through the galleries and offices at a brisk clip, addressing every staff member he encountered by his or her first name. This was not only a friendly spirit but also one that constantly showed his passionate interest in the high standard of every link in the complex chain of the Museum's management. Every December a bibulous Christmas party was held for the entire staff, which by

the mid-1960s had grown to four hundred. While many Boston-area institutions and businesses had begun to phase out the Christmas party as an unnecessary extravagance, the MFA staff fondly adhered to its traditional festivities, where the spiked punch flowed freely, musicians inspired all manner of dancing, and scholarly curators broke into song. On a more regular basis Elizabeth "Betty" Riegel,

Virginia Fay, Santa Claus, Sylvia Purrins, and Perry T. Rathbone in Greek line dance, Christmas party, Museum of Fine Arts, Boston, 1960s.

the head of the sales desk, held an informal sherry hour in the gift shop every Friday afternoon at five o'clock as her way of marking the end-of-week balancing of the books. Rathbone often dropped in for Riegel's sherry hour, and many other staff members were regulars as well. These were the gestures that buoyed morale in immeasurable ways and reinforced the feeling that every constituent was a member of the team.

But by the mid-1960s there was a seismic change rumbling beneath the surface. The pressure rose like the mercury in a thermometer – the demands of the centennial compounded by the need for new kinds and sources of money. The Museum's operations had reached a tipping point in their size and scale. While Rathbone instinctively understood how to raise revenue by enlarging the membership and increasing the programs of the Museum, he had never considered direct fund-raising a part of his job. This was not what he had been trained to do. Furthermore, it was no part of the thinking of the genteel board of trustees. As the gentlemen they were, they prided themselves on the occasional burst of generosity for the sake of a special project or acquisition or the covering of a small debt. But the idea of making a major donation to a general fund drive was outside their habit of mind or range of vision.

At the start of the centennial drive Rathbone started looking around for a professional fund-raiser, at the time a fairly new concept. After interviewing a few candidates, he hired a firm by the name of Ketchum, a name, he mused, that suited a fund-raiser. But Rathbone quickly saw that the Ketchum firm, or anyone else outside the museum family, would not be an answer to all the challenges. A professional fund-raiser can lay out a timetable and keep track of progress. Essentially, he surmised, "you pay someone to force you to do the job you have to do."[24]

What Rathbone also needed was leadership from inside the museum family – namely, a trustee to chair the campaign. His notion of the perfect fit was John "Jack" Gardner, whose family had served cultural institutions in Boston for generations, whose great-aunt Isabella Stewart Gardner, a native New Yorker, stunned Boston society with her extraordinary collection of European art and the creation of Fenway Court. Young Jack had followed his father George Peabody "Peabo" Gardner onto the board, representing the fourth generation in his family serving as stewards of the great Museum. Jack Gardner was "the right kind of proper Bostonian,"[25] Rathbone believed, to assume the role of figurehead for the campaign. Furthermore, he had recently been elected treasurer to the trustees in 1960, replacing one of Rathbone's closest confidantes, Robert Baldwin, a broker at State Street Bank, who had served for

many years "untangling administrative knots and making himself useful to everyone."[26] But Rathbone had no success persuading Gardner, or any other member of the board, to take on this important role, for the Museum had never had to reach outside its own little family for anything before, and it seemed impossible to change the habits of even the younger members of the old guard. The last thing any of them wanted to do was to go around the town with a tin cup.

Besides, these same board members were all busy supporting a full range of other beloved nonprofits. Boston had more than its share, and each commanded a loyal following. There was Harvard and MIT, the Boston Symphony Orchestra, and the brand-new Museum of Science, headed by the aggressive Bradford Washburn. There were hospitals and schools. "Owing to the great number of nonprofit institutions," lamented Rathbone, "the competition is keener [in Boston] per capita than anywhere else in the country."[27] While competition outside the walls of the MFA was rife, the spirit inside was tepid. Not since its inception had there been any kind of fund-raising effort, and among the general population, as well as the inner circles, "there was no habit of giving to the MFA."[28]

The Changing Face of the Board

In the 1960s Rathbone actively sought to change the complexion of the Museum's aging board of trustees, to bring in younger members "whose minds were open, and who already had different ideas of what a museum might be."[1] Among the young trustees of an old Boston tribe was Lewis Cabot, who joined the board in 1966. A keen collector of modern art as well as a recent graduate of Harvard Business School, Cabot, who was a youthful twenty-eight at the time of his election to the board, later somewhat facetiously commented that his election was part of an effort "to bring the average age down from senility."[2] In seeking out younger individuals of wealth with a passion for art, Rathbone knew better than to confine himself to old Boston society. He introduced Landon Clay, a collector of pre-Columbian art from Savannah; John Goelet, a collector of Asian and Islamic art from New York; and Jeptha Wade, whose grandfather was a well-known collector in Cleveland. Also noteworthy were the growing number of women on the board, with Helen Bernat, a collector of Asiatic art and also one of the first Jewish members, joining in 1966, and contemporary art collector Susan Morse Hilles in 1968, not to mention the steady representation of the Ladies Committee by its standing chairwoman. Thus new blood began to trickle in – an emerging generation of trustees with a different kind of attitude.

Rathbone also managed to persuade the trustees to make a landmark decision he had been promoting for some time. This was to open up their efforts to raise money to the business sector and to

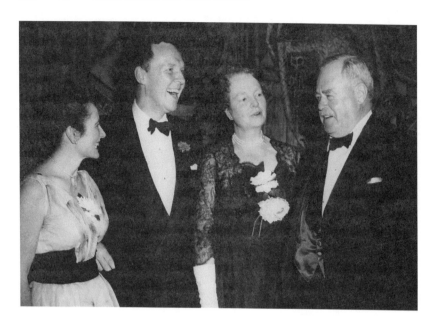

Rettles and Perry Rathbone, Charlotte and Ralph Lowell, receiving line, Museum of Fine Arts, Boston, 1960s.

institute corporate memberships. "No individuals such as those who built this place are going to pull us out of the fiscal problem we have,"[3] Rathbone told an interviewer in 1967. A promising alternative, which was gaining some credibility at that time, was for the corporate wealth of the country to "step into the breach."[4,5] While before it was considered inappropriate for a cultural institution to accept money from a business (and plenty of corporate executives felt the same way), the time had come to actively engage Boston's business community, to reach out to "more entrepreneurial people who had larger sums of money to play with," said Lewis Cabot, "and who were – dare I say it – anxious to make a social position of their lives."[6] Rathbone would be the first to admit that pure devotion to art was not the only motive of the corporate sponsor, that to have one's name attached to the Boston Museum of Fine Arts was "a passport to higher things or better circles. It's quite a feather in one's cap."[7] While this remained an embarrassment to some members of the board, the resolution passed.

Among the first corporate members to respond to this initiative was the local canned-food enterprise, the William Underwood Company, with a gift of $500 in 1965, which in the context of the times seemed promising. Underwood was doing very well with its signature product Underwood Deviled Ham and had accelerated into takeover mode, expanding its base that year with the acquisition of Burnham & Morrill of Portland, Maine, best known for its B&M baked beans (and incidentally a traditional, if somewhat disparaged, staple of the Boston diet). Underwood's CEO, a tall, imposing man named George Seybolt, was acquainted with MFA trustee William Appleton Coolidge, who had solicited his help in raising money for the Episcopal diocese. Coolidge made the introductions while Seybolt did the heavy lifting, and they managed to reach their goal of $5 million. Bill Coolidge (not to be confused with his distant cousin, John Coolidge, of the Fogg), a senior partner with the Boston law firm Ropes & Gray and a founder of Digital Equipment Corporation, was generally considered the richest man on the board, and in his quiet, patrician way, he was a force. "When Bill Coolidge had something to say," recalled trustee Jack Gardner, "everybody listened."[8] At the start of the centennial fund drive in 1965, Bill Coolidge recommended Seybolt as the kind of business mind they needed to enlist and consult. An aggressive fund-raiser with a high profile in the Chamber of Commerce and a lively interest in American antiques, Seybolt, as Rathbone later summarized, "seemed to be the man."[9]

Even though Seybolt was an altogether different kind of person from any other member of the genteel museum community – a high school graduate of the Valley Forge Military Academy among the overwhelmingly Harvard-educated board – once he began offering his services pro bono, it was but a short step to his becoming a trustee. Rathbone vividly recalled the meeting to which Seybolt was invited as a special guest to offer his advice on fund-raising tactics ahead. Seybolt looked around the table, meeting the eyes of everyone assembled, and said meaningfully, "This is a job for a trustee, isn't it?"[10] And in short order, he was elected in February 1966.

At first Rathbone was relieved to have Seybolt on the board to help him focus the trustees' attention on the Museum's financial needs

and shoulder the burden of fund-raising. If more established members of the board were unwilling to lead the charge, what could he do? If Seybolt wasn't exactly the image of old Boston, he was the image, perhaps, of the new Boston. Rathbone had understood from the moment he arrived there that the mold had to be broken, and here it was breaking in a new way. Seybolt was ready and willing. More than that, he was aggressive, he was ambitious, and it was clear that he had his eye on the bottom line, and that was what mattered now.

Seybolt immediately perceived flaws in the system. For one thing, the board meetings were too short, and too few – President Ralph Lowell saw no reasonable call for more than three or four meetings a year and took pride in the fact that they usually concluded within two hours. For another, the board did not seem to be presented with any real problems to solve. Lowell would review the director's report about an hour before the meeting, and then they would all sit down around the table to listen and discuss it. "Everything at that point was very polite, deferential," remembered Cabot, "a steward without being a visionary was the way the trustee saw his role."[11] These were the quiet, responsible guardians of a public trust, stewards of a great ship, but they were not her captain. When faced with a proposal of any kind, Ralph Lowell "just smiled and signed, smiled and signed."[12]

"What they got was canned food," Seybolt complained with an interesting choice of metaphor, "all prepared, even chewed and regurgitated – they got this pat stuff." As he observed the proceedings at one meeting after another, Seybolt quickly concluded that he himself was "the only one there that was really living in the world as it was."[13]

Around the Museum, staff and trustees alike noticed that Seybolt's ideas were strikingly corporate, his manners were alternately intimidating and overfamiliar, and it was clear he had an agenda. Some perceived his ambition was not just for the MFA but also for himself – to gain access to the top tier of Boston society. Lewis Cabot regarded him as "a very complicated man, driven by social prestige, wanting to be acknowledged as one of the substantial people in what was then called 'the Vault'[14] downtown."[15] It was rumored that Seybolt's election to the board was contingent on his membership to the

exclusive Somerset Club on Beacon Hill. With his wife, Hortense, he began to appear at high-profile museum events, where the columnists from the *Boston Globe* and the *Boston Herald* would spotlight the up-and-coming and where the old money would rub shoulders with the new. His tall, heavy figure, dressed in a white dinner jacket and a dress shirt embellished by an extravagant ruffle, betrayed that Seybolt's origins were far from Back Bay Boston.

At the start of the capital campaign Seybolt accompanied Rathbone to New York to meet with all the heads of the big foundations, the first time ever that the Museum had approached them for funding. Seybolt had already observed that Rathbone was "a master salesman."[16] He had watched him raise money for the acquisition of a medieval sculpture – the bewitching *Virgin and Child on a Crescent Moon* – in the midst of a dinner party, with not one person at the table suspecting they were being "set up." In New York, as Rathbone recalled, they did their Mutt and Jeff act, with Rathbone talking up one aspect of the Museum, and Seybolt another. They made an odd pair – Rathbone, charming and ebullient, a person whose instinct was to make each encounter social and personal, easily conveying his knowledge and passion for art and for the Museum, alongside Seybolt, with his intimidating eagle eye and razor-sharp business sense to remind everyone exactly what they were really there for. With their assault on the big foundations, Rathbone and Seybolt garnered the first round of centennial donations.

In 1968, as the centennial drew near, they had raised about $8 million, but their goal of $20 million was still far from achieved. Ralph Lowell retired as president of the board that year. Seybolt, who had vowed as a young boy that he would be president of something by the time he was forty,[17] having surpassed his goal by his midfifties and was ready to be president of something else. Furthermore, he had proven to his fellow trustees that he had the administrative skills they either lacked or did not choose to apply to the MFA, and to some trustees he seemed to be the obvious candidate to succeed Lowell as president of the board.

As the new president, Seybolt immediately laid out his agenda. The Great Inflation was up and running, and museums across the country were experiencing financial strain as never before. Seybolt's

approach was first of all to confront "the practical hard realities of the world"[18] that his fellow board members had ignored. The MFA's annual report of that year presented a dire picture. "1968 was a year of physical expansion, administrative enlargement, and financial retrenchment,"[19] as Rathbone broadly stated the facts that year. Treasurer Jack Gardner admitted a deficit that had grown alarmingly "due to the net increase in exhibition expense"[20] and announced that a major overhaul of the budget was under way.

Suddenly, everything had to be accounted for – every dollar, every minute of the day. "All of a sudden everyone woke up," recalled Lewis Cabot. "How much did it cost to change a lightbulb? There were new ways to size up the total value of the museum as compared

Perry Townsend Rathbone, Director, and George Seybolt, President, Board of Trustees, 1967–1971.

to the total cost of maintaining it, in ways taught at the Harvard Business School – the museum itself as one big cost operation."[21] In 1967, they estimated, it cost about $15,000 a day to keep the doors of the Museum open.

Seybolt's appointment as president in 1968 also coincided with

the Museum's decision to charge admission for the first time in decades. It was an action Rathbone was reluctant to take, but in the face of the Museum's financial straits, it was unavoidable – the kind of hard-nosed business decision that required a real businessman to make. As a result, attendance figures dropped for the first time since Rathbone had been director; until then they had been steadily on the rise. The downside of the admission charge, however, was somewhat mitigated by a related initiative that helped maintain the Museum's democratic goals and commitment to the community: an appeal for public funds to admit children younger than age sixteen free of charge. Rathbone made the Museum's case to the General Court, inviting city leaders and legislators to the Museum for luncheons and special tours, and aided by strong editorial support from the local press, the MFA received public money from the city of Boston for the first time in its history.

Also that year, Rathbone hired the Museum's first in-house head of development, the amiable James Griswold, formerly treasurer of Phillips Exeter Academy.[22] At the time the very idea of a development department was a new concept for art museums, and its exact position within the hierarchy of the administration not fully defined. It was soon evident to Griswold that "they didn't know what to do with me." Not only were the boundaries of his position unclear, but the chain of command was too – he didn't know whether he was working for the director, as he had been led to believe, or the president of the board. As Griswold recalled, Seybolt had "a totally different concept of what a trustee's job was. He wanted to be the boss and he ran it with a horse-whip."[23]

Seybolt had a vision and a plan, and he took on the presidency in a strikingly proactive spirit. It appeared that for him the MFA was becoming a nearly full-time occupation. He suggested to Rathbone that he needed "a place to hang his hat,"[24] then requested his own telephone, and soon he wanted a desk to put it on. It would not be long before he commanded his own office suite, which meant the regrettable closing of the primitive art gallery[25] in the ongoing encroachment of offices on gallery space, and two private secretaries.

Seybolt also perceived problems in the structure of the board going forward. "To make big changes in the system wasn't possible,"

he said, "unless you brought in new votes, so to speak." Even with
the addition of new, younger members, there was still a majority of
old-timers, "who tended to be drenched and instilled and distilled
with their ancestors,"[26] as Seybolt described them. Furthermore, the
structure of the board as originally laid out in the bylaws was top-heavy
with ex officio members, including not only the token representa-
tives of the city government, such as the mayor and the superinten-
dent of schools, but also three each from the Museum's founding
institutions: Harvard, MIT, and the Boston Athenæum. "The cradle
of the Museum of Fine Arts was so surrounded by fairy godmothers,"
wrote Nathaniel Burt of its early years, "that it almost suffocated."[27]
Rathbone, who as director was also automatically a trustee with a
voice and a vote,[28] agreed with Seybolt. For while this arrangement
represented a balance between professional input and financial sup-
port, it also meant that the ex officio members had other priorities.
Said Rathbone, there was "a need for new blood and people who
were devoted to the Museum first, last, and most importantly, and
not to others."[29] In due course Rathbone and Seybolt persuaded the
rest of the trustees to agree to change the bylaws to cut back on the
ex officio members from nine to three – one from each of the found-
ing institutions – and thus expand the limit of elective trustees by six.

As president, Seybolt did not confine himself to his office or board-
room. Like the director, he began to make a habit of touring the
Museum, encountering staff members from every department, and
taking a seat beside them in the staff dining room. "He was nosy and
pokey, and very pompous," recalled the Museum's graphic designer
Carl Zahn, who had contributed significantly to the fresh image of
the Museum under Rathbone. "He would always buttonhole me as if
he was my boss."[30] Others were bold enough to remind Seybolt that
they answered not to him but to Rathbone. He seemed to be looking
for holes in the system and signs of inefficiency at every turn. "You
felt somehow disapproval in his every glance,"[31] recalled Rathbone's
secretary Virginia Fay. To the staff, Seybolt was a stern and over-
bearing figure. Furthermore, he was becoming increasingly uncom-
fortable with the fact that, as he put it, "the actual management of
the museum and really all of its force came from the director."[32]

Soon he began to create a deluge of memoranda that landed on

Tamsin McVickar, administrative
assistant to the director, 1960s.

Virginia Fay, administrative
assistant to the director, 1960s.

Rathbone's desk at an alarming rate – with questions, calculations,
and propositions that demanded an immediate response – and he
popped up on the trail of the director's movements throughout his
busy day. "I'm here because you're here," he would say, wrapping
one arm around him, and, "You're a great guy,"[33] giving him a punch
in the shoulder. Eleanor Sayre, curator of prints and drawings,
recoiled at Seybolt's gestures of intimacy and regarded them skepti-
cally as a power tactic. "Seybolt grabbed me in his arms and kissed
me, wanting to show his power over me," she recalled. Sayre could
see that the new president intended to run the Museum himself,
even though "he knew absolutely nothing about art or museums."[34]
As Seybolt made his personal study of the Museum's management,
he was fascinated by Rathbone's involvement with every single detail,
and by the continuous parade of staff members in and out of the
director's office. "Mr. Rathbone was the boss," said Seybolt. "Practi-
cally all decisions, by his admittance, even to the placing of the
guards in the museum, had been observed or directed by him."[35]

Rathbone needed plenty of air, and Seybolt didn't seem willing to
give him, or anyone else on the staff, the space to breathe. While the

trustees were the custodians of the Museum, they were not respon-
sible for, nor greatly aware of, its day-to-day operations, and this, to
Rathbone's mind, was as it should be. His most sensitive task was in
the direction of his curatorial staff, and this he did with a keen
instinct for the curatorial mind and a singular talent for inspiring
its heart. "He was in and out of every curatorial department at least
once a week," remembered Laura Luckey, an assistant curator in
the paintings department, "lifting everyone to a different level.
Nobody slouched around; we all worked hard."[36] While he kept in
close touch with his staff, he also gave them "a great deal of lati-
tude," and in responding to their problems or questions, "he was
very approachable,"[37] remembered assistant curator Lucretia Giese.

The combination of his high professional standards and personal
approachability made Rathbone an effective leader, and the Museum
a happy place to work. When Seybolt became president of the board,
the mood inside the Museum shifted palpably. He wanted to estab-
lish strict budgets for each department along with a strict definition
of its function, and he pressed the curatorial staff to observe a con-
ventional eight-hour workday. He aggressively pushed for the
entirely new concept of cost accounting, which would consolidate the
Museum's use of outside vendors and freelancers, sometimes adding
to the cost of services and eliminating long-trusted relationships.
"Cost accounting has its advantages for an institution over a certain
size," Rathbone later said, "but it was never presented [by Seybolt] in
a sympathetic way."[38] As Rathbone's secretary, Tamsin "Tammy"
McVickar, recalled, "Seybolt was a tough business man; he was rough
around the edges."[39] Carl Zahn remembered that with Seybolt's style
of management, "everything was bent to the buck."[40] As Laura
Luckey described the change in atmosphere, "It was as if someone
came in with a gigantic bowl of cold water and threw it all over us."[41]

The feeling of estrangement was mutual. As Rathbone was even-
tually to determine, Seybolt was out of his depth, and from the start,
he "nourished a great distrust of the professional staff."[42] Like many
people who know very little about a very esoteric subject, Seybolt
did not have the tools to assess the quality of the experts around him.
He was "intimidated by scholars,"[43] as Rathbone observed. In his
impatience for a managerial makeover, the subtleties of the curato-

rial enterprise puzzled and confused him. The care of unique objects was alien to the tenets of mass production. The combination of talents required for museum work was in no way akin to those of factory work or the strictures of the military academy.

Under Rathbone's directorship, salaries were negotiated and job descriptions shaped around an individual's skills, which often overlapped with others as the need arose or the talent manifested itself. Rathbone encouraged the curators to be entrepreneurial, to build support for their own departments among collectors and donors, to supplement their limited budgets with outside support in their own creative ways. Seybolt wanted those organizational lines to be drawn clearly, to minimize the budgetary unknowns, which included minimizing the director's discretionary spending, the flexibility of his budget, and the multiple opportunities for exercising his judgment. "His wings were clipped,"[44] said Tammy McVickar, who had witnessed him move through this awkward transition. Seybolt, with his sharp business tactics, seemed to be showing up Rathbone as an administrative lightweight – all charm and no numbers.

Under the increasing pressures of the director's job, in 1968 the trustees voted to establish a new position: assistant to the administration. Heyward Cutting, an architect and former trustee, was perceived to be a good fit. Cutting was something of an adventurer whose finest hour was as perhaps a lieutenant with the British army in North Africa during World War II; later he spent five months living with Eskimos on the Arctic Slope. He had a habit of expressing himself in mysterious metaphors and circuitous prose, as if everything had the quality of an intrigue. Almost immediately, having rather enjoyed him as a friend, Rathbone distrusted him in his new administrative capacity. As one former staff member said frankly of Cutting's appointment, "Heyward was a secret enemy. He was always undermining Perry whenever he had a chance. Basically [the trustees] put a spy in his pocket."[45]

Given the economic climate, it was natural for board members to be drawn to a program that seemed to be fiscally responsible above all else. Seybolt embodied that notion. To Virginia Fay, Seybolt's restructuring plans seemed like "a bill of goods he could sell to people who didn't know money very well."[46] While museum man John

Coolidge respected Rathbone's integrity and style, he also viewed Seybolt with a certain awe. "George was very good at breaking out the pattern of trustees," recalled Coolidge. "He was very active, astonishingly more than Ralph Lowell had been."[47] Like the standing president Lyndon Johnson, Seybolt was a workaholic and a natural at legislation. He lived for administration in the same way that Rathbone lived for art. While in the old days trustees' meetings were held quarterly, now they were once a month. Paperwork was the new president's medium, and meetings were his game of chess as he calculated his next move depending on who was present and who was not. His experience in naval intelligence during World War II had equipped him with the tools for sizing up the other men at the table.[48] If they were powerful, he looked for signs of weakness, for these were the ones he needed to conquer; the rest would fall in. Rathbone would sometimes catch Seybolt's eye across the table and realize that his every word and gesture was under scrutiny. The longer they spent in each other's company, the less their goals seemed to match.

The effective museum director walks a delicate line between the socially and financially powerful board of trustees and the brilliant and sometimes temperamental professional staff. This delicate passage that Rathbone regularly navigated as messenger and interpreter between them was "the neck of the hourglass," as he described it, and not easily understood by the trustees, "who are not involved with the day-to-day operation of the museum, and should not be – at all."[49] From Seybolt's point of view, the exact opposite was true. He was uncomfortable with Rathbone's directorial power. "He was obviously, and the museum was obviously, going to get into trouble very shortly," he later said of Rathbone's directorship, "because of the lack of anything else but this single person, who held all the strings in his hand."[50]

As Seybolt's initiatives were gaining ground with some of the trustees, Rathbone began to think his power usurped, and "for the first time in his professional life as a leader, probably even questioning his own judgment about how he should handle things," commented Fay. "He was a little flamboyant, too, for their taste – this group of so-called serious moneymakers. Suddenly the fun was over, out – seriousness was in."[51]

Committees multiplied under the new regime. With every issue

that arose, Seybolt urged the trustees' involvement by forming an ad hoc committee to deal with it. For the longer term, he initiated a Men's Committee to further fund-raising efforts (his answer to Rathbone's powerhouse Ladies Committee), four separate committees to deal with the Museum's budget, and a special committee on the Museum's bylaws. With each committee meeting regularly and every board member expected to keep abreast of the minutes that circulated promptly afterward, the trustees of the late 1960s "began to have more detailed current knowledge of many phases of operations and policy than in the past,"[52] noted Walter Whitehill. But no one worked harder than George Seybolt. Besides being president of the Board, he served on nine committees at the Museum, several of which he had created himself.

While he was not universally liked by members of the board and many objected to his rough manners, as James Griswold explained the situation, "The trustees tolerated George Seybolt because he was willing to do the work they didn't want to do."[53] Seybolt, stepping into that vacuum, had gained the edge. The revelation came to Rathbone one day when he visited Seybolt at his home in the Boston suburb of Dedham. Showing him into his study, Seybolt pointed to the big, deep chair behind his desk, its cushions molded to the wear of his heavy frame. "I sit there until four in the morning, dictating,"[54] Seybolt told the director, providing a disturbing and indelible image of his searing ambition to keep his presence felt in every organization he served, every working day.

In retrospect, Rathbone perceived the downside of reducing the

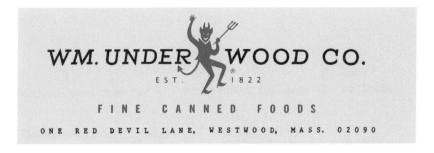

William Underwood letterhead, 1960s.

number of ex officio members of the board. With Seybolt now steering the nominating committee as well as chairing the board itself, he could handpick only board members who were open to his business ideas. In Rathbone's view, the old structure had ensured that the balance could never be tipped, that a single ambitious person could never dominate the board. "While the old system prevailed, there was a kind of preventive body of men who were very objective and disinterested, who could see things from their own points of view," Rathbone later reflected, "this objectivity was somewhat surrendered when the trustees reduced the number [of ex officio members] from nine to three ... and the way was open for an ambitious person who had some control of the nominating committee to get on to the board those people he wanted for his own ends."[55]

PTR's Other Hat

WHEN RATHBONE assumed the directorship of the MFA in 1955, William George Constable was curator of paintings. "W. G.," as he was familiarly known, a tall, chiseled Englishman and distant kinsman of the painter, had come to Boston from the Courtauld Institute, in London, in 1938. In his nearly twenty years as curator, Constable had many major acquisitions to his credit, among them Renoir's delightful *Bal à Bougival*, a shining star in what was already a dazzling impressionist collection, as well as Gauguin's arguably greatest late work, the epic, panoramic *D'où venons nous?* Works by Titian and Tintoretto also entered the collection, and Constable focused particular attention on filling the gaps in the Museum's seventeenth-century holdings with works by Rubens, Rembrandt, and his favorite, Canaletto. In American paintings, the department's longtime associate Barbara Parker helped to guide the hand of the MFA's great patron, the Russian-born Maxim Karolik, building important representations of Fitz Henry Lane, Martin Johnson Heade, and Thomas Cole.

But while his record for old masters and nineteenth-century acquisitions was admirable, Constable had little interest in art of the twentieth century, and the collection had lagged far behind in this regard, missing many opportunities for growth. His excuse was that he did not wish to interfere with the activities of the Institute of Contemporary Art, but since the ICA had no permanent collection, this was rather a feeble alibi. It is probably safe to say that modern

art simply did not interest him, just as it held little interest for the director, George Harold Edgell.[1]

For the incoming director, Constable's pace in his late seventies was ponderous, his ideas awfully old school, and his attitude a trifle condescending in that English sort of way. But if Constable was the biggest thorn in Rathbone's side, the opposite was also certainly true. Constable had experienced little conflict with the former director, and while some criticized Edgell for doing little in the way of curatorial leadership, for Constable this was probably just as well.[2] Under Edgell, he was given free rein. "As a matter of fact," Constable later admitted, "he'd take any suggestion I had."[3] Not so with the new director, who had ideas of his own. Even before officially taking office, in 1954 Rathbone craftily overrode Constable's dismissal of a fine Lucas van Leyden, *Moses Striking the Rock*, which was offered to the MFA from a dealer in New York, and persuaded the trustees to purchase it, the Museum's first by that artist. The acquisition of the van Leyden was but one of the several ways in which Rathbone would give Constable the distinct feeling that his retirement from the Museum would soon be welcome.

Rathbone was also determined to instigate an ambitious exhibition program in which the previous director had shown little interest. As early as February 1955, Rathbone had been consulting with acting director Henry Rossiter about a John Singer Sargent exhibition to mark the artist's centennial the following year. Rather than the obvious Sargent retrospective, Rathbone suggested something more focused to highlight Sargent's special ties to Boston and the Museum's outstanding works by the artist, including perhaps his greatest work of portraiture, *The Daughters of Edward Darley Boit*, as well as the late, mythological murals that decorated the domed ceiling of the Museum's rotunda. It would be a great opportunity to clean the murals and install up-to-date cove lighting so that they could be properly seen for the first time since anyone could remember. With the dome itself the centerpiece, the rotunda was the grand entrance to the show. This further inspired Rathbone to designate those galleries on either side of the grand staircase for special exhibitions for the rest of his tenure.[4]

Loans were easily at hand from among the many local subjects of

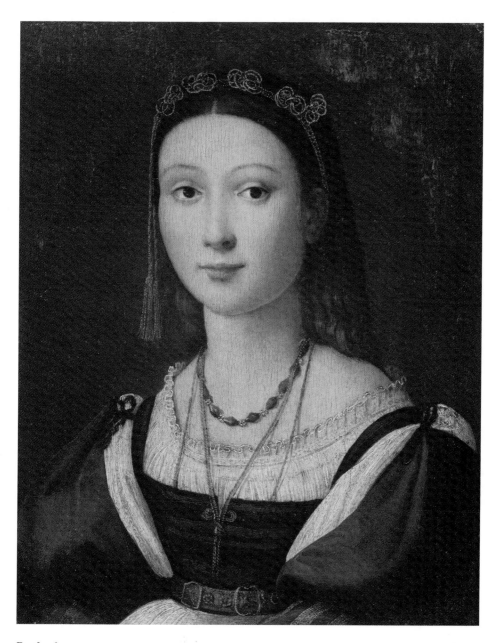

Raphael
Portrait of a Young Girl
Italy, 1505
Oil on panel (8 ³⁄₁₆ × 10 ⁹⁄₁₆ in.)

Rosso Fiorentino
The Dead Christ with Angels, about 1524–27
Oil on panel (52 ½ × 41 in.)

Lorenzo Lotto
Virgin and Child with Saints Jerome and Nicholas of Tolentino, 1523–24
Oil on canvas (37 ⅛ × 30 ⅝ in.)

OPPOSITE:
Bernardo Strozzi
Three Angels
Italy, about 1631–36
Oil on canvas Overall: (33 ⁷⁄₁₆ × 47 ¹³⁄₁₆ in.)

Bernardo Strozzi
Saint Sebastian Tended by Saint Irene and Her Maid, about 1631–6
Oil on canvas (65 ⅝ × 46 ¾ in.)

Giovanni Battista Tiepolo
Time Unveiling Truth, about 1745–50
Oil on canvas (91 × 65 ¾ in.)

Fitz Henry Lane
Boston Harbor, about 1850–55
Oil on canvas (26 × 42 in.)

George Romney
Anne, Lady de la Pole, about 1786
Oil on canvas (94 ⅞ × 58 ⅝ in.)

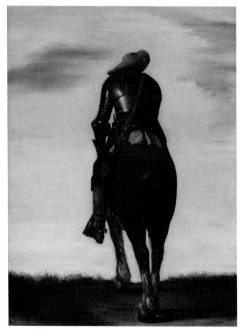

Jacob Isaacksz. van Ruisdael
Rough Sea, about 1670
Oil on canvas (42 ⅛ × 49 ½ in.)

Gerard ter Borch
Man on Horseback, 1634
Oil on panel (21 ⅝ × 16 ⅛ in.)

Nicolas Lancret
Luncheon Party in a Park,
about 1735
Oil on canvas (21 5/16 × 18 1/8 in.)

Giuseppe Maria Crespi
Woman Playing a Lute, about
1700–05
Oil on canvas (47 3/4 × 60 1/4 in.)

John Singleton Copley
Corkscrew Hanging on a Nail,
late 1760s
Oil on panel (5 ⅜ × 5 ⅝ × ⅞ in.)

Erastus Salisbury Field
Joseph Moore and His Family,
about 1839
Oil on canvas (82 ⅜ × 93 ⅜ in.)

Sargent's portraits or their descendants, which in many cases were still in the family. Sidestepping Constable, Rathbone invited a curator from the Boston Athenæum, David McKibbin, to contribute fresh scholarship to the catalog. A stylish installation was also essential to the show's success. Rathbone's idea was to integrate decorative arts and furniture to emphasize the painting's place in the private home – to warm the atmosphere with everything from antique chairs and tables to carpets and candlesticks and potted palms. He was especially keen to borrow the very same giant Chinese urns that are featured in *The Daughters of Edward Darley Boit* and approached a member of the family with his plea. To his delight he learned that they still owned the urns, but, to his dismay, declined to lend them, owing to the various precious things they had deposited inside them over the years, though exactly what and how precious those were remained a mystery. Admitting defeat with the family, Rathbone managed to borrow two similar, if slightly smaller, urns from an antique dealer of his acquaintance in Saint Louis to achieve the same general effect. Constable, who had been relegated to a backseat in these arrangements, played the good sport. "Splendid!" he exclaimed on a preview of the exhibition with Rathbone. "Capital! Don't change a thing!"[5]

Sargent's Boston was a major cultural event of the winter season of 1956, and the opening reception a great society affair. For the director it was also perfectly timed. Members of the old guard who might have been nervous about the exuberant young man from the Midwest with a conspicuous taste for modern art were reassured of his eminent good taste and judgment. Instead of portraying them as behind the times, Rathbone had reconnected local society members with Boston's golden age. Sargent's portraits of the great and the good – handsome, lively, and fashionably dressed – flattered them all.

"Boston at the end of the 19th century has come to life at the Museum of Fine Arts,"[6] declared the *Boston Herald*. "I've never seen so many second- and third-generation Sargents in one room," mused one guest. Mrs. James Lawrence posed before a portrait of her mother, and Miss Elizabeth Hammond was overheard exclaiming, "There's my father!" By staging a show that exuded all the comforts of a Brahmin family home, Rathbone had made his first strategic move in winning the confidence of influential Bostonians.

Amid the glamour of special exhibitions and opening festivities, there was plenty of housekeeping to do, some of it urgent. One of the first issues Rathbone had to address upon his arrival in Boston was the leaking roof and skylights over the Evans Wing, which housed the painting collections. The expedient solution, which many board members advocated, was to do away with the skylights altogether, cover the whole area with gypsum and slate, and rely on artificial lighting. Rathbone strongly believed in the value of natural light, and after countless rooftop meetings with building superintendent Walter Orech and trustee treasurer Robert Baldwin, the skylights were slated for preservation. His first decisive directorial act would cost nearly half a million dollars by the time it was done, and it wouldn't even show. Sizing up the magnitude of the job he faced at the MFA, Paul Sachs had warned Rathbone, "It will take five years before you get your fingers over the edge of this job."[7] Taking Sachs's wisdom to heart, Rathbone knew by then that he would have to actively cultivate the virtue of patience as never before.

In 1957, to Rathbone's great relief, Constable retired. At that time the paintings department staff consisted of the curator, the paintings conservator John Finlayson, and one young research assistant, Thomas Maytham, a blond, blue-eyed, twenty-six-year-old graduate of Williams College and Yale's graduate school, whom Constable had hired just six months before. Maytham recalled the surprising day when Rathbone walked into the department and announced that Constable was retiring and that, for the time being, he told him, "You'll be in charge."[8] Maytham could not have been surprised to learn that the job was not so much to be in charge as to be a ready and willing assistant to Rathbone, who could hardly wait to move forward with his vision for the department. Among its pressing needs was a complete restoration and reinstallation of the paintings galleries – removing dark, old-fashioned dado paneling and awkward wings that carved up the space and the sight lines, and completely rethinking and modernizing the rooms in terms of lighting, color, and the placement of pictures. Delighting in this task, Rathbone directed Maytham into running around after this wall fabric and that paint sample, as well as taking care of loan requests and other routine business calls for the department.

Equally urgent, if not foremost in Rathbone's mind, was the task of bringing the collection more fully into the twentieth century. Rathbone had come of age in an era when first-rate modern works had been a bargain for any collector, but now the market for them was heating up fast – too fast – and Boston had a lot of catching up to do. It had been almost thirty years since the Museum of Modern Art opened in New York, in 1929, at just about the same point when the Boston Museum had abruptly ceased to collect or exhibit the art of its own time. The Harvard Society of Contemporary Art had been the audacious precursor of the Museum of Modern Art, and the Institute of Contemporary Art in Boston had been established soon afterward as a regional satellite. Meanwhile, the MFA had taken a backseat, with Constable focusing his efforts on old masters and impressionists. The prints and drawings department had actively collected modern works on paper, as this could be more discreetly and less expensively done than with paintings and sculpture, but they were only sporadically exposed to light. By the mid-1950s Boston's art-minded community, except for a very determined few, was woefully out of touch with modern art.

At that time Boston was also conspicuously lacking in major collectors in any field. In modern art there were none that even approached the commitment Rathbone had come to know and to nurture in Saint Louis. His aim from the start was to reverse what he already perceived as a worrisome prejudice. "If modern art is withdrawn from the public," he commented in one of his first Boston interviews, "prejudice against it will linger indefinitely."[9] Those less inclined to seek out the latest events at the ICA (which lacked a permanent collection, as well as a permanent home)[10] needed the commitment of the MFA to believe that modern art was not peripheral but central to their lives.

Therefore, one of Rathbone's first priorities was to clear a large ground-floor gallery at the Museum for the display of modern art. This would showcase both recent acquisitions and temporary loans on a rotating basis, its main purpose being "to provide a suitable space in the museum where the visitor may count on seeing important examples of the art of our own time always on view."[11] With the opening of the new gallery in August 1956, Robert Taylor of the

The Beal Gallery before renovation, Museum of Fine Arts, Boston, 1961.

Boston Globe heralded this "an event of enormous significance to local art and artists."[12] Among the Museum's new acquisitions were Ernst Ludwig Kirchner's *Mountain Landscape from Clavadel*, a Matisse still life, and works on paper by Picasso and Braque, while abstract painting made its debut with works by Mark Tobey and Nicolas de Staël. Temporary loans from private collections added to the scope of the display with *The Tempest*, by Max Beckmann; a Calder mobile; a carved stone figure by Henry Moore; and a surrealist Miró – all in Rathbone's sights for the permanent collection.

The establishment of the ground-floor gallery at the MFA was just a beginning. With the popular 1957 Sargent show behind him, Rathbone planned the Museum's first major loan exhibition of modern art in forty years.[13] At the time, the prevailing trend in contemporary art was for abstract painting. Jackson Pollock's violent death that year made the abstract expressionist movement even more sensationally newsworthy, and the movement nearly historic by the time it had come of age.

The Beal Gallery after renovation, Museum of Fine Arts, Boston , 1962.

Instead of focusing on the trend of the moment, Rathbone chose to provide a broader European foundation of modernism to a neglected Boston audience,[14] a perspective that might "give meaning to future exhibitions of a more specialized nature." In particular he hoped that the exhibition would serve "several purposes peculiar to our problem in Boston."[15] First, it would provide a foundation for the appreciation of modern art; second, it might revive an interest in collecting contemporary art that had not been seen in Boston since the Spaulding brothers had actively collected the French impressionists fifty years earlier. Drawing from eighty-two public and private collections from America and abroad, including from some close ties Rathbone had made in Saint Louis with avid collectors such as Joseph Pulitzer, Jr. and Morton May, *European Masters of Our Time* was a major event.

In his catalog introduction, Rathbone tactfully admitted that modern art was difficult at first for many people to appreciate but that it had proven to be worth the effort. "Fifty years have worked

extraordinary change on the part of the lay public," he asserted, "a public which no longer stopped at the realist watercolors of Winslow Homer, or the dashing portraits of John Singer Sargent." Museumgoers were ready to engage in the conversation that modern art introduced – a conversation with the viewer on a more personal level. "The tree of modern art has continued to bear strange, exotic,

New gallery for modern and contemporary art, Museum of Fine Arts, Boston, 1956.

and sometimes bitter fruit,"[16] he admitted, citing the shift from representational art to abstraction as the most challenging aspect of the change. It was high time that Boston had a taste of it.[17]

The opening of *European Masters of Our Time* in October 1957 attracted a "genteel crush" of three thousand museum members, reported Edgar Driscoll in the *Boston Globe*. With this show, Boston "has taken a giant step forward in its belated acceptance and encouragement of contemporary art."[18] Howard Devree, of the *New York Times*, noted, "The response to Mr. Rathbone's challenge has been immediate and surprising."[19] While the show had its share of vocal detractors resistant to modern art, this only helped to stimu-

late a lively interest in seeing it. The nine galleries devoted to the exhibition were thronged throughout the day, and students from schools and colleges up to a hundred miles away came by the busload. As the notably conservative Walter Whitehill commented years later in his centennial history of the MFA, "Like Serge Koussevitzky,[20] who often made Bostonians listen to contemporary music whether they wished to do so or not, Perry Rathbone rubbed their noses in contemporary art."[21]

Of all the many challenges of running a museum, the search and capture of great works of art was the one Rathbone loved the most, and the role he was most reluctant to relinquish upon leaving Saint Louis, where he had exercised full curatorial power. As Jim Ede, the former curator of modern art at the Tate Gallery, in London, reminded him before he went to Boston, Rathbone's acquisitions for Saint Louis were very much a part of his "name and fame." Ede encouraged him in accepting Boston's offer to make sure that he would have "free movement in the department of painting."[22] In a 1960 article for *Canadian Art*, "On Collecting," Rathbone wrote of the "supreme obligation of the office which beyond question endows the director with lasting satisfaction: collecting, making acquisitions." This was the challenge that made the more arduous burdens of the job worthwhile. This was the elixir, the act that "elevates the spirit, this is the deed that makes glad the directorial heart." Rathbone enjoyed exercising that part of his mind and his taste perhaps more than any other – where his judgment was "brought to bear most vitally,"[23] his expertise most depended upon, and his deeply concerned knowledge of the collection he was building the most important factor of all. Furthermore, he understood that his legacy to posterity would depend on great acquisitions more than anything else. But with every passing year, the sense of the growing rarity of great works of art accelerated, along with the higher stakes required to obtain them. A single event dramatically signaled the change in the art market for old masters at midcentury. In 1961 the Metropolitan Museum bought at auction Rembrandt's *Aristotle Contemplating the Bust of Homer*.

Rathbone was in New York to witness the spellbinding evening sale at the leading auction house Parke-Bernet, having already surrendered to the unhappy fact that the MFA was out of the running.[24] The Rembrandt had attracted so much media attention that crowds lined up around the block, and many of those who managed to get inside the building were relegated to watching the proceedings on a television monitor in the lobby. Only the power elite were inside the salesroom. "Atmosphere was electric," noted Rathbone in his journal. "The bidding began at one million, in four minutes it was over, with the Met as winner of this world contest.... Cleveland was the under bidder. And this is as it should have been, the two richest museums in the US vying with one another, the richer the winner."[25] A burst of applause followed the sale of the Rembrandt for a record $2,300,000. It was the highest price ever paid for a work of art and would remain so for some years to come.

Was this good news for the art museum director? While it proved there was a strong appetite for art, and while it raised the profile of all museums as high-stakes players in a glamorous world competition, it also confirmed the need for new kinds of money, and on an entirely new scale. While the Met could tap a Havemeyer or a Rockefeller when they needed to, Boston had no such benefactors, neither on the same order of wealth nor with such ready generosity. And while Cleveland's museum was only half as old as Boston's, it was, according to Rathbone's calculations, about three times as rich. Acquisition funds at the MFA were typically earmarked for one department or another, and cautiously parceled out, and it was never easy to raise the money from scratch nor to secure the trustees' approval in time to compete with other big players at auction. "There were funds," said Rathbone of his acquisitions budget, "but they were nothing compared with what Toledo, and Cleveland, and the Metropolitan, and Chicago had had for years."[26]

In a time of sharply rising prices, the MFA would have to curb its appetite for acquisitions and court the great collectors as never before. As assistant curator Laura Luckey remembered, Rathbone was "constantly looking for ways to build the collection."[27] He often visited the elderly spinster sisters Aimee and Rosamond Lamb at their townhouse on Dartmouth Street surrounded by works by

Renoir, Monet, Whistler, and Cassatt. He befriended Eugenie Pren-
dergast, the widow of Charles Prendergast and sister-in-law of Bos-
ton impressionist Maurice Prendergast, and inspired her goal of
making the MFA the largest repository of his work anywhere. He
courted the aging automobile dealer and onetime governor of Mas-
sachusetts Alvan Fuller, with an eye on his prize collection of old
master paintings. He sought out William Lane, the reclusive collec-
tor of American modernism with a discerning eye for the works of
Charles Sheeler, Arthur Dove, and Georgia O'Keeffe, an area the
MFA had entirely neglected. As a first step, he persuaded Lane to
join the department's visiting committee.[28] And from the heirs to
the Ogden Codman estate in Lincoln, he extracted John Singleton
Copley's exceedingly rare *trompe l'œil* still life of a cork screw.

Another significant gap in the MFA's holdings – French art of the
eighteenth century – would be rectified overnight with the addition
of Forsyth Wickes's collection. A New Yorker who summered in
Newport, Wickes had no personal connection to Boston or to the
Museum, and major museums around the country had been court-
ing him for years. With his usual optimism, Rathbone joined the
competition for the endgame, making several trips to Starbord
House, in Newport, to visit the aging collector. Amid the impeccably
decorated rooms that provided an authentic context for art collec-
tions as a way of life, Rathbone patiently and persuasively answered
his many questions about the MFA. Though Wickes died before mak-
ing his commitment, several months later his widow and heirs were
sufficiently convinced that Boston was his first choice for the perma-
nent home of his incomparable collection.

Boston had its share of eccentrics, and Rathbone was not in a
position to avoid them. This was certainly the case with Maxim Kar-
olik, who was already well into the process of endowing the MFA
with an incomparable collection of American paintings, drawings,
and furniture. A professional opera singer born in czarist Russia,
Karolik loved an audience, and he was a constant presence in the
Museum. By the time Rathbone arrived at the MFA, Karolik's Bos-
ton Brahmin wife, Martha Codman, who was thirty years his senior,
had passed away. While Codman had bequeathed her collection of
family furniture and portraiture to the MFA, Karolik continued to

supplement this treasure with paintings, drawings, and even more furniture, delighting in his ongoing education in American art. Superb examples of the Hudson River school were then available for a song – works by Asher B. Durand, Albert Bierstadt, Thomas Cole, and Frederic Edwin Church, as well as Boston's masters of luminism Martin Johnson Heade and Fitz Henry Lane. Karolik also appreciated the anonymous, the unusual, and the unsigned masterpiece. He believed in collecting not names, but pictures. In this and many other ways, he loved to challenge the established view, to flout the manners and mores of his wife's Boston. When Maxim emerged one winter day from the Somerset Club dressed in a fur-lined coat[11], a cousin of Martha's advised him that advised Maxim that "gentlemen" did not wear fur collars in Boston. Replied Karolik accurately and without shame, "No one ever accused me of being a gentleman! I am a tenor!" This was but one of many colorful Maxim Karolik anecdotes that Rathbone was fond of retelling.

In many ways the ongoing adventure of the Karolik collection was a museum director's dream – everything he bought was designated for the Museum. But in dealing with it, Rathbone's task was not only to guide the growth of the collection with particular recommendations but also to keep Maxim's ego in a permanently polished condition, a time-consuming and often tedious business. Early on Rathbone made a decision he may have later regretted – to endow him with the title of Honorary Curator of American Arts. Though not a salaried member of the staff, Karolik was thereafter at the Museum every weekday from nine to five, regaling visitors in the galleries with stories and pronouncements, and ever ready to corner Rathbone to remind him of the greatness of the collection. "Karolik is fearful lest his collection, his 'trilogy', should one day not be on exhibition," Rathbone wrote in his journal after one such occasion. "The harangue required that we listen to the entire history of the formation of the collection, a story I have heard at least a hundred times in five years." At length he admitted candidly that "[Maxim] almost makes me despise at times my own inherent love of American art."[29]

In Rathbone's quest to strengthen the MFA's holdings of postwar American art, an obvious target was Susan Morse Hilles, whose collection was just what the MFA needed to catch up quickly in this

neglected area. A graduate of the MFA's museum school, Hilles had given up painting herself and with her considerable inherited wealth had turned her attention to collecting contemporary art. With her educated eye for color and design, she assembled key works by Frankenthaler, Motherwell, Rauschenberg, and Calder. By the 1960s she was emerging as a conspicuous presence on the boards of various East Coast art museums. In 1966 Rathbone honored Hilles with a major exhibition of her collection, *Painting and Sculpture Today*, complete with an illustrated catalog. In its introduction, Rathbone praised Hilles's "unbiased mind and discriminating eye" as well as her "sense of adventure" and "the daring and resilience of the gambler."[30] Following the show, Hilles allowed a large oil by Franz Kline, *Probst 1*, to stay on loan at the Museum. "I was thrilled to hear you say that the big Kline Probst as well as the Onion [a Calder stabile] might be in our future,"[31] wrote Perry to Sue a few days after the opening. In the ongoing effort to keep the flame alive and her commitment firm, in 1968 Rathbone invited Hilles onto the MFA's board of trustees. But there was competition for Hilles's collection, and she played it to the hilt, enjoying the courtship of the Whitney, the Guggenheim, the Museum of Modern Art, and the National Gallery. Like any important collector, Hilles had to be carefully nurtured. Rathbone's secretaries often bore the brunt of her imperious and capricious character. "She was very demanding," recalled Rathbone's secretary Virginia Fay, and she was also "sort of a loose cannon."[32] On one occasion Hilles commandeered Fay into driving her all the way to Nova Scotia on a mission that had nothing to do with the MFA.

For many years Rathbone also pursued Peggy Guggenheim, whose collection of European surrealism and postwar American art was unparalleled. In the late 1950s Guggenheim's days as a prominent dealer of the avant garde in London and New York were behind her, and she was beginning to consider the future of the increasingly valuable collection she had amassed over the years. She made it known that she was not necessarily inclined to favor her uncle Solomon Guggenheim's museum in New York City. Courting Peggy Guggenheim was not difficult, and for Rathbone it was also far from painful. What was required, when traveling through Europe, was a regular stopover in Venice to stay at the Palazzo Venier dei Leoni,

her home on the Grand Canal. Guggenheim's collection, including surrealist work by her two former husbands – Max Ernst and Laurence Vail – was part of the fascination of the place, and a striking contrast to a city steeped in the High Renaissance. Furthermore, there was no lack of social life chez Guggenheim. "Peggy lives amidst the considerable confusion of 9 Llasa terriers," Perry wrote to Rettles on his first visit there in 1956, "and the constant flow of visitors." Over the course of only three days at the palazzo, Perry met author Mary McCarthy, composer Virgil Thomson, artists Graham and Catherine Sutherland, and "Lady Oonagh something or other."[33]

Although she was not at all beautiful, Peggy was something of a fashion statement all her own – she wore giant, dangly earrings (often the unique creations of an artist friend), harlequin sunglasses while out on the lagoon, and brightly colored feather housecoats at home. With her spontaneity, her wit, her wealth, and her genuine love of art, she was indisputably seductive. She was also used to having her way, and generally good at getting it. After Perry's first visit, in 1956, and perhaps to ensure that he would make a habit of staying with her whenever he passed through Venice, Peggy offered him his choice of works for the MFA by abstract painter Jean Hélion (her son-in-law) and hinted at other things to come. While Alfred Barr and James Johnson Sweeney of the Museum of Modern Art had been vigorously courting her, she assured Perry, "confidentially," that she was interested in "Boston's need."[34] As he consistently expressed this to her thereafter both in person and by letter, Boston was the "only major cultural center in the United States without an important collection of modern art."[35] Clearly Guggenheim's collection would make all the difference.

In 1963 Rathbone invited Guggenheim onto the visiting committee, and looking ahead to the eventual expansion of the Museum, he suggested to her that "there is nothing I would rather do than to incorporate in these plans the space for the Guggenheim collection."[36] Peggy continued to feed minor works into the MFA's permanent collection.[37] But like Sue Hilles, she had other fish on her line, and she kept them all jumping.

Rathbone inherited an aging senior curatorial staff upon his arrival in the mid-1950s, and one by one, as they retired, he replaced them. By the late 1960s he had completed the turnover of every senior curatorial position in the Museum. According to historian Walter Whitehill, Rathbone's "skillful choice of scholarly curators"[38] was the most significant contribution of his tenure as director. He recruited Cornelius Vermeule to head classical art, Jan Fontein as curator of Asiatic art, and William Kelly Simpson as curator of Egyptian art. Among those curators already on the staff, he promoted Adolphus "Dus" Cavallo as senior curator of textiles, Hanns Swarzenski to curator of decorative arts, adding sculpture to that department, and Eleanor Sayre to head prints and drawings, adding photographs. Before he retired in 1972, Rathbone would also create new senior positions for three new curatorial departments – American decorative arts, contemporary art, and pre-Columbian and primitive art.

Rathbone was popular with his curators. He supported their cause; he was on their side. After all, he was one of them. He met with them frequently – as a group they lunched together once a week, and he actively encouraged their interests and ambitions. Recalled assistant curator of decorative arts Robert Moeller, when Rathbone was director, "It was all about art, looking at an object. That's what we were there for."[39] Rathbone encouraged them to develop their own programs with a liberal hand, but he also drew the line. As they came to him one by one with their wishes and problems, he listened. As Jonathan Fairbanks, curator of American decorative arts, recalled, "Although you might disagree with him, by the end of the conversation, as you walked out of the office, you felt good about it."[40] Observing individual curators emerging from a private consultation with the director, Virginia Fay noticed that, whatever problems they might be discussing inside, "they always came out laughing."[41] Said Fairbanks, "He was a tremendous leader."[42]

As much as Rathbone enjoyed the circles of Boston's social elite, he was more at home with artists, scholars, collectors, and connoisseurs; his true friends were those who lived for art as he did, and he continued to learn from their expertise. His breadth of taste, his interest in every field – a hallmark of Paul Sachs's training – was

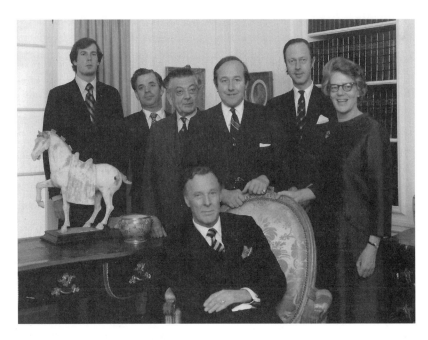

Perry T. Rathbone (seated) and his chief curators (left to right) Larry Salmon, Jan Fontein, Hanns Swarzenski, Cornelius Vermeule, Kelly Simpson, Eleanor Sayre, c. 1970.

evident to art professionals both inside and outside the Museum. Richard Feigen, a dealer in old masters, remembered seeing Rathbone at the auction houses "looking at not just paintings but antiquities – all kinds of things." When Feigen started his business in the early 1960s, "There were really only three major American museum directors, and when they came to your gallery, it was a big deal," he recalled. "One was Perry Rathbone, another was Dicky Davis [Minneapolis], and the third was Sherman Lee [Cleveland] – the three grandees of the field."[43]

As interim curator of paintings, Rathbone built up his staff over the years. Angelica Rudenstine joined the department in 1961 as research scholar, assigned to the major task of cataloguing the collection, Laura Luckey arrived as assistant in 1964, and Lucretia Giese, also an assistant, in 1967. All the while Rathbone enjoyed keeping an active hand in the big decisions, planning exhibitions,

making acquisitions, arranging the galleries, and courting the big collectors. Tom Maytham, the last of the W. G. Constable era, harbored hopes of becoming the head of the department but eventually came to understand the doubts that surrounded him about his inalienable right to such a promotion. Having finally earned the title of assistant curator, Maytham resigned in 1967 to accept a job as associate director of the Seattle Art Museum.

That year, in the absence of any prospects for a new curator, the trustees voted in favor of giving Rathbone the title of acting curator of paintings, awarding official recognition to what was already a well-known fact. But this might have given some trustees a reason to think over his spreading responsibilities with renewed concern. If they were hard-pressed to identify any specific failures on Rathbone's part, it came down to appearances.[44] Likely, Seybolt sowed the seeds of doubt among them, convinced that "they did not see Perry as he was,"[45] and then nurtured any sign of their enlightenment. According to Seybolt, the curators "did not know where the hell they stood from one year to the next,"[46] and he cast the director's sensitive negotiations with them in an unflattering light, suggesting that Rathbone was competing with them for acquisitions funds. "If [Rathbone] wanted something from them and they wanted something, they would make a little deal."[47] At the same time he believed that the curators were given too much latitude and that Rathbone had created (perpetuated, more accurately) a system of departmental fiefdoms. He regarded Rathbone as a capricious leader, an insecure egotist who needed to be constantly praised and admired by "sycophants," and a crafty manipulator. Seybolt, who mistrusted the director's natural charisma and his delight in sharing his enthusiasm with those around him, saw these gifts in a darker light. "He was there to play the trustees, manipulate them, manipulate his staff, and not deal with the problems which were standing at his door and beginning to flow into his museum."[48]

By the late 1960s the Boston community of local artists was also beginning to express its impatience with Rathbone's curatorial power. Many did not believe that the MFA took enough interest in them. "There is much dissatisfaction here among local artists with the disregard they receive from the museums," wrote artist Maud

Morgan to Sue Hilles, congratulating her on her show in 1966. "Most of them feel that Perry doesn't like or know about contemporary work."[49] It seems that Rathbone's early initiatives were by then either forgotten or taken for granted, his ongoing efforts to secure modern works for the Museum not widely recognized, and the frustration he himself experienced with certain trustees who opposed buying art by living artists, unacknowledged.[50] Furthermore, his attitude had changed. The era of his greatest enthusiasm for the art of his own time had passed; his modern was no longer contemporary.

As Rathbone explained in an August 4, 1967, interview with the Christian Science Monitor, when he first went into museum work, he was "an absolute champion of modern art, because modern art had not won the day by any means. But now it is entirely different. Today modern art has the whole field." As for the growing pressure to exhibit outstanding living artists around Boston, the problem was in the definition of the word outstanding. And as for the MFA's

Laura Luckey, Perry T. Rathbone, and Angelica Rudenstine examine a painting, Museum of Fine Arts, Boston, 1960s.

ability to purchase outstanding contemporary art from anywhere, he stressed its limitations. "Modern art is not rare," he said. "It's just terribly expensive." To the press he expressed confidence in the Museum's prospects for important gifts of twentieth-century art from private collections. "One is promised," he assured the journalist, "and another is a very likely prospect."[51] It was on these private collectors that he was now depending – for their judgment, their generosity, and their loyalty to the Museum's cause.[52]

As was his custom, in 1967 George Seybolt formed an ad hoc committee, in this case to study the Museum's position regarding contemporary art. The committee proposed establishing a department of contemporary art and beginning an immediate search for a curator. Rathbone favored Dorothy Miller, longtime curator of painting and sculpture at the Museum of Modern Art, highly respected among collectors and artists alike, and furthermore an old friend. Lewis Cabot argued that to try to imitate the program at MoMA at this late date would be a mistak. As he put it, "You can't make it shine in the sunshine."[53] Momentum also stalled on the question of funding for the new position. While some looked to Cabot for the money, there were also concerns that his own growing contemporary art collection, and the knowledge that he was in the market to sell as well as to buy, might suggest an obvious conflict of interest. Above all the question for the MFA and many other encyclopedic museums at the time (and even for the Museum of Modern Art) was how to collect contemporary art that over time would hold up against the treasures of the past.

In 1968 the Guggenheim Museum, directed by Thomas Messer, organized a show of Peggy Guggenheim's collection, with the MFA among the hosts of its tour. Formerly director of the ICA in Boston, Messer was a friend, or so Rathbone had always thought.[54] When he learned that the show had been abruptly rescheduled, he was quite sure that Messer had deliberately maneuvered Boston out of the tour. After a decade of careful courtship, there was the writing on the wall, and Rathbone suspected "the deft hand of Tom Messer at the switch."[55] To Boston, Peggy Guggenheim had given a picture here and a sculpture there. But finally, when all was said and done, her heart belonged to New York, and to the museum that began with

the collection of her uncle Solomon Guggenheim and that had recently added the revolutionary new building on Fifth Avenue designed by Frank Lloyd Wright. In 1969 she bequeathed her Venetian palazzo and its collections to the Guggenheim Foundation, thus officially ending Boston's hopes for acquiring her collection.

Meanwhile, younger museums were growing in stature throughout the country, and while they could not compete with Boston's older collections, they had money to spend on contemporary art as well as on ambitious new building projects. In 1965 the Los Angeles County Museum of Art opened its first permanent home on a seven-acre site on Wilshire Boulevard and began rapidly building up its collection of postwar American art. In 1966 the new Whitney Museum of American Art opened its audaciously modern building, designed by Marcel Breuer, on Madison Avenue in New York. At the Kimbell Art Museum, in Fort Worth, Texas, there were exciting plans for a groundbreaking museum design by Louis Kahn and a healthy operating budget to match.[56] In Boston, the downtown skyline was belatedly but dramatically on the rise, with every new office building presenting a need for big modern pictures to warm the bare white walls and to demonstrate that their businesses were fashionably up to date. Thus the local business sector joined the local artists in the rally for a greater commitment to contemporary art at the MFA.

In this climate of scrutiny, some trustees began to wonder how much Rathbone's influence as acting curator of paintings might detract from forward-looking initiatives. Lewis Cabot, who was strongly opinionated about which paintings in the Museum's collection deserved masterpiece status and which did not, advocated the concept of de-accessioning the collection as a portfolio of assets, which Rathbone regarded with deep skepticism. Others simply questioned how much time acting as the curator of paintings was taking from his administrative responsibilities. Trustee Nelson Aldrich later asserted, "You can't be director and curator of paintings at the same time and do justice to both jobs."[57]

Seybolt recalled approaching Rathbone on several occasions, trying to force him into hiring a curator of paintings.[58] "I said to Perry one day – Lookit Perry, people are unhappy about this because you

not only have no curator, but the job isn't well done."[59] Some members of the board, he told him, felt that Rathbone wasn't getting paintings that were "up to the standards" but rather picking from "what rolls up on the beach in the tide," and furthermore "not driving hard enough bargains."[60] For Rathbone, the problem was how to respond to the crude level of understanding implied in these charges. How to explain to the corporate businessmen that except for those collectors (usually private) daring enough to buy against the trends, there is no such thing as a bargain in the art market; that everything about it is tidal, even to those like Rathbone who are first in line with the top dealers; that the curator's job is to perceive the opportunity and seize it where he can; and finally that a great museum is not in the business of acquiring only masterpieces for box office appeal but also the work of the demigods, the *petits-maîtres*, or what Seybolt would call "the little junk."[61] How to educate the trustee?[62]

The Man behind the Man

Without the ongoing counsel of Hanns Swarzenski, Rathbone might not have remained in charge of the paintings department as long as he did. When Rathbone first arrived at the MFA in 1955, Swarzenski was a research fellow in the decorative arts department. Rathbone almost immediately promoted him to curatorial rank and not long afterward to head of the department. From the start they were natural allies.

Even before accepting the job as director, Rathbone found in Hanns Swarzenski an invaluable confidante, for he represented a critical link between this new chapter in his life and earlier ones. "No one could have taken a deeper or more sympathetic interest in my prospects,"[1] he wrote to Rettles, after meeting Hanns and his second wife, the German film star Brigitte Horney, for dinner in New York in late November 1954. They stayed up talking until five o'clock in the morning, with Hanns and Brigitte wholeheartedly encouraging Perry to move to Boston while at the same time offering their candid appraisal of the various curatorial staff members he would encounter at the MFA. This animated nocturnal meeting in New York would soon develop into a cherished habit for both Perry and Hanns. At the end of the evening, when the day was done and the party was over, they often looked forward to its soothing aftermath – the nightcap.

Around the Museum it soon became evident to all that they were the closest of friends. Rathbone, the socially at ease American poly-

math, and Swarzenski, the strutting, mumbling, lisping, and reserved German scholar, made an odd-looking pair. "It was a very unlikely combination," recalled Jan Fontein, curator of Asian art, "but it worked out very well."[2] Robert Moeller, an assistant curator in the decorative arts department under Swarzenski, remembered, "They were very close – inseparable and a perfect match."[3] The ties that bonded them as friends over the years went beyond compatibility. They were deeply rooted in shared loyalties. Together they could keep these loyalties alive.

Perry and Hanns had first met in New York at the art gallery of their mutual friend, Curt Valentin. From 1937 until his sudden death in 1954, Valentin's midtown gallery was a major force in the burgeoning modern art scene, where curators and collectors gathered regularly to view his latest show. For American collectors new to the modernist spirit and bewildered by its movements, Valentin was their consummate guide. His understanding of this tumultuous passage – with its multiple isms and its radical departures – was intimate and intuitive, his enthusiasm and love for it real and contagious.

A refugee from Nazi Germany, Valentin had worked in the galleries of Henri Kahnweiler in Paris and Alfred Flechtheim in Berlin. As assistant to these top dealers, Valentin became personally acquainted with leading European artists of his time, including Picasso, Paul Klee, Max Beckmann, and many others, honed his eye for modern art, and learned his business methods from the best. When Hitler was appointed chancellor of Germany in 1933, the bright days of Valentin's apprenticeship came to an abrupt end. Flechtheim's Berlin gallery was among the first casualties of the Nazis' war on contemporary culture. With his high profile as a dealer of modern art, an influential trendsetter and man about town, together with his distinctly Semitic features, Flechtheim was an obvious target. In 1933 he was forced to close the gallery and flee to London where he lived and worked in exile. This left Valentin in search of a new job, and also – as a Jew and a specialist in modern art – with the need to lower his profile. Karl Buchholz, a dealer of books and prints in Berlin, cautiously put Valentin in charge of his "back room," where he quietly carried on selling modern German expressionist art in an increasingly treacherous political climate.

In 1937 the Nazi government began to systematically cull modern art from public museum collections throughout Germany, proclaiming that this art was not only "degenerate" – a poisonous influence on the moral values of the German people – it was also an outrageous waste of public funds. In its place the Nazis promoted a social realist aesthetic, idealizing the image of the Nordic race and Germanic folklore. Already, leading artists like Paul Klee and Max Beckmann had been fired from their teaching positions. Furthermore the Nazis made their artistic activities against the law, with the Gestapo regularly conducting raids on artists' studios. As a Jew and a champion of modern artists, it was clear to Valentin that he was no longer safe in his native country. In 1937, he joined the wave of artists, designers, art historians, and art dealers who fled to America.[4] With the backing of Karl Buchholz, Valentin arrived in New York with a suitcase full of art and the equivalent of $75.00 in his pocket. He set up shop in a small room on West 46th Street, which soon captured the attention of Alfred Barr, the founding director of the Museum of Modern Art.

For Perry Rathbone, then in his midtwenties, it was an education to personally witness Valentin perform the complicated juggling act that is the daily life of a first-rate contemporary art dealer. At the time Rathbone was a junior curator at the Detroit Institute of Arts, where he had landed a job soon after completing Sachs's museum course at Harvard. His boss was the legendary German director, William Valentiner, who with discernment and dedication had built the DIA's collection into one of the finest in America. Valentiner was also a champion and collector of modern German art, and he urged Rathbone to visit Valentin's gallery in New York to further his education in this exciting new field. Soon afterward, as assistant to Valentiner in organizing the blockbuster *Masterpieces of Art* exhibition for the 1939 New York World's Fair, Rathbone spent nearly two years in the city, and Curt Valentin's gallery became the focal point of his social life. There he met artists, art dealers, collectors, and critics, as well as all the bright and attractive young men and women who had gathered to form the staff of the Museum of Modern Art. Thanks in large part to his friendship with Valentin, who partied as hard and as late as he worked, these were among the

Curt Valentin, cross country road trip with Rathbone, 1940.

halcyon days of Rathbone's young professional life. Valentin him-self – ten years his senior, sophisticated, worldly, and intimately engaged with the artists's process – seemed to embody the very soul of modern art, with all its tortured beauty and all its angst.

In the summer of 1940 Perry and Curt toured across the country together in Rathbone's Ford Phaeton, calling on Valentin's expand-ing network of collectors and museum curators along the way, both seeing for the first time the geological wonders of the Far West, and collecting souvenirs of Native American culture from northwest Washington to Santa Fe. One month and seven thousand miles later, they arrived in Saint Louis where Rathbone, at the tender age of twenty-nine, would begin his new job as director of the City Art Museum. Before leaving him there, Valentin introduced him to the most exciting collector of modern art in town – the dashing young Joseph Pulitzer III and his piquant wife, Louise "Lulu" Vauclain.

Perry and Joe had briefly crossed paths at Harvard when Perry was a senior and Joe a freshman. They knew the same professors and shared Paul Sachs as a mentor. Since their college days they had

become acquainted with the same modern art dealers in New York. For Perry, nothing could have been more encouraging than to meet the Pulitzers amidst their stunning collection of paintings by Matisse, Picasso, and Modigliani. Perry and Joe would soon become close friends and allies. For both of them, Curt Valentin would be a whetstone of their growing enthusiasm for European modernism.[5]

Valentin had an infallible eye for quality and a voracious appetite for new work. While his commitment to German artists remained strong, in the postwar years Valentin expanded his roster to include artists from Britain, such as Henry Moore, from Italy, Marino Marini, and from America, Alexander Calder. To the artists he represented Valentin was constantly available, eager to see their latest work and discuss whatever was on their minds, if not in person, by letter. He not only displayed, published, interpreted, and sold their work, he acted as their financial advisor, immigration officer, travel agent, and the pivot of their social network. For many, he was their lifeline.

Valentin's personal magnetism was hard to define - he was as con-

Rathbone and Curt Valentin with Calder mobiles, Curt Valentin Gallery, 1952.

fessional as he was secretive, as needy as he was stoic. He walked with a bounce and laughed often, sometimes for no apparent reason. He seemed to rush through life, as if he were running out of time. He was also quite often depressed, and he despaired at the appalling consequences of the war in Europe and especially his native Germany's role in perpetrating them. He soothed himself by drinking liberally and smoking heavily, even after his doctors' stern warnings of his declining health. In 1954 at the age of fifty-two, he died of a heart attack while visiting the sculptor Marino Marini in Italy. At his death *Art News* called Valentin "probably the most widely appreciated and respected dealer in modern art in America."[6] In the *New York Times*, Aline Saarinen wrote "there is no corner of America where people care for art which did not feel his influence."[7] Valentin's closest friends were inconsolable, the artists he represented desolate. At the time of Rathbone's appointment to the Boston Museum, Valentin's untimely death left a terrible void. Hanns Swarzenski felt it equally. That they would find one another in Boston that very year meant an extension of Valentin's memory that was precious indeed.

In Rathbone's student days, German art historians were the leaders of the field. It was in German that much of the scholarship was written and to the Hegelian philosophy of the art museum that most adhered. But this culture was tragically debased by Nazi fervor and further depleted by Nazi's expulsion of great Jewish art historians and the modern artists they considered "degenerate." For Rathbone, these figures represented a cultural treasure too few Americans understood. William Valentiner was his early mentor and the first link in a chain of introductions, beginning with Curt Valentin, who in turn introduced him to Max Beckmann, and also to Hanns Swarzenski. These men perceived young Perry Rathbone as their champion in America, awarding him the honor of looking after their heritage. Perhaps his most important act in that regard was the role he played in Max Beckmann's immigration to America in 1947 by securing him a teaching position at Washington University in Saint Louis. Throughout his formative professional years, Perry had been nurtured and educated by Germans. Hanns would soon be the only one left.[8]

From the start, Rathbone was enthralled by the depth of Hanns's knowledge of art. He was, as Rathbone described him, that rare specimen not only among men but also among art historians, "*un vrai connoisseur.*" He responded to works of art with his eye and with his heart. He was governed "by that subtle emotion we call empathy"[9] – in German, *Einfühlung.* His approach was hard to explain but fascinating to watch, and Rathbone would have many opportunities to do so. "Those who can recapture the rapt delight of a child with a toy know something of Hanns Swarzenski's first encounter with a work of art," wrote Rathbone in a forward to Hanns's Festschrift in 1972:

> He quickly makes it his own. One is tempted to believe that the object has not been so loved, understood, appreciated – really savored – since it left its maker's hands. Hanns experiences objects with all his senses, not with his eyes alone. He does not know a work of art until he has touched it, caressed it, weighed it in his hands, smelled it, and yes, even listened to it. Hanns talks to objects and they talk to him. No, they talk to us; to Hanns they sing![10]

Swarzenski's eye was as passionate for the minor arts as for the work of the great masters. From his point of view the division between the fine and applied arts "really didn't apply to the Middle Ages," said medievalist Nancy Netzer,[11] "when the so-called minor arts, or *kleinkunst*, were more major than minor in conception and importance."[12] Swarzenski furthermore had a special affection for small objects, believing that size had nothing to do with monumentality. Tom Hoving, who was a medievalist and curator of the Cloisters before becoming director of the Metropolitan Museum, was fascinated by the way Hanns would size up a work of art. "To watch him pick up and scrutinize a small bronze enamel or piece of jewelry was to see a man whose fingers, eyes, and mind became magically wedded to the artifact. But ask him to expound upon it? Impossible! He was seemingly inarticulate."[13, 14]

Rathbone would be the first to admit that Hanns's commentary was sometimes hard to follow. He spoke several languages, but none

of them, except for his native German, in a way that could be easily understood, with his thick German accent and his habits of nodding his head, mumbling into his chin, saying "yes" and "no" in the same breath, and repeating himself, perhaps to gain time to search for the right word. "He was a little shy, a little reticent," recalled a German friend Constantin Boden, whose wife, Katherine, worked as an assistant in Hanns's department, "as though he didn't really think people would be interested in what he had to say."[15] In this way he also had something in common with Curt Valentin, who was tongue-tied when he first arrived in America. But Valentin, like Swarzenski, had a passion for art that was infectious, a belief that works of art could speak for themselves. Rathbone was therefore accustomed to these nonverbal appraisals; perhaps he trusted them even more than words. He patiently developed his skills at conversing with Hanns, and it was worth the effort.

Hanns stored an incalculable fund of firsthand knowledge of medieval art. In those days, long before the mighty search engines

Hanns
Swarzenski
installing the
Forsyth Wickes
collection,
Museum of Fine
Arts, Boston,
1968.

of the Internet put works of art from around the world at our finger-tips, Hanns carried in his head a visual dictionary of enamel, gold, stone, and wood carving, an atlas of medieval guilds all over northern Europe, and an inner compass that showed him the way from one association to another. He was particularly astute at perceiving the connection between a certain painting or drawing – in the fold of the cloth or the gesture of a hand – and its three-dimensional counterpart in some far-flung location on the other side of the English Channel, or the other side of the Alps, with which he was already personally acquainted.[16] His knowledge was so vast, he seemed to speak in riddles. For to him, there was no difference between history and the present – the whole world of art was an ongoing conversation among living things. He wrote little, but when he did, the full magnitude of his knowledge was evident. Hanns would take the reader straight to the heart of the matter with the majesty of understatement achievable only among the most learned.

Hanns Peter Swarzenski displayed an eye for art from an early age. Born in 1903, he was the eldest child of Georg Swarzenski, a renowned art historian and director of the encyclopedic Städel Museum in Frankfurt for thirty years. Medieval art was Georg Swarzenski's area of expertise, and perhaps for that reason he had developed an eclectic taste not bound to the conventions of the classical realm. Medieval art, he wrote, had "an unrepeatable beauty, independent of and in opposition to conventional reality."[17] This prepared him well for the departures of modernism as they took off all around him. Calculating resistance from Frankfurt's town fathers, he started the modern collection with the French impressionists and moved on to the late works of Van Gogh, which had informed the expressionist trend then ascending in Germany. With the help of a roster of dealers all over Europe, Georg Swarzenski assembled modern German paintings, drawings, prints, and sculpture, meanwhile befriending many artists, in particular Max Beckmann, who taught at the Städel's museum school. He also acquired works by artists of the School of Paris, including Matisse, Braque, and Picasso. In the 1920s Swarzenski broadened the base of his power, eventually becoming the

head of all the Frankfurt museums.

When the Nazis came to power, in 1933, Georg Swarzenski did not take any chances – on high alert for the safety of the collection, he removed the modern works that were considered "degenerate" from the walls and hid them in storage. But he was unable to save

Vincent Cerbone, head carpenter; Dows Dunham, curator of Egyptian art; Hanns Swarzenski; rotunda, Museum of Fine Arts, Boston, 1960s.

them. This little man with his round face, well kept goatee, penetrating gaze, and deep voice, seemed to be invincible. But he was not. Soon after the Nazis confiscated the museum's entire modern art holdings – seventy-seven paintings and nearly four hundred works on paper – Swarzenski resigned from the Städel. Like Curt Valentin, Swarzenski's allegiance to modernism was compounded by his Jewish origins. Fortunately both Georg and Hanns were offered jobs in America during the war – Georg's began with an offer from art historian Erwin Panofsky to assist him in his research at the Institute for Advanced Study at Princeton, where Hanns was already safely ensconced.

In 1939 Georg accepted an invitation as research fellow in the
decorative arts department at the MFA, specifically to provide advice
on their medieval collection, which badly needed strengthening by a
first-rate curator familiar with every collector and dealer in the field.
Hanns's appointment as research fellow in the paintings depart-
ment followed in 1948. Although he operated in the long shadow of
his father's great reputation and closely followed his taste and method,
Hanns was also earning a reputation in his own right. While Georg
was the classic medieval scholar of iconography, Hanns had, accord-
ing to some experts, the greater artistic intuition. While Georg had
been a great museum director, Hanns was a scholar of profound
talent. No matter what, as one observer put it, "Hitler had shaken
the tree, and the two best apples of medieval art history had fallen
to the ground in Boston."[18]

Rathbone's secretary, Virginia Fay, was a witness to the director's
special friendship with Swarzenski. They were on the same wave-
length, she observed. "They knew instantly what each other was
thinking about and hoping for." If there was something Rathbone
was in turmoil about, "[Hanns] would be the person – almost like a
father figure, that he would turn to, to talk about it. This wasn't
anything decisive, just a philosophical going over of things."[19]

Hanns never learned to drive, and Perry regularly gave him a
ride home to the Swarzenskis' converted carriage house on Raymond
Street in Cambridge. This meant braving the elements in Rathbone's
1936 windowless Ford Phaeton – the original isinglass had disinte-
grated years before and by this time was impossible to replace. But
the Phaeton was a precious souvenir of Rathbone's early years in
Detroit and his friendship with the Ford family, and the longer he
held on to it, the more interesting it became, windows or no windows.
Having delivered Hanns to his door and returned home for dinner,
Perry would often head back over to the Swarzenskis' for a nightcap.
There and well into the night, they would talk of art, of mutual
friends, and most of all, of the latest concerns of the MFA. With
Hanns, Perry could unload the trunk full of problems on his mind –
the latest gallery renovations, staff issues, and desires for the collec-

Hanns Swarzenski
and Perry T. Rath-
bone, Cambridge,
1960s.

tion. In his close friendship with Perry, Hanns had constant and direct access to the director. In return, Perry was on intimate terms with the curatorial mind of his museum. Whatever topic they discussed, Hanns provided perspective, comfort, and privacy. Also, as a European, he loosened the straitjacket of the Boston Brahmin stronghold. He exerted a refreshing worldliness as well as a free spirit, a sensuality and a playfulness that Perry responded to naturally.

For his part, Hanns was fortunate to have in Rathbone such a sympathetic director, a man who tolerated his particular style and idiosyncrasies. Inge Hacker, a German art historian and research assistant in the paintings department in the mid-1960s, observed that Perry gave Hanns considerable leeway in his actions and working style – his messy desk, his casual observation of normal working hours, his elliptical explanations – all affectations another director might not tolerate. "It was always fun to see them together," remembered Hacker of their friendship. "They were a good combination – Rathbone was very open and very social, while Hanns was always very reserved, not as interested in meeting people."[20] Nevertheless Rathbone cultivated Hanns socially like a rare gift, a treasure that he felt compelled to share with everyone. Both Perry and Hanns

rejoiced in the company of artists, encounters that to them were an essential ingredient of *la vie civile*. With the young Belgian artist Jan Cox, who headed the painting department at the museum school, they shared a close friendship and many gemütlich evenings. While in Cox they encouraged the extension of northern European expressionism, in the Greek American Dimitri Hadzi, who taught at the Carpenter Center for the Visual Arts at Harvard, they celebrated the ongoing concerns of modernist sculpture. From the latest events at the ICA to the gallery openings on Newbury Street, Perry and Hanns delighted in opportunities to stay tuned with what was up in Boston.

Hanns and Brigitte were regular guests at our home on Coolidge Hill for family feast days and much more. As children we were expected to embrace this exotic couple as members of the family and immediately to call them "Hanns" and "Brigitte" (dispensing with the more formal "uncle" and "aunt" of the Saint Louis era). We took this in stride. That they had no children of their own was perhaps what made the Swarzenskis wonderfully nonjudgmental adult company. The boundaries of age dissolved with them – we were offered a sip of wine, and in exchange, they could behave like children when they wanted to. Hanns, to my young eyes, was a cross between a wise old owl and a cuddly tomcat, and he took a childish delight in everything we did and said, laughing and gesturing with his hands, as if interpreting for the hard of hearing. Hanns made up for his height, or lack of it, by holding himself very erect, and he walked with a kind of short man's strut, carrying his head high and his round girth before him with pride, as if in tribute to his love of good food.

Brigitte, the actress, was always on stage. She was the daughter of Karen Horney, a student of Freud, who in her own right had significantly advanced psychology for a younger generation, advocating self-analysis and demystifying Freudian neuroses. Most famously, Horney had countered Freud's chauvinistic theory of women's penis envy with a corresponding "womb envy" for men. It went without saying that Brigitte would grow up a liberated woman. But unlike her mother, Brigitte was also a rare beauty. She had been a star of the German screen in the 1930s, and she was still striking in her middle age, with a perfect figure, high cheekbones, and a permanently animated face. She was as physically flexible as Hanns was

Perry T. Rathbone, Hanns and
Brigitte Swarzenski, Christmas at
the Rathbones', 151 Coolidge Hill,
Cambridge, c. 1963.

Perry T. Rathbone and Brigitte
Swarzenski, c. 1963.

stiff, as articulate in her movements as he was inarticulate in his
speech. She dressed with great style, gathering much of her ward-
robe from secondhand stores and discount outlets and then handily
adjusting them to suit her figure and bohemian taste. She loved full
skirts to allow for dancing and brightly patterned shawls to wrap
around her arms or toss over her shoulder. On the Christmas feast
day, which Jan Cox and his wife Yvonne also regularly helped to
celebrate, she would lead the postprandial dance orgy. We would put
a on record, push back the furniture, kick off our shoes, and do the
polka, the Greek hasapiko, the Twist – whatever the music sug-
gested and Brigitte inspired. And with the cast-off Christmas gift
wrapping, Brigitte would improvise fanciful hats for all.

She was also a great cook. She shopped at all the local ethnic
markets around Boston, and she knew just how to poke a fish in the
eye to determine how fresh it was, and then, to the dismay of the
fishmonger, to march away if it didn't meet her high standards.
"Rettles, you must come with me to the Haymarket," she would say

to my mother. "It's *fantastic!*" And she would reel off the bargains she'd found, and the rare ingredients – in those days these encompassed arugula, Feta cheese, dried mushrooms, exotic spices. My mother was also an excellent cook, but she could never be persuaded to trail after Brigitte to the North End, preferring her own routine at the nearby Star Market on Mount Auburn Street. World traveler that she was, my mother rarely ventured beyond her well-trodden routes of West Cambridge. Beyond Harvard Square to the east, she was utterly lost.

In Brigitte's eyes, Hanns could do no wrong. And yet there was an air of mischief about him, as well as a self-containment born of a rarified background suggesting he was something of a law unto himself. Some would attribute this to an insecurity born of working in the shadow of his father's great reputation. He clung to what he knew so well – art – and relied on others to take care of the details. He trusted his own intuition implicitly, which made him a brilliant curator and also, for some, a difficult man to work for.

Clara Mack (later Wainwright), who was briefly his secretary, regarded Hanns as "a Romanesque lion of a man." She admired him unreservedly, but she also witnessed the frustration of some who worked for him, especially assistant curator Katherine Buhler, who specialized in American silver. One day Hanns arrived at the department earlier than usual to encounter Buhler taking out her frustrations by scolding a small bronze sculpture of Adam on his knees. Hanns silently slipped into the closet until she was done. Later that day, after Katherine had left for home, he poured a little calvados into a Paul Revere porringer and passed it around. "Hanns and Katherine were like dysfunctional parents," recalled Clara. "You couldn't take direction from one without being in the wrong with the other."[21] Clara also remembered the day when Hanns arrived back from Europe and brought forth a three-decker box of Swiss chocolates. After offering them around the department with great ceremony, he then lifted up the top tray to reveal – voilà! – a small objet d'art he had smuggled in underneath.

Dick Randall, an assistant curator in the decorative arts department in the 1960s, was not especially amused by this kind of childish caper. He found Hanns temperamental and disorganized, and he

also sensed a hint of insecurity caused by Dick's own youthfulness, enthusiasm, and eagerness to arrive in the office on time and work hard. He chafed at Hanns's disdain for American decorative arts and his dominance over all things European. For his part, Hanns found it difficult to direct his younger colleague,[22] who eventually left the MFA to become the distinguished director of The Walters Art Gallery.

But whoever worked under Swarzenski learned much from him. Inge Hacker remembered the great privilege of assisting him in an installation in the medieval galleries. They worked late into the evenings for a whole week on two shelves of little sculptures. "Hanns was the most artistically minded art historian I have ever known. The installations took forever, but in the end, you felt that the objects might have grown there."[23] Clifford Ackley, a young curator in the prints department, also learned from observing Swarzenski and Rathbone as a team working on an installation. Instead of making a didactic display of similar works all in a row, they were guided by aesthetics and the element of surprise. "I learned that two alike pieces can kill each other,"[24] said Ackley, who was fresh out of Harvard graduate school.

Every summer, Rathbone traveled to Europe for meetings and information gathering, strengthening relationships with curators and museum directors over important loans or exhibitions. Ever in search of treasures for his own museum, he also visited artists, collectors, and dealers. Swarzenski would prove his most valuable link to the postwar European art market. The lesser-known dealers in provincial cities throughout Europe were "as familiar to Hanns Swarzenski as the well-known marts of Bond Street, central Paris, and mid-Manhattan,"[25] observed Rathbone. Buying art at a well-established art gallery on Fifty-Seventh Street might have been less risky, but it was also more expensive. In Swarzenski, Rathbone was confident that he had the expert eye he needed to locate the treasures that others might overlook. It takes considerable confidence to doubt where others rush in, but it takes an even greater nerve to rush in where others have doubts. Swarzenski trusted his own eye more than the opinions of others, and it was an eye that almost always

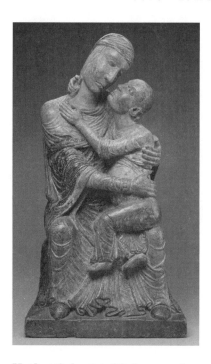

Unidentified artist, *Madonna and Child*, Italy, Lombardy, Second quarter of 12th century

served him well. Two outstanding medieval pieces in the MFA's collection had been passed over as forgeries by other curators. One of these was a highly unusual twelfth-century limestone sculpture of the *Madonna and Child* from Lombardy. Swarzenski proved the skeptics wrong. Despite layers upon layers of nineteenth-century paint, he perceived its authenticity and he knew how it should look underneath. In the Museum's conservation laboratory the original colors of the sculpture's polychrome finish were gently and gradually revealed. To this day the Lombardy *Madonna and Child* is a centerpiece of the MFA's medieval collection. "Hanns had an enormous advantage over other European art historians of this period because he was second generation. He'd seen a lot, he knew where everything was," said Nancy Netzer. Pointing out a tiny twelfth-century English enamel box in the MFA's medieval gallery, she commented, "There can't be more than six or seven of these, and Hanns knew them all."[26]

Rathbone's annual summer sojourn typically lasted about a month, during which he briefly appeared in the major art capitals, staying at the art world's familiar haunts – the Cavendish in London, the Amstel in Amsterdam, the St. John in Zurich, and the Pont Royal in Paris. The summer of 1960 found Hanns "happily strutting back and forth between the British Isles and the continent," as Perry wrote to Rettles, adding that "crossing the channel or the Irish Sea is like crossing the street for him."[27] Sometimes accompanied by Brigitte,

Hanns would rendezvous with Perry all over the map. Writing letters on air-weight hotel stationery, Perry kept Rettles abreast of his business, his pleasures, and also his travel woes – lost baggage, missed flights, and the occasional bout of food poisoning. But whatever his problems of the moment might have been, the general feeling was one of delight in what he saw, the excitement of the unexpected, and the temporary mental relief from museum administration.

Though he missed my mother on his European travels, with her steady attention to logistical detail and her fluency in French and Italian, and he often wrote to her of what she would have enjoyed and how he longed to share it with her – from Copenhagen, "I wish I could airmail you the almond kuchen"[28]; from England, "Longed to have you with me to enjoy the beauties of Cambridge wither Jim Ede drove me Friday"[29]; from Milan, "It is too strange to be in Italy without you"[30]; and from Athens, "You can only arrive in Greece for the first time once. It really isn't fair for you not to be with me"[31] – my father was, for the most part, quite happy to be the freewheeling extra man. They had quite different appetites. His were voracious – for sightseeing, for all kinds of people, for leisurely meals with plenty of wine, for spontaneous late-night adventures. My mother's were modest – a little sightseeing, a light meal, a bath. So it was just as well she was not present on a particularly memorable evening in the St. Pauli district of Hamburg where the local art dealer, Hauswedell, led Perry and Hanns on an unforgettable crawl. In one night spot they danced on the tables; later on they "landed in an underground *boite* called the Barcelona where the 'girls' turned out to be men";[32] and finally they wrapped up the evening at an all-night café before retiring to bed at five o'clock in the morning. During a two-and-a-half-day trip through southern Germany, Perry told her, "The S'[warzenski]s are wonderfully indifferent to schedule,"[33] a proclivity she would not have found wonderful at all. Traveling around in a Volkswagen "bug," they toured the spectacular baroque palaces – the Residenz Würzburg, the Schloss Schönborn, and the lesser churches in Waldenburg and Rohr – and Hanns knew how to persuade the priest to open the sanctuary and show them the treasures within and also just where to stop for a skinny-dip in the most beautiful spot on the Danube.[34]

Hanns was Perry's "bird dog,"[35] said George Seybolt, and it is true that Swarzenski was responsible for sniffing out some of the finest works of European art acquired during his tenure. By the mid-1960s it was increasingly a seller's market, and buying art was not what it had been twenty years before. "This has become an increasingly competitive pursuit in our frenzied times," wrote Rathbone for the 1965 annual report. "The supply dwindles alarmingly, the prices rise even more alarmingly. The competition multiplies in Europe no less than in this country."[36] Confronting these challenges, he depended more than ever on the trusted advice and efforts of Hanns Swarzenski.

Part II

The Prize

At the approach of the centennial year, Rathbone conceived a program of important loan exhibitions that would highlight the special strengths of the MFA's collections – ancient Egyptian, classical Greek, and Japanese. These ambitious plans set off a round of diplomatic correspondence and visits by MFA curators to each country. Aided by a research grant from the Smithsonian, the director, the designer, and the head of the research lab visited Cairo, while the assistant curator of Egyptian art, Edward Terrace, stayed there for an extended period. To secure important loans for the Greek show, curator Cornelius Vermeule entered negotiations with the director general of the Archeological Service in Athens. In addition to these major exhibitions, there was to be a two-volume centennial history of the MFA by trustee and Boston historian Walter Whitehill, whose association with the Museum dated back several decades. For the more general audience Rathbone came up with the idea for a museum cookbook, with recipes contributed by the museum staff and friends, handsomely illustrated with food-related works of art from every department. Now a staple of nonprofits everywhere, the MFA's cookbook was the first of its kind.

Also imperative was acquiring new works of art for the permanent collection across the board for what Rathbone hoped would amount to a spectacular centennial display in 1970. Already beginning to shore up such treasures – both outright acquisitions and promised gifts – he held some in abeyance for the great show to

come, *Art Treasures for Tomorrow*. With luck, the exhibition would include a crowning jewel – something rare, attention-getting, an indisputable treasure for all time. An old master painting was exactly the kind of prize the MFA needed to attract the press and galvanize the public's enthusiasm for its 100th birthday.

In 1967 the National Gallery, in Washington, snagged the *Ginevra de' Benci*, a small, mysterious portrait of a Florentine lady by Leonardo da Vinci. John Walker, then director of the National Gallery, later admitted in his memoir that "to purchase *Ginevra de' Benci* took me sixteen years and almost cost me my life."[1] Since the moment he first viewed the picture on a visit to the chilly Liechtenstein palace in January 1931, Walker was enthralled by the subject's "moon-pale face":[2] he perceived in her expression "a sense of secret bitterness, of sad disillusionment."[3] He developed an unquenchable desire to capture this mysterious lady and followed her progress from Vienna to Vaduz Castle, the official residence of the prince in the capital of Liechtenstein, where she took cover in a wine cellar during the war. All the while "memories of that stony, resentful stare, of that grim, unforgiving mouth haunted me."[4] Finally, in 1967 Walker was able to buy the picture from the Prince of Liechtenstein's heirs for a price somewhere in the seven figures (six million, in fact) that he was not at liberty to reveal at the time. The picture's arrival in Washington (conducted with the utmost secrecy and hand-carried by a courier in a Styrofoam-lined suitcase) was the climax of Walker's career and a coup for the National Gallery. The picture was small – just 15 by 14½ inches – and it had been cut down by about a third, probably because of irreparable damage to its lower section that would have included the subject's hands. Still, it had been more than worth the struggle. That stony stare, that mysterious beauty, was to be our own *Mona Lisa* – the only painting by Leonardo da Vinci in America.

Like great dynasties, great museums inspire feelings of rivalry among their directors, and the higher the stakes, the more acute the rivalry. When Tom Hoving heard that the National Gallery had scored the *Ginevra de' Benci* for $6 million, "I couldn't sleep all night," he confessed. "We should have reached for it.... If you lose that one day of going for the great thing, you can lose a decade."[5]

The event was not lost on Rathbone either, who was under increasing pressure from the board to prove himself as a more-than-capable acting curator of paintings. How wonderful it would be for Boston to also score a rare and magnificent old master painting just in time to be the crown jewel of the centennial year.

Just one year before, in 1966, Hanns Swarzenski was informed of a little-known source for Italian Renaissance art while visiting Dr. Peter Metz, a colleague in Germany and the retired curator of sculpture at the Berlin Museum. Works of art of the Italian Renaissance had become exceedingly scarce on the market, and collectors and museum curators were ever more secretive about their sources, so this was a welcome tip. No longer a player in the competition, Metz offered up this information as a special gift to his old friend Swarzenski. The source the Berlin curator mentioned was Ildebrando Bossi, a dealer in Genoa. Swarzenski immediately followed up, first meeting Bossi later that year.

Bossi might not have been so well known all over Europe, but he was a well-known figure in Genoa, and among Italian art circles beyond. "He was a big man and forceful-looking," remembered Marco Grassi, a painting conservator whose father and grandfather had both been prominent art dealers in Florence. Grassi recalled that Bossi "would turn up in Florence for the art dealers' *Biennale* in a Mercedes 600 and hold court at the hotel."[6] Genoa was then a rich city compared with Florence, which was very poor after the war, and the Genoese women were known for their high fashions and flashy jewelry. But Genoa was also known for shady dealings, while the Florentine's credentials were more easily trusted. While Grassi represented a long line of respected dealers, Bossi had another kind of pedigree. His father was also a dealer, but not in the same class. Young Ildebrando had begun his career as a "runner" – that is, someone who scouted out material for the major dealers, such as the Grassi. These runners were very faithful to their clients, and dealers were very careful to mind their own territory and did not encroach upon others. "There was a real etiquette about it,"[7] recalled Grassi. Bossi eventually started a shop of his own – not an open shop but more of a private storehouse of eclectic treasures.

By the time Swarzenski came knocking, Bossi was well into his

eighties. "He was an old chap who had been a dealer amongst Italian families all his life, a dealer in furniture and decorations," remembered Rathbone. "If you were looking for a seventeenth-century fabric to cover the walls of your palazzo ... he would have a few bolts left over ... but he also had works of art, fine bronzes, majolica, a number of paintings, all sorts of things." To be in Bossi's shop, a mesmerizing horde of "Genoese this and Venetian that"[8] – inlaid cabinets and gilded mirrors, girandoles and consoles, balusters and headboards, clocks and boxes, coffers and chests, chandeliers and candelabras, tapestries and carpets – was exactly the kind of experience that Rathbone and Swarzenski thrived on during their travels around the continent. To find treasure in the midst of this was the test of their connoisseurship they lived for. Furthermore, buying art in Italy was big game hunting, not only because of what might be found in that cradle of Western art but also because of the complications involved in getting it out.

Infant Hercules Wrestling with the Serpents, Florence, Italy, c. 1600

For Swarzenski, this new source for his own decorative arts and sculpture department was made to order. On his first visit he alighted on a classic fifteenth-century Flemish chandelier and an Italian Renaissance bronze statuette of the infant Hercules wrestling with a serpent. It was also on this first visit that Bossi brought out an exquisite little portrait of a young girl, an oil on panel, just 8½ by 10½ inches. Its previous owners, the aristocratic Genoese family Fieschi, believed it to be by Raphael. It had also been studied and authenticated by at least one Italian scholar, Pietro Toesca, who had stated his opinion in writing. Other than that, Bossi assured

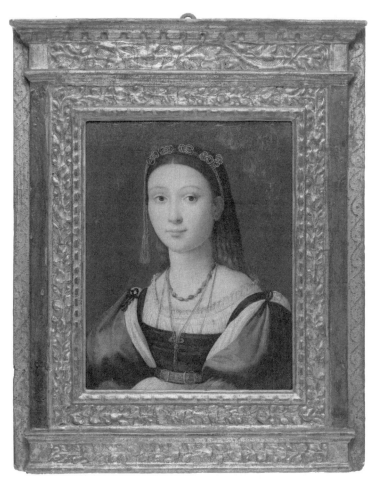

Raphael (Raffaello Sanzio or Santi), Italian, 1483-1520, *Portrait of a Young Girl*, Italy, 1505.

Swarzenski, no one else had seen the portrait outside the Fieschi circle of family and friends. It was essentially unknown.

Bossi stressed not only that the painting was in excellent condition but also that he had located its original tabernacle frame – a richly carved and gilded architectural treatment, with pilasters and pediment – that elevated a small portrait to a personal shrine. He compared the portrait with Leonardo's *Ginevra de' Benci* in its nearly identical dimensions while noting that the *Ginevra* was lacking its original frame. This one, he suggested, was probably designed

and ordered by Raphael himself. Since the late 1940s Bossi had apparently stored the little treasure away in his shop. While the art market in Europe languished after the war, when even a rich American patron was hard to come by, he had patiently awaited the perfect client. And here, at last, one had appeared.

Raphael, the darling of the High Renaissance, created what were widely thought to be the most beautiful portrayals of the Madonna and child in the entire history of art. There was never a more sublime beauty than a Raphael Madonna, nor one more sympathetically attuned to the Christ child, and never a more adoring son. In his tragically short lifetime (he died at thirty-seven at the height of his fame), Raphael also took on major commissions for Pope Julius II and others. *The School of Athens*, *The Parnassus*, and the *Triumph of Galatea* – these great murals displayed his prodigious compositional range, his confidence with the human form. At the start of the twentieth century, a painting by Raphael was considered the ultimate symbol of the most desirable artistic treasure. And there were virtually none left to obtain. With the rise of modernism, Raphael's reputation went into an eclipse for a period – nothing in Raphael seemed to have paved the way for the paroxysms of the twentieth century (as the work of El Greco, for instance, might have), and, having been held up for centuries as the essence and pinnacle of artistic evolution, he was suddenly unfashionable. What had made him the born genius who died too young was exactly the problem – he did not live long enough to outgrow the easy allure of his natural perfectionism and therefore lacked the emotional depth that might have made him a more interesting artist to early-twentieth-century eyes.

"The sentimentality of Raphael," Rathbone told an interviewer in 1940, "doesn't have the same appeal for us that it had for our fathers and mothers." But with a prescience that would seem to foretell a later chapter in his own story, he added, "What meant much yesterday, but means nothing today, tomorrow may be full of meaning again. As the conditions of life and culture change, reactions to art change also."[9] Indeed, by midcentury Raphael was beginning to regain his stature, and the scholarship continued. If there was nothing left to discover, there was still much to be learned. And there

was always the very slight chance that some unknown work by Raphael would surface that might add fresh insight and dimension to the artist's life and career.

At Swarzenski's signs of interest, in early 1967 Bossi sent him a photograph of the painting, along with Toesca's authentication. Upon seeing the photograph, sent by his most trusted advisor, Rathbone was understandably excited. There was no question but to follow up with the dealer without delay. While there were several hurdles ahead, Rathbone wanted to demonstrate enough immediate interest to keep other potential clients at bay.

As it was essential to meet Bossi and view the picture firsthand, Rathbone put Genoa on his travel itinerary for the summer of 1968. On July 1st, Bossi warmly welcomed him and Swarzenski to Genoa. Along with his charming nieces, Bossi laid on the Italian hospitality at his villa in Recco, twelve miles north of the city on the Italian Riviera. Upon viewing the little painting firsthand, Rathbone's interest was heightened, but so was his sense of caution.

Despite Toesca's statement that the picture was in "perfect"[10] condition and that it was a "precious jewel among the early works of Raphael,"[11] Rathbone was not content with its authentication, by only one Renaissance scholar, whose opinion dated back twenty years or more. Art historical scholarship is in a constant state of development, and revised opinions are par for the course. In the case of old master paintings where rarity is extreme and values extraordinary, a single opinion is not enough to bank on, and Rathbone had learned this well. His early mentor at the Detroit Institute of Arts, William Valentiner, had many a cautionary tale to tell. One was about his purchase of a Raphael painting from a well-known dealer on Fifty-Seventh Street that turned out to be not by Raphael after all but by a lesser artist of the same period. Then there was Valentiner's recommendation of a sculpture by Desiderio da Settignano to his important Detroit patron, Edsel Ford, which turned out to be a forgery. Valentiner confessed to Rathbone that it was one of the most difficult moments in his life when he had to go to Ford and confess, "I have been deceived and I have misled you, and I will do all I can to make recompense, but I couldn't live without you knowing what I have since discovered."[12] Valentiner was a respected scholar and an experienced

museum man, and no one would have doubted his integrity. But these were among the natural hazards of the business, and no one was immune to them. Valentiner had often said that if a museum director didn't make one mistake in ten, he wasn't doing his job.

As an experienced museum director, Rathbone had himself already confronted problems of authenticity more than once. In 1953 he acquired for the City Art Museum in Saint Louis what was thought to be a third-century BC sculpture of the goddess Diana. The agent was Alfred Loewi, an Italian dealer who had already provided them with a key acquisition – the fabulous sixteenth-century Montorsoli fountain in the form of a sprawling satyr – and he had guaranteed the authenticity of the *Diana*. Furthermore, its provenance looked fail-safe. But five years later the *Diana* was revealed to be the work of a well-known twentieth-century imitator. Tempting as it was to accept Toesca's attribution of the Raphael, caution was his watch-word. "Toesca's expertise was impressive," said Rathbone, "but an up-to-date opinion by the foremost living Raphael scholar was imperative before negotiating."[13]

For this important assignment he decided to approach John Shearman, a professor at the Courtauld Institute at the University of London, considered by many the leading expert on Raphael. Shearman had been associated with a previous MFA acquisition of 1958 – Il Rosso Fiorentino's *Dead Christ with Angels*, which he had greatly admired, and his scholarly analysis of the picture was published in the Museum's bulletin. Like the Raphael in question, the Rosso had been out of circulation, "lost" for generations in a private collection in Spain. This was a masterpiece by an artist whose output was small – only twenty finished works were known to exist. Rathbone was justifiably proud of having secured it for Boston; Rosso's *Dead Christ* was generally considered to be the greatest example of Italian mannerist painting in America. Thus it is not surprising that he was inclined to return to the expert with whom he had had such a successful association and whose expertise in Raphael's work was also highly regarded. He approached Shearman confidentially to discuss the prospect in the summer of 1968.

At first Shearman greeted the news of a Raphael unknown to him with amazement and skepticism. Despite having worked on

Raphael for twenty years, he had not seen nor even heard of the picture. But when Rathbone followed up by sending him photographic documents supplied by Bossi, including a group of infrared photographs as well as an X-ray, in February 1969, Shearman found the evidence convincing enough to justify further study. On stylistic grounds the picture had, Shearman observed, the overall perfection of a Raphael – the balance of color and form, the refinement of detail, and the overall design, which, as he said in a letter to Rathbone, was "wonderfully coherent" and "stands up to long examination."[14] Shearman could see in the infrared photographs some damage and repainting, but "just the extent of damage that is necessary if we are to take the attribution to Raphael seriously."[15] While the girl's head seemed disproportionately large, this reminded him of another early Raphael, *The Lady with the Unicorn*, in the Borghese Gallery, in Rome. It had the character, he observed, of a marriage portrait, "made to delight and made to travel."[16] But then who was this young girl? It was essential to find the connection between the artist and his subject to place it in Raphael's œuvre. Bossi had identified the sitter as Maria della Rovere. The painting had allegedly been in the Fieschi family for some four centuries – a family with an illustrious connection with the Catholic Church including numerous cardinals, two popes, and even a saint. A marriage between a della Rovere and a Fieschi in the seventeenth century brought this precious memento from Urbino to Genoa, where it had apparently resided ever since.

The picture was small, but it was beautiful; obscure but potentially significant. "Naturally I am still impatient to see the original," wrote Shearman to Rathbone in March 1969, "but I do now feel pretty confident that it is real. There is, to my knowledge, no imitator who could have done it." In sum, Shearman concluded, "Given the means I should buy it instantly."[17]

That Shearman found it convincing enough to want to see the original was encouraging. That it was previously unknown to him added to its promise, for it was only such an unknown work that could stand a chance of export from Italy. Published or known works of art were considered part of Italy's cultural heritage and were not legally exportable ever since the passage of the 1939 law for the protection of artistic patrimony. These regulations were generally

known, if not always observed, in art circles both in Europe and America.

Before going further in this delicate negotiation, Rathbone sought the approval of the president of the board. He told George Seybolt that there was a rare and beautiful painting in Italy that could be theirs, and furthermore that it stood a chance of export only because of its obscurity. As Rathbone explained to Seybolt, they would be making the purchase under "difficult conditions," that the "actual owner did not wish to be traced,"[18] and the whole transaction would have to be conducted in the strictest confidence. As Rathbone recalled, Seybolt, without hesitation, encouraged them to pursue it. "I hope you can get it,"[19] he said to Rathbone, to which Rathbone replied, "It remains to be seen."[20]

For his part Seybolt was apparently less concerned with the delicate issues surrounding the picture's exportation from Italy than with Rathbone driving a hard bargain with the dealer. He lectured him on the practices of experienced businessmen while instructing him to counter the dealer's bid, whatever it was, with a figure lower than he expected him to go and then to meet him halfway.

Rathbone then proposed to Bossi that he bring the painting to Boston on approval in April. But negotiations with Bossi proved tricky from the start. While Bossi responded that he was willing to personally escort the painting to Boston, he would do so only if they had already agreed upon a price. Rathbone explained to Bossi that this would be "contrary to the firm policy of [the] trustees,"[21] to make an offer or approve of a purchase without seeing the actual work of art. "I implore you to reconsider," wrote Rathbone to Bossi, not wishing to endanger their chances, "and try to give some idea of the price you had in mind."[22] While Bossi assured him that "from the heart I would like this little painting to have the honor of finding itself in your museum,"[23] he could not be persuaded to come to Boston without an agreement on the price. Though a sum had not been precisely named, Rathbone knew for certain that it would be more than the Museum had ever before paid for a work of art. Tapping the Museum's available acquisition funds was essential before returning to Genoa to negotiate.

Some years before, the Museum had learned that they were to be

the beneficiaries of a fund established in 1923 by one Charles Bayley of Newbury, Vermont, specifically earmarked for the purchase of a very important painting. No one at the Museum had ever heard of Bayley, but these are the kinds of welcome surprises that sometimes come the way of museum directors – unbeknownst to them, a quiet admirer had remembered them in his or her will. Unfortunately, even though Charles Bayley died in 1928, the Bayley fund was not scheduled for release to the Museum until after the death of the two remaining legatees, which likely meant for some years to come. Was there any way they could change the terms of the will to speed things along? Without such funds at hand, the Raphael could easily slip from their grasp. While Rathbone assured Bossi of their real interest in the piece, he also dispatched trustee treasurer Jack Gardner to Vermont to see what he could do about adjusting the terms of Bayley's will to pay off the two legatees ahead of schedule.

Rathbone followed up by inviting Shearman to Genoa, where he would be stopping on the weekend of July 12, 1969, to meet with Bossi and to view the Raphael himself for the second time. With a very full summer ahead, Rathbone departed Boston the night of June 20. He began his travels in Cairo to negotiate plans for the centennial loan show of Egyptian art the MFA would share with the Metropolitan Museum, and then, nearly incapacitated by a bout of food poisoning, he flew on to Athens to discuss plans for an exhibition of Greek antiquities. From Athens, his digestive system having recovered to approximately normal, he flew to Paris to meet John Goelet, whose family home, Sandricourt, was a few miles north of the city in Oise.

A big man with a boyish face, Goelet was always in a ferment about his next idea and his next business enterprise. His family fortune came from Manhattan real estate, and he had a number of properties and businesses around the world, including a prestigious vineyard in Napa Valley, and a keen eye for art as well. As a museum trustee, he was not only among the youngest and richest but also, as Rathbone noted, "one of the more adventurous,"[24] a quality he found most refreshing. A knight-errant ever in search of the most exciting as yet undiscovered thing, Goelet was well protected by an illustrious family background and considerable wealth.

Goelet's interest in art was wide-ranging, but he was especially

interested in Islamic art and often visited the Asiatic art department at the MFA. He would drop in unexpectedly, arriving like a whirlwind. "All of a sudden all the phones were ringing at once," as curator Jan Fontein described the scene when Goelet swept into the department. "He would spend most of his time on the telephone explaining to people why he couldn't do something because he was doing something else."[25] Goelet also took a special interest in Swarzenski's decorative arts department, and the two of them had previously visited Bossi's shop together. There, Goelet had found to his delight a group of six life-size eighteenth-century Italian gilded putti playing musical instruments.[26]

On July 3 Rathbone and Goelet left Paris for Munich, where Swarzenski joined them, and then the happy trio set off on a ten-day road trip, with Salzburg their first stop. This was a welcome break from Rathbone's heavy business schedule, and he could not have wished for more compatible travel companions. He was always happy to let someone else drive so that he could sit back and enjoy the view, and since Hanns had never learned to drive at all, Goelet was left alone at the wheel of his Mercedes. John, as Perry observed, was "most adept at biting the nails on one hand and driving with the

John Goelet and
Hanns Swarzenski,
Paris, c. 1968.

other."[27] From Salzburg, they headed east through Austria, visiting museums and art dealers in Linz, St. Florian, and Vienna, then southwest through scenic Styria and Carinthia to Klagenfurt, and finally into northern Italy, stopping first to visit a dealer in Bergamo. All anticipated with excitement their important meeting in Genoa, where John Shearman would be joining the party from London. On Saturday, July 12, Rathbone, Swarzenski, and Goelet checked into three single rooms at the Hotel Aquila Reale in central Genoa. At the appointed hour the next morning, they met John Shearman and, thus assembled, set off for Bossi's shop.

Upon seeing the picture firsthand, Shearman confirmed his confidence in its attribution to Raphael before the morning was over. He noted a certain flatness in the execution, which led him to speculate that Raphael had never actually seen his subject but had worked from drawings the bride's family had sent to him from Mantua. He also noted that the condition of the picture was remarkably good considering its age. "Some damage and repainting over the nose and along the jaw, yes, but eminently desirable,"[28] as Rathbone recalled Shearman's observations on that warm summer day.

With Shearman's confidence in the painting, Bossi invited Rathbone, Swarzenski, and Goelet to meet again later that evening to negotiate the deal at his villa in Recco. They gathered on the terrace overlooking the Mediterranean. Bossi had already told them that his asking price for the painting was $1 million.[29] Heeding Seybolt's advice, Rathbone then countered Bossi's price with an offer of $600,000. It was a bold move. To his relief and amazement, Bossi accepted the offer without further haggling. Bossi had set his sights on the picture going to an important museum collection, and here was his chance. He asked for a deposit of 10 percent – $60,000 – which Goelet immediately cabled from his own private account, to be reimbursed at a later date.

Friendly as the meeting was, Bossi now laid out the ground rules in no uncertain terms. First, he wanted the payments to be deposited into his Swiss bank account. Second, he asked that for the time being, both he and the painting's previous owner remain anonymous until the payment was complete, hopefully by the end of the calendar year. And third, he insisted that the little painting be hand-carried

to Boston, owing to its fragile nature and exceptional value. Bossi insisted that they sign a written agreement to these terms before the negotiations could be finalized. With the little treasure nearly within their grasp, these conditions did not seem at the time to be unreasonable or onerous. Rathbone signed the agreement.

It was understood that the final sale would depend on the examination of the picture in the Museum's laboratory and the approval of the board of trustees. But Rathbone had reason to be confident. The hardest part, he thought, was over. "That evening after dining with old Ildebrando at his villa at Recco on the Riviera," Perry reported to Rettles, "we closed the deal with me as spokesman in my best French (!) and John following up with discussion of the financial details – and with great heart. Of course I can hardly believe it."[30]

The next day Bossi invited them back to Recco for lunch, "after which John departed," wrote Perry to Rettles, "and Hanns and I spent the afternoon sun-bathing and I swam and swam again from the rocks."[31] The tension left his mind and his body. Thanks to Shearman, he could be confident that the picture was real. And thanks to Goelet and the promise of the Bayley fund, it would be coming to Boston. Swarzenski would take care of the details of transportation later that summer.

In August Swarzenski returned to Genoa for one last meeting with Bossi. Soon afterward Bossi arranged for the picture to be transported to London, where John Shearman viewed it for a second time. On Friday, September 4, 1969, Hanns and Brigitte Swarzenski took a Pan American flight from London to Boston. Hanns carried the little 8½-by-10½-inch painting wrapped in tissue in his briefcase, and its frame in his valise on top of his clothes, both of which he kept with him throughout the flight. Arriving in Boston, the Swarzenskis were shown through customs without incident. Then they took the painting straight to the Museum by cab, where Hanns carefully locked it up in the conservation laboratory for the weekend.

The following Tuesday, Rathbone met Swarzenski at the Museum to view the picture. Later on in the privacy of his office, he showed it to George Seybolt and Laura Luckey, from the department of paintings, swearing them to secrecy. "Good old Hanns,"[32] said Seybolt upon learning that it was he who had brought it in. But now that the

painting was in hand, it seemed to Seybolt, Rathbone wasn't quite sure what to do with it. As Laura Luckey recalled, he was particularly anxious about the news leaking out to the Metropolitan Museum. As Seybolt recalled, "He kept using the word jealous" and saying things like "This would be a great coup."[33] He stalled for time as to how to present it to the board while maintaining confidentiality. But it was not only a sense of competition, real or imagined, that directed Rathbone's movements, but also fear. The painting was not theirs yet, and any chance of a leak would ruin not only the performance but also the deal. For the first time, he also neglected a routine part of the process when a work of art arrived on the premises – protocol demanded that it be presented to the Museum's registrar with the requisite paperwork. Since this would normally have included the provenance of the picture, he was inclined to put it off for as long as possible.

Meanwhile, Shearman delved further into the minutiae of his research – what his students later characterized as his "strip-mining approach"[34] to attribution – the circumstances of the artist's life, the physical likenesses between this and other early works by the young Raphael, Italian genealogy of the period, and as much as he could learn about the provenance of the picture. Then came the deep drilling. He noted that the light and texture of the red sleeves matched Raphael's portrait of Francesco Maria della Rovere, another early work. While the girl's bodice, or *camicia*, was typical of the period, she wore an unusual headdress – double knots of gold chain link and silk cord – which closely resembled one belonging to Isabella d'Este, the Duchess of Mantua. Shearman surmised, therefore, that this was not Maria della Rovere (as Bossi had asserted) but Isabella's daughter, Eleonora Gonzaga, at the time of her betrothal to Francesco della Rovere, the future Duke of Urbino, a match celebrated in 1505. Shearman speculated that Pope Julius II had commissioned the young Raphael that year, as the future duke was the Pope's nephew. If so, it was a commission that would have far-reaching consequences for the artist, as it represented a link that brought him to his most important patron, Pope Julius II, and ultimately to Rome. Keeping Rathbone in touch with his latest research, Shearman also suggested publishing his scholarship in the prestigious *Burlington Magazine* to coincide with the Museum's centennial.

Meanwhile, Rathbone, at Seybolt's suggestion, planned a small luncheon in his office for a select group of trustees deemed most critical to the decision to formally introduce them to the picture, the idea being to feel them out and, assuming their attitude was positive, to accelerate the acquisition process to meet Bossi's deadline. Seybolt recalled that Rathbone staged this performance in his "inimitable style,"[35] regaling them with the story of its discovery (omitting some details) and its potential significance for the Museum's collection. On a long refectory table in his office, he unveiled the little picture, which, owing to its small size, required the trustees to kneel before it as if before an altar.

As Seybolt recalled, the reaction among the group was respectful but subdued. Somebody raised the question of provenance. Rathbone explained the problems of revealing it before the approval of the purchase. At the collections committee meeting a few days later, someone pressed for its examination in the Museum's laboratory. Bill Young, head of the department, examined the picture under X-ray and microscope and confirmed that it was genuine and of the period, while noting some restoration on one side of the subject's face.

On November 19, the executive committee voted "to purchase one painting by Raphael, 'Portrait of a Young Girl' for $600,000."[36] The funds would be forthcoming from the Bayley fund just in time to include the Raphael in the centennial exhibition, *Art Treasures for Tomorrow*. At that point John Coolidge urged Rathbone not to wait for the official centennial kickoff in February to announce the arrival of this splendid acquisition. For maximum publicity, he suggested making its arrival a singular event and to announce it just before Christmas. Now that it was theirs, why not tell the world? Furthermore, as Rathbone considered the proposition, the February kickoff was still several weeks away and, as he explained to Shearman, "35 people cannot keep hot news to themselves very long, no matter how confidential."[37]

Laura Luckey noted that she had not received the usual paperwork on the picture for their department files – its size, date, and previous owner(s). Susan Okie, the Museum's acting registrar, remembered pressing the department for some record of the painting being in the building, even if the information was for the time incomplete.

She recalled that there was supposed to be a sealed letter attached to the picture, presumably including the provenance, but it never appeared. Jean Baker, one of Seybolt's two secretaries, was anxious to fill in the minutes of the board meeting with further information about the picture, but she could not get it from the registrar. So with the entrance of the picture into the collection, as Laura Luckey observed, "the usual procedures were not followed."[38] Meanwhile, Rathbone kept the picture in a little cabinet in his office, always ready to share his secret with members of the staff as the mood dictated.

A catalog of centennial acquisitions and promised gifts for the exhibition *Art Treasures for Tomorrow* was now in the works. As a gesture of friendship, Bossi had made his own centennial gift to the Museum – a sixteenth-century gold and enamel marriage ring in the shape of a little house – as if to celebrate and symbolize their happy union. In the catalog the ring was illustrated with the donor's name beside it, which at the eleventh hour was changed, at Jan Fontein's suggestion, to "anonymous gift."

Rathbone assured Shearman that the portrait would get plenty of international media attention and asked his advice on how to describe its provenance to the press. Answered Shearman, "'Swiss collection' always suggests to me Italy, and 'an old European private collection' sounds much better."[39]

Bossi, meanwhile, excited by the prospect of his little picture landing in a great American museum, wrote to Rathbone of his intention of coming to Boston "to assist in its inauguration."[40] Rathbone graciously but firmly put him off, pointing out that "from your own point of view in order to conceal your identity as the former owner, it would be unwise to come.... Your presence would quickly lead some to the conclusion that the picture came from you."[41]

Rodolfo Siviero, Art Sleuth

O N THE AFTERNOON of December 15, 1969, the Museum held a press conference to announce the purchase of the Raphael. John Shearman had flown in from London for the occasion and was photographed, along with Rathbone, peering at the painting with his magnifying glass. To the press, both Rathbone and Shearman spoke of the portrait as if it had assumed a vivid human life in their midst and as if they were now all personally connected – like family – to Eleonora Gonzaga. The press conference provided an occasion to "launch the charming young girl into the world,"[1] said Rathbone, while Shearman described himself with obvious pride as "the godfather."[2]

A special dinner that evening was catered in the trustees' room to a select group of about fifteen, including members of the executive committee, Dr. Shearman, and out-of-town press. After dinner at eight o'clock, Shearman delivered a lecture to the Museum's "family circle" – professional staff, friends, trustees, and committee members – detailing the process of his authentication. The painting's provenance was an essential key to the portrait's identity and attribution to Raphael. By way of explaining the path of his research, Shearman said that the picture had at one time belonged to an old Italian family in Genoa. This was just enough information for a suspicious press to plumb for clues about its source, but Rathbone was not worried. As he wrote to Shearman after the event, "You parried the provenance question with great skill, and I know that the reporters were so impressed that they could not stump you."[3]

Portrait of a Young Girl on view at the Museum of Fine Arts, Boston, December 1969.

The next day, Eleonora Gonzaga was unveiled to the public. At the top of the staircase in the rotunda, the picture was hung in its own special niche to the left, its elaborate frame against a backdrop of red velvet, behind a sheet of protective plexiglass. Immediately, and as anticipated, John Coolidge's suggestion of an early debut took its effect: the news of the unknown Raphael made headlines around the world. "Boston unveils hidden Raphael,"[4] reported the *Associated Press*. "Girl, shy 460 years, to debut in Boston,"[5] announced the *Boston Globe*. The *Art Gallery Magazine* called her the "Boston Bombshell."[6] The *Boston Herald* announced the "New Girl in Town."[7] Eleonora Gonzaga was featured in the People section of *Time* magazine. "Boston's centennial coup" was the full-color feature story in *Life*. "It's not every year that a museum can bag a Raphael," the article explained, "but this isn't an ordinary year for Boston's Museum of Fine Arts."[8]

Yet there was an intriguing, if not troubling, air of mystery around Boston's sensational purchase. Not that the Museum was

obligated to reveal precisely what it had paid for the picture, because the money had not come out of public funds, nor was it a published auction record. Furthermore, it was not unprecedented for a picture such as this to have been out of circulation for so long – old European families often held on to their personal treasures for generations until the need or circumstance arose to sell them off. But to the attentive viewer, the Museum's deliberate vagueness around the details of the painting's source was notable.

Rathbone was confident that the heat of the spotlight could only mean good news. "I am congratulating myself," he wrote to John Goelet on January 12, "on the smoothness of the Raphael announcement and the fantastic coverage in the world press – just the kind of shot in the arm the old MFA needs once in awhile. No difficulty so far and I don't really anticipate any trouble because we have been so discreet." He added by way of further reassurance to the somewhat doubtful Goelet, "I have not succumbed to any entreaties to tell more than we have announced."[9]

Eleonora Gonzaga's Boston debut transpired without anyone involved being aware that Rodolfo Siviero, head of Italy's Commission for the Recovery of Works of Art, was already on the move. In November he had received a letter from a colleague about the movement of one small painting, and thanks to the international press coverage of the Raphael's arrival in Boston, his suspicions were heightened. Siviero immediately sounded a quiet alarm through a network of Italian art historians, determined to trace the picture to its source.

Siviero was responsible for retrieving for Italy hundreds of works of art removed by the Nazis during World War II. His background made him unusually qualified for such a mission. Growing up in Florence, Siviero was well acquainted with the city's artistic treasures. As a young man striving to become an important art critic, he routinely availed himself of the fascinating company of the young women who came from all over the world to Florence to study art history. Though he never married, he enjoyed a reputation for regularly appearing with an interesting woman on his arm. The son of an officer of the carabinieri, Siviero also had an instinct for police work. In the 1930s he worked for Italian Army Intelligence in Ger-

many under the guise of an art student traveling on a scholarship while in fact gathering information about Germany's plans to invade Austria.

During the war Siviero switched his allegiance from the reigning Fascist government under Mussolini to the resistance movement. In 1943, enraged by the Nazis' plunder of Italian works of art after their occupation of Italy, he made the restitution of Italy's artistic heritage from the Germans his personal mission. As an agent for the military information service, he tracked down the movements of Hitler's Kunstschutz – the military commission charged with gathering artworks for the regime – and the development of Hermann Göering's private collection. In 1944, while on a mission to safeguard a Fra Angelico from Nazi thieves, he was captured by the SS and spent several weeks in the infamous prison of Villa Triste, in Florence, where he was tortured, starved, and interrogated night after night. He resisted the interrogation, and also the temptation to kill himself. After his rescue by two partisans in disguise, it took months for him to feel normal again. "What's hard after an experience like that is to come back to life afterward," said Siviero. "I went a year without laughing."[10] After the war, having earned the respect of the Italian government for his bravery, Siviero was named the minister plenipotentiary, chief of the Foreign Ministry's Delegation for the Retrieval of Works of Art, under Prime Minister Alcide de Gaspari.

Siviero was "the perfect double agent,"[11] according to Attilio Tori, curator of the Casa Siviero, for by the end of the war, he had developed a network of contacts among the Fascist regime, the resistance movement, and the Allies. In the delicate negotiations that followed, he helped to persuade the Allies to designate Italian art as Nazi war loot – not only art taken after the German occupation but also those treasures removed earlier with the complicity of the Fascist regime as special gifts from Mussolini. More a man of force and cunning than diplomacy, Siviero could sometimes be an embarrassment to his own government, entering into press polemics and offending American officials. Nevertheless, he must be credited with helping to supervise the recovery of some 2,500 works of art that left Italy in one way or another during the war.

By 1950 Italy's mission to retrieve its artistic heritage was con-

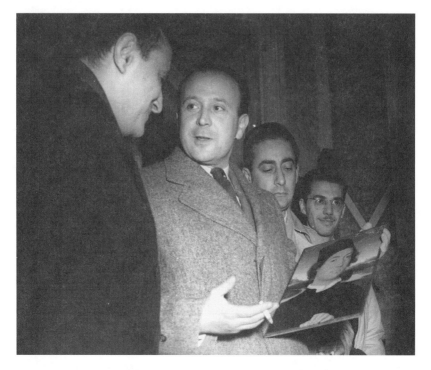

Rodolfo Siviero with *Portrait of a Gentleman* by Hans Memling, 1948.

sidered more or less complete. But Siviero had found his calling and continued to operate under whatever auspices of the Italian government he could invoke. From that point on, his job was never official, he had no pension, and every year he had to fight for his position to be reinstated all over again, for Siviero's ongoing program was not met with enthusiasm from the Italian government. By midcentury he had stirred up too many political issues that were considered best left undisturbed. A delicate peace then reigned between Germany and Italy, which was in everyone's interests to maintain. But Siviero kept his wartime files open, suspecting that many people were sitting on stolen works of art, waiting for his retirement. He estimated there were at least one thousand works of art yet to be recovered, while others claimed this figure was exaggerated and that furthermore very little of what remained missing was of great importance. But it was hard to prove Siviero wrong since he was highly secretive

about his sources and his lists. Working out of a small office on the ground floor of the Palazzo Venezia, in Rome, he struggled along with a limited budget and skeleton staff, relentlessly gathering evidence and keeping the Italian press lively with his latest discoveries and accusations. And as his files grew, apparently so did his hold over the high level of government. "[Siviero] survived various governments that changed every couple of years," said painting conservator Andrea Rothe, who had lived much of his formative years in Italy and among Italian art professionals. "Everyone said he had the job because he had some scoop on all the ministers."[12]

Siviero was by nature a lone wolf. He had no interest in integrating his efforts with the civil administration of the carabinieri, over which he claimed vastly greater experience. "It was very important to him to be recognized," explained Attilio Tori, "not just as carabinieri. He dreamt of being a great art historian, of being recognized among intellectuals."[13] Siviero also cultivated his acquisitive urge for Italian art. It was said that he sometimes elicited gifts from compromised individuals, and when he turned up to bid on a work of art at auction, no one dared to bid against him.

As a former double agent, it came naturally to Siviero to play every side of the game. He was just as ready to work with a foreign police force as his own. Finding the spies or allies he needed in the enemy camp was as natural for Siviero as any other aspect of secret-agent tactics such as blackmail, bribery, and spreading falsehoods. To encounter him as a person, Marco Grassi remembered, "He was very opinionated. He was abrasive, combative, ornery. He was one of those people who was always mad about something."[14] In his zealous pursuit of suspects, Siviero thrived on controversy. "Everything he did was always right, and everybody else was always wrong,"[15] said Attilio Tori about Siviero's attitude. "He was a very hated man,"[16] remembered Andrea Rothe.

To the consternation of many Italian art dealers, by the 1950s Siviero no longer confined his role to the restitution of Nazi plunder. He had defined a new mission for himself: to safeguard works of Italian art from illegal exportation. According to the Italian export laws established in 1939, called the Protection of Artistic Patrimony, any work of art considered an important piece of the nation's cultural

heritage could be exported only after the state was given a two-month option to acquire it. Furthermore, if the option wasn't exercised, a hefty 30 percent export tax was imposed on any buyer from outside of Italy. Because this law would effectively paralyze the Italian art trade, the Art Dealers Association of Italy fought the export tax for years without success. In the midst of this stalemate, dealers and collectors alike applied their own interpretations to what constituted an "important" manifestation of Italy's cultural heritage.

Thus there were gray areas of the law, and there were loopholes in the system, and many took advantage of them. The first question the dealer and foreign buyer would ask about an object for sale was whether it was a known work. Was there any trace of it in the literature, any exhibition history at all? To be safely exported, it had to be a "discovery," something buried in the house of a noble family, perhaps hidden away in a servant's room or lying underneath a layer of grime for so many years that nobody could remember what it was. An unknown or unpublished work – and there were plenty in Italy – stood a reasonable chance of legal export; it could have come from anywhere. While technically an important work of art should be registered with the government whether known or not, it was unusual for private owners to volunteer such information. Italian art dealers and collectors also knew that to put one's name on any government list in Italy was to ask for trouble. Countless works of art in private hands were not registered with the Italian government, and while exporting such articles was a calculated risk, it was not a criminal offense. Typically they were spirited across the Italian border to Switzerland in the trunks of cars or the bottoms of suitcases, and few came to the attention of the authorities. In the rare case of a dealer or collector being caught in the act, the object would be confiscated and the buyer fined.

Another calculated risk was to apply for the export license but assign a deliberately reduced value to the work, thus reducing the tax – but not so low that the state might exercise its right to buy. Yet another was to pay a shipping firm to take care of the border crossing of an unlicensed work. The most serious infringement of the law was to bribe a member of the police force to create a fraudulent permit. While dealers and collectors weighed the options, of one

result they could be quite sure – once the object was safely outside Italy, Italian law did not apply. As explained by art law specialists John Henry Merryman and Albert E. Elsen in *Law, Ethics, and the Visual Arts*, "Although the offended nation could punish the smuggler, if it could catch him, and might have the power to confiscate the illegally exported article if it should be returned to the national territory, it could not expect the foreign nation to punish the smuggler or seize and return the object."[17]

In the absence of what seemed a viable treaty between or among nations, and in the absence of a functioning system in Italy itself, the sense of justice and responsibility in the trafficking of artworks was more or less crafted privately between buyer and seller. In the 1960s there was still something of a postwar mentality about it. Swarzenski, having been a refugee from Nazi Germany, then allied with Italy, had grown up with his own ideas about what was best in the pursuit of artistic treasure for the greater good, not to mention perhaps for the safety of the object itself. As for Rathbone, if he felt a twinge of discomfort about engaging in the common practices of circumventing Italian export laws, he justified his actions, like others before him, by pointing out their flaws and inconsistencies. In questions of ethics versus the law, context was the key. In the case of buying art from a source-rich but cash-poor country, Americans had for years defined their own path with a relatively clear conscience. In essence, Rathbone, like many of his colleagues, was guided by the basic principle that Italy would hardly miss what would be treasured by the American museum. Furthermore, by spreading knowledge and appreciation of Italian culture, they were encouraging what they believed Italy needed most: tourism and also trade.

In addition, Rathbone was not the only museum professional inclined to consider how great a role the US government had played in the rescue and safeguarding of countless works of art and architecture in Italy during the war. The US government's Allied Protection Effort sent a corps of art experts – topflight museum directors, painting conservators, art and architectural historians – to Europe in 1943 to investigate and ensure the safety of irreplaceable buildings and works of art against both enemy and Allied bombing, and later to oversee their return. For many months, Italy was the benefi-

ciary of the American officers' expert services. For anyone in the
American art world at that time, the memory of these efforts was
still fresh.

More recently, in the immediate wake of the devastating Flor-
ence flood in 1966, dozens of experts from the United States had
flown over to lend a hand in the restoration effort as an act of char-
ity. The Florence flood inspired a collegial relationship that crossed
national boundaries, awakened a sense of community in the field of
conservation, and brought forth the creation of a center for the
study of conservation at the Palazzo Davanzati. From the Boston
Museum, Rathbone dispatched the head of conservation, the punc-
tilious and highly knowledgeable William Young, who arrived in
Florence in the first wave of emergency rescue efforts immediately
after the flood. Young had planned to spend two weeks but proved
so indispensable that he was persuaded to spend the next six months
there, directing the restoration of irreplaceable objects, working day
and night at the Bargello Museum, cleaning the oil stains from
Michelangelos, and salvaging arms and armor. "The past year was
very challenging for the department," wrote Young in the MFA's
annual report of 1967, "as it not only had to meet the growing
demands of the various departments of the museum but also had to
fulfill its commitment to Florence."[18]

Siviero would be the first to admit that indeed Americans did
deserve more credit than the people of his own country in caring for
their artistic heritage. He made a point of publicly distancing him-
self from his unresponsive countrymen. "Italy has fallen a long way
from the spiritual values represented by the artistic patrimony she is
supposed to preserve for the world and for which, in fact, she cares
little,"[19] he said in a statement in the late 1960s. Typical of his proc-
lamations, this kind of outspokenness only added to his reputation
as a controversial figure in his own country. But his greatest resent-
ment was reserved for the bureaucrats of his own government, those
who had relegated him to his little office and his limited budget, and
he continued to rail against their indifference to his mission.

At about the same time the Raphael was making its way to Bos-
ton in late 1969, Siviero's budget ran out, and there seemed to be no
plans to replenish it. Diplomats from Italy and West Germany had

a meeting that fall and agreed to officially wind up the postwar retrieval business by June 1970 and let remaining sleeping dogs lie. Siviero was furious. "No one wanted this service in Italy from the very beginning,"[20] he told the press. With little to chase after, he was more determined than ever to prove his importance. Now in his late fifties, balding and overweight, smoking his "evil smelling cigarettes,"[21] his health failing and his coffers empty, Siviero was poised to make waves at any opportunity – for him, it was literally a matter of personal survival. An obscure painting by Raphael that had just landed mysteriously in Boston was exactly the kind of target he was looking for to garner fresh publicity to his cause and maintain his position in Rome.

Siviero could find no record of the painting's sale or its movements, but pressing on, he perceived a possible new line of inquiry. One of

Perry T. Rathbone with the Honorable Piero Bargellini, Mayor of Florence, Italy, on a visit to Boston during a tour of American cities to report on the progress made in Florence since the flood and to thank Americans for their assistance, April 11, 1967.

the details that awakened his suspicions was the frame – the exquisite gilded tabernacle frame that nearly doubled the object's overall size. Bossi had told Rathbone that the frame was original, but Siviero, from somewhere or someone, had reasons to be skeptical. If the frame did not, in fact, belong to the picture, where did it come from? With press photographs in hand, he eventually located the framer, who not long before had skillfully customized an antique frame to fit the picture as if it belonged to it, a frame that Bossi would claim was original to the picture. And from the framer he extracted the name of the dealer to whom it had been sold: Ildebrando Bossi.

While the MFA was preparing to begin the celebrations of its centennial year, Eleonora Gonzaga held center stage. But less than one month into the new year, there was a disturbing development. On January 23, 1970, Siviero filed a complaint in the city of Genoa and alerted the international press that an important Italian picture had recently left Italy without the necessary export license. Rathbone responded to these allegations with "an enigmatically worded statement,"[22] saying that the reports from the press were "the first indication I have had that anyone, anywhere is concerned over the matter."[23] But while it may have been the first time that concern over the picture's exportation was publicly expressed, it would not be the last.

On February 4, 1970, the 100th anniversary of the Museum's incorporation to the day, a giant birthday cake was laid out in the rotunda, and every afternoon for the following week was ceremoniously lit with one hundred candles. Special guests lined up to take part in the honor of blowing them out – Boston mayor Kevin White, Massachusetts governor Frank Sargent, college presidents, and famous athletes. The opening of the exhibition *Art Treasures for Tomorrow* was preceded by a gala dinner with 332 special guests assembled in the candlelit paintings galleries. The guest of honor, the Earl of Crawford and Balcarres, delivered an elegant speech, adding the requisite touch of class. Museum directors from across the country were there to toast the MFA – Tom Hoving from the Met, Sherman Lee from the Cleveland Museum, Carter Brown from the National Gallery, and

TOP: Mayor Kevin White, Perry T. Rathbone, and Governor Francis Sargent celebrate the MFA's 100th birthday, week of February 1970.

MIDDLE: Thomas Hoving, Sherman Lee, Perry T. Rathbone at opening reception for *Art Treasures for Tomorrow*, Museum of Fine Arts, Boston, February, 1970.

BOTTOM: Rathbone escorts Rose Kennedy through the galleries during centennial festivities, Museum of Fine Arts, Boston, 1970.

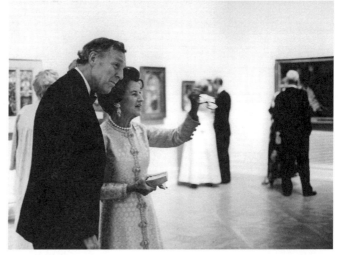

Otto Wittmann from Toledo, among others – and to congratulate Rathbone personally while they cast their judgments and gazed with envy at his centennial harvest – works of art that spanned the third millennium BC to the present day. More than 30 percent of the exhibition presented art of the twentieth century, making the point that Boston was finally catching up with the times. Many of these treasures were gifts from friends nurtured over the course of many years – young Boston collectors Stephen and Susan Paine gave David Smith's brushed aluminum sculpture from his Cubi series, a Juan Gris still life came from Joe Pulitzer, Bill and Gertrude Bernoudy presented a Paul Klee, Sue Hilles promised her gift of a major Franz Kline, along with her "intended" gifts of other modern works by Alexander Calder, Alberto Giacometti, and Hans Hofmann.[24] John Canaday, writing for the *New York Times*, was duly impressed "that a collection of such quality could be assembled today considering the state of the art market and the strain put on the generosity of donors."[25]

In the exhibition catalog, the Raphael was the frontispiece in a full-color illustration, while inside it was reproduced in black and white with its frame. "The frame is presumably the original one," the caption states. "The portrait is presumably a likeness of Eleonora Gonzaga," the artist (not presumably), "Raphael." Coinciding with the celebrations, the February issue of *Burlington Magazine*, the most highly respected scholarly journal in the field, published a feature article by John Shearman on the Raphael painting with copious details on the process of his attribution. Relishing his role in introducing this unknown treasure to the world, Shearman especially enjoyed the idea that its discovery required that his colleagues' "habits of mind"[26] be revised, and he called the painting "a tiny but in this case vigorous newcomer to the family of Raphael's works."[27]

Meanwhile, Siviero was working through his network of Italian art historians. It's a small world and not surprising that somebody remembered Toesca's attribution and that the painting had apparently once belonged to the ancient Genoese family of Fieschi, who were said to have owned it for four centuries. After World War II, the last Fieschi heir, needing money, had apparently sold off some family treasures to a local art dealer. This would suggest that the picture was still in Italy after the 1939 passage of the Italian law to

protect artistic patrimony. By rights then, it should not have left the country without an export license.

The picture may never have been stolen, nor was it registered. However, Siviero could make the case that any work by Raphael was an important piece of the nation's heritage, and that if it came out of Italy, by law it should have been registered and licensed before exportation. Even if by now it was inside the United States and outside of the Italian jurisdiction, Siviero was first of all intent on punishing the dealer who sold the painting without obtaining an export license. At the very least, he should be fined and forced to pay the 30 percent export tax, as well as the capital gains tax he had avoided in making the secret deal. As for actually retrieving the painting, now in the hands of an important American art museum, this would be the ultimate triumph but one he knew he was unlikely to achieve.

All signs pointed to Genoa. The frame fitter had provided an important clue, and so had the memory of the Toesca attribution. Siviero set to work, directing an assistant to search the hotel registers of Genoa during the previous summer. The investigation confirmed his suspicions when they found that two officials from the Boston Museum, Swarzenski and Rathbone, had checked into the Aquila Reale Hotel on the Piazza Acquaverdi in July, and that in August Swarzenski had checked in again. "Investigators have already proved the painting left Italy no earlier than last July," Siviero told the press. "The way the picture left Italy was undoubtedly clandestine."[28] The case of Boston's Raphael was, in Siviero's words, "one of the most serious losses suffered by the Italian artistic heritage in recent years."[29]

On February 1, with the help of Genoa's chief of police, Siviero approached Bossi with a photograph of the tabernacle frame and some carefully worded questions. Bossi admitted to having bought a similar frame and using it on a small portrait of a girl, but it was not by Raphael. Handing back the photograph to Siviero, he left his fingerprints on its glossy surface. From these, the chief of police promptly confirmed that Bossi had a criminal record dating back to 1924 with convictions for smuggling art and currency, and that he had served five years in prison.

On February 27, less than a month after the opening festivities

of the MFA's centennial, Italian newspapers reported that Bossi had been charged with illegally exporting a Raphael painting now in the hands of the Boston Museum. The news immediately hit the Boston press. Rathbone was worried. Even if he believed the picture to be legally safe inside the United States, the negative publicity that Siviero was kicking up was the last thing the Museum needed for a birthday present. Now for the second time he was questioned by the press about the exportation of the painting since the announcement of its arrival. He did his best to dismiss Siviero's accusations of smuggling. "How can he make such a claim," he asked, "when the painting was entirely unknown, uncatalogued, unlisted, unillustrated, and unpublished up till now? He's simply leaping to conclusions."[30] The obscurity of the painting was supposed to have made it untraceable to Italy. But this was only the first of Rathbone's assumptions that was now eroding.

In an effort to piece his case together from both ends, in early February Siviero asked a customs representative in Rome to contact the Boston customs office and request an investigation "into the disappearance of a Raphael painting from Italy in 1969,"[31] which had recently surfaced at the Boston Museum after a visit to Italy by the Museum's director, Perry Rathbone. In March a Boston customs agent contacted Rathbone with questions about the imported painting, explaining that this was a subject of interest to Italian officials. Among other things, they wanted to know who had brought the painting to the Museum. Rathbone replied by assuring the agent that "there had been nothing of a questionable nature in the proceeding."[32]

It was only after customs agents questioned him that Rathbone learned – apparently for the first time – that Swarzenski had not declared the picture upon his arrival in Boston the previous September. While in hindsight this was a serious mistake, Rathbone understood Swarzenski's reasons for not declaring the picture. To begin with, there was no duty to pay on a work of art that was more than one hundred years old. Though by law at that time, any object worth

more than $10,000 must be declared upon entering the country, whether dutiable or not, "the importation of non-dutiable objects is a matter of general indifference to customs officers," Rathbone later asserted, "as curators and collectors have known from long experience."[33] Swarzenski, among other curators, had more than one story to tell of entering US customs and verbally declaring a nondutiable work of art, then finding officials uninterested in having it unwrapped for their inspection and waving him through the gate. In the case of the Raphael, Swarzenski, as he later told the story, had verbally declared the picture. Apparently, at that point, no one had presented him with a declaration form.

It could also be argued that Swarzenski was acting out of a sense of caution for the safety of the object. Some years before he had brought in a spectacular medieval *oliphant*, or carved elephant horn. Upon revealing the value of the object, he found customs officials not so indifferent. Handed a "long form" to fill out, he was forced to leave it with customs overnight, only to find it damaged when he came to collect it a day or two later. The day Swarzenski arrived in Boston with the Raphael in his briefcase – September 5, 1969 – had been excessively hot, which might have made him especially nervous about leaving the article in the unknown conditions of the customs office. Furthermore, the fact that the Museum did not yet own the picture gave it a kind of limbo status that may have added an element of confusion as to correct protocol. Swarzenski was not adept at handling officials or at making his concerns or the complications of his position entirely clear.

"Hanns was unconventional, putting it mildly," commented John Coolidge. "He had a funny, erratic tendency to disregard expected behavior." Of Swarzenski's behavior at customs, Coolidge later surmised, "Hanns knew that rule and deliberately said, the hell with it."[34] As unconventional and erratic as he might have been by nature, Swarzenski's distrust of bureaucracy and government authorities had deep roots. To witness his father anguishing over the need to hide modern artworks from the Nazi authorities in his role as a museum director, and then to lose his job because of ideological and ethnic differences, was an education in extreme prejudicial treatment.

Playing hide-and-seek with the Nazi authorities was a memory in Swarzenski's curatorial psyche, and it is likely that to some extent he carried this experience into his later professional life. As long as he believed that what he was doing was right for the work of art, and right for the public he served (but especially the former), he believed that he was on strong moral ground, and that was all that mattered. As for the tricky details, he was a foreigner on foreign turf, and he trusted that someone who knew more about the ways of his newfound country would pick up the pieces – that was not his job.

Even if Swarzenski had, in fact, verbally declared the picture, he might not have been understood, considering his habit of nodding and gesturing and mumbling into his chin with his thick German accent. Perhaps he even deliberately sounded rather casual about the precious cargo he carried in his valise; his aim was to get through the process as quickly as possible. For what if they had asked about the source of this picture, which he had been strictly advised not to reveal? An awkward agreement had been struck with the seller, and now the Museum was stuck with it. Coming through customs, Swarzenski faced it for the first time, but not for the last. "Secrecy was the price of the deal,"[35] Rathbone admitted, and secrecy had guided their movements from the start.

As much as Rathbone understood Swarzenski's frame of mind, he also knew that not everyone would be inclined to do so. His tendency to protect Hanns from misunderstanding, to act as his interpreter, was habitual, but now it acquired a new edge of fear – for his friend's safety, for the Museum's, and also for his own. Failure to make a declaration in customs was potentially punishable by forfeiture of the imported object as well as a civil penalty equal to its value. Rathbone did not tell the customs official who had brought the picture into the country, apparently hoping to protect Hanns and the Museum from further damage, and perhaps assuming that the problem of the missing declaration form would somehow evaporate. From Siviero's point of view, meanwhile, the Boston customs investigation was playing into his hands with greater speed and success than he had any reason to expect.

Seybolt knew that Swarzenski had been the courier, but he did

not know that he had not declared the painting at customs, and Rathbone, in his increasing distrust of the board's president, was not inclined to tell him. Later, too much later, he regretted this and admitted his mistake. For the moment, in a discussion with the Museum's executive committee about his recent visit from customs, Rathbone was advised to seek legal advice. Seybolt recommended the then-largest law firm in Washington, Covington & Burling. In his capacity as president of Underwood, Seybolt was on friendly terms with Covington partner H. Thomas "Tommy" Austern, a smart, aggressive, self-made man from Brooklyn, who had handled regulatory issues involving the US Food and Drug Administration and whose advice and judgment Seybolt valued.

It might also have been Seybolt's sense that the Museum's issues had acquired a Washington dimension. While the export-import problem of the Raphael was a new one for the MFA, it also presented an unusual assignment for any law firm at the time. Most cases of contraband to date involved criminal activities such as drug trafficking. Furthermore, any kind of smuggling typically involved items the carrier was instructed to keep secret. That the Museum had immediately put the picture on public display and actively sought media coverage of the great event hardly suggested an undercover operation. There were no precedents for a case like Boston's Raphael. The Covington lawyers advised Rathbone and Seybolt that customs had a very large leeway in such matters and that the law was highly interpretive. The assignment, therefore, was to construct a viable position for the Museum regarding Italy before customs became further involved.

Attorney Tommy Austern called upon a young associate lawyer, Gerald "Jerry" Norton, to help carry out the legwork. On Friday, March 13, Norton was instructed to get ready to go to Boston on Monday to interview the director of the MFA. Norton borrowed some art books from a friend and crammed over the weekend for the background in Renaissance art he thought he might need. Arriving in Boston, his first stop was the MFA, where he viewed the little painting in question and wondered to himself what all the fuss was about. Then he called on Rathbone, who was not feeling well, at his

home in Cambridge. To the young lawyer, the venerable museum director seemed gentlemanly and refined, and his story both sympathetic and fascinating. Little did Norton know at that first meeting that "the whole truth" would not emerge for several months to come.

But Is It Really a Raphael?

THE FULL CENTENNIAL PROGRAM was now in the works, and it was moving forward at a brisk clip. An exhilarating year lay ahead, with nonstop celebrations. But the season also packed its fair share of shock and disappointment.[1] For more than two years the MFA had expended time, energy, and funds on the complex preparations for the exhibition of Egyptian treasures from the Museum of Egyptian Antiquities in Cairo. The show was to open at the MFA in April 1970, its first stop on the American tour, with the Metropolitan second, and the Los Angeles County Museum of Art, a recent addition, third. On March 9 all but five of the promised forty-three pieces were packed and ready for shipping at the Museum in Cairo. At the MFA the galleries were being painted and prepared for installation, and the catalog was printed and bound. At that point in the process, the Egyptians decided to "postpone" the show "until happier times should prevail."[2]

In Europe and the Middle East the number of attempted airline hijackings had been climbing at an alarming rate. Many of these were related to the ongoing Arab-Israeli conflict and the fresh memory of the Six-Day War in 1967. On a recent visit to New York, French president Georges Pompidou had been harassed by Zionist groups for his pro-Palestinian stance. Even more recently a group from the Jewish Defense League had disrupted a performance of Russian musicians in the Metropolitan Museum's auditorium, shouting and hurling stink bombs. In this heated and unpredictable

political climate, the Egyptian minister of culture, Sarwat Okasha, had reason to fear that, at worst, the plane carrying their treasures would be hijacked en route to Boston or that, at the least, some kind of demonstration might be visited upon the exhibition during its US tour and concluded that it was not worth the risk. Their lack of experience with international loan exhibitions also made the Egyptian officials nervous collaborators.[3] The MFA's eager young assistant curator Ed Terrace, who had spent months in Cairo organizing the show, argued that on the contrary, there could be no better time to cultivate diplomatic relations with the United States. Here was an opportunity to assert the power of culture over politics. But despite the MFA's enlistment of Scotland Yard for maximum travel security, despite their promise to donate all profits from the exhibition to the rescue of the Temple at Philae from the waters backed up by the Aswan Dam, despite the fact that the loans coming from the Museum in Cairo were reciprocal for loans of Islamic artwork the MFA had sent to Cairo's millenary that very year, the Egyptians could not be persuaded to change their minds.

Just two weeks before, Rathbone had been called to a last-minute summit meeting at the Metropolitan Museum, where Hoving, in consultation with his top advisors, decided on the spot to pull out of the Egyptian tour, thereby withdrawing their financial support as well. Hoving's decision may or may not have been justified by the recent disturbance in their auditorium. But the Met's withdrawal no doubt added to the Egyptian's resolve to "postpone." Rathbone was mightily disappointed and refused to take the official explanation at face value. After months of an agonizing joint effort over the loans of these great works of antiquity, all had gone to waste. Rathbone, ever alert to the competition, concluded that Hoving "just didn't want to play second fiddle to Boston."[4] In a letter he wrote to Ed Terrace but never sent, he said candidly, "Hoving as a politician blanks out any other Hoving that might exist."[5]

Further troubleshooting was just ahead, after the press release announcing the cancellation of the show at the MFA. By way of explaining this abrupt and disappointing change of schedule, Rathbone alluded to "the atmosphere of intimidation"[6] that was at its root, which then sparked a flow of angry letters from the Jewish

Elma Lewis, Edmund Barry Gaither, Perry T. Rathbone at press conference
for *Afro-American Artists: Boston and New York*, Museum of Fine Arts, Boston,
April 1970.

community in Boston. Without exactly spelling it out, it appeared
obvious that Rathbone was laying the blame on the Israeli side. A
public relations countereffort then ensued for weeks, with the direc-
tor answering each angry letter personally.

The dark cloud of this disaster, however, had a silver lining. To fill
the gap in the schedule at the last minute, the MFA gave the special
exhibition galleries reserved for Egypt to a show of contemporary
black artists instead. If politics was the reason for the cancellation
of the Egyptian loans, it was also very much behind the exhibition's
replacement with *Afro-American Artists: New York and Boston*.

Fortunately, a smaller version of the show was already in the
works at the MFA. Just two years earlier the Museum had officially
joined forces with the National Center of Afro-American Artists, in
neighboring Roxbury.[7] Established in Boston by the formidable
Elma Lewis in 1950, the Center's program embraced music, dance,
and theater, as well as the visual arts. As the program developed over
the years, along with Boston's growing black population, Lewis

successfully recruited leading cultural institutions to her power base. The MFA offered expertise, help with fund-raising, and temporary gallery space. Edmund Barry Gaither, a young black art historian from Atlanta, had become known as someone who could effectively put forward the African American cause in the visual arts, and in 1968 the MFA and the Center made his position official as "curatorial liaison" between the two institutions.

As the plans for a show of African American art at the MFA were made known, black artist and activist Dana Chandler, Jr., who had been agitating Rathbone for some time to make a greater commitment to the black community, expressed his dissatisfaction. Chandler publicly denounced the effort as "pacification, to keep black people quiet during the centennial celebration,"[8] and he threatened to boycott the show. The unexpected availability of the main exhibition galleries, therefore, provided a timely opportunity to escalate this into an event that would pass muster with even the most demanding activists for the African American cause.[9] With the MFA's go-ahead in March 1970, Edmund Barry Gaither immediately set to work expanding the show to include New York artists he had come to know, along with Boston's best. Everyone concerned was determined to make the best of it. "Perry gave me a lot of latitude," recalled Gaither. "I also got a nod from Eleanor Sayre from prints and drawings. I had stepped into such a compressed time frame; it was important to have acceptance within the curatorial family."[10] As the MFA smoothed over the change of plans in its advance publicity, this was "one historic show replacing another."[11]

Harlem on My Mind, the Met's spectacular public relations disaster of two years earlier, was still fresh in the minds of museumgoers. While it was politically well intentioned, this multimedia social history show was also misguided from the start. The title *Harlem on My Mind* derived its name from a lyric by Irving Berlin, a white Jew from the days before Harlem became a black neighborhood, and it came to symbolize the racial tensions between Jews and blacks that immediately surfaced around the show's content and purpose. Black artists, with Romare Bearden and Henri Ghent leading the charge, were enraged that the museum's exhibition included no paintings. The text of the catalog, which detailed the background of anti-

Semitism in Harlem, raised so many hackles among the Jewish community that New York City mayor John Lindsay threatened to withdraw city funding of the museum if the catalog was not removed from the sales desk. Not the least of the catalog's insults was Hoving's foreword, in which he invented a fictitious black maid and chauffeur from his Park Avenue childhood to add a dash of "authenticity" to his personal experience. Before the show ended, a vandal had carved the letter H on several paintings in the museum – whether it stood for Harlem, Hoving, or Hell, no one could determine. For all its good intentions, the show made few friends, and many enemies.

The MFA's exhibition, while a quieter event, turned out to be in many ways a greater success, for it had no such interpretive problems. The only question implied by its very concept was, what makes it black art? Although some of the work was racially political in content, much of it was not. Although some derived inspiration from the traditional arts of Africa (Gaither, among others, appeared at the opening dressed in an African *buba*), the majority had nothing to do with that Africa. Another question, raised by Hilton Kramer, the prickly and widely feared art critic of the *New York Times*, was about the quality of the art. To Kramer, the MFA show was "an art exhibition mounted under the pressures of political expediency that fails, by and large, to justify itself in terms of artistic accomplishment."[12] In an exchange of letters to the *New York Times*, Gaither sought to educate Kramer, who, he said, "came to the show with blinders on; he came with a commitment to late 1950s aestheticism in which figurative art was retrograde."[13] As much as Gaither would have liked the critical discussion to go further than it did, the event was in many ways a triumph – the most important show yet of black art ever mounted in a prestigious museum.

While African American art went on view in the main exhibition galleries, Eleonora Gonzaga continued to hold her own in the rotunda, intriguing visitors with her beauty and also her mysterious origins. Not only were there still questions about the picture's source, but now there were also doubts about its attribution to Raphael. Sidney Sabin, a dealer of old master pictures in London, fired the first

salvo in the *London Times* on March 3, 1970, unabashedly calling the picture a twentieth-century fake. A few weeks later Sabin traveled to Boston to view it firsthand only to publicly debunk it further. On April 25, Sabin declared that the picture was "chocolate-boxy," that the girl's head was too big for her body, that there were problems with her headdress, her necklace, her belt, the folds of her sleeves, and the gaze of her eyes. The light was too uniform, and the shadows made no sense. Sabin had lots of questions. "Take that ornamental headband, what are those weird festoons attached to it?... Now look at that belt. The buckles are devoid of structure. How do they work? Why does the necklace suddenly fizzle out below the knot?"[14] And so on.

At these public challenges to his authority, John Shearman stood his ground. He immediately provided a full-scale rebuttal to the *London Times*, criticizing Sabin's "irrelevant ... inappropriate, ill-judged and generalized criteria."[15] He went on to explain that the weaknesses Sabin perceived were typical of Raphael's early work, thus only reinforcing his attribution. "Mr. Sabin can see nothing good in the Boston portrait, but he has identified for us deficiencies peculiar to Raphael. I am quite grateful," he added with a touch of irony, "for there are some that I had not noticed."[16]

Shearman was not alone in hoping the controversy would die down, but it did not. Art dealers can be very wily in such a debate, observed Nicholas Penny, "at anticipating who will psychologically be played off whom."[17] Perhaps Sabin had an old bone to pick with Shearman – some slight, some insult to his authority, way back when. Whatever, he enjoyed playing his challenge to the hilt. On a chance encounter at a London bookshop with the chief editor of the *Burlington Magazine*, Benedict Nicolson, Sabin agreed to a wager: he bet that the painting was a fake, while Nicolson wagered that it was authentic. And now art historians on both sides of the Atlantic lined up on either side of the increasingly bitter debate. Cecil Gould of the National Gallery, in London, was quoted as saying that Sabin's accusations were "absurd" and "fatuous,"[18] while John Pope-Hennessy, director of the Victoria and Albert Museum, in London, offered a guarded appraisal that "from the pictures I've seen it has little family resemblance to the work of Raphael."[19]

Meanwhile, back in neighboring Cambridge, Harvard fine arts professor Sydney Freedberg seized the opportunity to educate his students in the subtle problems of authentication and presented the Raphael to them as an exercise. Freedberg, who delivered riveting lectures in a booming voice and self-styled British accent, specialized in the painting of the High Renaissance. For the sake of argument, he came up with a frankly insulting attribution to an obscure Renaissance artist from Gubbio, Sinibaldo Ibi. Under the surface of his apparent objectivity (as Nicholas Penny later explained), there was something of a backstory. Freedberg had been an "old, polite rival"[20] of Shearman's ever since they had published conflicting works on Andrea del Sarto at the same time, and as Freedberg's wife, Frances, recalled, there was "a prickly mess over that."[21] Freedberg might also have particularly resented that Rathbone sought out Shearman's expertise from across the ocean, while there he was, equally knowledgeable, just across the river.

On the other hand, Freedberg "adored Hanns [Swarzenski]," his wife recalled. "He reminded him of the German professors of his youth – [Jakob] Rosenberg and [Erwin] Panofsky"[22] – and he did not wish him ill. Negative as his attribution appeared to be, Freedberg declared that he was doing the MFA a favor. If the picture wasn't, in fact, by Raphael, there was no reason for the Italians to make any trouble over it.

In the MFA's conservation lab, X-rays had revealed that significant portions of the face – as Shearman had noted – had been repainted. They also penetrated to another layer of the original composition, the pentimenti, which revealed that the artist had shifted the focus of the subject's gaze to a more direct and formal position, thereby dispelling suspicions that it was copied from another painting. Pigment analysis further proved the original surface paint was of the period and therefore the picture could not possibly be a twentieth-century fake. But no X-ray or pigment analysis could determine that it was, or was not, a Raphael. "You cannot determine quality in a laboratory,"[23] said Shearman, who remained convinced of its authenticity, as did Rathbone. And Rodolfo Siviero.

Even before Sidney Sabin sparked the public debate with his letter to the *London Times*, Rathbone had privately received communi-

cation from art circles abroad expressing doubts about the picture's authenticity. On Christmas Eve, 1969, H. Lee Bimm, an art dealer in Rome, wrote to Rathbone to congratulate him on his purchase and also to inform him that he had been "introduced" to the painting the summer before and had been advised by "another English critic" that it could not possibly be "Raphaelesco."[24] Rathbone, suspecting professional jealousy at the heart of this missive, was also sure that the "English critic" Bimm referred to could not possibly know more than Shearman. Soon afterward Rathbone learned that a photograph of the painting had circulated to Sotheby's in London. Philip Pouncey of Sotheby's assured Rathbone that this was not with a view to selling but was sent "some time ago by someone in Italy who described himself as an agent of the owner, asking for an opinion of its authorship."[25]

Such debates about the authenticity of a given painting abound in the annals of art and museum history. For museum directors and curators, they have often meant a stumbling block in their careers. Kenneth Clark, director of London's National Gallery in the 1930s, bought a work in 1937 he believed to be by Giorgione – a group of four panels that once decorated the sides of a music box, depicting a tale of a shepherd's unrequited love in a poetic landscape. That anything at all might surface on the market by that mysterious and supremely rare Venetian artist was newsworthy in itself. To add a Giorgione to the collection, which had none, would indeed have been a triumph for the National Gallery. Clark was not 100 percent sure of his attribution, but the trustees told him that he would have to be in order for them to raise the funds to buy it. Hedging his bets and under pressure, he declared the panels genuine.

When the panels went on view to the public on October 20, 1937, intense skepticism surrounded their attribution to Georgione almost at once. Just as the Raphael was later to stir up feelings of rivalry among experts, so did the Giorgones. Tancred Borenius, an expert in the Italian Renaissance, was the first to attack. It was said that he resented that Clark, twenty years his junior, was given the job at the National Gallery for which he apparently believed he was better

qualified. After a great deal of turmoil, the panels were demoted to the work of Andrea Previtali. Meanwhile, the revelations about his honest mistake almost cost Kenneth Clark his job.

In another case Clark had been among those who cast doubt upon a Botticelli, albeit one he had no stake in. A wealthy donor gave the *Madonna of the Veil* to the Courtauld Institute in 1947. Clark perceived "something of the silent film star" about the Virgin's rosebud lips, which had eluded the collector of the 1920s but which by midcentury was a dead giveaway. Upon further scientific investigation, it proved to be the work of a twentieth-century forger named Umberto Giunti. Styles of conservation, as well as forgery, have changed with the times. As former MFA paintings conservator James Wright has suggested, it is hard to perceive these differences without some distance of time. "It has as much to do with what we're bringing to it as it has with the object itself. Whenever a work of art comes out of obscurity and has a great deal of value attached to it, it needs time to settle."[26]

Methods of authentication also continue to change with the times, as the dual heads of science and connoisseurship seesaw for favor as the greater authority. At the time of the acquisition of the Boston Raphael, scientists were on the ascent, and connoisseurship was beginning to be considered "old school." Naturally Bill Young, head of conservation at the MFA, represented a scientist's approach. "There was a real swagger to science at that time," remarked Wright. "They probably overstated their objectivity. There's a tremendous amount of subjectivity in the scientific interpretation – it's just at a different level."[27]

The first theorist of art connoisseurship was the eighteenth-century English portrait painter Jonathan Richardson, whose *Essay on the Theory of Painting* of 1715 is still considered a seminal work. Richardson established guidelines for appraising a picture's quality with a detailed seven-point scorecard, and he developed a method of attributions that depended on a thorough understanding of the individual artist's ideas.

In the twentieth century, no one advanced the connoisseurship of Italian Renaissance painting more than the American historian Bernard Berenson. Berenson developed a new approach to analysis

following the path of Giovanni Morelli, who was among the first to identify "the hand" of the artist as compared with other artists of the period in the way he or she typically handled parts of the body, such as the subject's hand or ear. Berenson, who met Morelli in 1890, took his theories further. His criteria for attribution were based on the ways that the individual artist handled paint, surface

William Young, head of conservation, Museum of Fine Arts, Boston, 1960s.

texture, volume, composition, and the depiction of space, a then-novel approach that seems perfectly obvious today. Perhaps subtlest of all, Berenson believed that the clues to the artist's true identity were based on the feelings that the picture conjured up in the viewer, a visceral sense of the artist's intention – his inner soul – that no textbook could possibly convey.

After graduating from Harvard in 1887, Berenson made a name for himself by advising American collectors, most important, Isabella Stewart Gardner. By the early twentieth century, Mrs. Gardner had stopped buying, but by then she had made Berenson famous,

and his career took a new turn. Using the code name "Doris," he signed a secret contract with the dealer Joseph Duveen in 1912, which stipulated that he would receive 25 percent of the profits from the sale of any painting he had authenticated. Duveen was a master at pitting one American millionaire collector against another, and his top clients – Joseph Widener, Benjamin Altman, Henry Clay Frick, Henry E. Huntington – had voracious appetites in those early days of the century, plenty of cash (significantly more than Mrs. Gardner), and quite an ample palette to choose from. When it came to works of the Italian Renaissance, the Berenson stamp of authenticity could make or break a deal. There were far too many unknowns in the Italian picture market in the way of misattributions, outright forgeries, and restorations for the American collector to invest in the field with any confidence.

Brilliant as he was, Berenson was not infallible. Nor was he above the lure of the art market to satisfy his own financial needs, and he was not the only art historian to be thus tempted.[28] It has been speculated that Berenson was inclined to look more favorably upon works for sale from Duveen's inventory than he might have otherwise. To whatever extent this may be true, he certainly profited from the relationship, and with his handsome financial returns, he bought the Villa I Tatti outside Florence, furnished and decorated it, and installed his own incomparable collection of Italian art. There he lived out his days as the foremost authority – studying, writing, and denouncing the views of other leading historians. By then his books on the Italian schools, often referred to as the "Four Gospels," had become the standard texts for art history courses in American universities. At I Tatti, Berenson hosted a steady stream of devout followers, including John Walker and Sydney Freedberg. Each in his own way sought to model himself on the mentor's style and methods. In one such effort to capture Berenson's indescribable theory of subjective response, Freedberg, with characteristic flamboyance, grandiloquently described the work of Rosso Fiorentino as "so fine-spun that it is brittle, and so exquisite that its sweetness is exasperated, taking on a savor of acidity."[29]

There is no question that scientific advances have greatly aided the problems of authentication since Berenson's time – we can now

probe the layers of underpainting with X-radiography and infrared, compare the chemistry of paint pigment with others of the period, and, with dendrochronology, establish the exact age of the wood panel it was painted on. But while these tools can establish age and help rule out a forgery, they are no substitute for the subtle eye of the connoisseur – the hunch, the visceral punch, the "blink" of recognition that comes to those rare individuals who know an artist's work like the back of their own hand. Perhaps the greatest advances in the process of attribution since the 1960s have come not from scientific instruments but from the spread of digital information through the World Wide Web. Curators, scholars, and conservators now have the whole field at their fingertips. Instead of traveling the world to see works firsthand, and then remember them, they now have the ability to line up color reproductions and compare works of art with the stroke of a key. The Getty Conservation Institute has funded research projects on an international scale and made them available to the public. Today, for example, as the analysis of the condition of its eighteen panels progresses on Van Eyck's *Ghent Altarpiece*, we can tap into the extremely high-resolution digital imaging of the painting from our personal computers. While reproductive media can never stand in for a firsthand encounter with a work of art, these tools have greatly aided comparative studies. Since 1977 the *Technical Bulletin* of the National Gallery, in London, has helped to disseminate developments in conservation and attribution from both scientists and art historians and has become essential reading in the field. Another significant contribution has been the increase in the number of artists who now have catalogues raisonnés of their entire body of work, and these catalogues are constantly updated with corrections, additions, and deletions.

Yet, while it advances, the field is ever in flux. Opinions change with generations, and what seemed right to one becomes obviously wrong to the next. Expert opinions can travel in both directions. Occasionally, a work of art that has been declared a fake is rediscovered to be by the master after all. A painting by Vermeer of a young woman seated at a virginal, once demoted from the artist's œuvre as a fake, was reinstated as genuine in 2004. A late work, it was exceptionally small – just 10 by 8 inches – and while at least one expert

continued to view the folds of the girl's shawl as "un-Vermeer-like," pigment analysis proved an almost irrefutable connection to Vermeer's unique palette.

In 1966 a group of Dutch art historians convened in an attempt to settle the many questions of attribution of paintings to Rembrandt. But while they significantly reduced the number of misattributions, there were many that were never firmly settled, with the number of genuine works waxing and waning over the years. Finally, more than fifty years later and with a new generation of experts gaining ground over the old, the project has come to a halt in an admission of the impossible. As the renowned German art historian Max Friedlander said, "It may be an error to buy a work of art and discover that it is a fake, but it is a sin to call a fake something that is genuine."[30] Said painting restorer Marco Grassi somewhat more cheerfully, "I call it a moveable feast."[31]

In the spring of 1970 a special meeting of the American Association of Museums was held in Washington on the ethics of acquisition. That same year the United Nations Educational, Scientific, and Cultural Organization (UNESCO) convened to discuss for the first time a global approach to the regulation of illicit traffic in art as it related to the promotion of free trade. Seeking a viable balance between free trade and cultural patrimony, and a universal standard for the preservation and export of works of art, the discussion was groundbreaking, but far from conclusive. Far more pressing than the Raphael affair, the focus of the meeting was on the issues surrounding stolen antiquities and the ruin of archeological sites in Mexico and Italy.

On another front, Ildebrando Bossi had been incarcerated in Italy on charges of smuggling. He was questioned for the last time about the Raphael on April 19, finally admitting that he had sold it to the Boston Museum in 1969. He later fell ill, and on May 17 he died.

Seizure

In his vision for the centennial exhibition program, Rathbone believed it was imperative to celebrate the work of a living American artist. To begin with, such retrospectives tend to attract a large audience, all the more so if the artist is well known. A hundred years ago the obvious choice might have been Albert Bierstadt, the painter of magnificent landscapes of the Hudson River Valley and the American West, grandly symbolic of manifest destiny – in his time, the most popular painter in America. In the late 1960s quite another kind of aesthetic and sentiment had emerged, and for some time Rathbone had been considering a show of Andrew Wyeth. This distinctive artist was then at the height of his popularity – people who knew little about art admired his extraordinary realist technique, his virtuosity with watercolor and egg tempera, and responded to the wistful stories of a simpler, pastoral America he seemed to tell. In the 1960s Wyeth's *Christina's World* was etched in the collective visual memory as deeply as Van Gogh's *Starry Night* or Grant Wood's *American Gothic*. In times of social strife and momentous change, his portraits and landscapes celebrated sturdy rural values and the restorative beauty of the commonplace.

While there were those detractors who considered Wyeth a mere illustrator, and furthermore a complete stranger to the modernist canon, Rathbone genuinely admired his work, and he also saw him as a particularly appropriate figure to celebrate on this occasion. Wyeth's art, he asserted, was "distinctly American, and unmistakably

New England."[1] A Wyeth retrospective was bound to be a huge crowd-pleaser. And it was. The exhibition was thronged with visitors every day. The catalog sold out before it was halfway into its run and hastily reprinted to meet the demand. By the time the show closed, just after Labor Day, it had attracted nearly a quarter of a million visitors, the most popular special exhibition in the Museum's history to date.[2]

In June 1970 phase three of the Museum's building program was complete. The new five-story George Robert White Wing created a modern sculpture courtyard at the west end of the Museum and a third line of access between Huntington Avenue and the Fenway. A minimalist poured-concrete structure designed by Hugh Stubbins, the new wing provided 43,000 additional square feet of space for an expanded education department, an updated research lab, a chic new restaurant, and additional office space. Rathbone left his grand old office on the ground floor with its comforting proximity to the collections for the new executive suite on the second floor of the White Wing with its low ceiling, plate-glass windows, wall-to-wall carpeting, and sleek, modern furnishings. It was a distinctly corporate environment, reflecting the new style of management that was rapidly overtaking the old.

Earlier that centennial year, George Seybolt had moved to establish an ad hoc policy review committee to study "the present and future policies, objectives, and programs of the Museum of Fine

Andrew Wyeth and Perry T. Rathbone with portrait of Betsy Wyeth, at opening reception for *Andrew Wyeth*, Museum of Fine Arts, Boston, June 1970.

Arts"[3] and to compare its figures closely with those of other major American museums. To chair the committee, Seybolt elected trustee Erwin "Spike" Canham, editor of the *Christian Science Monitor* for three decades and president of the board of the Boston Public Library. At the second meeting of the committee in April, battle lines were clearly drawn in an animated debate between two camps: those who favored attention to the collections versus those more concerned with public outreach. The need for these two sides to find common ground had been strongly recommended by a professional consulting firm hired by the MFA, McKinsey & Company in 1969. "The Major Problem," as defined by the report, was first and foremost, "disagreement as to the basic role of the Museum, particularly its relationship to the community at large."[4]

While Rathbone had been effective at outreach from the start, he found himself defending the priority of the collections as he faced the headwinds of Seybolt's push for greater accountability to the general public. As Rathbone recalled, Seybolt went around the Museum spouting catchy one-liners, such as "The museum's going to be people-oriented from now on, not art-oriented."[5] Furthermore,

Construction of the George Robert White Wing, about 1968, Museum of Fine Arts, Boston.

it was clear that Seybolt was bent on a trustee-controlled institution, and a business model at that. "At the end of a very busy year," wrote Seybolt in the annual report on the Museum Year 1970–71, "it is quite apparent that the responsibilities of our trustees and their commitment to the museum have broadened and deepened."[6]

In the director's mind, there was a difference between commitment on the part of the trustees, which he welcomed, and interference, which he did not. While he admitted "in the financial crisis facing American museums today, it is hard for both trustees and staff to evade the pressure to program for income,"[7] he questioned the values at the core of that approach and the validity of its measurement of success. "It is no secret that the motivation behind this effort has been, perhaps, less to deepen the experience of our visitors than to broaden the appeal of the museum and thus increase its income," he wrote in the annual report. The year had been a success in the growth of its numbers, but Rathbone was even more concerned with the quality of the visitors' experience. "Such experience," he wrote, "does not admit to any commonly accepted mode of measurement or appraisal; but to induce this experience, to cultivate it, must be our constant goal."[8]

As perhaps only a close reader might discern, these back-to-back annual reports by the Museum's president and director revealed a contest of wills and a deep philosophical divide between the board and the administration of the Museum. Insiders were aware that Rathbone and Seybolt were locked in a power struggle, masquerading as teamwork. Nothing could have been more symbolic than the way the annual report itself was laid out. Until Seybolt's appointment as president of the board, the annual report had always opened with "the Report of the Director." The only other report came from the Treasurer, at the end of the book. Seybolt instituted "the Report of the President," and its placement, before the director's, was pointed.

There was an ideological power struggle going on behind the scenes as well. How had it come to be that Rathbone – the man who was known for his progressive vision and democratic outreach – was on the defensive? How had Rathbone, the champion of modernism, come to appear to his board of trustees as out of step with the times in the late 1960s? What had changed? Rathbone had achieved the

Museum's goals as a populist gentleman director and the arbiter of taste, and he had advanced its ambitions in his own way, as the star of the show. But who was leading the populist charge now? He stood in the same room, but the furniture had moved. While Rathbone's public image underwent an unplanned metamorphosis, Seybolt actively built the image of himself as the chief innovator, unabashedly calling the work of the ad hoc committee "the first long-term plan the Museum ever had."[9]

By this time, John Coolidge had become, by his own admission, "operationally very close to Seybolt."[10] In the background of this development were significant changes at the Fogg. The vaunted museum course of old, which Coolidge had inherited from Paul Sachs when the latter retired, was terminating. In the Harvard fine arts department, connoisseurship was no longer at the center of the curriculum but rapidly giving way to theory and contextual studies, and Coolidge was caught at the pedagogical intersection. Crossing the river to the MFA, Coolidge found another outlet for his museum work beyond the Fogg, and his closeness to Seybolt was an expression of his interest in keeping abreast with the latest ideas. In their shared desire to encroach upon the director's power, Coolidge and Seybolt made an awkward alliance – the one refined and academic, the other bluff and corporate. Each embodied qualities the other lacked. As one curator assessed the relationship, "It was a lethal combination of old and new Boston."[11] Personal accounts and later interviews suggest that John Coolidge was not always entirely sure where to stand or whom to side with in his newfound museological concerns.[12] While he considered Rathbone a very effective director – "There was

John Coolidge in the Fogg Art Museum, 1965.

no one you'd rather have" – he also admired Seybolt and joined him in various of his assertions, including that Perry "didn't really care very much about education" and had "absolutely no interest in planning or formulating a policy."[13] It was becoming difficult for Coolidge to embrace the values each man represented at once.

Trustee Nelson Aldrich was also impressed with Seybolt's businesslike style and adapted easily to the new ideas that were coming out of the meetings of the ad hoc committee. Rathbone, who was never one to rush into a decision of any kind, was even less inclined to embrace the committee's latest "findings." Furthermore, the number of decisions he now faced on a daily basis was becoming overwhelming. "He was quite a procrastinator," said Aldrich of Rathbone. "Those subjects of policy he was not enthusiastic about he would postpone. That was a characteristic that got a lot of us quite upset."[14]

As curator Jonathan Fairbanks observed, "The ad hoc committee was the enemy; [Rathbone] got surrounded with people who did not support him."[15] The old boys of the old boy network sat back and watched as they became ever more outnumbered by the new, and the chemistry of the board changed from polite and deferential to contentious. One board member remembered how "Seybolt's style was 'us against them.' He saw conflicts where there weren't necessarily conflicts. He thought in terms of taking control of the Museum rather than how to work together."[16] Virginia Fay noticed how the conviviality of the old days was lost, with trustees emerging from the boardroom after a meeting looking serious and worried. "The committees began to produce iconoclastic things," as Seybolt remembered those days, "and a new world began. And it became more and more apparent that the new world was not Perry's world."[17]

In the late 1960s the pressures from interest groups on any public institution were so powerful and threatening that it was impossible to ignore them. The civil rights movement had offered a recent model for civil disobedience, and many of its results were encouraging. These were the days of grassroots organizations born overnight, of antiwar marches, student demonstrations, and ongoing race riots in cities across the country. Whoever sat in a position of power was

both widely suspect and accountable. Private nonprofit institutions were not immune to such charges and proved just as vulnerable as any corporate enterprise or government body.

In the spring of 1969 Harvard students held demonstrations protesting the presence of ROTC on the campus and other university connections to "the American war machine" to little effect. On April 9 a group of students stormed University Hall and confronted eight deans and several faculty members, forcing the entire administration out of the building. Harvard president Nathan Pusey summoned the police to remove the demonstrators, which only served to further radicalize students, staff, and faculty. While the Harvard faculty was divided in their support of demonstrators versus administration, students went on strike for two weeks, adding to their list of demands a black studies program, a women's studies program, and in general, justice, peace, and the right to dissent. It was an era of rights consciousness like none before.

A similar sense of citizens' rights prevailed among the community of Boston artists, who were frustrated by the lack of attention they received from the local art establishments. With the financial instability of the ICA and the paucity of alternative venues and resources, Boston's contemporary art scene was at a low ebb. Because of its power and preeminence, the MFA was a natural target as the locus of controversy. Pressure was already building on the MFA for a greater commitment to contemporary art, and an exhibition of the popular but conservative Andrew Wyeth hardly qualified. As anger and impatience intensified over the centennial year, the conversation consistently circled around until it landed on the problems they perceived with its director. In the ongoing discussion about Perry Rathbone, "incredible amounts of theory and intrigue were bandied about," reported journalist Jean Grillo. "What really bugged everybody was their feelings of helplessness, of being closed out on museum policy and potential."[18]

The new crop of underground newspapers – *Boston After Dark*, the *Phœnix*, the *Real Paper* – and the young activist journalists who wrote for them contributed to the sense of urgency. In the spring of 1971 a group of Boston artists held a series of forums at a big loft gallery just across the trolley tracks from the Museum on Parker

Street, known by its address, Parker 470. At one of these meetings, as the participants engaged in a heated dialogue, an open letter was composed to Rathbone raging against his apparent reluctance to address their issues. After an interview with Rathbone in March, Jean Grillo reported in the *Phœnix* that Rathbone had accepted their invitation to take the floor himself at Parker 470. "The place was packed," recalled the combative young art critic Charles Giuliano. "It was like having an audience with the pope." At the same time, the negative publicity around the Raphael made Rathbone especially vulnerable. The Raphael incident "put some chinks in the armor, let some air through," said Giuliano. "Perry was a wounded animal, and we could smell blood."[19]

Addressing the group, Rathbone reviewed his efforts to bring the MFA's collection into the twentieth century and asserted that the museum school was their most important ongoing commitment to contemporary art, but this did not satisfy. He added that a contemporary art department was in the planning stages, but this was not enough. The group demanded an annual exhibition of local artists at the Museum and a representative artist on the board of trustees. Rathbone tentatively agreed to these demands. In the camp of the enemy, remembered Giuliano, Rathbone "was able to maintain his dignity,"[20] but also his distance.

While Rathbone was by nature open-minded and accessible, he was philosophically disinclined to ingratiate interest groups or to pander to the taste of passing trends. A business mind like George Seybolt's took to this shift in focus naturally. The ascendant management style was guided by pressure groups, the common denominator, insurance coverage, dollars and cents. As a fellow outsider, Seybolt embraced the Museum's detractors, further adding to the impression of Rathbone as patrician and remote. Rathbone's style had been to assert and affirm the taste and the judgment of his scholarly curatorial team, and to inspire excitement for the Museum's great collections, but this approach was beginning to seem irrelevant, a product of old school thinking. Rathbone still believed in his own intuitive sense of not only what the public wanted but also what it didn't even *know* it wanted. And his instincts were still sound.

The art of Japan was the only exhibition concept that survived

from the original centennial plan to celebrate the great collections of the MFA. Tuning into a youthful wavelength of the time, Rathbone came up with the idea of a show on the theme of Zen. Buddhist philosophy was especially popular with the younger generation. A new interest in alternative paths of spiritual life, and new ways of health and healing, had helped to move the idea of Zen Buddhism out of the esoteric and into the mainstream.[21] "The meaning of the word Zen is now widely understood in our country," commented Rathbone in his forward to the catalog. "A generation ago this would not have been the case."[22] *The Art of Zen*, which opened November 5, 1970, was indeed a critical and popular success. Deeply scholarly, it appealed to the knowledgeable and also notably attracted younger, less knowledgeable visitors to the Museum, many of them for the first time. Thus a season of Zen occupied a rare moment of relative calm in a tumultuous year. It was the calm before the storm.

At the time I was a twenty-year-old photography student at the MFA's museum school. Attending classes in the neighboring building on the Fenway, I was able to closely follow the centennial exhibitions, enjoying each one for entirely different reasons – from the meditative beauty of the Zen show to the exquisite mastery of Andrew Wyeth to the glorious *Masterpieces of Painting in the Metropolitan Museum of Art* (as well as deepening my appreciation for the one hundred masterpieces of painting the MFA sent to the Met in exchange that year). It was clear that my father enjoyed these exhibitions equally; he was inspired by the public's response and the excitement of seeing the Museum's audience literally building before his eyes. This was a thrill that he lived for as he strained to maintain his grip on a three-ring circus.

But there was another mood to that season, too. I noticed the tension mounting around the issue of the Raphael, of my parents' hushed conversations about the latest developments, and of the Swarzenskis' intense involvement in each new detail. Though I failed to understand why the case of the Raphael differed so greatly from other important purchases of European paintings my father had made for the Museum over the years, I could see that this was

an issue that was refusing to go away and that it was taking its psychic toll. Often my father left the house after dinner to visit Hanns, to talk into the early-morning hours. My mother confided in me that when he finally went to bed, he couldn't sleep without taking sleeping pills.

I was also aware of the talk, the press, and the rumors that circled around the Raphael. This was not confined to my parents' generation but had spread to my own, and I found myself in the odd position of needing to defend my father's actions without any idea of what he had done or where exactly it had all gone wrong. Everyone seemed to know more about the Raphael affair than I did, even if they didn't. In the stray comment, the raised eyebrow, and the odd question here and there, I felt the pressure to respond. But how, exactly? Was I to brush it off? Ask them what they knew and risk further embarrassment? Or blindly take his side? While I was used to my father being in the public eye, I was not used to him being a controversial figure. As far as I knew, he had always been successful, steadily facing the greater challenges and enjoying equally greater triumphs. Just as I had begun to form my own thoughts about the world, sometimes in opposition to his, just as I had begun to shake off his opinions, his critical eye, and his old-fashioned formalities, for the first time in my life my father appeared to be on unsteady ground. It was a surprising juncture. My coming of age literally coincided with the revelation of his vulnerability at this defining moment.

While the younger generation of Boston artists agitated for attention from the MFA, I was either subjected to their rants, if they knew me, or avoided like a pariah, if they did not. Among our own family circle of friends, the debate over contemporary art and how the MFA should deal with it went on regularly at Coolidge Hill, with my father openly engaging in the conversation, offering his perspective and experience, holding his own, and also patiently listening. Our house in those days was a place of candor and open-mindedness where the generations mixed freely and often. My mother went to bed early, but my father was always up to welcome the younger generation whatever the hour. "He'd be lying in wait for us," remembered our neighbor Bob Bowie, "ready to talk."[23] At the slightest sign of interest in a work of art, my father would seize the chance to

engage the inquisitive mind, to inform, to enlighten, and also to learn. For Bowie, our house was an education in art, where his art history studies at Harvard left the world of book learning and came alive. He also perceived its healing effects on the beleaguered director. "He found sustenance from the art; it's what gave him faith."[24] Nick Peck, another Coolidge Hill regular, saw Rathbone himself as the source of energy in a room. "If they could have figured out how to put Perry in a bottle, there would be no shortage of customers for a regular drop of his magic," said Peck, attributing "the tonic of Perry" most of all to his common touch. "I admired him not as an 'art man' but as a man."[25]

In late 1970 the Raphael crisis came to a head. In November my father traveled to Japan on the occasion of a loan show from the Museum's extensive holdings of Millet, accompanied by my mother, leaving Heyward Cutting in charge of administration. On November 30 two Boston customs officials – Richard Krueger and William Rudman – appeared unannounced at the Museum, demanding information about exactly how and when the painting had entered the country. A search through the Customhouse Brokers in Boston had failed to turn up any record of the painting's importation, and the Museum didn't seem to have employed its usual shipping firm, Dolliff & Company. Given the numerous articles in the press about the origin and authenticity of the painting, customs officials were spurred on to move the investigation to the Museum itself, from the bottom up. They began with a visit to the registrar's office, where Harriet Kennedy told them they had no record of the painting and suggested they try the director's office, where secretary Tammy McVickar told them that the director was out of town and his files were locked. They moved on to the Treasurer's office, where treasurer William Picariello told them there was no purchase and sale agreement on file, although he did have three memoranda from Rathbone authorizing payments for the painting. They returned to the Registrar's office, where chief registrar Linda Thomas showed them the only record she had of the painting's acquisition by the Museum – a document of approval for its purchase by the trustees on November 19, 1969.

Finally, frustrated by the lack of documentation and increasingly

suspicious that the Museum was attempting to conceal the details of the painting's importation, Krueger and Rudman went to the president's office to demand proof of its legal entry into the United States. Seybolt, unprepared to receive them, was outraged at the insinuation that the Museum had anything to hide and demanded that they repeat their accusations in front of his secretary, Jean Baker. He told them that the entrance of the Raphael deviated in no way from the Museum's "first-class history of cooperation with the customs agency."[26] Then, on the advice of counsel, he asked them to put their request for documents in writing, along with their reasons for the request, and showed them the door.

In fact, Seybolt recalled that just before leaving for Japan, Rathbone had warned him that the customs people were "snooping around the Museum"[27] and suggested that Seybolt assure them that everything was "all in the routine."[28] But Rathbone underestimated the pressure Siviero was exerting on Boston customs to follow up on the case, their eagerness to refute his suggestions that they might be lax in their border control, and that even a lofty institution like the Museum of Fine Arts might be getting away with a flagrant case of smuggling. William Rudman, an aggressive young lawyer with aspirations to federal management, was quick to see the potential for publicity in this high-profile case. Now the fate of the picture hung in the balance.

In Rathbone's absence the situation reached a new level of crisis. On Friday, December 4, Jerry Norton of Covington & Burling was instructed to get ready to go to Boston again the following Monday. He was to be prepared to represent the MFA before Boston customs officials, who would be returning to the Museum with further demands. On December 7, in Norton's presence, customs officials served a citation to Seybolt, demanding him to appear before them on December 15 to answer questions pertaining to the entry of the Raphael and to produce the relevant customs entry documents. In a memo to Rathbone, who was still in Japan, Seybolt wrote that he himself was off to London and would not be back by the fifteenth. "Norton advises me that I do not have to appear in person," Seybolt informed Rathbone, "but that you [Perry] will appear even though the citation runs to me." He closed by saying that he would be sorry

not to be there but added, "I highly recommend an exhaustive session with Norton before your appearance on behalf of the museum and myself."[29]

With Rathbone not due to return from Japan until December 14, Norton succeeded in getting a thirty-day extension on the citation that called for the production of documents from the Museum's administration. At the same time, the visit caused Norton to reassess the case.[30] He detected a communication breakdown at the top and a gap in some pertinent information, and he called his boss, Tommy Austern, to discuss his concerns.

On their way home from Japan on Sunday, December 13, my parents were held up at customs in Honolulu. They were taken into a small, brightly lit room where their bags were entirely unpacked and examined. They opened "every bloody thing," my father recalled, including an elaborately wrapped present from their Japanese hosts, a Heian doll. Finding nothing of interest, the officials released them but not before seizing their passports. My father was outraged. "Don't worry," said the agent. "You'll pick them up in Boston when you get back."[31]

Soon after Seybolt returned from London, Tommy Austern gave him a call. "George," he said, as Seybolt recalled his words, "I think you had better tell Rathbone and Swarzenski to get their own lawyers."[32] Seybolt got off the phone with Austern and called Rathbone. It was December 22 and Rathbone was putting on his white tie and tails for a Christmas waltz party that evening. He and Rettles were expecting ten guests for dinner at Coolidge Hill. Seybolt couldn't wait until the next day. He told Rathbone to call Hanns Swarzenski and for both of them to meet him at a bar on Soldiers Field Road in Cambridge within the hour. There he delivered instructions to Rathbone. "Austern says you, I, and Hanns have to get our own lawyers if he's going to be the lawyer for the Museum."[33] From then on, it would be every man for himself.

I shall never forget the evening of January 6, 1971, but I only wish that I could remember it better. It was Epiphany, King's Day, the Twelfth Day of Christmas, Twelfth Night. My father never wavered

from his custom of dismantling the Christmas tree on that hallowed date. Of his three children, I was often the one who assisted most enthusiastically in the trimming of the tree and also in the rather sad task of dismantling it. At the time my mother was off on her annual ski vacation in Switzerland; my brother, Peter, was in London; and my sister, Eliza, was in New York. Arriving at our home on Coolidge Hill, I found my father unusually distracted. His characteristic confidence had vanished; his usually buoyant holiday spirits had deserted him. As we carefully disentangled the decorations from the dry spruce branches and packed them into their boxes for another year, he told me of the latest twist in the story of the Raphael. I now believe that someone must have tipped him off. The customs authorities were planning to seize the picture the very next day. How this had come to his attention I do not know, but in retrospect I am sure that is why he appeared so unusually distressed.

He kept dwelling on the fact that Hanns had neglected to declare the picture at customs and how his failure to do so had left the Museum vulnerable to accusations of smuggling, though I do not recall that he ever used that word. He expressed a sense of helplessness in the face of Hanns's irregular ways. I struggled to understand the meaning of it all and regretted that I was my father's only confidante and that my mother was so far away. I wish I could remember now what morsel of comfort I might have offered him that evening to ease his anguish. The Christmas tree stripped bare, I went to bed, confused and worried, not realizing that he was making a conscious and surely tortured decision, possibly on the advice of counsel, in the midst of what was surely a sleepless night. This was apparently to lie low and not to appear at the Museum the following morning.

January 7, 1971, dawned bright and cold with temperatures well below freezing. Around midday, with no warning, four US customs officials entered the Museum along with Willie Davis, assistant US attorney for the district. That very morning customs agent William Rudman had approached Davis with an affidavit asking for his immediate assistance in obtaining a search warrant to confirm that the painting was in the Museum building and to seize it on the spot. As Davis recalled, Rudman was "hot to trot."[34] Davis would be obliged to accompany the customs officials to represent their legal

authority to act. Though he had lived in Boston for several years, Davis, a young African-American from Georgia, had never before entered the Museum of Fine Arts.

The party entered the building from Huntington Avenue and presented the search warrant to the nearest guard, who promptly got in touch with the director's office, only to find that he was not there. Davis then called him at home to inform him of their intentions. In the director's absence, Diggory Venn arrived on the scene to lead the men up the stairs to where the painting hung. It was not long before the press got wind of the story (if they hadn't already been tipped off), and reporters and photographers rushed to the scene. Clementine Brown, a savvy young publicist who had been appointed director of public relations just a few weeks before, was out to lunch. Someone on the staff reached her by phone, and she rushed back in time to see photographers surrounding the painting where it hung in the rotunda, shooting pictures of the museum workers unscrewing the bolts on the protective sheet of plexiglass. As Brown described the chaotic scene, "Everyone was talking at once. They were all red in the face. I thought someone was going to have a heart attack."[35]

George McQuade, a researcher, had the dubious honor of assisting the customs officials with the removal of the painting from the wall. Just as they began making their way to the staff door, painting in hand, conservator Bill Young rushed onto the scene in his smock with his stethoscope around his neck and declared, as Brown recalled, "If you take that picture outside in this weather, there will be nothing left but crumbs at the bottom of the frame."[36] Young ordered that it not leave the building. A tug-of-war of sorts ensued. Someone got on the phone to trustee Jim Ames, who was also the Museum's legal counsel at Ropes & Gray in Boston. Ames rushed into court to plead for an emergency restraining order. That afternoon, in a highly unusual ruling, Judge Anthony Julian informed Willie Davis of the order against the removal of the painting from the premises. A US customs seal was slapped on the storage bin; the painting was to be safeguarded in climate-controlled storage in the Museum's conservation lab until the matter was resolved.

The next day, Heyward Cutting encountered customs agent Wil-

liam Rudman waiting around the administration offices for a chance to speak to publicity director Clementine Brown. Cutting asked him how things had gone in court regarding the restraining order. Very well indeed, Rudman replied, adding with equal satisfaction that the worst was yet to come. On January 14 a registered letter arrived from US customs addressed to the Museum of Fine Arts and "Dr. Johannes Swarzenski." Ambiguously, the letter went on to inform the "Gentlemen"[37] that they (or he) were liable for payment of a penalty of $1,200,000 (the estimated domestic value of the painting, even though it was twice the settled price) for Swarzenski's failure to declare the painting at customs in violation of the provisions of Section 1497, Title 19, U.S. Code. The Museum (or Swarzenski) was given sixty days to act upon it.

Soon afterward in Genoa, on January 22, Italian district attorney Luigi Meloni notified Rathbone and Swarzenski that they were "suspects in a penal investigation and might face charges of receiving the Raphael illegally,"[38] according to Article 648 of the Italian Penal Code, an offense that carried a penalty of up to six years in prison. The letter advised them to take up legal domicile in Italy until the case was resolved.

A few days after the painting was seized by customs, Seybolt adopted the familiar corporate approach to dealing with problems: he formed a small committee of trustees to deal with the issue. William A. Coolidge was to head the committee with the support of just two others – James Killian, former president of MIT, and Erwin Canham, longtime editor of the *Christian Science Monitor*.

Both Killian and Canham had strong Washington connections, a critical ingredient that Coolidge lacked, but he had others. Between the money he inherited and the money he had made as an investment banker, Coolidge was among not only the richest members of the board but also the grandest. A direct descendent of Thomas Jefferson, he lived all alone in a vast neo-Georgian house commanding five hundred acres in Topsfield, north of Boston. His collection of paintings included old masters such as El Greco and Rubens, which the MFA would be happy to inherit, and considering his generous financial contributions over the years, there was every reason to think that they would. Patrician, disciplined, and deeply conservative,

Coolidge, beneath the surface of his aloof manner and prim little figure, was a passionate man. He had particularly strong feelings about the Raphael matter and was glad to take charge of the next step. Officially called the "Raphael Committee," and unofficially, the "Coolidge Committee," it was "empowered to act" without consultation with other members of the board. James Killian had much to offer as a strategist and organization man. He had expressed admiration for Seybolt's management style, praising his efforts "to bring order into the house."[39] The Christian Scientist Canham, a man who was drawn to people and situations in need of healing, was also a model of old-fashioned common sense. Clearheaded decision making was what mattered now in the delicate task at hand. The three men put their heads together.

The Raphael committee held their first meeting at Jim Killian's office on January 19 along with George Seybolt and Jim Ames from Ropes & Gray. They gathered talking points for a petition to the customs department and considered the most reasonable proposals for reconciliation with the Italian government. The most obvious was to offer to pay the export tax on the painting and if the offer was not taken, to return the painting on the condition of a full refund for the amount they had already paid. Acknowledging that the dealer was now deceased, it would be up to the Italian government to retrieve the money from his heirs.

A month after the seizure, the Museum was granted a thirty-day extension on retaining the picture, "or until we decide what do to with it," said Willie Davis. "We don't know what action will be taken. There are a thousand complications in a case like this. The State Department is interested, the Justice Department is interested, both criminal and civil actions are being considered, but we have made no decision as yet."[40]

As if to cap an exceptionally high-risk year, the most daring offering of the MFA's centenary year was the one that marked its closing in February 1971. Looking forward to the Museum's next hundred years, Rathbone staged an audacious show of contemporary art. *Earth, Air, Fire, and Water: The Elements* set out to address the growing con-

Red Rapid Growth by Otto Piene, *Earth, Air, Fire, Water: Elements of Art* exhibition at the Museum of Fine Arts, Boston, February 4–April 11, 1971.

cerns of a "post-object" age and the emerging trend for site-specific and time-based works of art. Virginia Gunter, an artist on the faculty of the Massachusetts College of Art, was program director for this complex enterprise. To realize its ambitions in the freshest way possible, most of the thirty-two artists were invited to create works on site, in and around the Museum itself, with some venturing several miles beyond.

Giant plant forms made of brightly colored silk by Otto Piene inflated and deflated with hot air in the Museum's rotunda in a triumphant, frankly phallic centerpiece. In an adjacent gallery one hundred eels slithered through vinyl tubing in an artwork called *Eel Track*, by Richard Budelis, while Andy Warhol installed helium-filled silver "clouds" in another. Christo proposed to wrap more than a mile of the walkways along the Fens with a bright synthetic fabric. Lowry Burgess loaded giant blocks of ice on the Charles River in an arrangement reminiscent of Stonehenge, with each block containing spring bulbs, the idea being that once the ice melted, they would float down the river in search of a suitable bank upon which, before the show was over, they might sprout.

Listening-for-Light-Hinge (Boundaries and Constellations) by Lowry Burgess, *Earth, Air, Fire, Water: Elements of Art* exhibition at the Museum of Fine Arts, Boston, February 4–April 11, 1971.

Being an exhibition that incorporated nature's unruly elements, things naturally did not always go easily or exactly as planned. The eels of *Eel Track* were dormant in their vinyl tubing, draining the life from this particular "living" artwork and inspiring morbid curiosity as much as intellectual contemplation; many visitors concluded the creatures were dead. The explanation that eventually emerged was that the heat of the bright lights of the exhibition galleries put the eels to sleep, while at night, after the Museum closed, the lights dimmed, and the crowds went home, they awoke and came back to life. Another problem was the piece called *Guarded Elements*, by Dennis Oppenheim, for which twelve police dogs were hitched up to a post on the Huntington Avenue lawn and barked for six straight hours. Cornelius Vermeule, curator of classical art at the MFA and a passionate dog lover, called up the Society for the Prevention of Cruelty to Animals and implored them to rescue the dogs from further cruelty. There was constant damage control. Rathbone assured one visitor that the SPCA had visited the Museum twice since it

opened to make sure that all was well with the animal life. He assured another that Marvin Torffield's artwork, which involved skywriting, would not contribute significantly to air pollution. But unexpected happenings continued unchecked. Otto Piene's inflated 1,000-foot polyethylene "rainbow" over the Charles River promptly collapsed after hitting a lamppost. Geny Dignac's eighteen-foot "fire tower" had to be removed from the galleries after a helpful visitor tossed a missile into the tank and threw the works out of order. Artist Robert Morris, whose concept involved dumping fifty feet of ready-mix cement on the Fenway lawn, admitted to the press that it was "not a work of art"[41] when a piece of metal fell into it, destroying the concept before it was dry.

Indeed, of the many issues and questions *The Elements* show raised, the overarching one was, What is art? Perhaps never before or since has Boston served up such a provocative show for its time. Hilton Kramer, writing for the *New York Times*, called it "one of those episodes in museological self-immolation." All the same, Kramer, who was famously hard to impress, was entertained by *The Elements* show. "Part carnival, part science museum," he called it, with Rathbone "the gracious host."[42]

In a way, *The Elements* had much in common with the circus acts of Rathbone's past, spirited and entertaining, attention-getting, bordering on the outrageous. And indeed, some were outraged. Board member Dick Chapman wrote to Rathbone that he considered the whole thing "a total disaster," and that if the trustees were crazy enough to let anything like it ever happen again, "I would hope that a group of aroused but merciful citizens would equip a special ward at McLean [mental hospital], complete with eels wriggling down troughs, beds of marijuana growing under klieg lights and large balloons, and have us committed to it for life."[43]

If Chapman had his misgivings, many others saw the installations as a positive message that the Museum was finally getting up to date with the times, and it coincided meaningfully with their readiness to establish a department of contemporary art. Negotiations were by that time well under way to appoint Kenworth Moffett, a young professor of art history at Wellesley College and a devoted follower of the reigning critic of postwar art, Clement Greenberg,

as the Museum's first curator of contemporary art.[44] Furthermore, *The Elements* show was getting plenty of media attention and perhaps helpfully distracting the public from other ominous developments at the Museum as the centennial celebrations staggered, through fire and ice, to their close.

The Return of the Raphael

THE DAY BEFORE *The Elements* show opened to the public with great fanfare, another event was playing out quietly in the background. On February 3 Rathbone and Swarzenski were summoned to appear before a federal grand jury for the case known as *The United States of America v. One Framed Painting.*[1] At the heart of the inquiry was whether Rathbone and Swarzenski had conspired to deceive the US government by not declaring the painting, which would make it a criminal offence.

Each witness testified alone before the grand jury. On the advice of his private counsel, Dan Needham, Rathbone exercised his right to take the Fifth Amendment to every question. As Willie Davis assured me recently, "He did what he was told."[2] Swarzenski was similarly advised by his counsel, Walter Skinner, but either because he did not entirely understand what the Fifth Amendment was or because his emotions got the better of him, he responded to the interrogation, perhaps somewhat to his disadvantage. While grand jury proceedings remain secret by federal law, the law does not apply to the witnesses involved, and Rathbone learned of Swarzenski's testimony soon afterward. Years later Willie Davis concurred that this was true. Exactly what Swarzenski said remains a mystery. Whatever was said or not said, as Willie Davis recalled, the grand jury testimony was over by the end of the day, and the twenty-one-member jury did not return an indictment.[3]

Meanwhile, George Seybolt, who had also been subpœnaed to

testify, was in London. While he was there, on February 7, the Boston Raphael made headlines in the *London Sunday Times*.[4] The story, as told by reporter Colin Simpson, was more sensational than ever, after the seizure of the picture by Boston customs. Simpson had been to Rome to interview Siviero, and he returned to London with some intriguing new allegations. One was that Swarzenski had smuggled the painting across the Italian border in a false-bottom suitcase in the summer of 1969.[5] Another was that Swarzenski had returned to Genoa in May 1970, where a detective directed by Siviero followed his movements. Swarzenski's phone was tapped in his hotel room when he put in a call to Bossi's daughter, Anna, his legal heir, and he was followed the next day when he paid a call on her. Siviero's theory was that this was to beg her to take back the painting, to which (he imagined) she replied, "Nothing doing." What actually was said between Swarzenski and Anna Bossi we will never know.

Siviero had also managed to track down John Shearman in London to determine that it was he who had authenticated the picture for the Boston Museum. Shearman admitted that he was present in Genoa for the meeting between Bossi and the MFA. But as the controversy intensified, he went to the US Embassy in London to disclose this fact and to make it plain that he had had nothing to do with the negotiations that followed. With every new complexity the scandal deepened, with the *Times* story highlighting the characters and their cloaked movements in new and ever more alarming ways. Seybolt scooped up thirty-five copies of the *London Sunday Times* and packed them off by airmail to his secretary at the MFA, Ingeborg Hollwoeger, instructing her to distribute a copy to every trustee.

Meanwhile, in Rome, the new Italian prime minister, Emilio Colombo, was looking forward to his first visit to the United States, with stops planned in Houston, Washington, New York, and Boston. With Columbo's state visit in the planning, the indefatigable Siviero continued his dogged campaign to get the picture back. Working through the Italian ambassador in Washington, Egidio Ortona, he attempted to persuade Colombo to skip his scheduled visit to Boston, hoping to send a strong message to that most cultured and refined city.[6] Despite his plea, Columbo did go to Boston, where the large Italian American community, including several notables such

as the secretary of transportation and former Massachusetts governor John Volpe, gave him a warm welcome. By far the most important mission of Columbo's first US tour was his stop in Houston to visit the NASA space center and meet with authorities. There he would represent Italy as a member of the European Launcher Development Organisation (ELDO) and their interest in participating in the post-Apollo space program, a discussion that had reached a delicate phase. According to a subsequent report on the visit, the issue of the Raphael was not on his agenda.

Indeed, Siviero's hand in having the picture seized from the Boston Museum was something of an embarrassment to the visiting dignitary and a public relations problem to contend with. Before departing for his first trip to America, Columbo was advised to avoid any mention of the Raphael, and if it came up, to apologize for any influence the Italians might have had on Boston customs. Within Italy's directorate of fine arts, an investigation was under way about whether to pursue any action to have the painting returned.[7] Emerging doubts about the artistic and financial value of the work helped to nurture misgivings about Siviero's aggressive pursuit of his goal, and they were more inclined to focus their efforts instead on the delicate NASA-ELDO alliance. They felt that Siviero's self-importance in the case of the Raphael was "highly exaggerated," according to Attilio Tori, and its restitution at that time "could not be a priority in Italian political relations."[8]

On the legal front, lawyers from both Covington & Burling and Ropes & Gray were at work on a petition to US customs for the mitigation of fines and the forfeiture of the painting. Covington's version was a highly detailed twenty-three pages. We can only speculate as to the reasons the Ropes & Gray legal team in Boston reduced this to nine pages, notably omitting all references to Rathbone and Swarzenski. It was this version that Bill Coolidge circulated to the trustees and, on behalf of the Museum, signed and submitted to customs.[9]

As set forth in the petition, the trustees reasoned that the seizure of the picture and its forfeiture to the government was not only legally unnecessary but also damaging for the general well-being of the Boston community.

> The action now threatened by the government i.e. the forfeiture of a Raphael painting purchased by the Museum for $600,000, and a proposed penalty of $1,200,000, would obviously be a devastating blow to the museum, the consequences of which would transcend the immediate financial loss. Such disastrous consequences should not be visited upon the museum because of the failure of one employee to declare a non-dutiable painting.[10]

The petition explained the importance of the Museum as a resource and its dependence on private patrons for its very existence. It went on to stress the significance of the painting in question and the reasons for the MFA's keen interest in obtaining it. Finally, it projected the consequences to the Museum's reputation and the subsequent damage to its ability to attract gifts of art and funding.

> The museum as a public institution has already suffered invidious publicity and a loss of confidence that have inevitably accompanied the seizure of the painting. It is the duty of the museum and its trustees to do everything in their power to restore the confidence of the community and to repair its reputation.

As the petition argued, "If ever there was a situation where circumstances called for the wise and generous exercise of discretion, this is it." In conclusion, the petition asserted that the rigorous enforcement of legal statutes in this case "will not advance, but seriously detract from, the general welfare," adding that the "penalty proposed is extremely severe, particularly when the government has no revenue at stake." It ended with the plea, "The museum therefore respectfully requests that all penalties and forfeitures in connection with the importation of the painting to be remitted or mitigated, and that the painting be released from customs' custody."[11] Discussions with Treasury officials were just ahead, for which the petition would serve as a template.

A new figure now emerged to take charge of the case at a national level. This was Eugene Telemachus Rossides, assistant secretary of

the Treasury under John Connally for the Nixon administration. A Greek American from Brooklyn, Rossides was a graduate of Columbia, where he was also a star quarterback, and later, turning down an offer from the New York Giants, he earned a degree from Columbia Law School. As assistant secretary, Rossides presided over several important entities at the Treasury, including the Secret Service, the Mint, the IRS, and the Bureau of Alcohol, Tobacco, and Firearms, as well as Customs.[12] As Jerry Norton wryly commented, "The acquisition or return of an Italian Renaissance artwork by a prominent museum does not seem an obvious fit in this eclectic bureaucratic portfolio."[13]

When the matter first came to Rossides's attention, he had been shocked at the manner in which it had been handled by Boston customs and was inclined to sympathize with the Museum. "I was annoyed they were making such a big deal about something where there is no duty involved," recalled Rossides. "The Museum was being picked on – abused in a sense. It was a big publicity thing – that's what annoyed me. I wanted to help out in any way I could." Some time in March, Rossides got a call from James Killian, whom he remembered favorably as a key advisor on NASA for the Eisenhower administration. "He was a distinguished person as far as I was concerned," said Rossides. "I picked up the phone right away."[14] Soon afterward, they met to discuss the Raphael.

"We still don't know how our case is going to be handled," Rathbone wrote to John Goelet in France on March 8. "As soon as I hear I will of course let you know. But it may be weeks and weeks. Meanwhile, we have to continue to survive and make plans."[15] Not long afterward, Goelet unexpectedly bumped into Seybolt in London, expressed his anxiety about the case, and asked him what was going on. Seybolt brushed the inquiry aside and reassured Goelet that the situation was well in hand and there was nothing to worry about.

Indeed, as winter turned to spring, there were reasons to be tentatively hopeful. Despite their threats, the Italians had only a point of honor to stand on, as the painting had never been officially registered with the Italian government, and once inside the United

States, the point was moot. Luigi Meloni's call for the arrest of Rathbone and Swarzenski was grandstanding, for the Italian law they invoked could not have been applied with any force. No treaty required the United States to return the painting, an action that could be considered only as an act of generosity. The UNESCO convention of 1970 had broken ground on new agreements among nations on the traffic in art, but these were far from fully formed and not codified when the picture left Italy in 1969. For several weeks, while it remained under US customs seal in the Museum's conservation lab, Rathbone lived in hope of retaining the little treasure in Boston and of putting the whole nightmare behind him.

But in other ways, continued survival was not overstating the case. Rathbone's job was on the line, and so was Swarzenski's, though to what extent they understood the size of this threat is hard to determine. Hanns's wife, Brigitte, had a keen psychological instinct for such things; she was an astute observer of the human drama, and she was not one to keep her observations to herself. I have a dim memory of one emotional evening at our home on Coolidge Hill when she followed my mother into the kitchen in the midst of a heated exchange. "Don't you see, Rettles?" she whispered loudly. "They're trying to get rid of Perry and Hanns!" To which my mother replied, "Nonsense," in her very English way. In fact, Brigitte was right. Discussions to that effect were already secretly under way. In a memo to the committee on the Raphael on May 12, 1971, George Seybolt wrote pointedly that after the Raphael matter was successfully resolved, "any adjustments in our personnel should follow at a respectful distance."[16] In another memo, he sought to prepare the Raphael committee to face the press in the wake of their ultimate decision. Of the twenty questions he instructed them to prepare for, number seventeen was "Has the board any candidates in mind to replace Rathbone and Swarzenski? Or will they be permitted to resign quietly later?"[17] And little did either of them know that the petition to customs had been abbreviated by more than half, leaving their positions as museum professionals, isolated and making the case only for the trustees.

As summer approached, my father made plans for his annual trip to Europe. To begin with, he and my mother would be cruising in

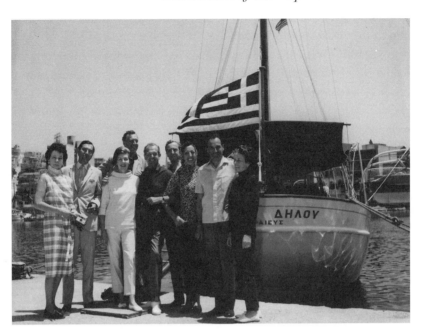

At port during Greek cruise. LEFT TO RIGHT: Lulu Pulitzer, (?), Patricia Clark, Perry T. Rathbone, Henry McIlhenny, Emlen Etting, Gloria Etting, Joseph Pulitzer, Jr., Rettles Rathbone, c. 1966.

the Aegean with his Harvard classmate, Henry McIlhenney. Since 1960 this had become an annual affair, with McIlhenny hosting a group of close friends to cruise the Aegean every June in a luxuriously appointed chartered yacht. That summer, for the first time, McIlhenny was to be the guest of the small band of Hellenophiles he had so generously nurtured.

After the cruise, Rathbone planned to meet Swarzenski and travel with him to Mount Athos, the Aegean peninsula where twenty Greek Orthodox monasteries preside over spectacular scenery and where a "males only" rule extends even to the domesticated animals. Aside from the fascination of visiting this ancient and sacred place was the promise of their being invited into the sanctuary. The monastic reliquaries were filled with treasures of antiquity and medieval works of art, and with Hanns, he would be sure to get inside them. Rathbone tried to persuade John Goelet to join them, as he had on

so many memorable jaunts in recent years, including their fateful trip to Genoa in 1969. At Mount Athos, he wrote to Goelet, there were fabulous libraries to be explored, "which I believe can really be poked into by a ranking medievalist." They planned to spend about a week "exploring the mysteries of the holy mountain."[18] Goelet regretted the invitation, saying that it might be wise at that point to observe "a temporary disbanding of the three musketeers."[19]

With Mount Athos in his sights, for the present Rathbone would enjoy the pleasures of the cruise – the delightful company of his wife and fellow travelers, ancient ruins to explore, wonderful meals in local *tavernas* at every port, midafternoon naps on the prow of the boat, and plenty of dry sunshine. On Saturday, June 26, the party anchored off the island of Paros. They swam in the turquoise-blue Naoussa Bay, and after lunch they explored the Byzantine church of Saint Helena. Joe Pulitzer, fellow veteran of the McIlhenny cruise, would be hosting dinner in the port that evening. At cocktail hour, Rathbone was called to the telephone. It was George Seybolt, informing him that in his absence the board had held an emergency meeting and voted unanimously to surrender the painting to Italy. In fact, they had already done so.

The day before, on June 25, a meeting of the board of trustees was held on forty-eight-hour notice. They met at ten o'clock in the morning, not at the Museum but at the apartment of Bill Coolidge on Memorial Drive in Cambridge. The purpose of the meeting was to inform the trustees of the recommendations of the Raphael committee – Coolidge, Killian, and Canham – who had been "empowered to act" between board meetings. There followed, according to the truncated minutes, a "very full discussion of the subject in its many ramifications."[20] By the end of the meeting, which lasted two hours and ten minutes, the trustees had approved the committee's recommendations. Upon motion duly made and seconded, it was voted into action. Because of its short notice and "informal" format, the minutes also conspicuously lacked their customary detail. Furthermore, George Seybolt himself took the minutes, as his secretary was not present at this highly confidential off-site meeting. Nor were many trustees – in a typical midsummer showing, just seventeen out of thirty attended, but enough to make a quorum. Notably absent were

Rathbone and Goelet, although Seybolt described it as a "meeting of the full board." Indeed, some were not even notified.[21]

John Coolidge, who attended the meeting, later confessed in an interview that as the committee explained their reasoning and recommendations and as they were voted into action, he had not fully understood what they were voting on. While he was aware that the Museum was involved with "some serious unpleasantness"[22] concerning the Raphael, and had, in fact, been privy to some confidential discussions regarding it, he had not digested the suggestion that the only way forward was to return the picture to Italy. Furthermore, it was apparently not clear to him that among the "many ramifications" of the return of the Raphael was that Rathbone would be asked to resign. Not until he was driving home after the meeting with a fellow trustee did Coolidge fully understand what had transpired. "My admiration and friendship with Perry was such that when the thing was explained at the meeting, I didn't take it in,"[23] Coolidge told an interviewer a few years later, his voice trembling and his words hesitant at the memory of that dreadful morning.[24]

Dick Chapman apparently understood what had transpired at the meeting, but he took little comfort in it. "I am greatly troubled by the public relations problems of the next few months,"[25] he wrote in a letter to Jim Ames at Ropes & Gray later that day.

Tammy McVickar, Rathbone's secretary, knew nothing of these proceedings until the following week. On Friday, June 25, she wrote the director a cheerful four-page letter reporting on the attendance figures for the popular Cézanne exhibition – "Tuesday nights have been impossible with crowds"[26] – and their decision to keep the Museum open until nine o'clock every weekday to accommodate them. In another quarter of the building, an unplanned exhibition had taken place a few days earlier. On Tuesday evening, June 15, with the Museum open late for the Cézanne show, a group of six young Boston artists, all members of the newly formed Boston Visual Artists Union, staged a surprise exhibition of their own work in the men's room on the lower level of the MFA. Calling the show *Flush with the Walls*, they had distributed invitations printed on toilet paper to the BVAU mailing list, as well as to select members of the underground press. The work was witty, on the whole conceptual

and not built to last, but meant to draw attention to the Museum's neglect of local artists.[27] As the sounds of merriment wafted from the men's room, other Museum visitors were drawn to the source, and it was not long before word reached the administration offices. Diggory Venn hurried down to see what was going on and found that the men's room exhibit had attracted a large, and on the whole orderly, crowd. But further problems arose the following day, when the cleaning crew tidied up and threw much of the artwork away. One of the artists, Bob Guillemin, who went on to make a name for himself as "Sidewalk Sam," seized on this to perpetuate the media attention. Heyward Cutting issued guidelines to the staff on how to handle questions from the public and the press. "The fact remains," he stated, "that the Museum cannot accept any responsibility for works of art that enter the building in such an irregular way."[28]

More unwanted publicity came that week in a ten-second promotion spot on WCRB advertising the local *Metro* magazine with a feature on the Raphael called "Scandal at the Museum." In a letter to Rathbone – "a quick report from the combat zone"[29] – Venn reported that he had persuaded WCRB to take the spot off the air. But there was nothing he could do about the *Metro* article, which, just when they had begun to hope that the public's interest in it had died down, rehashed the entire Raphael saga along with the latest allegations and speculations.

Meanwhile, McVickar also reported that on the day after the opening of *Flush with the Walls*, museum guards found that a number of American portraits of notable Bostonians by Copley and Stuart had been vandalized with two- to three-inch scratches on their surfaces, obviously deliberate. "We still don't know who did it," wrote McVickar to Rathbone, "but think it was a group of kids roaming around together and not connected to the Men's Room exhibition."[30]

The news of these latest attacks on the Museum and his administration, which he picked up several days later at the post office in the port of Piraeus, was a minor affair compared with the blow Rathbone had already received in the transatlantic phone call from George Seybolt. "We hope you have a good, meditative visit to Mt. Athos,"[31] McVickar wrote before signing off. Rathbone would certainly need the monastic peace of Mount Athos, remote from all

worldly cares, to digest and meditate on this final twist of the knife.

The very day that the board had convened, Rodolfo Siviero arrived at the MFA with a full phalanx of reporters to sign the official agreement between them. Well before the vote of the board had been taken – indeed, before the meeting had even been called – its outcome had been carefully planned and staged. Siviero had, in fact, been in Boston a few days in advance to hammer out the written agreement with the president of the board, which was fully drafted by the time the board met and ready for signatures. Signor Siviero, the agreement stated, "expresses in the name of the Italian Government its gratitude for the museum's high sense of responsibility and friendship." Siviero went on to say that his government had "no further claim against the Museum of Fine Arts in Boston or its Board of Trustees or any of its personnel." In return for the voluntary restitution of the Raphael painting, Siviero promised in the name of his government "to provide an exhibition of Italian art in the Boston Museum."[32]

Italian ambassador Egidio Ortona was joyous. He later wrote to James Killian that with the return of the painting, "we were able to achieve our common goal of restoring and in fact, strengthening the traditionally close and friendly relations between the Museum and the cultural and artistic circles in Italy."[33] For Italy, the little David against the mighty Goliath of the American museum, nothing could be more effective in making their point to the world at large than the restitution of the Raphael from the prestigious Boston Museum. As a source country Italy had been pillaged again and again. Complicit as they had been in the dispersing of their own treasures over the years, it was time to settle the score.

Perhaps it was the pressure Siviero exerted for the endgame that made Seybolt and his committee turn from some form of compromise they had been working toward to a complete surrender. Perhaps there were other factors that played into their thinking. As long as Siviero was alive and kicking, would the Italians ever drop the case? Even if the Museum stood a good chance of retaining it, would the picture continue to haunt them? How quickly would the public forget that it had been smuggled into the country? Even if the wall label said "Raphael," might scholars continue to cast doubts

upon its authenticity? With more than half the payments on the painting already made, Bill Coolidge stated summarily, "We didn't think it was worth the money we hadn't paid for it."[34] And what about the Museum's director, whose judgment had been called into question, whose actions had turned the centennial celebrations into a year of nonstop crisis management? Seybolt's vision in the settling of the affair was to reassure the public that "things have been put to right, and it is a fine capable institution after all." From his point of view, there was no way to put this message across "before the Raphael is interred."[35] Some admitted that there was another motive in the return of the Raphael to Italy. Nelson Aldrich said frankly that the Raphael resolution became "a very valid means of changing the leadership."[36]

The statement the trustees crafted for the press made the point that the portrait attributed to Raphael came to the Museum through irregular channels "without the knowledge of those responsible as members of the Board of Trustees."[37] But the credibility of this statement was rightly questioned by Stanford law professor John Merryman following the case study of the Boston Raphael by his former student, Clive Getty. "Given the organization of boards of trustees into committees on acquisitions and on finance," commented Merryman, "it is possible that one or more members of the board of trustees of the museum knowingly condoned or played a more active role in acquiring the painting, knowing that its export from Italy was legally prohibited and could only be accomplished by smuggling."[38] George Seybolt was apprised by Rathbone prior to negotiations that the purchase of the painting had a chance of export only because it was unknown to the Italian government. Though he later played innocent to fellow trustees,[39] some recalled the impression that he was aware of the inherent risks well in advance. Furthermore, those on the committee that approved the purchase might have stopped at the red flag when Rathbone told them he was unable to disclose the source until they had agreed to buy the painting.[40] By voting to acquire it, they officially sanctioned a degree of ignorance that would probably not be considered unaccountable today. John Coolidge did not help when he urged drawing advance media attention to the acquisition. It is fair to say that

everyone involved was naive about the Museum's potential for liability in making this unusual purchase, and the extent to which the well honed habits of American collectors buying art abroad would have to adjust to a new world.

For Eugene Rossides, the Boston customs problem with an undeclared Italian painting seemed minor, to say the least. To his mind, instead of seizing the picture, they might have respectfully presented the Museum with a request that they file a delayed customs form retroactively. This would be the way to treat an honorable institution. But in his meeting with James Killian and Erwin Canham, Rossides was puzzled to discover that they were so obviously ashamed of what had happened that they expressed a surprisingly preemptive willingness to part with the painting. "The issue of 'Can the Treasury help us in keeping the Raphael?' never came up," Rossides recalled. "Killian – he was very conciliatory – we're happy to send it back, and so on."[41] Nor, it seems, did the committee plead the case of Rathbone and Swarzenski.[42] For Rossides, except for a follow-up publicity photo session in his office with Killian and the Italian ambassador, the matter was off his desk. Compared with the international drug traffic and other issues he was facing at the time, he could truthfully say, "This was an easy one."

Swarzenski's fine was reduced from $1,200,000 to $5,000, which Rathbone and John Goelet insisted on covering personally.[43] While the committee presented a face of optimism about being refunded what they had already spent on the painting – by March 1970, $360,000, or slightly more than one half of the negotiated price – it was just as well that the payment by the Museum into Bossi's Swiss bank account was incomplete. Unfortunately for the MFA, when Ildebrando Bossi died in May 1970, the Italian government seized his assets, for at the time of his death, Bossi was in jail awaiting trial on charges of illegally exporting the Raphael. Who knows how much Bossi owed the Italian government in fines and unpaid export taxes over the years, but the MFA's deposits on the Raphael would certainly help cover them. Meanwhile, Bossi's daughter, Anna, had filed a suit against the MFA, presumably for the balance still due on the disputed painting.

Siviero found records of Bossi's illegal activities going back to

1924, when he was handed a five-year conviction for art smuggling. Adding a puzzling detail, members of the Fieschi family, as reported by Grace Glueck for the *New York Times*, stated that they never sold the little painting to Bossi, though which members of the Fieschi family might have said this was not reported. If Bossi had indeed invented the Fieschi provenance out of thin air, it was a clever move, because the attribution not only endowed the painting with a noble Genoese lineage but also made it almost impossible to challenge the claim since so many branches of the family were by then extinct. In addition to these speculations, it was later rumored that Bossi had offered the painting to several museums or collectors in Europe (as Rathbone had begun to ascertain soon after the purchase), but there were no takers. To what extent any of this was true – and if so, whether it was because potential buyers didn't believe the painting could be legally exported from Italy, because they didn't believe it was really a Raphael, or because Bossi was asking more than they were willing to pay – will probably never be precisely known.

On September 10, 1971, Eugene Rossides in Washington issued an official statement to the press[44] that the Treasury Department had absolved the Museum of guilt in the smuggling of the picture. That night in Boston, Museum officials handed over the Raphael to Gino Gobbi, Italian vice consul in Boston, who personally escorted it onto a flight to Rome. Upon arrival in Rome on the following morning, Siviero was at the airport to greet the "Raffaello di Boston" and to broadcast its safe arrival to television and newspaper reporters from all over Italy. He proudly declared that it was the first time in history that any country had voluntarily returned a smuggled work of art without asking for reimbursement.[45]

For the Boston Museum community, this was the last straw. If Seybolt's aim was to reassure the Boston public that "things have been put to right,"[46] the return of the painting to Italy was an admission of wrongdoing that stained their reputation. As longtime Museum member Frances Erwin wrote to Seybolt, "The financial loss may be recoverable, but the ethical damage is irreparable, and infinitely saddening to hundreds of loyal supporters of our great institution."[47] Boston artist Lonny Schiff also expressed to Seybolt in writing her dismay at the way "Mr. Rathbone ... has caused the MFA

to lose more than $300,000 by his poor judgment … this debacle over the Raphael's return is a final insult to the art lovers and creators of the Boston area."[48] If Rathbone was to blame for poor judgment in acquiring the painting, the trustees' final decision to return it only added insult to injury.

For almost a year, the painting remained in Siviero's office undergoing "preliminary examination" while to the press he grandly predicted a battle over its custody, which would ultimately be decided by a committee. Should it go to Genoa, where the picture had lived for generations with the Fieschi family? Urbino, the birthplace of Raphael? Rome, the nation's capital? Or Florence, the capital of Renaissance art and the official repository of Italian art in the country? But there was no such battle. In his private diary Siviero confessed that he was deeply disappointed in the lukewarm reaction among Italian officials and enraged by their lack of interest in his latest triumph.

Questions lingered about the real value of the painting, all centering on the accuracy of its attribution to Raphael. Eventually Siviero removed the painting to the conservation lab at the Istituto Centrale del Restauro in Rome, where conservators Paolo and Laura Mora cleaned and restored it, with Siviero hovering over the operation. During the painting's restoration, its authenticity was challenged again. "It was found to be so heavily overpainted that little, if any, of the work can with confidence be attributed to Raphael,"[49] reported Clive Getty some years later. Although he had asserted the picture's authenticity all along, Siviero could not have been surprised. Still, he remained adamant about his cause: "If it were a fake," he told the press, "it would still be ours, and we want it back."[50] Now that it was back, what to do with it?

Rathbone's questions were of a different nature. How could he remain director of an institution with a board of trustees that had deliberately abandoned him in his time of crisis? He soon would have his answer. The scandal behind the official scandal, as some insiders knew, was that the trustees had operated secretly behind his back and had exposed him as the culprit with an eye to protecting

themselves at all costs.[51] Seybolt, CEO of the William Underwood
Company, was the consummate outsider, but he had built the sup-
port he needed from the inside, adding to the board like-minded
businessmen, administrators, and scientists who were more inclined
to see things his way. The notion had been spread among them that
Perry was not entirely competent, that he had led them into a morass.
One by one, each had internalized the case for Rathbone's dismissal.
Those who did not feel that way believed themselves outnumbered.[52]

When Rathbone returned from Europe in mid-July, Seybolt
bluntly told him that the trustees felt that it would be in the best
interests of the Museum if he would promptly resign. Rathbone,
who must have seen this action coming, was already quite prepared
to respond. On August 9 he obligingly handed Seybolt his letter of
resignation. But to Seybolt's consternation, he would be taking his
time. Never one to speed into major life transitions – in this case,
there were too many projects yet to see through, and an abrupt
departure would not serve his staff well – his terms were that he
would stay on through the next fiscal year to the following June and
that he would be honored with the title director emeritus.

As the news of Rathbone's resignation spread internally through
the Museum, the curatorial staff closed ranks. A group of them went
out to lunch to talk it over, taking a private dining room at that most
discreet of Boston restaurants, Locke-Ober. Soon afterward they
gathered in Rathbone's office and implored him to retract his resig-
nation. A few days later a delegation of curators held a meeting with
him at Coolidge Hill to review their petition to the trustees to recon-
sider their acceptance of his resignation request. It stated:

> It is the feeling of the Curatorial Staff that any change in the
> Directorship of the Museum would not serve the best interests
> of the Museum, especially at a time when Trustees, the Muse-
> um's Administration and Staff are devoting intense energy to
> the reorganization of the Museum, as called for in the Ad Hoc
> Committee Report. We believe that such an action would not
> only severely affect the "attitude and morale" which we agree
> are "keys to success in any institution", but it would also dis-
> rupt the current productive and unified effort which is basic

to the achievements of the tasks given the Museum Staff and Administration by the Trustees.

We should like to have the Office of the Curatorial Representative informed of and consulted about any proposed change in the Directorship of the Museum.[53]

In a separate note, Robert Moeller, who had been elected to represent the curatorial staff, emphasized that "every department has contributed to the statement" and "has carefully considered the history of Perry Rathbone's leadership."[54] Every senior curator signed it, and those who were abroad at the time asked that it be signed in their absence.

The curators asked Jim Ames to deliver their petition to the trustees. There was no answer. Just as many had feared he might, Seybolt ignored the document. On two occasions, smaller delegations traveled up to Topsfield to call on Bill Coolidge and plead their case to no avail. On another, curators pressed trustees into a tense meeting at a hotel near MIT. "We didn't want Rathbone to go," recalled Cornelius Vermeule, "but (the trustees) were calling the tune, however sugar coated they did it."[55] Moved as he was by their plea, Rathbone had adjusted himself to the idea of stepping down. Even knowing that he had the support of his staff, he felt paralyzed under the present board. It was time to gracefully make his exit rather than remain in place as an object of contention.

At the news of Rathbone's resignation, John Goelet sent a telegram from abroad to Perry imploring him to reconsider. "I URGE YOU TO RECONSIDER YOU HAVE THE CONFIDENCE OF ALL THOSE WHO SHARE YOUR ASPIRATIONS FOR THE MUSEUM THE INSTITUTION HAS WEATHERED OTHER STORMS AND WHILE I UNDERSTAND YOUR SENSE OF DISILLUSIONMENT IT DOES NOT JUSTIFY YOUR LEAVING THE HELM."[56]

Once he realized there was no changing Rathbone's mind – and, in fact, that it was not his own decision – Goelet sent his letter of resignation to the board of trustees. At this, Rathbone wrote to Goelet to express his great disappointment, for it was not a point of personal honor that concerned him as much as the health of the Museum. He pleaded with Goelet, "The Museum needs you, and in

all our thinking, we must put the Museum first. I agree with you that the President [Seybolt] does not know what a museum is all about, and I am now convinced, reluctantly, that he never will.... For the Raphael affair, one blood sacrifice, one scapegoat, is enough."[57][58]

At the September meeting of the board, Rathbone read his letter of resignation aloud. In the interests of keeping a steady ship and a strong self-image, it was agreed that they would not announce Rathbone's retirement until the end of the year. Strategically, the trustees hoped to dispel any illusion that his action had anything to do with the return of the Raphael and to discourage inquiry into the details behind it.

But in early September the city desk at the *Boston Globe* got a tip and ran with it. Rumors and gossip spread like wildfire. Anguished letters in support of the director poured in from Museum friends and former staff members. David Little, former registrar and secretary of the Museum, perceived a lack of internal support at the heart of the situation. Little had only recently retired as registrar of the MFA when the Raphael arrived. The new, younger staff members did not have enough authority to insist that the painting be registered upon its arrival, as Little surely would have done. "Had he had these officers," wrote Little in a letter addressed to the entire board, "the illegal entry of the Raphael into the US would have been promptly remedied." And he added, "The responsibility for the Raphael blunder rests firmly and entirely on your shoulders. You cannot evade this responsibility by letting Perry go. You will, indeed, be placing an even bigger blunder on top of the one you have already committed."[59]

The women of the Ladies Committee would be losing their founder and leader, and they were up in arms. One wrote that she was "appalled that the trustees propose to let Perry resign.... The trustees have been silent when they should have spoken, have let every imaginable rumor spread without a clarifying statement, and now want to get their inadequacies swept under the rug.... What manner of people are these trustees?"[60] Another declared, "The board of trustees has lost its sense of responsibility to its members, its staff, and the community."[61]

Now confronting the ongoing need for damage control, Seybolt asserted his own version of the facts to another outraged friend,

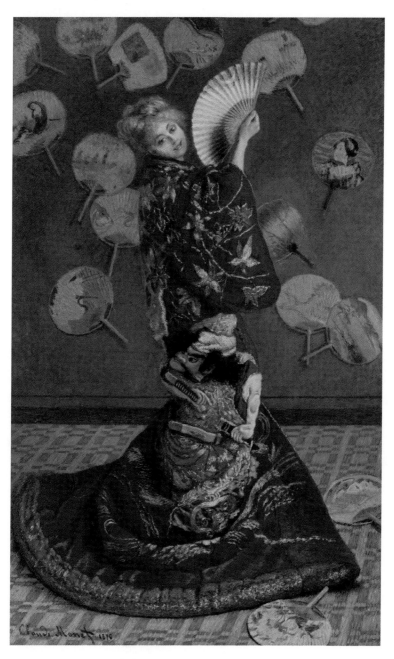

Claude Monet
La Japonaise (Camille Monet in Japanese Costume), 1876
Oil on canvas (91 ¼ × 56 in.)

Maurice Brazil Prendergast, *Umbrellas in the Rain*, 1899
Watercolor over graphite pencil on paper (13 15/16 × 20 7/8 in.)

Edouard Manet, *Music Lesson*, 1870
Oil on canvas (55 ½ × 68 ⅛ in.)

Edgar Degas
Visit to a Museum, about 1879–90
Oil on canvas (36 ⅛ × 26 ¾ in.)

Edvard Munch, *Summer Night's Dream (The Voice)*, 1893
Oil on canvas (34 ⅝ × 42 ½ in.)

Ernst Ludwig Kirchner, *Mountain Landscape from Clavadel*, 1925–26
Oil on canvas (53 ⅛ × 78 ⅞ in.)

Pablo Picasso
Standing Figure, 1908
Oil on canvas (59⅛ × 39½ in.)

Juan Gris
Still Life with a Guitar, 1925
Oil on canvas (28¾ × 37¼ in.)

Alexander Calder
4 Woods (Diana), about 1934
Walnut with steel pins, iron base
Overall: (30 ½ × 17 ¾ × 19 ¼ in.)

David Smith
Cubi XVIII, 1964
Polished stainless steel (115 ¾ × 60 × 21 ¾ in.)

Nicolas de Staël
Rue Gauguet, 1949
Oil on plywood panel (78 ½ ×
94 ⅝ in.)

ackson Pollock
Number 10, 1949
lkyd (synthetic paint) and oil on canvas
ounted on panel (18 ⅛ × 107 ¼ in.)

ranz Kline
robst I, 1960
il on canvas (107 ¼ × 79 ¾ in.)

Max Beckmann
Perry T. Rathbone, 1948
Oil on canvas (65 × 35 7/16 in.)

Harvard professor Wilhelm von Moltke, about the return of the Raphael. "The director was consulted in the matter before the action was taken," he wrote, "and his counsel agreed it was the proper one."[62]

On December 16, 1971, exactly two years after the announcement of the Raphael's arrival in Boston, Rathbone, who had just passed his sixtieth birthday, officially announced his forthcoming "early retirement" from the MFA to commence July 1, 1972. "It is a time for pause and reflection in any man's life," he wrote in his official letter to the board of trustees. "Museums today are changing and asking unexpected and inordinate demands on their executives.... A director must have ample time to spare for the artistic judgments essential to the conduct of the museum; and ample time to act as the whetstone for his staff.... The time has come for a younger man to take the helm of this great museum."[63]

While his statement was sincere, few believed these were the real reasons behind Rathbone's retirement, and they were right. Many speculated that Seybolt and other members of the board had deliberately exposed Rathbone to incrimination rather than seeking a resolution that might save him.

Rathbone's "premature retirement from the directorship of the Boston Museum of Fine Arts was met with sober acceptance and regret," commented Caron Le Brun Danikian for the *Boston Phœnix*, adding that Rathbone's "impact on the Museum has been astounding." She also noted the oversize responsibilities he faced in the job and furthermore his "perplexing insistence on not only shouldering the burdens of the directorship but also overseeing the Museum's department of paintings – work that would stagger two men." Even before the troubles began with the Boston Raphael, "the demands and pressures exerted on the office of director of the Museum were becoming unbearable – yet Rathbone was weathering them."[64]

Although Seybolt provided the press with his official response, expressing that the trustees "have acceded to your request with great reluctance,"[65] no one inside the Museum's inner circle believed him. Jerome Facher, an important donor, confronted Seybolt with his impression that there was "a certain lack of candor and courage in

the pretense that Mr. Rathbone has voluntarily sought retirement."[66]

"There were some who thought Rathbone was leaving under a cloud," wrote Charles Giuliano for *Boston* magazine, "and a persistent undercurrent whispered that he'd been asked to leave, that it was all because of the unfortunate affair of the smuggled Raphael." If in retrospect the Raphael seemed a tragic error, "even if his sin was getting caught in the act," continued Giuliano, always interested in prizing out the real story behind the official one, "why did [the trustees] try to make an example of him when there is so much precedence for this kind of behavior – unless they were just looking for an excuse to replace him?"[67] Many insiders would regard the situation similarly. The Raphael was Rathbone's "Achilles heel," remarked head of development James Griswold. "Seybolt took advantage of it and used it as a tool to get Perry out of a job."[68] Cliff Ackley, then a young assistant curator of prints and drawings, believed that "Perry had achieved too much power and independence, and the trustees wanted to take it away. The Raphael was a pretext they used to force his resignation."[69] As Cornelius Vermeule perceived it, "the real issue was a power struggle between the president and the director." [70]

Some art world insiders who watched the Raphael saga unfolding from a distance saw it perhaps even more clearly. "I suspect that the trustees did not understand the value of Perry to that institution – his standing in the art world and museum world," remarked art dealer Richard Feigen. "Had they understood it better, they could have quietly minimized the brouhaha."[71]

Thus, the happy reign of Rathbone and Swarzenski had come to an end. Hanns, by then in his late sixties, was past official retirement age. For him the deceit of the trustees in handling the Raphael incident and Perry's resignation were perhaps eerily reminiscent of his father's precipitous exit from the Städel Museum, in Frankfurt, under the Nazi regime. Until these recent events, nothing at the MFA had resembled those terrifying years. Swarzenski had been fortunate to have a director who valued him, who understood him and allowed him to do things in his idiosyncratic way. With the prospect of Rathbone's resignation, Swarzenski knew that his life at the MFA would never be the same. In October 1971 he announced his

retirement and forthcoming position as a research fellow in the Museum's decorative arts department.

In retrospect, the Raphael fiasco was not so much a plot as what we would now call a perfect storm of personalities, ambitions, and circumstances, and Rathbone had not seen it brewing. His boldness and independence that had served him well for many years finally collided with multiple forces that had lined up against him: Seybolt's determination to control the Museum and to develop it in the model of a corporate enterprise; Siviero's zealous ambition to make a point to the international community; Bossi's shady past and untimely death; Shearman's single-minded attribution; and Swarzenski's eccentric style and political naïveté. In addition, the requirements of the centennial year to outperform any other, the changing landscape of the American museum, and the turning tides of cultural patrimony added unforeseen pressures. On top of all these factors was the power of the press, an instrument that Rathbone had until then been singularly brilliant at aligning to the Museum's cause and which, for the first time, worked entirely against him in its pursuit of headlines and scandal. If any of these factors had been in his favor, the situation might have been rescued from disaster.

How might Rathbone have played it differently? Should he have avoided the risk in the first place or, after having taken it, changed course midstream at the first signs of trouble? In his desire to land the ultimate prize, did he overreach himself? Had he trusted the wrong people? Curiously, he never expressed anger with Bossi, the clever dealer who ensnared him in his tangled web of criminal activity. But Rathbone could sometimes be a poor judge of character – trusting those he should not have trusted, including some he believed to be true friends to his dying day and who, in fact, were not. It was not so much hubris, as some have suggested, that led him astray, as his trusting nature, his boyish love of excitement, and his confidence that his devotion to the cause of the Museum would always serve him. "What did the downfall of Perry," commented *Boston Globe* critic Robert Taylor, "was that he was too enthusiastic. He was carried away."[72]

Bill Coolidge expressed it differently. As the trustee appointed in charge of, and also largely responsible for, Rathbone's early retirement, he could hardly wait to see him swept out of the building

when the date of his retirement finally came in June 1972. In a letter to my mother, he told her bluntly that "Perry was very lucky to have been born when he was, because the era in which his talents could be given full expression is, I firmly believe, coming to an end."[73] The trustees and their ad hoc plans for the future would attempt to make sure that this was true. Their own day of reckoning, as it turned out, was just ahead.

Upon the announcement of Rathbone's resignation in December 1971, the press release stated that during his seventeen-year run as director of the MFA, "The museum increased its membership seven and a half times, and membership income fifteen times. The staff tripled,[74] the budget quadrupled, and the annual sale of publications increased more than 1,000 percent."[75] Attendance figures reached nearly a million in the centennial year. These were achievements of which Rathbone was justly proud, but numbers were not his own measurement of success. More than anything, he was proud of the acquisitions that had been made under his directorship for the Museum's permanent collection. For as he once wrote, the museum director "knows that the affairs of the day that tower before him will fade. The real and lasting concern is the acquisition of a masterpiece."[76] His curators understood this – most of all Hanns Swarzenski, who was the driving force behind the exhibition of acquisition highlights under his directorship, *The Rathbone Years*. Assembled in a mere eight weeks, the entire staff enthusiastically participated in the homage – a grand public refutation of any aspersions one might have cast upon his leadership. It was a glorious show of some 170 outstanding works of art, ranging from Greek antiquities to modern American paintings and everything in between. A full-color catalog designed by Carl Zahn, who had seen him through all of them, ensured that the Rathbone years would not soon be forgotten.

"This tribute to a retiring director is, we believe, without precedent,"[77] wrote the editor of *Art in America* and director of the Williams College Museum, S. Lane Faison. In his review of the show, Faison extolled its extraordinary quality and variety, "revealing

Entrance to *The Rathbone Years* exhibition, Museum of Fine Arts, Boston, June, 1972.

innumerable works of stunning beauty."[78] Faison took the opportunity to praise not only the outgoing director's taste and judgment but also the values he stood for that were increasingly under threat. "If museum educators and social activists run the show, if they – not the curators – can decide what can be exhibited, then the wrong Rubicon has been crossed."[79]

On June 1 the celebration of *The Rathbone Years* went on all day and well into the night. It began with a staff party where the outgoing director was presented with a touching gift: a seventeenth-century Delft charger with an image of Hercules shedding his labors. Cornelius Vermeule organized a scrapbook of photographs of memorable moments of his tenure. The curators put together a slide quiz for the director with tiny details of works of art from every department for him to identify. "He got 'em all,"[80] remembered Laura Luckey. "The Rathbone years were vintage years," toasted Diggory Venn, who could never resist a pun, "with wine trod from the grapes of Rathbone."[81]

Later that day there was a seated dinner followed by a black-tie evening reception for more than eight hundred friends that went on

till nearly midnight. Climbing the grand staircase to the Museum's rotunda for the last time that Rathbone would preside over that grand space, the guests came face-to-face with Tiepolo's grandly symbolic *Time Unveiling Truth*. Truth, a beautiful young woman, serenely accepts her unveiling by the dark, gnarled, winged figure of Father Time, while a mirror, signifying vanity, lies on the ground; a parrot, signifying deceit, perches nearby; and Cupid, representing earthly love, gazes up at her. The allegory, perfectly chosen as a centerpiece for the occasion, provoked the question: Would Father Time ultimately unveil the truth, and how would that truth reflect on the retiring museum director and, more important, on the board of trustees he would leave behind?

"Rathbone, shaking hundreds of hands in the neoclassical rotunda, was characteristically charming and ebullient," reported Bill Fripp for the *Boston Globe*. "Dozens of women openly wept at the sayonara."[82]

Christie's

In the aftermath of the Raphael affair and my father's resignation from the MFA, he underwent a quiet period of adjustment, a reckoning with his past as a high-profile figure in the art world, and an unknown future. In his official statement to the press, he said that he was retiring to "pursue long-delayed plans for research and publication."[1] But as far as I know, there was no pressing topic, only a general feeling of regret that he had let these areas languish for so many years under the pressures of other responsibilities and a desire to return to them. He was sixty years old and had always seemed young for his age, but the last few years at the MFA had taken their toll. He had visibly aged.

An outpouring of affection and sorrow came from far and wide, and with no greater warmth than from Saint Louis, where many still remembered the Rathbone years as their museum's finest. Martha Love, who rightly claimed her role as my parents' matchmaker (she was also Eliza's godmother), invited the whole family for Christmas that year, and breaking with years of tradition in Cambridge, we all said yes. From her grand old neocolonial brick mansion on Westmoreland Place, where she presided over a small domestic staff and two generations of whippets now numbering about seven, "Aunt Martha" scheduled a full calendar of parties and outings for all ages. Over nightcaps in the drawing room she regaled my parents with the latest Saint Louis gossip, from Joe Pulitzer's latest amorati (his first wife, "Lulu" Vauclain, died in 1969) to Charles Buckley, the

current director of the art museum, and exactly what everyone thought of him. There was nothing my father needed more – indeed, all of us needed more – than the warm embrace of a loyal community of yesteryear to restore his equilibrium and confidence.

Back in Cambridge there was hardly a lull in his activities. Turning down various job offers from museums and universities across the country,[2] he picked up a variety of freelance projects. He accepted David Rockefeller's invitation to conduct a review of the Chase Bank art collection and to recommend further purchases and activities; the Seattle Art Museum's, to lead a members' tour to Egypt; and a private client's, to broker the sale of a painting – a portrait of Benjamin Franklin by Greuze – for which the percentage fee, along with one or two smaller commissions, was more than my father had made in any previous year of his working life. From Japan came an invitation to organize an exhibition of paintings by Andrew Wyeth. This was inspired by the Wyeth exhibition at the MFA in 1970 and by my father's sense that this taciturn American realist artist, with his deft hand at watercolor, his restrained palette, and his feeling for nature – as well as his aesthetic of poverty, or what the Japanese call *wabi* – would resonate with the Japanese. The Wyeth show, which was sponsored by the leading financial newspaper company Nihon Keizai Shimbun, would travel from Tokyo to Kyoto, prompting my father's third trip to Japan, a country that had captured his affections as his first trip to Greece had some ten years earlier.

There was, therefore, no shortage of offers, and no time to feel either bored or dejected. But working freelance out of his little study at Coolidge Hill was not ideal for a man used to the hurly-burly and staff support of office life and the camaraderie of teamwork. So when a call came in the winter of 1973 from Peter Chance, chairman of Christie's in London, he was intrigued. Chance was asking him to head up their New York office, represent the firm in all its departments, and expand its presence in America.

Though my father was loath to leave his comfortable life in Cambridge (and my mother was dead set against it), Christie's presented an offer that was hard to refuse. As he recalled, "[Peter Chance] twisted my arm pretty hard."[3] They promised him a rent-free pied-à-terre in New York and the freedom to return on weekends to Cam-

bridge. Here was an opportunity to let the trials of his recent Boston years fade into the background of his professional life. Here was an invitation to return to the city of his youth and the capital of the art world. Perhaps no small part of the decision was also influenced by his son Peter's appointment as a cataloguer trainee in the American paintings department at the rival firm, Sotheby's. A long-anticipated father-son professional relationship was at hand. And with the assurance that their relationship would not constitute a conflict of interests, since Christie's did not yet deal in American art, he embraced his new career.

It was obvious that Perry Rathbone – with his wide-ranging knowledge, contacts, and exceptional social gifts – would make a great ambassador for the English firm. The international network of art collectors, dealers, curators, and scholars was at his fingertips, and he was a popular figure on both sides of the Atlantic. They needed a consummate insider, "a highly visible American presence," recalled Christie's expert Christopher Burge, who joined Rathbone in the New York office, "somebody who had stature, somebody who had the gravitas, and the knowledge of where things were."[4]

But now the Raphael story had to be contended with on another level: Was a man once accused of art smuggling an appropriate candidate for a high-profile position in the trade? The consensus was resoundingly yes – particularly outside of Boston (where the pain and embarrassment had been most keenly felt), and especially in New York, a city that knew better about such things. "We would never have treated you that way,"[5] Met trustee Brooke Astor assured Rathbone in confidence, referring to the Raphael fiasco. He was vindicated, ready to taste the forbidden fruit on the other side of the garden. In announcing Rathbone's appointment, how would Christie's handle the inevitable questions from the press about the Raphael affair? With the simple line "The matter was settled two years ago, and we have nothing further to add."[6]

At that time the New York offices of Christie's were in the old Rhinelander mansion at the corner of Madison Avenue and Seventy-Second Street, a neo-Gothic extravaganza of which the auction house claimed most of the second floor, including the ballroom. Arriving at his new post in the spring of 1973, Rathbone found to

his delight that the ceiling of his office was decorated with an angel at each of its four corners, and outside his window on Madison Avenue were two saints, "so I really was protected in my office as never before or since,"[7] he later quipped.

In the early 1970s the art market was on the brink of a period of extraordinary growth, and the auction houses were helping provide the momentum – they were broadening their client base and refining their methods, catering to the private collector, not just the trade. Their catalogs were soon to be fully illustrated, with many lots reproduced in full color, the most noteworthy carefully researched and annotated with provenance and exhibition history. In the struggling economy of the early 1970s, many American investors were developing more confidence in the value of art than they had in the dollar, and foreigners were flocking to New York to buy. There was "a lot of loose change in the world," observed Rathbone in his newfound capacity, "especially in Germany and Japan."[8] In New York, "the capital of capitalism," buyers the world over added to the competitive frenzy for old masters and French impressionists.

Like the art museum, the art market was in a state of growth and change. New fields opened up as collectors' tastes adjusted to the rising prices of older ones. As contemporary art entered the resale market, the auction houses played an ever more powerful role in establishing its respectability, glamour, and marketability. Pop art had become outrageously chic (and in many ways more collectible than performance art, earth art, minimalism, and other movements of the 1960s), prices for American folk art soared, and photography, heretofore a bit player confined to the margins of print dealers and rare-book collectors, was the newest medium on the block.

Fresh from Christie's London office was the genial young Christopher Burge,[9] a specialist in nineteenth- and twentieth-century painting and sculpture. Soon after arriving on the job, Perry took Christopher on a cross-country tour of museums and galleries, introducing him to curators, collectors, and dealers, and entertaining him with his encyclopedic knowledge, his war stories of life in the art world, and his occasional bursts of modern Greek. Burge was fascinated by the art he saw in collections across the continent, and also by the people he met, among them some of Rathbone's oldest

friends. In Saint Louis, Burge was cajoled into playing backgammon till two o'clock in the morning with architect Bill Bernoudy and his exotic Czech wife, Gertrude, in their stylish modern house, amid their Klees and Morandis.[10] From San Francisco Perry and Christopher were invited into the secret world of the Bohemian Grove, an exclusive men's club whose membership – a powerhouse of figures in American politics, business, and the arts – retreat regularly to a 2,700-acre woodland campground in Monte Rio. This was thanks to Perry's Harvard classmate, Bohemian Tom Howe, who had recently retired as director of the Palace of the Legion of Honor. Perry "paved the way," said Burge. "He was our senior ambassador."[11] Senior as he was, Rathbone still had the energy of a much younger man. "You felt that he wasn't any older than we were," remembered Burge. "He was so physically exuberant as well; you couldn't keep up with him."[12] He was also positive. "Say anything to Perry and the answer was always 'Sure!'" A father figure such as few an Englishman ever had, he listened and seemed always to be "unfailingly interested" in what the young had to say and "fantastically encouraging."[13]

Happily, Rathbone was immersed once again in a constant flow of works of art and people who cared for them – but without the onerous demands of a museum director. He was no longer in the business of building collections but rather in the business of dispersing them. It was, as far as he was concerned, part of the ebb and flow of the art world. While the Christie's job involved a good deal of travel, which meant piles of paperwork on his desk to catch up with upon his return, it was nothing like the pressures of the previous thirty-two years, and the relief for a man of his age was apparent. He no longer had a huge staff to look after, or the need to beg for money from lofty millionaires or to explain every single move he was making to a demanding board of trustees. Perhaps best of all, he was not responsible to his public. "You have no idea what a relief it is not to have the public on your mind,"[14] he told an interviewer upon his move to the private sector.

While Rathbone embraced the world of commerce with an open mind and a philosophical attitude, it did not stop him from criticizing museums for de-accessioning their treasures and moving them

into the marketplace. When Tom Hoving went on his famous sell-
ing spree in the early 1970s – with the bequests of many benefactors
compromised to the point of illegality to shore up funds for expen-
sive acquisitions, including the debt of more than $5 million the
Met had paid for Velázquez's *Portrait of Juan de Pareja*, a world
record for any work of art at that time – many museum profession-
als were outraged. As art critic John Canaday put it, such an action
on the part of a museum "violates a fiduciary trust."[15] Included in
the sell-off was a vast and priceless collection of Greek coins. As
Hoving himself flamboyantly proclaimed his collecting philosophy
in the early 1970s, "The hell with the dribs and drabs – the little
Egyptian pieces, the fragments, the also-rans." From then on he
would aspire to collect "only the big, rare, fantastic pieces, the
expensive ones, the ones that would cause a splash. With the incal-
culable number of treasures already in the museum, *why* bother
with the footnotes?"[16] Rathbone considered Hoving's actions uncon-
scionable. To his mind, ancient coins were not only the linchpins of
any classical collection but basic to the culture of the Western world,
not small pieces of metal to be relegated to numismatic footnotes.

On the other hand, Rathbone could hardly avoid confronting
these same questionable deaccessioning practices on the job. When
a Boston parish approached him to sell off its finest silver to raise
funds to maintain the church building, he confessed he found him-
self in an "odd role."[17] And as he tallied his lists of aging collectors,
it was strange to be considering their estates in terms of hopeful
sales rather than hopeful gifts. Anne Poulet, who had taken over
Hanns Swarzenski's position as curator of decorative arts at the
MFA, recalled the awkwardness of Rathbone's visit to the depart-
ment as she showed him through a selection of works intended as
promised gifts to the Museum but whose owners were now consid-
ering their sale at Christie's. It crossed Poulet's mind as they
reviewed the pieces one by one that Rathbone might himself have
solicited these promised gifts years before, but they were no longer
under his purview. She sensed his discomfort, and even perhaps
embarrassment, at his new position on the other side of the table.

Richard Feigen, who had come to know Rathbone as an import-
ant client, did not like to see "this august figure" transformed into

his new role in the trade, "in a dinner jacket standing in front of an auction room."[18] Feigen considered his new position in the market-place conspicuously degrading. MFA trustee Lewis Cabot believed it must have been quite a letdown for Rathbone to go to work for Christie's. "That was sort of like saying, 'I'm moving over to where the devil resides.'"[19] But others did not see it that way. Rathbone was not the first museum professional to move to the other side, and he would not be the last. Younger men looked on in wonder as the veteran museum director adapted to his new role. Peter Sutton, who joined the MFA paintings department in 1984, said, "I never saw a man regain his balance as gracefully as he did."[20] Ashton Hawkins, who was vice president and legal counsel at the Metropolitan Museum under Hoving and had closely watched events unfold at the MFA in the 1960s, reflected years later that Perry "had made peace with himself and made something more of his life than being just a director."[21] As Burge perceived it, the Christie's position "suited him terribly well.... What he felt about the commercial side, he never let on if he felt uncomfortable with it."[22] On the other hand, Burge remembered, "there were some museums he was a little uncomfort-able with – obviously Boston – the Raphael trailed after him."[23]

For several years the Christie's office on Madison Avenue with its skeleton staff served its purpose, while Sotheby's, the rival firm, had enlarged their operations in New York in 1964 by taking over the New York–based Parke-Bernet Galleries to become Sotheby Parke Bernet. In the spring of 1977 Christie's opened a full-fledged auc-tion house at 502 Park Avenue at the corner of Fifty-Ninth Street. The building, formerly the old Delmonico Hotel, suited the auction house's needs, with its prestigious midtown address, revolving doors, gracious mezzanine to accommodate the friendly front counter to greet walk-in traffic (a Christie's specialty), and the old ballroom just grand and ample enough to be transformed into a world-class auc-tion room. But the sense of togetherness of the Rhinelander man-sion was lost, recalled Ildiko von Berg, Rathbone's first secretary at Christie's; the offices were off a long corridor, and "suddenly you didn't know what was going on down the hall."[24] It was a dramatically

different work environment. Christopher Burge admitted that his "close relationship with Perry, which had been so much fun, was rather changed."[25]

To head the new enterprise, Christie's sent David Bathurst, who had spearheaded the first department of modern and contemporary art in London. Bathurst was the son of a viscount, a product of Eton and Oxford. Playful and gregarious, he enjoyed grouse shooting in Scotland and was famous for his Burns Night suppers and boozy office parties. For all his aristocratic background, Bathurst, like Rathbone, was "a foe of stuffiness," and they were instantly compatible. In fact, they had known each other for years. Bathurst supervised an assorted team of experts imported from London, the "number twos" in their departments, to become, in New York, the number ones. With the opening of the new auction house in New York, Rathbone's role became more specialized. Under his new title, museums liaison, he dealt with the sensitive business of museum deaccessions as well as keeping his former colleagues personally up to date with forthcoming sales at Christie's.

His position at Christie's also meant regular visits to the London office on King Street, Saint James, where he developed a special rapport with Noel Annesley, head of prints and drawings. Perry had "impeccable manners," said Annesley, and wherever they went, he would "always have something good to say, unlike some in the firm."[26] Annesley made frequent trips to the New York office and as often as possible, he confessed, would conjure up an excuse to visit Boston for the pleasure of staying at Coolidge Hill as the guest of Perry and Rettles and the agreeable company of their fellow Bostonians. He enjoyed the Boston clubs my father took him to – bastions of New England tradition such as the Somerset, the Tavern, and the Odd Volumes. It was an education in American manners and mores, a revelation that some Americans might be even more proper than, and at least as well educated as, the most properly raised Englishman.

Rathbone embraced the company of his younger, mostly British colleagues. While some in the firm may have grumbled that Rathbone didn't have the mind of a businessman, they also realized that

he had not been hired for that attribute. At the same time, there was the odd quirk about him that was harder to understand. Burge noticed that Rathbone sometimes went off on his own and could be quite secretive about his actions. "He loved to make a score – to land things," recalled Burge. "Often he would keep it very much to himself." But sometimes these scores didn't work out as anticipated, and then, according to Burge, "the whole thing had to be sort of unraveled. It really would have been much easier if he'd involved us all from the beginning."[27] Whether this behavior was a holdover from his childhood or the unchangeable habits of a previous museum director was hard to say. Whichever it was, Burge surmised that this tendency had perhaps not served him well in the case of the Raphael.

Among art world insiders, the saying went that the experts at Christie's were gentlemen trying to be businessmen, while their rivals at Sotheby's were businessmen trying to be gentlemen. On the face of it, there was no telling which served the delicate business of the auction world more effectively, nor was it that easy to tell them apart. With slightly different strategies for success, each strove to capture the most valuable properties, their eyes keenly fixed on the competition at all times, making sure they were all playing by the same rules, or if, and how, they were changing them. In 1977 Christie's introduced the buyer's premium to New York, which added 10 percent to the "hammer price" for the object while at the same time reducing the seller's commission to the same amount. Sotheby's New York offices asserted this policy to be un-American, but as the Christie's arrangement quickly proved popular with consigners, Sotheby's had no choice but to catch up quickly in 1979.

My brother, Peter, having spent a year at a Sotheby's training "scheme" in London, started as a cataloguer trainee in American paintings at Sotheby's and was soon on the rise in that burgeoning department.[28] At my father's pied-à-terre on East Seventy-Eighth Street, he and Peter held long late-night conversations about the American paintings market, collectors, dealers, and the latest sales, each steadfastly loyal to the superiority of his firm. As a witness to some of these discussions, I can attest to their intensity. For here it was not just company loyalty at work but a manifestation of father-son rivalry that provided a new level of passion. When rumors

circulated that Christie's was going to open a salesroom in New York in 1977, Peter was urged by his colleagues at Sotheby's to exercise his special access to the inside scoop at the rival firm, but to no avail. "I would ask him and he would play dumb,"[29] recalled Peter of this frustrating exercise.

While he plied the trade in New York during the week, Rathbone took the Eastern Airlines shuttle back to Boston every Friday afternoon. He treasured his weekends with Rettles at Coolidge Hill, which remained a place of rest and contemplation. He loved to breakfast in his kimono in the dining room, with his tea in his silver teapot, his one fried egg on toast, and the leisurely reading of his books and journals, all the while meticulously waited on by Rettles. Sunday mornings he attended the service at Memorial Church in Harvard Yard to hear the sermon by his friend the Reverend Peter Gomes,[30] and Sunday afternoons he fell asleep in his favorite armchair listening to the live opera broadcast. In the warmer months he worked in his garden and took his correspondence out to the patio. If home was no longer the scene of the glamorous events of earlier

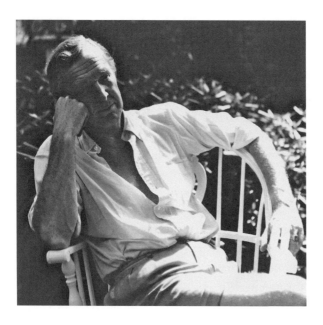

Rathbone takes a break from gardening, 151 Coolidge Hill, Cambridge, MA, 1970s.

days, my parents now enjoyed more intimate visits with friends and the comings and goings of their grown children.

Cambridge and Boston held their grip on my father – on his mind and his conscience as he looked to his last years to make a difference, to set the record straight, or to right a nagging wrong. He took more time over his family history, frequently going off to the New England Historic Genealogical Society, on Newbury Street, to plumb the depths of their archives in search of one or another of his Yankee ancestors. He attended to his favorite local nonprofits – among the many, the New England Conservatory of Music, Sarah Caldwell's Opera Company of Boston, and Harvard. Doggedly interested in preserving the honorable past – whether it was the lost bell tower of Memorial Hall or his Willard ancestors' tomb falling into disrepair in Stafford Springs, Connecticut – he maintained his vigil. For this was the ongoing work of a museum man, the habit of a cultural leader. He could not stop caring, nor voicing his views to anyone, young or old, who cared to listen.

He also kept an eye on the latest developments at the MFA and with mixed feelings witnessed the Museum's painfully slow recovery from the Raphael episode and his subsequent resignation. The most obvious loss was one of spirit among the staff, but there were more tangible losses as well. Promised gifts of works of art in honor of the centennial did not all come through,[31] and promised gifts of money were not all in cash. Attendance figures plummeted from their record high of nearly a million in 1970 to a little more than half that figure in 1973. For the century ahead, so grandly welcomed in by the centennial celebrations, these were to be trying times.

While he empathized with the staff, Rathbone felt a sense of ironic justice for the lot of the trustees. It proved to be very difficult to find his successor. In their search for a new director, a committee of ten gathered recommendations from far and wide, considering about 130 candidates from the entire roster of museum professionals in America. After researching all and interviewing several of them, the committee whittled the list down to six. It was said that none of these finalists passed muster with either the trustees on the one hand or the professional staff on the other, or both. Another problem the search committee faced was voiced by Lewis Cabot. By that time, "the

Boston Museum had a reputation for being very tough on directors."[32] Seybolt would argue a different angle on the same situation. "Boston had a bad reputation of the staff being out of control," he later explained.[33] The search went on into the spring of 1973, while the staff remained frustrated at the absence of stable leadership and anxious about the future. Meanwhile, Cornelius Vermeule, curator of classical art, was acting director. Said publicity director Clementine Brown, "My heart was in my mouth the whole time."[34] In this atmosphere of confusion and despair, as Ariel Herrmann, a newcomer to the curatorial staff, recalled, "Rathbone was a sainted memory."[35]

In March 1973 Seybolt, sidelining the search committee, appointed Merrill Rueppel as the MFA's new director. It was an unexpected development for all concerned. Rueppel, who was then director of the Dallas Museum of Art,[36] was not even on the long list. Earlier that year he had been touring around the country consulting various museum administrators for a report to the Association of Art Museum Directors. Stopping in Boston, he made an appointment with George Seybolt. By the end of the meeting, which lasted more than two hours, Seybolt had decided that Rueppel was perfectly suited to carry forth the recommendations of the ad hoc report and therefore to direct the Museum. "I thought, gee, this fellow is unusual," recalled Seybolt. "I've never heard anybody like him. He's a positive kind of person."[37] He offered Rueppel the job on the spot and then drove his appointment through a weakened and divided search committee following the elimination of the short list. Rueppel had "sort of come along as being the only candidate," Seybolt later summarized. "The rest were all bubbleheads."[38]

It could be inferred that Seybolt was in a hurry. Among his stated personal policies when it came to serving nonprofits was never to remain in power for more than five years, his view being that "if you can't get it done in that time, you're not gonna get it done."[39] He may also have sensed that his effectiveness at managing his fellow trustees was on the wane, that disillusionment was in the air. Whatever his calculations, he wanted a new director in place before stepping down, preferably one of his own choosing. With Rueppel to direct the Museum in the spirit of the new management, Seybolt planned to step aside, telling Rueppel, "The leadership should not

come from me now; it should come from the director."[40] His plan to pass on the presidency of the board to a more passive trustee was conscious and predictable. There was John Coolidge, recently retired from the Fogg, ready and willing.

Soon after his appointment, Rueppel appeared before the senior curatorial staff for what they were led to believe was an opportunity to vet him for the job. Growing impatient with the somewhat contentious process of the meeting, Rueppel told the staff that their questions were "academic," because he had already been appointed their new director.

The choice of Rueppel seemed odd, but if tidying up the Museum's public image following the Raphael affair was part of the plan, it was especially so. His field of expertise was pre-Columbian art, of which he had acquired several pieces for Dallas, some of questionable provenance. At the meeting of the Association of Art Museum Directors in January 1973, Rueppel was the only museum director who had spoken out and voted against the recommendations of the UNESCO convention of 1972 regarding acquiring antiquities from questionable sources in foreign countries. Rueppel had also raised a few eyebrows in Dallas for accepting a gift of a painting by Fantin-Latour that was "not right,"[41] apparently to ingratiate a patron needing a tax deduction.

The new director was tall and gaunt, with silver-black hair, and he always dressed in a dark suit. His physical height and the dark hollows around his eyes caused many to describe him as Lincolnesque. From the start he was also strikingly uncommunicative. His poker-faced demeanor seemed designed to repel questions, and when they came, he dodged them. In Dallas, Rueppel was known for his stiff personal style, and even Seybolt admitted that Rueppel "doesn't play the violin all the time."[42] But if in seeing new policies through, Rueppel "steps on a few corns,"[43] this was perfectly in keeping with Seybolt's idea that a brusque and intimidating manner was the most efficient way of getting things done. In keeping with the highly irregular circumstances of his abrupt appointment, "the starlet from Texas," as one member of the staff referred to him, operated as if under a secret deal with the president to follow up on the recommendations of the ad hoc report.

Twenty-four meetings and countless memos later, the ad hoc committee had come up with their first round of recommendations. The basic thrust of these initiatives was to make the Museum more "open" and to bring "the reality of the fine arts into the minds and emotions of the people."[44] What was more apparently new was the style of management. "No museum director here has had this place under control, really – ever,"[45] Seybolt told the incoming director. Soon after Rueppel's appointment, the staff was called to the auditorium to view a film on the business practices of the William Underwood Company. The curatorial staff was deeply insulted. As curator Cliff Ackley recalled, "It was the beginning of a corporate takeover."[46]

If the Museum under its new regime was supposed to be more businesslike, the years following Rueppel's appointment were financially disappointing. Attendance fell just as the cost of energy went up in the early 1970s, and the deficit ballooned from $125,000 at the time of Rathbone's retirement to nearly $600,000 just three years later, and with little to show for it in the way of curatorial developments or even the promised community outreach. Meanwhile, the promise of a show of art treasures from Italy, which was supposed to be the Italian Ministry's gesture of gratitude for the return of the Raphael, never materialized. But perhaps by that time there were so many other problems to deal with that nobody cared.

A general feeling of malaise soon affected the entire staff, a feeling that the new director had no regard for their interests. Seybolt's impression that Rueppel was a "very, very plainspoken, straight-thinking guy"[47] might have looked good to him, but it did not play well in the unique and sensitive context of a major art museum. Administratively tone-deaf, Rueppel referred to his curatorial staff as his "subordinates" and instituted performance reviews. By the end of his first year, he had made enemies of nearly everyone.

Board meetings were tense. "People were always taking sides," remembered Graham Gund, who joined the board in 1973. "There was not a sense of common goals; it was very fractured."[48] Amid the tension of the typical meeting, as Gund recalled, somebody would light up a cigarette, and Sue Hilles would start to wave the smoke away, then she would start to cough, and finally she would march

over to the window and try to open it, requiring another board member to rise and help her.[49] Such behavior was apparently typical of the unspoken hostilities and cross-purposes of an increasingly unwieldy thirty-plus-member board. In this dysfunctional atmosphere, trustees and senior staff members took to airing their issues to journalists at the *Boston Globe*, who were all too happy to oblige with a series of articles on the sad state of affairs at the MFA.

The Rueppel-Coolidge years were guided by ad hoc restructuring – a thorough "self-examination" in terms of the Museum's role in the city and how it might better fit into the lives of the average citizen. The effort included extensive surveys of the Museum's visitors – who they were, how often they came, and what they were looking for. Logical and mathematical, it would all come down to numbers. As Nelson Aldrich envisioned the changes ahead, the Museum would evolve from "the treasure-house of yesterday to the educational institution of tomorrow."[50]

These studies indicated an entire rethinking of the building in a new master plan. The proposed installation of climate control throughout the building had been a priority for some time, but the committee had further ambitions. In an effort to make the Museum more accessible to the public and more people-oriented, John Coolidge, along with architect trustee Nelson Aldrich, who spearheaded the effort, conceived of an architectural plan that included the removal of the grand staircase at the Huntington Avenue entrance.[51] Aldrich led the discussion at a meeting of the board on November 19, 1973. The staircase, he asserted, was psychologically "overwhelming" and also offered no choices to the visitor but rather "pressures visitors to make a decision immediately upon their arrival."[52] Removing the staircase would allow for direct access to the middle of the building and make the so-called crypt into a central crossroads and information center – the "core" of the Museum. Here they planned an approximately twenty-foot circular hole in the floor of the rotunda above which would "enable the visitor to view the structure of the Museum from the Reception area."[53]

Not every trustee was impressed with these ideas. John Goelet queried, "Is there any reason to believe that the taste of our interior desecrator [*sic*] will be superior to that of the original architect?"[54]

Dick Chapman wrote with typical forthrightness, "If that sterility is what the next century means, it will not be worth living in. I say it's spinach, and I say the hell with it."[55] And when the public got wind of the plan through a leak to the *Boston Globe*, it quickly became clear that surveys could be misleading. By mid-December the Museum had received 270 letters of protest, an "extraordinary unsolicited expression of concern"[56] that demanded a considered response. John Coolidge rather condescendingly assessed the public's general feeling as one of "emotional attachment"[57] to the old staircase. Thus, after a bitter and embarrassing controversy, the plan for dismantling the staircase was abandoned. The main thrust of the improvements plan was pared down to air-conditioning the building, a project many other large museums were undertaking at the same time.[58]

In the midst of the Museum's identity crisis, a fragment of the design concept lingered – the proposal for a massive circular hole in the floor of the rotunda, which was ultimately won by the assertion that the floor, after eighty-some years, was structurally unsound.[59] Thus the space at the top of the stairs that Rathbone had made into the beating heart of the Museum with countless receptions and celebrations over the years would never again function in the same way. Meanwhile, the floor directly below, while it offers a distant view of the Sargent murals above, has never achieved the sense of the "core" or the "heart" of the Museum that Aldrich and his committee envisioned.

The Rueppel years would perhaps be remembered best for what did not happen more than for what did. When the great *Treasures of Tutankhamun* show was offered to American museums from Egypt in the early 1970s, naturally the Boston Museum was among the first invited to participate in the tour.[60] But King Tut never came to Boston, allegedly because Rueppel had insulted the Egyptian dignitaries when they came to discuss the project at the MFA. Rueppel's mishandling of the offer was not untypical. "He was the most undiplomatic person I could imagine for that job,"[61] recalled trustee Graham Gund. Meanwhile, *Treasures of Tutankhamun* went on to become a sensational hit at other museums across the country, including the Metropolitan, where it attracted eight million visitors during its six-month run. This was the event that inspired a journal-

ist to apply the term "blockbuster"[62] to museum exhibitions, a trend for which Tom Hoving was thereafter somewhat erroneously credited with inventing.

Another disappointment at the MFA, perhaps even more damaging in the long run, was the Museum's failure to act on a unique opportunity to purchase one of Jackson Pollock's greatest works, *Lavender Mist*, from the private collection of the artist Alfonso Ossorio.[63] Despite having earned his doctorate at the University of Wisconsin in twentieth-century American art, Rueppel was both ungracious and unenthusiastic about the offer when escorted by Lewis Cabot to visit Ossorio on Long Island. Rueppel expressed reservations about the painting's big price tag, a somewhat negotiable $1 million, and also the potential restoration issues presented by Pollock's materials and technique. Conservator Bill Young did not assuage them. Without the support of the director, the trustees voted against purchasing the painting in an unforgettably contentious meeting of the board. The owners immediately turned around and sold *Lavender Mist* to the National Gallery, in Washington, where it maintains a place of pride in their postwar art collection. Later that same year, an equally important Pollock, *Blue Poles*, sold at auction for $2 million, the prize going to the National Gallery of Australia.

Rueppel had a three-year contract, but it hardly took that long to determine his profound unsuitability to the leadership of the MFA. Among the many issues that continued to emerge was "that Merrill did not communicate well with his staff," said John Coolidge, adding that "he denied this."[64] On May 27, 1975, in an off-site meeting, the executive committee agreed that it would be best to terminate Rueppel's contract without delay. Bill Coolidge, John Coolidge, and Jim Ames delivered the gist of the meeting to Rueppel, a verdict that apparently came as a shock to him. Seybolt, who was not at the meeting, considered this conduct toward his unfortunate, hand-picked director "a lynching bee."[65]

At least in retrospect, Rueppel understood that his closeness to Seybolt was something of a liability. "Somehow, I was linked to Seybolt," he later told a reporter from the *Boston Phœnix*, "and there were those on the board who wished to see him step aside.

I feel that that attitude prevailed in firing me."[66] Almost as soon as the trustees fired Rueppel, John Coolidge, also under pressure from the board, admitted that the responsibilities of the president were more than he had bargained for and resigned the same year. At the news of these latest developments, Hanns Swarzenski wrote to Rathbone of the MFA's widely aired "untidy mess." The trustees had got what they deserved, he said bitterly, and with a touch of medieval imagery added, "Let them be drowned or fried in their own mess they have so carefully planned."[67]

In the awkward interim, Jan Fontein, senior curator of Asian art, was elected as acting director. A search committee convened again, and Rathbone was invited to a meeting to express his view of the situation. There he had the satisfaction of saying that it was high time that the trustees took a critical look at themselves and to recognize that, as an effective body, they were seriously flawed. A professional consulting firm, Barnes & Roche, was engaged in 1975 and arrived at much the same conclusion. The trustees themselves weighed in. "Individually it is composed of fine people," Dick Chapman said of the MFA board. "Collectively it is weak and ineffectual."[68] The changes that Seybolt had wrought – a larger elective board and a proliferation of committees, each with its own power to act outside the full board's approval – had often created, and certainly contributed to, a divisive atmosphere and the creation of what Rathbone called "power cliques."[69]

The distrust of the trustees that had built up among staff signaled the need for a time of healing, a need for their core interest in the Museum to be credited once again. Several months afterward, Fontein was appointed permanent director. Fortunately for him, this coincided with a new president of the board – the businesslike, communicative, and generous Howard Johnson, formerly president of MIT. Rathbone wrote to congratulate Johnson on his and Fontein's appointments. "I join with my former colleagues in expressing deep confidence in your vision," he wrote, also heralding the appointment of Fontein "the man amongst all the staff best qualified for the task."[70] Fontein would also be aided by the MFA's first associate director for administration, Robert Casselman, which left Fontein

in charge of the curatorial issues in an arrangement that was gaining ground in larger museums across the country. To those working there, and also those who served on the board, the change in atmosphere was apparent almost overnight, and distinctly for the better. Johnson was a strong administrator with a light touch. Perhaps only to Seybolt were his tact, diplomacy, and patience seen as a weakness. "Howard Johnson doesn't want to fight with anybody," Seybolt later said. "He hasn't got any more spine than wet spaghetti."[71]

While the debacle of the Rueppel years was behind them all, Rathbone remained highly protective of his own legacy. When the annual report came out, remembered Fontein, "he would critique it."[72] And when the press reviewed the latest changes at the MFA, he was ever alert to distortions of history as it was now being told, critical and suspicious of slights that Fontein would later argue had no foundation. Of all the ways the museum administration rewrote the history of the MFA after his departure, the most vexing was the "neglect" of the paintings department during his tenure.

One of Fontein's top priorities was to appoint a full-time head of the paintings department. John Walsh, who was lecturing at Columbia and Barnard at the time, accepted Fontein's offer in 1977. Fontein told the press of Walsh's appointment, "For more than twenty-two years, we didn't have a curator of painting."[73] John Walsh – perhaps at the prompting of Rathbone – composed a letter to the editor of *Art News* to straighten out the perception of negligence. "My position as curator of paintings," he wrote, "was not 'mysteriously vacant for 22 years,' but was held for most of that time by Perry Rathbone, director of the museum from 1955–72. During his tenure there were important acquisitions, renovations, and exhibitions."[74] And when, in a letter to the arts editor of *Boston Globe*, John Coolidge referred to the "shamefully neglected"[75] paintings department of the recent past, Rathbone felt the need to address this comment fully, and for posterity. In a nine-page letter to John Coolidge,[76] he detailed every major acquisition, exhibition, conservation, and scholarly effort of the paintings department during his tenure. Paintings curator Peter Sutton praised the quality of acquisitions under his direction. "[Rathbone] had the foresight to buy

those big Italian paintings that are rarely given to this museum,"[77] he told the *Boston Globe* in 1993.

Rathbone also kept a close watch over the treatment of acquisitions the MFA had made in his time. In 1980 the Museum suffered the loss of Brancusi's *The Fish*, which Rathbone had bought for the Museum from his friend Jim Ede in 1957. To his dismay and bewilderment, the Brancusi had not been on view in the galleries for some time. During an inventory of the decorative arts department, a night watchman got hold of the combination to the storage unit where the Brancusi had been languishing out of sight. Apparently believing more in the sculpture's value as raw material – which they mistakenly based on its name – than as a work of art, they attempted to melt down the bronze fish with a blowtorch. Rathbone, who learned of the theft from curatorial staff members, was as appalled as he was heartbroken. In an all-too-small collection of twentieth-century art that he had worked so hard to build, the Brancusi had been a priceless addition, now lost forever.[78] At the same time, a key went missing in the Asiatic art department, and in this case the same thieves did manage to steal objects of real gold.[79]

But of all Rathbone's regrets of his professional life, none was greater than the false perception that Seybolt and Siviero had emerged from the Raphael fiasco as paragons of honesty and good will – and that the Italians had not only managed to retake the prize but had then put it out of sight.

Constantin Brancusi,
The Fish, 1924

The Big Picture

T HOMAS JEFFERSON smuggled plants and seeds from Italy into France in the 1780s. Carrying as much as he could stuff into his coat pockets on his journey across the Italian Alps, he risked punishment by death. While living in France, he also obliged his French friends by importing seeds from America for their own experiments. Jefferson believed philosophically that "the greatest service which can be rendered any country is to add an [*sic*] useful plant to its culture."[1] His abiding idea was to constantly expand the scope of horticulture and agriculture and to expose the knowledge of their practical and ornamental uses to the population of the young republic. This was the age of the British plant hunters who scoured the Americas searching for specimens of agriculture and ornamentation for their landscape gardens. It was the age of the Grand Tour, when educated Europeans traveled to the ancient world with their diaries and sketchbooks and brought back with them souvenirs of antiquity to study and to preserve for the generations to come. It was the Age of Enlightenment, when the idea of an encyclopedic museum was born in Europe and not long afterward in America. But in the late twentieth century, we underwent a philosophical shift that had been rumbling beneath the surface since the late 1960s – a return to native species when it comes to horticulture, and of cultural patrimony when it comes to art.

The purist gardener now endeavors to extricate every nonnative plant from a park or landscape and replace it with a native. Trees

and shrubs we have come to think of as our own and that have thrived since their introduction have recently been dug up and replaced in the interests of horticultural purity and authenticity. By the same token, many works of art have been extracted from American museum collections and returned to their source countries. For centuries, the trend was one of gathering treasures from cultures around the world to educate and elucidate in a comprehensive way. It was an expansionist era. Today, in a reversal of the colonial spirit, the trend to dig out, retract, to replant and repatriate, is on the ascent. Where or when this trend will peak is still unclear. An argument can be made that wilderness is in some ways more orderly than a garden, just as an object in the ground is more enlightening than an object on a pedestal. The debate over the ethical and cultural values of each remains lively. Which is better for more people, and what, in the dissemination of art around the world, matters more?

In 1972 Tom Hoving acquired an exceedingly rare and great work of Greek antiquity, the Euphronios krater, for the Metropolitan Museum. A large vessel for mixing wine and water, the krater was decorated with a scene from the Trojan War by the greatest painter of the classical period, Euphronios. Naturally Hoving found the prospect of having this incomparable prize for the Met irresistible, and knowing full well that its source was questionable, he bought it for more than $1 million – at that time, the highest price ever paid for an antiquity. Indeed, the krater's exportation from Europe immediately raised many of the same issues as the Boston Raphael had just a year before. While the MFA submitted to its historic defeat over the Raphael in 1971, the Met entered the fray with the Euphronios krater.

Just as Rathbone had done with the Raphael, Hoving chose to broadcast his triumph to the media right away – a fatal mistake. The Met's latest purchase was a case of not only illegal export but also stolen property and vandalism. Italian authorities suspected that the vase had been recently raided from an ancient Etruscan grave site outside Rome. Confronting the controversy head-on, Hoving took more or less the same stand Rathbone had in the case of the Raphael; when faced with negative press and confrontation, he brushed it aside, assuming there were no provable facts on which the skeptics

could pin their story. But the media worked against him.[2] Among others, a savvy *New York Times* reporter, Nicholas Gage, was on the case.

The controversy raged on for months while the "hot pot" continued to garner publicity focused more on the legal issues surrounding it than its greatness as a work of art. But the Met took the position of sitting tight. Soon enough they found an alibi in the personal account of a Chicago collector, Muriel Newman, who emerged out of the shadows to verify the krater's existence in a private collection in Beirut many years before. She asserted that the dealer, Dikran Sarrafian, had offered her the Euphronios vase before restoration, in dozens of pieces that he kept on a shelf in a collection of shoeboxes. With Newman's story, it seemed that the krater fell within the legal time frame of exportability. However, her account from personal memory as "proof" remained questionable, and in 1977 a grand jury was convened in New York to study the case again. No indictments were returned, and eventually the fuss died down. The krater stayed, and so did Hoving. But thirty-five years after the Met purchased the krater, Hoving having long since retired, they returned it to Italy.

In 1995 a warehouse full of looted antiquities was discovered in Geneva. This was the domain of Italian dealer Giacomo Medici, who had been trafficking in stolen antiquities for years. The raid uncovered evidence of Medici's connections to many antiquities that had entered permanent museum collections in America, including the Euphronios vase. Ten years later Medici was convicted for dealing in antiquities dug up by tomb raiders, or *tombaroli*, and the krater's illegal origins could no longer be denied. As for Muriel Newman's testimony, it still held true, because it turned out there were two great works of Euphronios out there – the one she saw in pieces with the dealer in Beirut and the other the Met bought perfectly restored in 1972.

Many other museums and collections were implicated in the Medici raid, including Boston. To what extent these American museums knew, or even sought to know, about the sources of their objects will probably remain a matter of conjecture and debate for years to come. But we can be sure that Medici's indictment was a major event in the history of art exported from Italy. The biggest

loss was to the J. Paul Getty Museum, in Malibu. With their ambition to create the greatest collection of classical art in America, and the funds to buy virtually anything on which they set their sights, the Getty had bought heavily from sources unable to provide a clear provenance. In 2005 these issues came to a head when their senior curator, Marion True, went on trial in Rome along with Robert Hecht, the dealer behind many of the high-profile acquisitions of antiquities by American museums in the last half-century. The Euphronios krater was once again in the spotlight.

That very same month Philippe de Montebello, then director of the Met, negotiated an exchange with the Italian government – the return of the krater and other pieces of questionable provenance in the Met's collection for loans from Italy of comparable works of antiquity over a period of years. Apparently there was no conceivable way they could hold on to the krater and save face. "The Met made a public-relations virtue of legal necessity over the return of the Euphronios krater,"[3] wrote Rebecca Mead for the *New Yorker*. But Montebello wanted to make sure that the Met accepted no liability for wrongdoing in the case, stating emphatically that they had bought the piece in good faith. Nor did Montebello go along with the prevailing view of archeologists – that objects removed outside the boundaries of an official archaeological dig could never be fully understood in the absence of their context. In the ongoing debate between archaeologists and museums, Montebello would argue that there is less to be gained from the knowledge of the particular hole the object came from than from the examination of the object itself. From his point of view, speaking of the Euphronios masterpiece, "Everything is on the vase."[4] Nevertheless, he had capitulated, and at the annual meeting of the Association of Art Museum Directors, he was given a standing ovation by his colleagues for his prudent handling of the case.

Malcolm Bell III, an American archaeologist who directed a dig in Morgantina, Sicily, another source of looted antiquities, disagreed with Montebello's point of view. He stressed the importance of understanding the piece in the context of its setting. For the Italian official for cultural heritage, Giuseppe Proietti, the vase is beautiful regardless of the context, but "alongside other materials from

a burial site, it becomes something more. It's like reading just one page of a book. You will never experience the pleasure derived from reading the entire novel."[5]

But the relative importance of context is always in flux, as well as the question "Which context is most valuable?" While archeologists tend to argue that the context of the object's excavation is the most valuable, a museum director might argue that it is more valid for it to be seen alongside other great works of its kind, and furthermore in the context of the entire history of art. The ground is always shifting, and there is probably no right answer.

How far should the source country go in restricting the flow of works of art? Once exported, how far should the country go to retrieve them? And what happens when they get back to where they came from? In the distribution of cultural artifacts around the world, how do they best serve scholarship and the general public? Zahi Hawass, who recently stepped down as the minister of culture for Egypt, would say that Egyptian antiquities, no matter how legitimate their acquisition by another country, are "icons to our Egyptian identity" and, therefore, "they should be in the motherland. They should not be outside Egypt."[6] Hawass vigorously campaigned for the return of many objects that left his country long before the passage of international laws protecting cultural patrimony, including the bust of Nefertiti from Berlin, the Rosetta Stone from the British Museum, and the bust of Ankhhaf, the earliest-known work of antique portraiture in the world, from the Boston Museum.

The Greek authorities have expressed a similar point of view. "Whatever is Greek, wherever in the world, we want it back."[7] The Elgin Marbles in the British Museum is the most famously die-hard case of them all. Even though many of these pieces were almost certainly rescued from neglect, and perhaps even destruction, even though all were acquired by mutual agreement and for a price, and even though the motherlands of Egypt and Greece still have vastly more in the way of their own heritage than any other country in the world, they continue to seek the repatriation of significant pieces they willingly and knowingly gave up so long ago.

———————————

In its founding years, the MFA acquired works of art and antiquity from abroad in a variety of ways that were not only legal but also laudable. Its outstanding Egyptian collections were the result of a collaborative project between the MFA, Harvard, and the Egyptian government at the turn of the last century. Beginning in 1902 American Egyptologist George Reisner led a joint expedition with Harvard and the MFA to Giza. They struck a deal with the Egyptian government in which the spoils of the dig would be shared equally. This resulted in the foundation of the MFA's renowned Egyptian collection, second in America only to the Met's and first in its collection of the Old Kingdom. Dows Dunham, former curator of Egyptian art at the MFA, explained that Egypt, while intent on the archaeology of their own treasures, "needed foreign help. They couldn't possibly do it themselves. They hadn't the personnel or the money."[8] As a result, these collections have been made accessible and served to educate an American public in the wonders of ancient Egypt since the 1920s.

The story of the MFA's Japanese collections is also a case of American collectors arriving in a foreign country with a special appreciation for its native culture. In the 1870s, at around the same time the French impressionists developed their fascination with Japanese prints, Bostonian Ernest Fenollosa traveled to Japan to teach at the Imperial University in Tokyo. Over the next twelve years his passion grew for Japanese art and also Japan's way of life. Fenollosa, along with William Sturgis Bigelow, Edward Sylvester Morse, and Charles Goddard Weld, a group later known as the "Boston Orientalists," to varying degrees went native, learning the language, the religion, the arts, the food, and the manners of Old Japan. They not only collected Japanese paintings, prints, and pottery but also led many efforts to restore and safeguard their national treasures and monuments. Buying with knowledge and taste, they formed the greatest collection of Japanese art in the world and were instrumental in spreading an appreciation for the particular aesthetic that is Japanese. Rather than being regarded as pillagers of an unsuspecting source country, these American collectors were her heroes. They had treasured the unique style and workmanship in traditions dating back for centuries, while Japan, in its hurry to catch up with the industrial West, was poised to throw it all away. Here was a perfect

demonstration of how the foreigner's appreciation and curiosity can be a savior of an endangered culture. Detractors might call this a hunt for "trophies," but at its highest level, it is human nature to rescue objects of beauty from oblivion, neglect, or destruction. On a minor level, it is the instinct of any tourist who returns from a foreign country with a souvenir.

There is another side to this effort – the cross-pollination of cultures – that happens when objects, like people, leave their homeland and mix with others. In recent years the Japanese have aggressively collected Western art, and so the tide runs both ways. In view of these fascinations, a valid argument can be made for the experience of differences, as well as a sense of universality, in an object's message. As Neil MacGregor, director of the British Museum, wrote, "Objects speak truths, and objects from other cultures tell us not only about distant people but about ourselves too, about our souls."[9]

At the height of their empire, the British were at their most avaricious, eagerly collecting and bringing back to England art and antiquities from Europe and the Mediterranean. As a result their castles and country houses are museums in themselves. While much of their contents are not home-grown, the British have nonetheless come to regard these objects as their heritage, just as the Italians now claim the treasures of ancient Greece as their own. About a hundred years ago, as American tycoons began to encroach on their territory, dealers Joseph Duveen and Thomas Agnew moved in on noble British families in need of cash to pay the ever-rising death duties on their estates, and many great works of art left England for America, including Raphael's *Small Cowper Madonna*, now in the National Gallery, in Washington. In 1903 British art lovers set up the National Art Collections Fund,[10] a charity organization that helps pay for important works of art as they come up for sale, thus rescuing many works of art from going abroad.

As Americans, we have our own heritage to protect. Our Native American archaeological sites are comparable with those of ancient Mediterranean cultures and equally vulnerable to theft and destruction. Throughout the twentieth century, developers, both private and federal, played the most significant role in the destruction of these sites, against which federal programs designed to protect them

fought a mostly losing battle. In his 1973 book, *The Plundered Past*, Karl Meyer predicted "that between the bulldozer and the pot hunter, little will be left of the American Indian past by the year 2000, barring a change in official attitude."[11]

Within the United States we have also seen the loss of regional treasures to other regions. In 2005 the New York Public Library, needing funds, sold at auction Asher B. Durand's painting *Kindred Spirits*, a cherished emblem of the Hudson River school. Wal-Mart heiress Alice Walton bought the painting for her museum of American art in Bentonville, Arkansas. To many New Yorkers, the sale of *Kindred Spirits* was a shocking loss of their local heritage. Thus, the chase and capture of great works of art will go on as opportunities present themselves, and so will the efforts, in certain cases, to retrieve them.

Today American museums are vulnerable to claims of cultural patrimony as never before. Many cases involving illicit traffic in works of art have surfaced in recent years, most notably those pertaining to modern art stolen or pressured from Jewish collectors by the Nazis and to Greek antiquities illegally removed from Etruscan grave sites in Italy. A legal specialty has grown out of these contentious claims with some firms specializing in cultural property law. As Lawrence Kaye of the New York firm Herrick, Feinstein said on the side of protecting the claimant, "There has been a new recognition that claims for the return of property stolen at any time have to be dealt with seriously."[12] But the law is highly interpretive, including the definition of the term "*stolen*."[13] On the opposite side of the issue, law firms have also developed a specialty in protecting the American collector from foreign claims.

In the aftermath of the raid of Giacomo Medici's warehouse in Geneva, the MFA took a harder look at their recently acquired antiquities under Cornelius Vermeule in the 1960s, a period of significant growth. In his time, there were few dealers of antiquities who matched the knowledge and resourcefulness of Robert "Bobby" Hecht. For Cornelius and Emily Vermeule, among many other scholars, Hecht made interesting, not to mention valuable, company. But it was also true that any museum curator, including Vermeule, who had dealings with Hecht was often entering the unknown in

terms of the object's source. Hecht developed a personal style of keeping his sources sufficiently vague to hide behind while revealing just enough to be credible. In 2006 the MFA returned thirteen objects of antiquity to Italy, some of which were directly related to Hecht's illegal sources and the Medici raid. The MFA at this writing is among the few museums in the country to employ a full-time curator of provenance whose research focuses primarily on the art of Europe.

The question remains: What happens to the objects once they return to Italy? Carlos Picón, curator of Greek and Roman art at the Met, has expressed doubt about Italy's ability to properly look after the treasures they retrieve. "The things they took from Boston were shown in Italy for one week," he said. "Where are they now? In some basement, crumbling away?"[14] Given the austerity measures imposed on state governments all over Europe in the recent economic turmoil of the eurozone, the question is all the more pertinent. In his essay "The Nation and the Object," Stanford law professor John Merryman defines the alternative positions as either "object-oriented" or "nation-oriented."[15] The object-oriented position takes its primary interest in preservation, truth, and access; the nation-oriented position asserts that objects should remain within the physical boundaries of the nation where they were made or found. From the object-oriented point of view, an argument can often be made that, in many cases, an expatriated object is more highly valued, better cared for, and more accessible abroad than at home.

Said Rathbone about the Raphael, "Italy needs that picture like they need another Canaletto."[16] He scoffed at Siviero's well-publicized claim that in bringing home the Raphael, he had retrieved another "masterpiece" for the Italian state. Rathbone never called the little portrait a masterpiece, even while he believed in its attribution to Raphael. To his mind, it was, in the greater scheme of things, "a little pinch of the Renaissance."[17] Indeed, it would be hard to argue that this little painting, which is never on view to the public, is essential to Italy's national pride and identity. Its ownership by the Boston Museum would have ensured its care and its enjoyment by the public, and opened it to fresh scholarship that began with John Shearman's analysis and the identity of the young girl, even if he was wrong. It was only the infraction of the US customs law that opened

the way for Italy to reclaim it. The Boston Raphael remains a rare case in history in which an unregistered picture was returned to its source country without ever having been stolen, a landmark in US customs law as well as international restitution that was largely symbolic – a triumph for the source country, a red flag for America.

An interesting comparison can be made with the case of the Cleveland Museum's acquisition of a painting by Poussin, *The Holy Family on the Steps*, in 1981, just ten years after the Raphael incident. French authorities asserted that the Poussin had been exported illegally, as all artwork predating 1900 required certification before an export license could be granted from France. Cleveland Museum director Sherman Lee countered the claim, asserting the legal exception in the case of a work that had actually been returned to France from England some years before, which would obligate France to grant it an export license again. Despite the fact that the Poussin had been brought through US customs with a false declaration, the US government not only forgave the infraction of the customs law but also rejected claims by France to return the picture. Despite a warrant for his arrest by a French judge in 1984, Lee did not capitulate. Three years later the Cleveland Museum reached a settlement with France. The key to their success, it seems, was that Lee had a board of trustees that supported his mission and chose to interpret the incident in his favor. The settlement took seven painful years to resolve, but from the Cleveland Museum's point of view, it was well worth the struggle. From the point of view of France, it was hardly a great loss. A similar, probably superior version of the same painting was in the collection of the Louvre. In 1974 Lee also survived the purchase of a painting attributed to Grünewald for more than $1 million. Three years later, when it was discovered to be a fake, the Cleveland Museum was refunded their money, and Lee's reputation as a great museum director remained intact.

The Met's handling of the Euphronios krater was in the same tradition of caution, patience, and respect for every angle of the situation. As the current president of the Met, Emily Rafferty, said in dealing with complex legal and ethical issues that continue to face the museum, "It comes down to one word: process. If we follow process, we never get ahead of ourselves. It frustrates people who want to

resolve things overnight, but it helps all of us; process is our friend."[18]

Once done, events of significance acquire an air of inevitability about them. It is perhaps less painful than contemplating alternative paths that might have produced a more sensible and, in the long run, happier resolution. In the case of the Boston Raphael, for a start, it might have been prudent to gather a qualified consensus about the value of the object in question before surrendering it to the other side. It seems in retrospect that there was more at stake than the painting in question, and Rathbone was struggling to hold on not only to a work of art but to the values he held sacred to a great art museum. In their impatience for new leadership, the Boston trustees lost a rare work of art, a good deal of money, the confidence of the community, and a much-loved director. It was the end of an era, and not only in Boston.

Just how much has the job of the museum director changed since the 1960s? If Paul Sachs or his reincarnation were to train a new generation of museum professionals, how would he or she do it? Before Sachs's time, a director might have been a retired Civil War general, a scholar or an archaeologist, or a collector of wealth and social status. The first professional museum directors were unique products of the Sachs curriculum, trained to address the full scope of the job – from caring for the collections to attracting the public – while simultaneously, in Henry Watson Kent's words, being ideally "a gentleman of some presence and force." Connoisseurship, showmanship, and diplomacy were the essential qualities of the modern museum director, and their combination in one human being was a rare breed. Perry Rathbone embodied all these attributes, or as MFA historian Maureen Melton wrote, he was "the very model of a modern museum director."[19] But times have changed and so, it seems, has the model.

"In the past," wrote Kathy Halbreich, associate director of the Museum of Modern Art, in 2010, "museum directors have been portrayed as these great puppet masters – the person who invents the story, writes the script, and manipulates the characters."[20] Halbreich wonders whether it is still true, or was ever true, that the

public must shake the hand of the person in charge to truly feel connected to the place. She questions, "Whose values are on view anyway?" From Rathbone's point of view, and that of many others of his generation, this was an essential part of the job – to make the public feel there was a highly accessible personality in place to interpret and guide them to the greatness of their museum collections. It was a progressive and democratic approach that came naturally to anyone who had lived through the Depression and World War II. But it was also based on a hierarchy of artistic values the qualified museum director was expected to discern for the general public – in other words, aesthetic leadership. Sachs taught connoisseurship, first and foremost. It is now but a small piece of the museum director's concerns or, indeed, the majority of today's art professionals. "If you go to the College Art Association," said Montebello in 2002, "connoisseurship is practically a dirty word."[21] Rathbone was among the last generation of art history generalists for whom that training was central.

There was another quality to their vision that had less to do with formal training. Those who came of age alongside the modernist revolution instinctively connected its movements to the art of all cultures and periods and endowed them with fresh life. While modernism in itself encountered resistance from the old guard, modernism's effect permeated the art world at midcentury in its appreciation of every kind of art for its formal and innovative qualities. This was the first generation to share in the excitement of the Museum of Modern Art when it was new and to absorb its democratic atmosphere and its architectural restraint. It is hard to reconstruct, but there was perhaps never before or after a more dynamic combination of values than those of the American art museum at that time, when the object reigned free of context, and when interaction between viewer and object was a private matter that eschewed any conventional measurement.

The first professional museum directors were also the last whose values were largely uncompromised by social, political, commercial, and architectural pressures. That particular state of mind – in its openness and daring and intuitive stylishness – cannot be expected or created again; it was a product of its time. MFA trustee Bill

Coolidge was right, in a way, when he said that the era in which Rathbone's talents could be given full expression was coming to an end in the early 1970s. What he did not say was that his particular set of talents and ideals would not be seen again, even if they were wanted. The postmodern art museum calls for leadership of quite a different kind. Its directors are not so accessible, and their values not so clearly on view, but they are busier than ever writing the script and mastering the puppets.

Rathbone's directorship was followed by a trend in many big museums to split the tasks of the director into a two-headed administration: a director to lead the curatorial division and a salaried president to look after administrative issues as the corporate model gained the edge. Arriving at and securing that arrangement was a long and painful procedure at each institution it visited. Rathbone found himself caught in the crossroads of this transition. When Hoving retired after a tumultuous ten years at the Met, in 1977, the trustees voted to rein in the director's power or, to put it another way, relieve his successor of the administrative burdens as they multiplied. With the subsequent appointment of Montebello as director, the Met installed a paid president to whom he would answer, but Montebello eventually persuaded the trustees that the president should answer to the director, not the other way around.[22] In Boston the system was instituted with the directorship of Jan Fontein and the addition of Robert Casselman as salaried president. In Minneapolis and Chicago similar divisions of power were explored. In this bifurcated system as it continues in various forms to the present day, it is no longer obvious which individual will drive the corporate model more aggressively. But "if we are to win the battle of the 'curator/director' over the 'administrator/director,'" Montebello advised the Curator's Forum in 2001, "a profile with which increasingly Boards of Trustees are instinctively more comfortable, then it is essential to enlarge the pool of curators with the qualifications to be tomorrow's museum directors."[23]

When former president of MIT James Killian joined the MFA's board of trustees in the late 1960s, he was surprised by the way the Museum was run. In 1973 he wrote to George Seybolt, "I must say I was taken aback, when I became a trustee of the Museum, by the

way business was conducted and decisions were made … and I debated for some time as to whether museums were so different from other institutions that they required a wholly different philosophy of trusteeship and management."[24] My own research suggests that Seybolt would have assured Killian that museums were no different from any other kind of large organization. But Killian's question was a valid one. Museums are not businesses, although today many are expected to operate, perform, report, and sustain growth as if they were. Their directors are not so much the public servants they were seen to be in Rathbone's day, but CEOs of a considerable corporate enterprise with salaries to match.[25]

The job of the curator has also changed. Today they are counted on for publicity appearances, special events, Web site management, interactive displays, programming, grant writing, and exhibition planning as never before, as well as the constant courting of potential patrons. There is little time left over for scholarly research or acquisitions. Loan requests from other museums are a constant workload on the curator's desk, and while these help shore up goodwill in the interests of comparable loans from the borrowing institution sometime in the future, other kinds of loans pay the overhead. The recent trend for branch museums, such as the MFA's in Nagoya, Japan, which opened in 1999, adds further pressures to the collection as a whole. Paintings are the museum's ultimate "cash cow."[26] They are also the stars of the collection in the eyes of many visitors, who all too often cannot count on finding them on view because of the persistent demands for their appearances elsewhere.

As box office attractions, special exhibitions rule the day. The greater number, and greater size, of museums in America also mean increasing competition for loans. As art historian Francis Haskell has observed of recent times, "Directors are judged less by purchases that they have made or gifts they have attracted or for the skill with which they have displayed works in the permanent collection than for their success in mounting exhibitions." As a result of these pressures, Haskell commented, "It is not a coincidence that now one can be less sure than ever before that even the greatest masterpieces in these collections will be on display."[27]

Rathbone's generation was charged with dusting off the old mausoleums, ejecting the plaster casts of yesteryear, and turning their prize contents into a riveting and coherent display. As one critic said of Rathbone's style of presentation soon after his arrival in Boston, "Every stratagem of display and publicity has been used to attract. The single object of beauty spotlighted in a doorway has an allure no Baedeker could rival. It assures the visitor that only carefully selected treasures will be presented."[28] By contrast, in today's museum, wrote Nick Prior, "The eye is never allowed to settle, but is constantly distracted, drawn into a culture of simultaneous presence." Prior cites the postmodernist critic Frederic Jameson, who called it "the permanent inconsistency of mesmerizing sensorium."[29]

Today accountability to the general public is foremost in the mind of the museum administration. This has always been truer of American museums than of their European counterparts, where the collections were largely assembled under a series of reigning monarchs. "Public service became the raison d'être of the museological institution," wrote Germain Bazin of the postwar period. "This was particularly the case in America."[30]

As attendance at American museums grew to new heights in the 1960s, efforts to accommodate them in new ways also proliferated. Audio guides accompanied the big exhibitions, helping to educate the uninformed visitor, and wall labels became ever more detailed. As Andrew McClellan has commented, the proper balance of the art museum's goals of collecting and interpretation is "an equilibrium difficult to establish owing to the imbalanced power structure within the museum: on the one side, collectors and directors upholding the standards inherited from Europe, and on the other, educators mindful of a broad public hungry for knowledge."[31]

The need to educate can easily be confused with the need to attract the uninitiated with the bait of popular culture. In the postmodern world it is more challenging to define the difference between high and low art. When Rathbone proclaimed that "art is for everyone," he did not mean by a lowering of standards, and when he strove for box office success with special exhibitions, he did so with crowd-pleasing retrospectives of artists of the highest caliber:

Matisse, Cézanne, Van Gogh, and Modigliani. Today, when corporate sponsorship often goes hand in hand with a specific program that serves its own needs, the art museum is easily compromised.

Efforts to attract and please an audience that will in turn create income also multiply costs and tax the collections at a comparable rate. Many American museums in recent years have achieved ambitious new building programs in the altogether valid interests of displaying more of their permanent collections and bringing the institution up to date with the times. Accessibility and visitor amenities are central to these plans and are both admirable goals, but the cost per visitor far exceeds the income they generate. Furthermore, the sense of leadership they sacrifice in the so-called democratization of the space can be hard on the old museum. The lofty Beaux-Arts buildings of the founding era of American art museums are not easily adapted to the model of the suburban shopping mall. In the big museums, galleries have become thoroughfares through which visitors hurry from one special attraction or amenity to another.

The MFA in particular still lives with the results of the architectural initiatives of the ad hoc committee of the early 1970s in their efforts to make the museum of Guy Lowell's original neoclassical design more accessible. It began with the proposal to take down the Huntington Avenue staircase in 1972, continued with the hole in the rotunda floor, and for many years refocused its efforts on the 1981 West Wing designed by I. M. Pei, reorienting visitors to a side entrance of the Museum for immediate access to the crowd-pleasing attractions, while making its true center half a building away. From the I. M. Pei Wing, the permanent collection galleries stretched ahead like an endless highway, and fewer visitors were inclined to make the journey into the unknown. From that point on, the logic and the narrative of the MFA's incomparable collection has been sidelined by other priorities. While the latest architectural developments at the east end of the building by Foster + Partners have returned the access to the middle of the building and the original staircases on either side, it is still – from the point of view of many a visitor – in search of its center, a sense of direction, and itself. Today the visitor to the MFA and many other American art museums is overwhelmed, not by an imposing neoclassical edifice but by incoherence.

An entirely new population of cultural consumers has grown to expect the Museum to be a part of their lives. But though this population has swelled in numbers, it has not expanded demographically with any real significance. Today's regular museumgoers are still the same predominantly white, middle-class, and college-educated people they were forty-five years ago. They seem to demand more than in the past, but what exactly are they getting?

As museums continue to expand their facilities, their public programs have become not peripheral but central to the enterprise. Have we reached a point at which the collections serve programming rather than the other way around? Are museums now places where art follows rather than leads the way? It is easy to see what we have gained from the advances in art museums over the last half century. It is harder to see what we have lost.

In 1992 Rathbone gave to the MFA his full-length portrait by Max Beckmann, a modern swagger portrait of the youngest museum director in America (in 1948) and a conspicuous champion of modern German art. This gift made a fitting companion piece to Hanns Swarzenski's gift of his double portrait with Curt Valentin by Beckmann to the MFA in 1985. "It was an extraordinarily generous gesture," said Jan Fontein of his colleagues, "to make such a gift to an institution that had treated them both so badly."[32]

Following his retirement from the MFA, Hanns Swarzenski was honored by a Festschrift in 1972, to which some forty scholars contributed scholarly articles and for which Rathbone wrote a fond and vivid introduction. Hanns and Brigitte not long afterward moved to Haus Hollerberg, Hilzhofen, a village in Upper Bavaria. There Hanns kept in touch with colleagues from afar, often took the train into Munich, and was always available to scholars eager to plumb his encyclopedic firsthand memory for medieval objects everywhere. A few weeks before he died, in June 1985, he was reviewing his manuscript with Nancy Netzer for their catalog of medieval objects from the MFA. Several American friends and colleagues attended his funeral, where one mourner reported that he had never before seen so many grown men weep.[33]

George Seybolt lowered his profile on the board of the MFA in the wake of Rueppel's dismissal and turned his attention to building his ties in Washington. In the early 1970s he helped to found a trustee advisory group that was soon to become the Museum Trustee Association. But perhaps his most important contribution to the museum field was to assist Douglas Dillon, president of the Met's board, in promoting a proposal to the US government to sponsor indemnity for important international loans, which in 1975 became the Arts and Artifacts Indemnity Act under President Gerald Ford. Without this measure, with the value of works continuously on the rise, the international loan shows we have now come to expect from our great museums would be impossible.

Rodolfo Siviero died in 1983. He had prepared well for his posterity and the careful editing of his life story. Knowing his days were numbered, he tossed much of his archival material into the River Arno. He commissioned a circular bronze plaque portraying his stern profile, in the style of a Roman emperor, to hang in the Accademia delle Arti del Disegno, where he had been president since 1970. To the Accademia he also left his diaries, stipulating that nothing from them be published or quoted for seventy years. He designated his burial in the common vault in the Basilica della Santissima Annunziata in Florence along with the great artists of the Renaissance, Cellini and Pontormo, and he made sure that his birthplace in the little town of Guardistallo in the province of Pisa was marked by a carved stone. In addition, he left his house on the Lungarno in Florence, once the home of art historian and critic Giorgio Castelfranco, to the region of Tuscany as a permanent monument to his memory. With the collection he had assembled over the years – a mixed bag of antique pictures and objects, some real, others questionable – he hoped to be remembered not only as Italy's art supersleuth but also as a great art historian and connoisseur.

At this writing the Boston Raphael remains in storage at the Uffizi, as it has been for the last thirty years, under the auspices of the Soprintendenza Beni Artistici e Storici, or the official art storage site for the Italian state.[34] A recent online magazine, 3 *Pipe Problem*, dedicated to the mysteries of art attribution, raised the issue again in 2012. In the article, editor Hasan Niyazi notes that

the painting "seems to suffer from having a far shorter critical history than its counterparts.... With the controversy that consumed this panel in the 1970s, it seems this charming portrait has not had its chance to be adequately discussed."[35] Perhaps at this date there is only one point of consensus among experts that is consistent – that the painting, after multiple restorations over the years, has become the work of more than one hand.

John Goelet, who resides in Oise, France, and Washington, DC, continues to pursue his many business and cultural interests all over the world. As an honorary trustee of the MFA, he occasionally drops in unexpectedly with fresh thoughts and questions on his mind. Given the Boston Raphael's recent history and its consignment to storage, he believes that the Italian government should return it to Boston.

My father died after a long illness in 2000. When interviewer Raymond Daum of the Columbia Center for Oral History asked him in 1981, "If you were to write your own epitaph, what would you put down?," he laughed. "I don't know," he answered. "He tried hard and he sometimes succeeded."[36] As a family we agreed that it would be more fitting to mark his grave in his ancestral plot in Greene, New York, with a quote from Psalm 100: "Make a Joyful Noise," for that is what he did, throughout his life, for all who were lucky enough to find themselves in his company.

The author and her father, 1992.

Photograph © Mariana Cook 1992

Acknowledgments

Every book that involves research is to some extent a journey into the unknown. Like any journey, it is guided by individuals – both living and dead – and the knowledge and signposts they offer us along the way. In researching this book, my greatest thanks go to my parents for keeping faithful and extensive personal records of their lives, and for storing them away in relatively approachable order. The file cabinets, trunks full of letters, journals and appointment diaries, photographs and press albums, spanning nearly a century, landed in my basement after my mother died in 2003. Ignoring this hoard was not an option. This book is inspired by their extraordinary gift to all of us.

My original effort was toward the creation of a book-length group portrait, a story of friendships in the shaping of my father's professional life. I would have devoted at least a chapter to each of the following important friends and mentors: William Valentiner, Curt Valentin, Max Beckmann, Joseph Pulitzer, Jr., William Bernoudy, Henry McIlhenny, Jim Ede, William F. Draper, his cousins Donald Oenslager and Beatrice Oenslager Chace, and his wife and my mother, Rettles de Cosson Rathbone, as among his most formative influences and faithful friends. Since I found little interest from publishers in this approach, I regret that I have not been able to give them the space they deserve in this book about his life.

In 2011, I turned instead to the most challenging years of his career, those dominated by the controversial case of the Boston Raphael. In taking this course, I ventured deeper into this mystery

than I ever expected to, sidelining other, happier times. I consoled myself with the conviction that my parents had always wanted the full story of this debacle to be more fully known and understood.

The first step into the labyrinth was to locate the actual painting at the center of the controversy. I am grateful to George Shackelford, then chief curator of the MFA's Art of Europe department, for assisting me in this search. Frederick Ilchman and Martha Clawson from that department assisted in subsequent research, and I am particularly grateful to Victoria Reed, who devoted many hours to locating, translating, and interpreting various documents on my behalf.

For her assistance with viewing the painting in Florence I am grateful to curator Giovanna Giusti of the Uffizi Gallery, and also to my sister Eliza Rathbone and my cousin Cecilia Scovil for accompanying me on this important mission. Raphael experts Nicholas Penny, Paul Joannides, Everett Fahey, Konrad Oberhuber, and Carol Plazotta generously offered their views of the picture's attribution.

The legal issues surrounding the case of the Boston Raphael were also basic to my research. Gerald Norton, though he has since left the firm, was the only member alive from the team at Covington & Burling who had handled the case. While maintaining the attorney–client privilege the firm continues to honor with the MFA, Jerry was an invaluable guide through the legal terms and conditions of the case, as well as a fund of suggestions about further avenues of research. I am grateful for his continued interest and encouragement throughout the process. For important conversations with other legal minds directly involved with the case, I wish to thank Willie Davis, Eugene Rossides, Clive Getty, and John Merryman.

Documentary evidence beyond the Rathbone Family Archive was essential to my research, and I am therefore grateful to the many archivists who have assisted me throughout the process. In 1985 my father deposited his professional papers with the Archives of American Art of the Smithsonian Institution in Washington, DC. For their generous help over the course of multiple visits to Washington I would like to thank Marisa Bourgoin, Elizabeth Botten, and Margaret Zoller. The Documentary Archives of the Museum of Fine Arts has been an equally important source, and I am grateful to Maureen Melton for her unstinting assistance with my research over the

course of several years, as well as Deborah Barlow Smedsted and Paul McAlpine of the MFA Library, and Sue Bell of the MFA's Digital Image Resources. I am also grateful to Norma Sindelar at the Saint Louis Art Museum Archives, Judith Huenneke and Kurt Morris at the Mary Baker Eddy Library and Archives, Nora Murphy at the MIT Institute Archives and Special Collections, Susan von Salis, Jane Callahan, and Megan Schwenke at the Harvard Art Museums Archive, Virginia Hunt of the Harvard University Archives, Michelle Romero of the Snell Library at Northeastern University, James Moske and Adrianna Del Collo of the Metropolitan Museum Archives, Jane Martineau and Alice Hopcraft of the *Burlington Magazine,* the staff of the Hoover Institution Archives, Stanford University, and James Feeney and Emilia Mountain of the circulating desk at the Boston Athenæum. I wish to thank photographer Frederick G. S. Clow, whose work is well represented in these pages, for providing the most vivid photographic record of the MFA in the 1960s. I am also grateful to my cousins who have kept archives of family interest and generously shared them with me, in particular Tammy Rathbone Grace and Sue Connely Rands.

The Archives of American Art were also an invaluable source for oral histories of key members of the MFA staff, since deceased. The most important of these for my purposes was my father's seventeen-hour interview with Paul Cummings between August 1975 and September 1976. Other interviews in the collection made by Robert Brown with key figures relating to the Boston Museum – Nelson Aldrich, Dana Chandler, W. G. Constable, John Coolidge, Charles Cunningham, Dows Dunham, Eleanor Sayre, George Seybolt, and Robert Taylor – have also been an important resource. The Columbia University Center for Oral History Collection, for which Raymond Daum conducted a ten-hour interview with my father between 1981 and 1982, has also been an important resource. While covering much of the same territory as the AAA interview, it was equally valuable in fleshing out both the big picture and small details of his life.

My own interviews with key witnesses have been essential to my understanding of the events, personalities, and attitudes involved. I am indebted to many for offering their first-hand accounts and candid commentary – first to many present and former members of the

MFA staff, some of whom have not lived to see this book published: Clifford Ackley, Katherine Boden, Clementine Brown, Jonathan Fairbanks, Carol Farmer, Jan Fontein, Edmund Barry Gaither, James Griswold, Lucretia Giese, Inge Hacker, Ariel Herrmann, Laura Luckey, Tamsin McVickar, Thomas Maytham, Robert Moeller, Kenworth Moffett, Nancy Netzer, Roy Perkinson, Virginia Fay Pittman, David Pickman, Anne Poulet, Angelica Rudenstine, Geraldine Sanderson, Isabel Shattuck, Peter Sutton, Cornelius Vermeule, Clara Wainwright, John Walsh, James Wright, Florence Young, and Carl Zahn. I am equally grateful to MFA trustees and committee members past and present: Dorothy Arnold, Ed Brooking, Lewis Cabot, Charles Cunningham, Jack Gardner, John Goelet, Graham Gund, Connaught Mahoney, William Osgood, Susan Paine, Ellen Stillman, Jeptha Wade, Katherine White, and Martha Wright. Friends and relations of members of the staff and committees and others close to the scene added further insight and connections: Joseph Barbieri, Constantin Boden, Robert Bowie, Kathryn Brush, Tim Cabot, Marjorie Cohn, Marie Cosindas, Robert Duffy, Beatrice Edgar, Frances Freedberg, Shelagh Hadley, Gerry and Dorothy Gillerman, Estrellita Karsh, Tim and Elizabeth Llewellyn, Todd McKie, Nicholas Peck, Pat Pratt, David Prum, Emily Pulitzer, Lilian Randall, Seymour and Zoya Slive, and Veronica Von Moltke. I am also grateful to MFA curators Elliot Bostwick Davis, Christraud Geary, Christine Kondoleon, and Stephanie Loeb for introductions and conversations in the course of my research, to Debra LaKind in Business Development and to Carol Farmer in Development for her ongoing efforts to connect me with staff members past and present. For their helpful views and commentary I wish to thank members of the staff of the Metropolitan Museum past and present, Philippe de Montebello, Ashton Hawkins, Timothy Husband, and Emily Rafferty. Former and present staff members of Christie's helped to vivify my father's presence amongst them. I am grateful to Noel Annesley, Ildiko Von Berg Butler, and Christopher Burge. Art dealers Warren Adelson, Richard Feigen, and Robert Light added perceptions of Rathbone as a curator and connoisseur, while journalists Charles Giuliano and Otile McManus contributed to the palpable memory of those turbulent years in Boston. In Florence, keepers of Rodolfo

Siviero's heritage Attilio Tori of the Regione Toscana and Enrico Sartori of the Accademia delle Arti del Disegno provided insight into his life and character. For their first-hand accounts of Siviero and the Italian art market of the 1960s I am grateful to Marco Grassi and Andrea Rothe. I am also grateful to Lynn Nicholas for many conversations about European export issues of WWII and its aftermath.

For their generous hospitality when research took me beyond Boston I wish to thank Peter and Pippa Fairbanks, Tim Husband and Nicholas Haylett, Beatrice Kernan, Tim and Elizabeth Llewellyn, Emily Pulitzer, Emily and John Rafferty, Peter and Alanna Rathbone, and Eliza Rathbone.

For reading the manuscript for clarity and accuracy in its final stages I am grateful to many. From amongst the MFA community I wish to thank Clifford Ackley, Katherine Getchell, John and Yetta Goelet, Laura Luckey, Maureen Melton, and Victoria Reed. For legal accuracy and clarity I wish to thank Jerry Norton for his careful review of several drafts of the manuscript. I am also grateful for the astute comments of readers Nick Kilmer and Anson Wright. Not the least, my brother and sister, Peter Rathbone and Eliza Rathbone, also contributed important questions and corrections, as well as a point of view that did not always match my own. I am deeply grateful to them for their candor and forbearance throughout the development of this book. These readers are not responsible for the point of view found in these pages.

I wish to thank my literary agents: first Charles Everitt, who with his indomitable spirit, assisted me with the first version of this book and sadly died before the present version was realized, and second, Ike Williams, who has faithfully seen this book through to completion, and his assistant Hope Denekamp for patiently and expertly handling all details. For his faith in the project in its nascence, and his expert and sensitive editing, his pertinent questions, and his attention to every detail of this book's publication, I wish to thank my editor and publisher David Godine. I am also grateful for the production assistance of Kristin Brodeur and Heather Tamarkin, to Kelly Messier for her meticulous copyediting, and Aaron Kerner for its final review. Lastly, for the sensitive and elegant design of this book, I wish to thank Carl W. Scarbrough.

This book is by no means a definitive account of the fascinating and turbulent period in the history of the MFA and indeed, a turning point in all American museums at the time of these events. I hope that it will inspire further research and discoveries of that period, and further discussion of the various issues it presents but does not pretend to resolve.

Selected Bibliography

History of the Museum of Fine Arts, Boston

MFA Annual reports 1955–1972

MFA Exhibition catalogues 1955–72

Maureen Melton, *Invitation to Art: A History of the Museum of Fine Arts, Boston*, Boston: MFA Publications, 2009

The Rathbone Years: Masterpieces acquired for the Museum of Fine Arts, Boston, 1955–1972 and for the St. Louis Art Museum, 1940–1955, Boston: Museum of Fine Arts, 1972

Hanns Swarzenski, Nancy Netzer, *Catalogue of Medieval Objects in the Museum of Fine Arts, Boston*, Boston: Museum of Fine Arts, 1986

Mathew Weinberg, "Abstract Expressionism at the Museum of Fine Arts, Boston: The Story of a Belated Arrival," Harvard University Extension School, 2009 (unpublished thesis)

Walter Muir Whitehill, *Museum of Fine Arts, Boston: A Centennial History*, Vols. I and II, Cambridge: Belknap Press of Harvard University Press, 1970

General

Kathryn Brush, *Vastly more than Brick and Mortar: Reinventing the Fogg Art Museum in the 1920s*, Cambridge: Harvard University Art Museums, New Haven: Yale University Press, 2004

Nathaniel Burt, *Palaces for the People: A Social History of the American Art Museum*, Boston: Little, Brown and Company, 1977

David Carrier, *Museum Skepticism: A History of the Display of Art in Public Galleries*, Durham and London: Duke University Press, 2006

James Cuno, ed., *Whose Culture? The Promise of Museums and the Debate over Antiquities*, Princeton: Princeton University Press, 2009

Marjorie B. Cohn, *Classic Modern: The Art Worlds of Joseph Pulitzer, Jr.*, Cambridge: Harvard Art Museums, New Haven: Yale University Press, 2012

Dictionary of Art Historians, www.dictionaryofarthistorians.org

Jason Felton and Ralph Frammolino, *Chasing Aphrodite: The Hunt for Looted Antiquities at the World's Richest Museum*, Boston: Houghton Mifflin Harcourt, 2011

Richard Feigen, *Tales from the Art Crypt*, New York: Alfred A. Knopf, 2000

Francis Haskell, *The Ephemeral Museum: Old Master Paintings and the Rise of the Art Exhibition*, New Haven: Yale University Press, 2000

Thomas Hoving, *Making the Mummies Dance: Inside the Metropolitan Museum of Art*, New York: Simon and Schuster, 1993

Thomas Hoving, *King of the Confessors*, New York: Simon and Schuster, 1991

Andrew McClellan, ed., *Art and its Publics: Museum Studies at the Millennium*, Blackwell Publishing, 2003

John Henry Merryman and Albert Elsen, *Law, Ethics, and the Visual Arts*, Vol. 1. Philadelphia: University of Pennsylvania Press, 1987

Karl E. Meyer, *The Plundered Past*, New York: Atheneum, 1973

Lynn H. Nicholas, *The Rape of Europa*, New York: Alfred A. Knopf, 1994

Calvin Tomkins, *Merchants and Masterpieces: The Story of the Metropolitan Museum of Art*, New York: E.P. Dutton, 1970

Cynthia Saltzman, *The Portrait of Dr. Gachet: The Story of a Van Gogh Masterpiece, Modernism, Money, Politics, Collectors, Dealers, Taste, Greed, and Loss*, New York: Viking, 1998

Notes

THE GREATEST ADVENTURE OF ALL

1. Perry Townsend Rathbone to Euretta de Cosson Rathbone, July 15, 1969, Rathbone Family Archive, Cambridge, MA.
2. Ibid.
3. Nicholas Penny interview with the author, April 19, 2006, Washington, DC.
4. Nicholas Penny is currently the director of National Gallery, London.
5. Roger Jones and Nicholas Penny, *Raphael* (New Haven and London: Yale University Press, 1983) fig.5.
6. Penny interview.
7. Paul Joannides interview with the author, July 25, 2005, telephone.
8. Reminiscences of Perry Townsend Rathbone (with Raymond L. Daum), March 17, 1982, on page 9-421, Columbia University Center for Oral History Collection.
9. Clementine Brown interview with the author, April 2005, Boston.
10. Louise Dahl-Wolfe, photographer, "Weekend at Stowe," *Harper's Bazaar*, March 1, 1942. 84.

1965

1. Perry T. Rathbone, journal, December 16, 1965, Rathbone Family Archive.
2. Ibid.
3. Reminiscences of Perry T. Rathbone, Dec. 17, 1981, on page 7-349. Columbia University Center for Oral History Collection.
4. Rathbone journal, December 16, 1965. (Rembrandt's *Man in a Fur-lined Coat* did not come to the Museum of Fine Arts after all, but nine major paintings from the Fuller Foundation had already been given to the MFA in 1961, including a Van Dyck, a Romney, and a Renoir.)
5. The Rathbones did not attend the inauguration because of a blizzard that

paralyzed the Northeast. All flights were canceled, and there was a railroad strike at the same time.

6. Emilie Tavel, "Boston Art 'Elected' to White House," *The Christian Science Monitor*, April 25, 1961.

7. Edgar J. Driscoll Jr., "11 Hub Paintings Selected for White House," *The Boston Globe*, April 7, 1961.

8. Rathbone journal, November 17, 1961.

9. Fred Brady, "Bypass Boston? Jamais, Jamais," *The Boston Herald*, December 21, 1962.

10. A. S. Plotkin, "Museum Fears Belt Road Vibrations Would Injure Fragile Art Treasures," *The Boston Globe*, May 4, 1960.

11. Boston Redevelopment Authority.

12. Rathbone journal, October 19, 1965.

13. Ibid., October 1, 1960.

14. Ibid., December 18, 1962.

15. Harvard presidents at that time lived on Quincy Street on the edge of Harvard Yard in what is now known as Loeb House. Pusey's experience of living in the heart of the campus in the midst of student protests in the 1960s led to the move of the presidential residence to "Elmwood," about a mile west of Harvard Yard on Elmwood Avenue, Cambridge.

16. Rathbone journal, February 28, 1964.

17. Ibid., summer 1964.

18. Signing up for an additional year or more provided options, for either a military occupational specialty or a location. Peter chose location.

19. Rathbone journal, December 13, 1964.

20. Ibid., September 30, 1966.

The Making of a Museum Director

1. Henry W. Kent to Paul J. Sachs, October 13, 1922, Paul Sachs papers (HC3), file 1342. Harvard Art Museums Archives, Harvard University, Cambridge, MA.

2. The original Fogg Museum was inside Harvard Yard, where Canaday Hall stands today.

3. Janet Tassel, "Reverence for the Object: Art Museums in a Changed World," *Harvard Magazine*, September–October 2002, 51.

4. James Willard Connely, memoirs (unpublished manuscript, c. 1962), Rathbone Family Archive.

5. Harvard University. Faculty of Arts and Sciences. Undergraduate Student Records. Rathbone, application for admission to Harvard College, April 16, 1929, UAIII 15.88.10, Series 1922–1925, Folder for Perry T. Rathbone, Box 4031. Courtesy of Harvard University Archives.

6. Ibid. Letter from Thaddeus R. Brenton to A. C. Hanford, April 29, 1929.

7. Ibid. Letter from Rosetta Shear to A.C.Hanford, April 25, 1929.
8. Ibid. Letter from Howard Betts Rathbone to A.C.Hanford, September 4, 1929.
9. Ibid.
10. Reminiscences of Perry T. Rathbone, Feruary. 3, 1981, on page 1–24, Columbia University Center for Oral History Collection.
11. Perry Townsend Rathbone, oral history interview with Paul Cummings, Archives of American Art, Smithsonian Institution, August 19, 1975. Reel 1, Side 1.
12. Harvard University Faculty of Arts and Sciences. Undergraduate Student Records. Letter from Beatrice E.C.Rathbone to A.E.Hindmarsh, May 7, 1930, UAIII 15.88.10, Series 1922-1925, Folder for Perry T. Rathbone, Box 4031. Courtesy of Harvard University Archives.
13. Rathbone interview, August 19, 1975, Archives of American Art, Reel 1, Side 1.
14. Reminiscences of Perry T. Rathbone, Feb. 3rd, 1981, on page 1-34, Columbia University Center for Oral History Collection.
15. Ibid.
16. Ibid.
17. Nicholas Fox Weber, *Patron Saints: Five Americans Who Opened America to a New Art, 1928–1943* (New York: Alfred A. Knopf, 1992), 4.
18. Reminiscences of Perry T. Rathbone, March 4, 1981, on page 1-41, Columbia Center for Oral History Collection.
19. Ibid., on page 1-43.
20. Tassel, "Reverence for the Object," 50.
21. Sally Anne Duncan, "Harvard's 'Museum Course' and the Making of America's Museum Profession," *Archives of American Art Journal* 42, nos. 1–2 (2002): 8.
22. Reminiscences of Perry T. Rathbone, February 3, 1981, on page 1-47, Columbia Center for Oral History Collection.
23. Rathbone interview, Archives of American Art, August 19, 1975, Reel 1, Side 1
24. Ibid.
25. Reminiscences of Perry T. Rathbone, March 4, 1981, on page 2–53, Columbia University Center for Oral History Collection.
26. Ibid.
27. Duncan, "Harvard's 'Museum Course,'" 12.
28. Weber, *Patron Saints*, 25–26.
29. Ibid., 26.
30. Ibid., 26.
31. Rathbone interview, Archives of American Art, Reel 1, August 19, 1975, Side 1.

THE CENTENNIAL LOOMS

1. Nathaniel Burt, *Palaces for the People: A Social History of the American Art Museum* (Boston: Little, Brown and Company, 1977), 106.

2. John McPhee, "A Roomful of Hovings," *The New Yorker*, May 20, 1967, 62.

3. Calvin Tomkins, *Merchants and Masterpieces: The Story of the Metropolitan Museum of Art* (New York: E. P. Dutton, 1970), 351.

4. Paul Giguere, "Perry T. Rathbone to Head Museum: St. Louis Man, 43, Foe of Stuffiness," *The Boston Herald*, May 4, 1955.

5. Karl E. Meyer, *The Plundered Past: The Story of the Illegal International Traffic in Works of Art* (New York: Atheneum, 1973), 102–3.

6. Warren Adelson interview with the author, May 17, 2011, New York.

7. Now the Calderwood courtyard.

8. The Forsyth Wickes Collection galleries opened in 1968. His will specified that the collection be displayed as a whole at the MFA for at least twenty-five years. The collection was deinstalled in 2003 and dispersed among several departments, much of it on view today in various galleries.

9. Rathbone journal, October 22, 1965.

10. Ibid., October 27, 1965.

11. This projection was later reduced to $13 million, although Rathbone continued to regard $20 million as the Museum's longer-term goal.

12. The City Art Museum of Saint Louis was renamed the Saint Louis Art Museum in 1972.

13. Perry T. Rathbone to William Valentiner, February 23, 1956, Rathbone Family Archive.

14. Reminiscences of Perry T. Rathbone, Dec. 17, 1981, on page 7-355, Columbia University Center for Oral History Collection.

15. During Rathbone's tenure, Thomas Hoopes, a specialist in arms and armor, was the only full-time curator at the City Art Museum of Saint Louis.

16. Rathbone interview, Archives of American Art, February 10, 1976. Reel 7, Side 1

17. Louis LaBaume, a retired architect who was famously brusque, conservative, and overbearing, was president of the board of the City Art Museum of Saint Louis when Rathbone assumed the directorship in 1940. Fortunately for Rathbone, LaBaume retired six months after he arrived and was succeeded by the gentlemanly and supportive Daniel Catlin.

18. "St. Louis Art Museum Praised by John Coolidge, Harvard Expert," *St. Louis Post-Dispatch*, May 19, 1952.

19. Lewis Cabot interview with the author, June 30, 2011, Cambridge, MA.

20. In the spring of 1955, Arthur Houghton, chairman of the search committee for the Metropolitan Museum, approached Rathbone to see if he would consider the directorship, but he declined, having already accepted Boston some months before. James Rorimer was appointed director of the Met in

the fall of 1955. While he was director of the MFA, Rathbone was also asked to consider the directorship of the Art Institute of Chicago, the Philadelphia Art Museum, and the Los Angeles County Museum of Art, but he turned them all down. See Perry T. Rathbone to John Floyd, March 13, 1973, Rathbone Family Archive.

21. Francis Henry Taylor to all assembled at Copley Society dinner for Perry T. Rathbone, telegram, October 18, 1955, Rathbone Family Archive.

22. Walter Muir Whitehill, *Museum of Fine Arts, Boston: A Centennial History, Vol. 2*, (Cambridge, MA: Harvard University Press, 1970), 625.

23. To mark the opening of the special exhibition *The Civil War: The Artist's Record* in January 1962, Rathbone borrowed an 1864 Confederate cannon to place at the Huntington Avenue entrance, along with members of the Ninth Massachusetts Battery, Army of the Potomac, dressed as Union soldiers and armed with muskets. Because of the freezing temperatures outside, the reverberations resulting from the cannon fire blew out seventeen windows in the apartment building on the other side of the avenue. These were hastily replaced by the Museum, but the event went down in the annals of Rathbone publicity stunts.

24. Rathbone interview, Archives of American Art, September 9, 1976. Reel 11, Side 1.

25. Ibid.

26. Ibid.

27. Ibid.

28. Ibid.

THE CHANGING FACE OF THE BOARD

1. Rathbone interview, Archives of American Art, August 18, 1976. Reel 10, Side 1.

2. Cabot interview.

3. Rathbone interview typescript, source unknown, November 10, 1967, Perry T. Rathbone papers, Archives of American Art.

4. Perry T. Rathbone, "Director's Report," *Annual Report*, Museum of Fine Arts, Boston, 1958, pg. 2.

5. Aline Saarinen called corporate giving "the Great White Hope" of cultural institutions in the *New York Times* in 1959, and quoted Perry Townsend Rathbone as a spokesman on the art museums' need for "hard cash." Aline B. Saarinen, "U.S. Museums Seek New Revenues," *New York Times*, August 16, 1959.

6. Cabot interview.

7. Rathbone interview, Archives of American Art, August 18, 1976, Reel 10, Side 1.

8. Jack Gardner interview with the author, January 15, 2013, Boston.

9. Rathbone interview, Archives of American Art, September 9, 1976, Reel 11, Side 1.

10. Ibid.

11. Cabot interview.

12. Clifford Ackley interview with the author, March 16, 2005, Boston.

13. George C. Seybolt, interview by Robert F. Brown, April 2, 1985, Archives of American Art, Smithsonian Institution, Tape 2, 10.

14. A coalition of business leaders in Boston.

15. Cabot interview.

16. Seybolt interview, Archives of American Art, Tape 2, 7.April 2, 1985.

17. By that time Seybolt was president and CEO of Underwood and also president of the Boston Chamber of Commerce.

18. Seybolt interview, Archives of American Art, Tape 4, 13, April 2, 1985.

19. Perry T. Rathbone, "Director's Report," *The Museum Year: 1968*, Museum of Fine Arts, Boston, 6.

20. Ibid., 73.

21. Cabot interview.

22. Diggory Venn, who had administrated the capital campaign drive, soon afterward became special assistant to the director.

23. James Griswold interview with the author, May 29, 2007, telephone.

24. Rathbone interview, Archives of American Art, September 9, 1976, Reel 11, Side 1.

25. Rathbone oversaw the first exhibition of African, Oceanic, and pre-Columbian art at the MFA in a collaboration with Harvard University's Peabody Museum, *Masterpieces of Primitive Art*, in 1958. From 1959 to 1968, a small ground-floor gallery was devoted to rotating loans from the Peabody Museum.

26. Seybolt interview, Archives of American Art, Tape 4, 13, April 2, 1985.

27. Burt, *Palaces for the People*, 106.

28. Said Rathbone in favor of the director as trustee, "He should be meeting with his peers and not as a hired hand when it comes to making policy and other decisions it falls upon a board to make." Rathbone interview, Archives of American Art, August 18, 1976, Reel 10, Side 1.

29. Rathbone interview, Archives of American Art, August 18, 1976, Reel 10, Side 1.

30. Carl Zahn interview with the author, June 5, 2007, Cambridge, MA.

31. Virginia Fay Pittman interview with the author, December 15, 2011, Boston.

32. Seybolt interview, Archives of American Art, Tape 2, 11, April 2, 1985.

33. Rathbone interview, Archives of American Art, September 9, 1976, Reel 11, Side 1.

34. Eleanor Sayre, oral history interview by Robert F. Brown, July 26, 1996, Archives of American Art, Smithsonian Institution.

35. Seybolt interview, Archives of American Art, Tape 3, 1, April 5, 1985. Tape 3, 1.

36. Laura Luckey interview with the author, August 10, 2012, Salem, MA.

37. Lucretia Giese interview with the author, September 8, 2010, Lincoln, MA.

38. Rathbone interview, Archives of American Art, September 9, 1976, Reel 11, Side 2.

39. Tamsin McVickar interview with the author, October 26, 2011, Marblehead, MA.

40. Zahn interview.

41. Luckey interview.

42. Rathbone interview, Archives of American Art, September 9, 1976, Reel 11, Side 2.

43. Ibid.

44. McVickar interview.

45. Jonathan Fairbanks interview with the author, July 27, 2012, telephone.

46. Pittman interview.

47. John Coolidge, oral history interview by Robert F. Brown, March 7–May 4, 1989, Archives of American Art, Smithsonian Institution.

48. Seybolt described General Eisenhower as "nothing but a little Irish politician," and of Winston Churchill, he said, "You knew when he was lying." Seybolt interview, Archives of American Art, Tape 1, 10, April 2, 1985.

49. Rathbone interview, Archives of American Art, August 18, 1976, Reel 10, Side 1.

50. Seybolt interview, Archives of American Art, Tape 2, 21–22, April 2, 1985.

51. Pittman interview.

52. Walter Muir Whitehill, *Museum of Fine Arts, Boston: A Centennial History*, *Vol. 2*, (Cambridge, MA: Harvard University Press, 1970), 843.

53. Griswold interview.

54. Rathbone interview, Archives of American Art, September 9, 1976, Reel 11, Side 2.

55. Rathbone interview, Archives of American Art, August 18, 1976, Reel 10, Side 1.

PTR's Other Hat

1. Philip Hendy, an Englishman who preceded W. G. Constable as paintings curator at the MFA from 1930 to 1933, took an active interest in modern art and bought for the Museum twenty-four works of art by modern European artists, including Matisse's 1903 painting of a seated nude, *Carmelina*, which scandalized some trustees.

2. Several curatorial departments were then defined by category, such as prints and drawings, decorative arts, and textiles. Today they are all defined by continent, such as Art of Europe, Art of the Americas, and Art of Asia,

with the exception of the department of prints, drawings, and photographs.

3. W. G. Constable oral history interview by Robert F. Brown, July 1972–June 1973, Archives of American Art, Smithsonian Institution.

4. Today these galleries are used by the department of Asia, Oceania, and Africa, on the west side of the staircase, and on the east side they are used for services and closed to the public.

5. Rathbone interview, Archives of American Art, February 10, 1976, Reel 7, Side 1

6. Alison Arnold, "Sargent Brings 19th Century Boston to Life," *The Boston Herald*, January 4, 1956.

7. Reminiscences of Perry T. Rathbone, Dec. 17th, 1981, on pg. 7-339, Columbia University Center for Oral History Collection .

8. Tom Maytham interview with the author, October 11, 2011, telephone.

9. Emilie Tavel, "Rathbone Outlines New Plans for Boston Art Museum," *The Christian Science Monitor*, May 4, 1955.

10. The ICA was at the time temporarily housed on the second floor of the museum school.

11. Perry T. Rathbone, "Director's Report," *Annual Report*, Museum of Fine Arts, Boston, 1957, pg. 16.

12. Robert Taylor, "Museum Opens Gallery of 20th Century Art," *The Boston Sunday Globe*, August 12, 1956.

13. The last time was in 1913, when Boston hosted the traveling *Armory Show*, which was somewhat reduced from its original form in New York.

14. Rathbone's belief in this approach was no doubt reinforced by the illustrated catalog of Joseph Pulitzer, Jr.'s collection the year before, a project Rathbone was involved with as consultant and writer.

15. Perry T. Rathbone, "Director's Report," *Annual Report*, Museum of Fine Arts, Boston, 1957, 16.

16. Perry T. Rathbone, "Introduction," *European Masters of Our Time* (Boston: Museum of Fine Arts), 1957, 7.

17. Mathew Weinberg wrote a graduate thesis in museum studies at the Harvard Extension School, "Abstract Expressionism at the Museum of Fine Arts, Boston: The Story of a Belated Arrival," in 2009, that deals extensively with Rathbone's efforts to bring the MFA up to date with modern art.

18. Edgar J. Driscoll, "Museum Show Hails Europe's Modern Artists," *The Boston Globe*, October 11, 1957.

19. Howard Devree, "Boston Challenge," *The New York Times*, October 20, 1957.

20. Conductor of the Boston Symphony Orchestra, 1924–1949.

21. Whitehill, *A Centennial History*, 639.

22. As quoted by Euretta Rathbone to Perry T. Rathbone, July 1954, Rathbone Family Archive. Additionally, Jim Ede wrote to Rathbone, "First and foremost it does depend on whether you think you will be happy [in Boston],

whether you will have free movement in the department of painting and in the general arrangement and allure making of the whole gallery. If you are to be sabotaged into an administrative office what is the use of having Perry Rathbone?" Ede to Rathbone, Summer 1954, Rathbone Family Archive.

23. Perry T. Rathbone, "On Collecting," *Canadian Art*, January 1960.

24. Rathbone had approached trustee William A. Coolidge as well as collector David Bakalar for funds to purchase the Rembrandt for up to $1,500,000, but to no avail. As he recorded in his journal, "David B.'s millions (reputed 50 to 100) are very new: too new to spend on Rembrandt of great price, perhaps. The other Boston millions are too old. What a predicament." Rathbone journal, October 28, 1961.

25. Rathbone journal, November 17, 1961.

26. Rathbone interview, Archives of American Art, March 31, 1976, Reel 8, Side 1.

27. Luckey interview.

28. Decades later, in 2012, William Lane's second wife, Saundra Lane, bequeathed this important collection to the MFA.

29. Rathbone journal, March 21, 1961.

30. Perry T. Rathbone, "Preface," *Sculpture and Painting Today: Selections from the Collection of Susan Morse Hilles* (Boston: Museum of Fine Arts, 1966).

31. Rathbone to Susan Morse Hilles, October 15, 1966, Susan (Morse) Hilles Papers, Schlesinger Library, Radcliffe Institute, Harvard University.

32. Pittman interview.

33. Perry T. Rathbone to Euretta Rathbone, September 15, 1956, Rathbone Family Archive.

34. Ibid.

35. Perry T. Rathbone to Peggy Guggenheim, February 5, 1962, Documentary Archives, Museum of Fine Arts, Boston.

36. Ibid., July 18, 1963.

37. Beginning with the work by Helion, and including two works designed by Max Ernst and Hans Arp in Murano glass and a model of the wire and glass gates to her palace in Venice designed by Claire Falkenstein, Peggy Guggenheim gave the MFA a total of eighteen works of art between 1957 and 1967.

38. Whitehill, *A Centennial History*, 649.

39. Robert Moeller interview with the author, October 1, 2011, telephone.

40. Fairbanks interview.

41. Pittman interview.

42. Fairbanks interview.

43. Richard Feigen interview with the author, October 12, 2012, New York.

44. It was not untypical of museum directors to play a big hand in building the paintings collections. Otto Wittmann was chief curator as well as director

of the Toledo Art Museum from 1938–1978 and was particularly active in acquiring paintings. As Sally Ann Duncan wrote, "At that time no museum professional in America had more freedom to purchase works of art for a collection. Wittmann's unprecedented buying power and board support would become the envy of directors around the country." *Otto Wittmann: Museum Man for All Seasons*, Toledo Museum of Art, 2001. At the Metropolitan Museum, Thomas Hoving worked closely with paintings curator Theodore Rousseau. Rathbone's predecessor at the MFA, George Harold Edgell, was acting curator of paintings for six years, as well as being director.

45. Seybolt interview, Archives of American Art, Tape 2, 14, April 2, 1985.

46. Seybolt interview, Archives of American Art, Tape 2, 21, April 2, 1985.

47. Ibid.

48. Seybolt interview, Archives of American Art, Tape 4,19, April 2, 1985.

49. Maud Morgan to Susan Morse Hilles, undated, 1966, Susan (Morse) Hilles Papers, Schlesinger Library, Harvard University.

50. Nelson Aldrich admitted that Rathbone faced a daunting prospect in trying to persuade the trustees to buy a modern work. "There were many things that Perry brought to the committee on collections that were turned down because they were too advanced." Nelson W. Aldrich oral history interview by Robert F. Brown, January 22, 1982–April 4, 1985, Archives of American Art, Smithsonian Institution.

51. Christopher Andreae, "Rathbone and the Museum's Role," *The Christian Science Monitor*, August 4, 1967.

52. In December 1964 the MFA exhibited the contemporary art collection of Joseph Hirshhorn, who was then considering the question of a permanent home. Ten years later, the Hirshhorn Museum opened in Washington, DC.

53. Cabot interview.

54. Upon Messer's appointment as director of the Guggenheim Museum in 1961, Rathbone wrote in his private journal that the appointment was "an honor richly deserved. [Messer] has great pluck, seriousness, and intelligence. I wish him well." Rathbone journal, January 28, 1961.

55. Rathbone to Guggenheim, May 21, 1970, Documentary Archives, Museum of Fine Arts, Boston.

56. As Rathbone lamented, "The Kimbell will yield conservatively $2,000,000 per annum for operating and acquisitions. In other words a new threat to the ever-increasing competition for great works of art." Rathbone journal, November 14, 1964.

57. Aldrich interview, Archives of American Art.

58. Rathbone courted at least two candidates to be curator of paintings: Everett Fahy and John Walsh. Walsh did eventually come to the MFA five years after Rathbone retired, in 1977.

59. Seybolt interview, Archives of American Art, Tape 4, 15–16, April 2, 1985.

60. Ibid. (regarding bargains,Seybolt refers here to Sidney Rabb, owner of the Stop & Shop supermarket chain, who joined the MFA board in 1961).

61. Seybolt interview, Archives of American Art , April 2, 1985, Tape 6, 18.

62. Rathbone often encountered resistance from the trustees to his proposed purchases, and not only in the modern field. Of his purchase of Tiepolo's *Time Unveiling Truth*, he recorded, "Showed great Tiepolo to Ralph Lowell who was impressed. Also to Henry Shattuck.... This legal sage said he thought we had 'enough paintings of that kind.' Of course we haven't any! Is it a deep and unconscious mistrust and antipathy to baroque exuberance born from puritan antecedents? He is 83 or 84. In any case it is utter aesthetic blindness which deserves no respect whatsoever. I admire his honesty but deplore his ignorance and patent blindness in sitting in judgment on the work of a genius." Rathbone journal, December 8, 1961.

The Man behind the Man

1. Perry T. Rathbone to Euretta Rathbone, November 29, 1954, Rathbone Family Archive.

2. Jan Fontein interview with the author, October 26, 2011, Newton, MA.

3. Moeller interview.

4. The Bauhaus was reborn in Chicago under the direction of Laszlo Moholy-Nagy, Josef and Anni Albers joined the faculty of the newly established Black Mountain College in North Carolina, and Walter Gropius, once director of the Bauhaus, was made head of the Harvard Graduate School of Design. Leading Jewish art historians Erwin Panofsky and H.W. Janson, fired from their teaching posts in Germany, took faculty positions at Princeton and NYU respectively.

5. For a thorough account of the Rathbone-Pulitzer friendship and alliance in Saint Louis, see Marjorie B. Cohn, *Classic Modern: The Art Worlds of Joseph Pulitzer, Jr.* (New Haven and London: Yale University Press, 2012).

6. "Curt Valentin dies," *Art News*, September 1954.

7. Aline B. Saarinen, "A Fitting Memorial: Exhibition Pays Homage to Curt Valentin," *The New York Times*, October 10, 1954.

8. Max Beckmann died in 1950, Curt Valentin in 1954, Georg Swarzenski in 1957, and William Valentiner in 1958.

9. Perry T. Rathbone, "Necrology—Hanns Swarzenski (1903–1985)," Publication unknown, Rathbone Family Archive.

10. Perry T. Rathbone, "Hanns Swarzenski, the Curator Connoisseur," *Intuition und Kunstwissenschaft: Festschrift Hanns Swarzenski* (Berlin: Gebr. Mann Verlag, 1973).

11. Netzer coauthored with Hanns Swarzenski *Medieval Objects in the Museum of Fine Arts, Boston* (Boston: Museum of Fine Arts, 1986).

12. Nancy Netzer interview with the author, July 1, 2011, Boston.

13. Thomas Hoving, *King of the Confessors* (New York: Simon and Schuster, 1981), 70.

14. Hoving sought Hanns Swarzenski's advice before buying the Bury St. Edmunds Cross for the Metropolitan Museum. "[Swarzenski] wanted to buy it for Boston, but could not raise the funds," wrote Hoving in *King of the Confessors* (New York: Simon & Schuster, 1981). In collegial spirit, it was Swarzenski who alerted Hoving to the existence of the cross.

15. Constantin Boden, telephone interview with the author, July 20, 2012.

16. Nancy Netzer has speculated that Georg and Hanns Swarzenski kept vast numbers of photographs of objects, sometimes cut out of books, as an aid to memory.

17. Cynthia Saltzman, *Portrait of Dr. Gachet: The Story of a Van Gogh Masterpiece* (New York: Viking, 1998), 136.

18. Hoving, *King of the Confessors*, 70.

19. Pittman interview.

20. Inge Hacker interview with the author, October 9, 2011, Frankfurt, Germany.

21. Clara Mack Wainwright interview with the author, January 26, 2010, Boston.

22. Rathbone's journal mentions an evening at the Swarzenskis' when conversation turned to the "difficult relationship between Hanns and Dick Randall, who, it seems, cannot tolerate any superior." Rathbone, journal, March 26, 1963.

23. Hacker interview.

24. Ackley interview.

25. Rathbone, *Hanns Swarzenski: Festschrift*, 1972.

26. Netzer interview.

27. Perry T. Rathbone to Euretta Rathbone, June 22, 1960, Rathbone Family Archive.

28. Ibid.

29. Ibid., n.d.

30. Ibid., September 7, 1956.

31. Ibid., June 28, 1961.

32. Ibid., July 19, 1957.

33. Ibid.

34. Traveling in Germany with the Swarzenskis had an added feature as Brigitte Horney was easily recognized as the famous film star. "Moving through G[ermany] with B[rigitta] is an experience. Everywhere the heads turn, the astonished faces, the autograph hunter." Perry T. Rathbone to Euretta Rathbone, July 6, 1957, Rathbone Family Archive.

35. Seybolt interview, Archives of American Art, Project Tape 4, 18, April 2, 1985.

36. Perry T. Rathbone, "Director's Report," *The Museum Year*, Museum of Fine Arts, Boston, 1965.

THE PRIZE

1. John Walker, *Self-Portrait with Donors: Confessions of an Art Collector* (Boston: Little Brown, 1974), 46.
2. Ibid.
3. Ibid., 47.
4. Ibid.
5. McPhee, "A Roomful of Hovings," 129.
6. Marco Grassi interview with the author May 18, 2011, New York.
7. Ibid.
8. Reminiscences of Perry T. Rathbone, March 17th, 1982, on page 9-408, Columbia University Center for Oral History Collection, New York.
9. Reed Hynds, "New Director at Art Museum," *St. Louis Star-Times*, August 15, 1940.
10. Ildebrando Bossi to Hanns Swarzenski, January 31, 1968, Documentary Archives, Museum of Fine Arts, Boston.
11. Ibid.
12. Reminisences of Perry T. Rathbone, April 9th, 1982, on page 3-96, Columbia University Center for Oral History Collection.
13. Perry T. Rathbone, White Paper, Documentary Archives, Museum of Fine Arts, Boston, 3
14. John Shearman to Perry T. Rathbone, March 17, 1969, Perry T. Rathbone Papers, Archives of American Art, Smithsonian Institution.
15. Ibid.
16. Ibid.
17. Ibid.
18. Perry T. Rathbone, White Paper, Documentary Archives, Museum of Fine Arts, Boston, 2.
19. Ibid.
20. Ibid.
21. Rathbone to Bossi, March 18, 1969, Documentary Archives, Museum of Fine Arts, Boston.
22. Ibid.
23. Ibid., Bossi to Rathbone, April 10, 1969.
24. Reminiscences of Perry T. Rathbone, March 17th, 1982, on page 9-412, Columbia University Center for Oral History Collection.
25. Fontein interview.
26. For several years, Goelet's *putti*, which he gave to the Museum, decorated the front of the MFA's Remis auditorium.
27. Perry T. Rathbone to Euretta Rathbone, July 15, 1969, Rathbone Family Archive.
28. Perry T. Rathbone, White Paper, Documentary Archives, Museum of Fine Arts, Boston, 4.

29. Approximately 6.5 million in 2014 dollars, according to the Bureau of Labor Statistics.

30. Perry T. Rathbone to Euretta Rathbone, July 15, 1969, Rathbone Family Archive.

31. Ibid.

32. Perry T. Rathbone, White Paper, Documentary Archives, Museum of Fine Arts, Boston, 5.

33. Seybolt interview, Archives of American Art, Tape 6, 3, April 2, 16, 1985.

34. Mary-Ann Winkelmes, eulogy, memorial service for John Shearman, Harvard University, April 4, 2004.

35. Seybolt interview, Archives of American Art, Tape 6, 3, April 2, 16, 1985.

36. Minutes, executive committee meeting , November 19, 1969, Documentary Archives, Museum of Fine Arts, Boston.

37. Rathbone to Shearman, October 6, 1969, Documentary Archives, Museum of Fine Arts, Boston.

38. Luckey interview.

39. Shearman to Rathbone, October 16, 1969, Documentary Archives, Museum of Fine Arts, Boston.

40. Bossi to Rathbone, December 3, 1969, Documentary Archives, Museum of Fine Arts, Boston.

41. Rathbone to Bossi, December 17, 1969, Documentary Archives, Museum of Fine Arts, Boston.

RODOLFO SIVIERO, ART SLEUTH

1. Pam Bishop, "Museum of Fine Arts buys 1505 Painting by Raphael," *Boston Herald Traveler*, December 16, 1969.

2. Ibid.

3. Rathbone to Shearman, December 19, 1969, Documentary Archives, Museum of Fine Arts, Boston.

4. *Associated Press*, December 16, 1969.

5. Edgar J. Driscoll, *The Boston Globe*, December 16, 1969.

6. Cover, *Art Gallery Magazine*, January, 1970.

7. Caron le Brun Danikian, *Boston Herald Traveler*, December 28, 1969.

8. *Life*, February 16, 1970.

9. Rathbone to John Goelet, January 12, 1970, Documentary Archives, Museum of Fine Arts, Boston.

10. Alan Levy, "Italy's Supersleuth for Art," *Art News*, February 1983.

11. Attilio Tori interview with the author, November 23, 2012, Florence, Italy.

12. Andrea Rothe interview with the author, June 3, 2012, San Francisco.

13. Tori interview.

14. Grassi interview.

15. Tori interview.

16. Rothe interview.

17. John H. Merryman and Albert E. Elsen, *Law, Ethics, and the Visual Arts*, (Philadelphia: University of Pennsylvania Press, 2nd. Ed., 1987), 78.

18. William J. Young, *The Museum Year*, Museum of Fine Arts, Boston, 1967.

19. Alfred Friendly, "Italian Sleuth Hunts Art Taken by Nazis," *The New York Times*, December 28, 1968.

20. Ibid.

21. Colin Simpson, "Clues on the Trail of a Smuggled Raphael," *The Sunday Times* (London), Feb. 7, 1971.

22. "Boston's Import of a Raphael said to worry Italy," *The New York Times*, January 23, 1971.

23. Ibid.

24. Just a few months before, Rathbone had been to Washington in his capacity as president of the Association of Art Museum Directors to put the case before the Senate Finance Committee opposing the proposed Tax Reform Bill that would have extremely adverse consequences for museums hoping to attract gifts of works of art. Rathbone's presentation was effective in blocking the bill.

25. John Canaday, "A Birthday in Boston," *The New York Times*, March 8, 1970.

26. John Shearman, "Raphael in the Court of Urbino," *The Burlington Magazine*, Vol. CXII, No. 803, February 1970.

27. Ibid.

28. "Italy checks on how Boston got painting," *The Los Angeles Times*, January 23, 1970.

29. "Art export charge holds Genoa dealer," *The New York Times*, February 28, 1971.

30. "Museum Head Denies Smuggling Charge," *The Boston Globe*, January 24, 1970.

31. Ibid.

32. Affidavit for search warrant, United States District Court, Boston, MA, January 7, 1971, Documentary Archives, Museum of Fine Arts, Boston.

33. Perry T. Rathbone, White Paper, Documentary Archives, Museum of Fine Arts, Boston, 5.

34. John Coolidge oral history interview by Robert F. Brown, March 7–May 4, 1989, Archives of American Art, Smithsonian Institution.

35. Los Angeles Times News Service, "Legal Dispute Centers on Raphael painting," *The Providence Journal*, April 26, 1971.

But Is It Really a Raphael?

1. Plans for a loan exhibition from Greece had also fallen through. Having vigorously courted the General Director of Antiquities at that time, Professor Spiros Marinatos, Rathbone eventually came to understand that he had little interest in sharing Greek art with an American museum. See William H. Freed to Diggory Venn, November 6, 1968, Documentary Archives, Musuem of Fine Arts, Boston.

2. Sarwat Okasha to Rathbone, March 5, 1970, Documentary Archives, Museum of Fine Arts, Boston.

3. In a letter to his wife from Egypt, Rathbone describes his general impression of the state of affairs. "To the Egyptian Museum to see Dr. Riad, Director. He was all smiles in his dusty old office, but he shies away from making decisions about possible precious loans. Then he led us forth into the colossal mess which is his museum ... terrible beyond my wildest dreams. Dirty, cheerless, dead. One half of the collection should be in storage. But first of all they should pull the building down and start all over again." Perry T. Rathbone to Euretta Rathbone June 16, 1968.

4. Rathbone interview, Archives of American Art, September 9, 1976, Reel 11, Side 1.

5. Rathbone to Edward Terrace, March 4, 1970, Documentary Archives, Museum of Fine Arts, Boston.

6. Statement by Perry T. Rathbone, Egyptian exhibition file, 1970, Documentary Archives, Museum of Fine Arts, Boston.

7. Today the National Center for Afro-American Artists is headquartered in a new facility at 300 Walnut Avenue, Boston, where Edmund Barry Gaither is director and curator of the Museum and special consultant at the Museum of Fine Arts, Boston.

8. Press file, Afro-American Art: New York and Boston exhibition, 1970, Documentary Archives, Museum of Fine Arts, Boston.

9. Dana Chandler delivered a formal proposal to the trustees and the director while they were raising funds for the centennial, a seven million dollar project to create galleries and storage space for a permanent collection of African-American art at the MFA. While this did not transpire, Chandler believed it propelled the Museum to a greater commitment to the black community. See Dana Chandler oral history interview by Robert F. Brown, March 11–May 5, 1993, Archives of American Art, Smithsonian Institution.

10. Edmund Barry Gaither interview with the author, April 9, 2012, Boston.

11. Notes for news conference, *Afro-Americn Artists: New York and Boston*, May 18, 1970, Documentary Archives, Museum of Fine Arts, Boston.

12. Hilton Kramer, "Black Art and Expedient Politics," *The New York Times*, June 7, 1970.

13. Gaither interview.

14. Peter Hopkirk, "Dealer Says Boston Raphael is a Fake," *The Times* (London), April 25, 1970.
15. John Shearman, "The Boston Raphael: Art Historian Puts His Arguments for Authenticity," *The Sunday Times* (London), April 27, 1970.
16. Ibid.
17. Penny interview.
18. *The Boston Globe*, April 25, 1970.
19. Bernard Weintraub, "Boston Raphael Challenged," *New York Times News Service*, May 3, 1970.
20. Penny interview.
21. Catherine Freedberg interview with the author, October 30, 2006, telephone.
22. Ibid.
23. *Associated Press*, December 16, 1969.
24. H. Lee Bimm to Rathbone, December 24, 1969, Documentary Archives, Museum of Fine Arts, Boston.
25. Philip Pouncey to Rathbone, January 23, 1970, Documentary Archives, Museum of Fine Arts, Boston.
26. James Wright interview with the author, July 31, 2012, Somerville, MA.
27. Ibid.
28. Distinguished Italian art historians Roberto Longhi and Federico Zeri were also criticized in their time for authenticating Italian Renaissance works of art for personal financial gain.
29. Holland Cotter, "Sydney J. Freedberg, 82, Art Historian, Dies," *The New York Times*, May 8, 1997.
30. McPhee, "A Room Full of Hovings," 74.
31. Grassi interview.

Seizure

1. Rathbone interview, Archives of American Art, September 9, 1976, Reel 11, Side 1.
2. "The Age of Rembrandt" exhibition broke all attendance records with more than 200,000 visitors, sold 13,000 catalogues and 50,000 postcards.
3. George Seybolt, "President's Report," *The Museum Year, 1970–1971*, Museum of Fine Arts, Boston, 1971.
4. Memo to George Seybolt from McKinsey & Company, "Preparing the Museum for the 1970s: Boston Museum of Fine Arts," 1969, Erwin Canham Papers, The Mary Baker Eddy Library, Boston.
5. Rathbone interview, Archives of American Art, September 9, 1976, Reel 11, Side 2.
6. Perry T. Rathbone, "Director's Report," *The Museum Year, 1970–71*, Museum of Fine Arts, Boston, 1971.

7. Ibid.

8. Ibid.

9. Seybolt interview, Archives of American Art, Tape 4, 27, April 2, 1985.

10. Coolidge interview, Archives of American Art.

11. Ackley interview.

12. John Coolidge inherited Paul Sachs's museum course at Harvard and led it into the early 1960s.

13. Coolidge interview, Archives of American Art.

14. Aldrich interview, Archives of American Art.

15. Fairbanks interview.

16. Graham Gund interview with the author, November 1, 2012, telephone.

17. Seybolt interview, Archives of American Art, Tape 4, 19, April 2, 1985.

18. Jean Bergantini Grillo, "Up Against the Fresco," *The Boston Phœnix*, March 23, 1971.

19. Charles Giuliano interview with the author, September 21, 2012. North Adams, MA.

20. Ibid.

21. Rathbone's sense of the currency of Zen predated the cult classic *Zen and the Art of Motorcycle Maintenance* by Robert M. Pirsig, which was published in 1974.

22. Perry T. Rathbone, preface to *Zen Painting and Calligraphy*, by Jan Fontein and Money L. Hickman (Boston: Museum of Fine Arts, 1970), ix.

23. Robert Bowie interview with the author, June 6, 2007, Cambridge, MA.

24. Ibid.

25. Nicholas Peck interview with the author, January 16, 2013, telephone.

26. Seybolt to "The Files," November 30, 1970, Perry T. Rathbone papers, Archives of American Art.

27. Seybolt interview, Archives of American Art, Tape 6, 7, April 2, 16, 1985.

28. Ibid.

29. Seybolt to Rathbone, December 8, 1970, Perry T. Rathbone papers, Archives of American Art.

30. This is the author's conjecture derived from account in Seybolt interview, Archives of American Art, Tape 6, April 2, 16, 1985.

31. Rathbone interview, Archives of American Art, August 31, 1976, Reel 10, Side 2.

32. Seybolt interview, Archives of American Art, Tape 6, 11, April 2, 16, 1985.

33. Seybolt interview, Archives of American Art, Tape 6. 12, April 2, 16, 1985.

34. Willie Davis interview with the author, June 27, 2012, Boston.

35. Clementine Brown interview.

36. Ibid.

37. Bureau of Customs to Museum of Fine Arts, Boston, January 13, 1971, Documentary Archives, Museum of Fine Arts, Boston.

38. Paul Hofmann, "Italy Presses Charges Against Hub Museum," *The Boston*

Herald Traveler, March 23, 1971.

39. Killian to Seybolt, December 26, 1973, James Killian Papers, Institute Archives and Special Colletions, MIT.

40. John B. Wood, "No deportation yet for disputed Raphael portrait," *The Boston Globe*, February 8, 1971.

41. Press file,"Earth, Air, Fire, and Water: The Elements," Documentary Archives, Museum of Fine Arts, Boston.

42. Hilton Kramer, "Playing the Gracious Host – but to What?" *The New York Times*, March 7, 1971.

43. Richard Chapman to Rathbone, May 27, 1971, James Killian Papers, Institute Archives and Special Collections, MIT.

44. Wary at first of encroaching on Rathbone's curatorial turf, Moffett found Rathbone "tremendously supportive" of his ideas and initiatives, and perhaps best of all, that the director "really loved the art." Kenworth Moffett interview with the author, January 3, 2014, telephone.

THE RETURN OF THE RAPHAEL

1. Louis B. Fleming, "International Wrangle over a Raphael," *The Los Angeles Times*, April 24, 1971.

2. Davis interview.

3. Even so, Seybolt and others continued to assert the conspiracy theory, that Rathbone had instructed Swarzenski not to declare the painting at Customs. "Erwin Canham eloquently maintained that in failing to declare the Raphael, Hanns was probably acting under orders. Linda Thomas independently advanced the same supposition," John Coolidge, memorandum to William Coolidge, James Killian, George Seybolt, October 29th, 1973, James Killian Papers, Institute Archives and Special Collections, MIT.

4. Colin Simpson, "Clues on the Trail of a Smuggled Raphael," *The Sunday Times* (London), February 7, 1971.

5. It remains unclear if Swarzenski physically carried the painting out of Italy or if someone else did. A November 14, 1969, letter from Bossi to Rathbone mentions the "question of payment for journey of Signoria della Rovere," which seems to indicate that Bossi transported the painting at least as far as Zurich, as he was in the habit of doing, and possibly as far as London.

6. Derived from Rodolfo Siviero diary, January 29th, 1971, Accademia delle Arti del Disegno, Florence, Italy.

7. Geraldine Keen, Peter Nichols, and Michael Knipe reported in *The Times*, (London), "Italians have second thoughts on the Boston Raphael." ("an investigation is underway within the Directorate for the Fine Arts to see whether action is needed. They are doubtful about the aesthetic or financial value of the work.... It is said that Signor Columbo's briefing from his advisors suggested that if the Americans insisted on raising the issue (of the

Raphael) he would say he was sorry." *The Times* (London), March 6, 1971.

8. Tori interview.

9. The longer version as constructed by Covington & Burling and not used (see Erwin Canham Papers, The Mary Baker Eddy Library, Boston) makes a forceful case for the innocence of Rathbone and Swarzenski, explaining their motives for secrecy and their best intentions for the Museum. The petition as edited by Ropes & Gray makes no such argument, stressing only the innocence of the trustees and the potential damage to the museum and community. This seems to indicate the Raphael committee's intention to isolate Rathbone and Swarzenski rather than to work together with them on a satisfactory resolution.

10. MFA Trustees to Commissioner of Customs, "Petition for Remission or Mitigation of Customs Penalty or Forfeiture," March 1971, Documentary Archives, Museum of Fine Arts, Boston.

11. Ibid.

12. Customs now falls under the jurisdiction of Homeland Security.

13. Gerald Norton in an email to the author, June 26, 2012.

14. Eugene Rossides interview with the author, September 11, 2012, Washington, DC.

15. Rathbone to Goelet, March 8, 1971, Perry T. Rathbone papers, Archives of American Art.

16. Seybolt, memorandum to Messrs. John Coolidge, W. A. Coolidge, J. B. Ames, J. Killian, and E. Canham, May 12, 1971, James Killian Papers, Institute Archives and Special Collections, MIT.

17. Ibid.

18. Rathbone to Goelet, April 8th, 1971, Perry T. Rathbone papers, Archives of American Art.

19. Ibid.

20. Minutes of "Informal Meeting of the Full Board of Trustees," June 25, 1971, Perry T. Rathbone papers, Archives of American Art.

21. Seybolt claimed to have notified Rathbone's lawyer, Dan Needham, but apparently, if this is true, not in time to contact him somewhere in the Aegean.

22. Coolidge interview, Archives of American Art.

23. Ibid.

24. Evidence indicating that John Coolidge had been a recipient of a confidential memo from Seybolt on May 12, 1971 makes this comment strangely disingenuous. See James Killian Papers, Institute Archives and Special Collections, MIT.

25. Chapman to Jim Ames, June 25, 1971, Erwin Canham Papers, The Mary Baker Eddy Library, Boston.

26. McVickar to Rathbone, June 25, 1971, Perry T. Rathbone papers, Archives of American Art.

27. The artists were Bob Guillemin, Kristen Johnson, Todd McKie, Martin Mull, David Raymond, and Jo Sandman.
28. Heyward Cutting, Memorandum to All Departments, June 22, 1971, Perry T. Rathbone Papers, Archives of American Art.
29. Ibid. Diggory Venn to Rathbone, undated.
30. Ibid. McVickar to Rathbone, June 25, 1971.
31. Ibid.
32. Ibid. Agreement between Rodolfo Siviero and George Seybolt, June 25, 1971.
33. Egidio Ortona to James Killian, September 13, 1971, James Killian Papers, Institute Archives and Special Collections, MIT.
34. John Coolidge interview, Archives of American Art.
35. Memorandum from Seybolt to Messrs. John Coolidge, W. A. Coolidge, J.B. Ames, J. Killian, E. Canham, May 12, 1971, James Killian Papers, Institute Archives and Special Collections, MIT.
36. Aldrich interview, Archives of American Art.
37. Clive F. Getty, "The Case of the Boston Raphael," In *Law, Ethics, and the Visual Arts*, John H. Merryman and Albert E. Elsen, (Philadelphia: Univeristy of Pennsylvania Press, 1987) 81.
38. Ibid., 82.
39. Lewis Cabot recalled the trustees' meeting in November, 1969, to approve the acquisition of the Raphael. "When the picture first came in, we were led to believe Seybolt knew the whole story, and that he had approved of it, and that these things were controversial – you didn't know too much and frankly you didn't want to ask too much." Cabot interview.
40. John Coolidge remembered, "Perry never told any detail of where it came from, except from Italy. We believed it was normal procedure for Italians to smuggle it to Switzerland, and sell it in Switzerland, which is legal." Coolidge interview, Archives of American Art.
41. Rossides interview.
42. "The Museum, but not necessarily its personnel, were absolved in the smuggling in a statement by Eugene T. Rossides, Assistant Secretary of the Treasury, on 10 September 1971." Getty, "The Case of the Boston Raphael."
43. John Goelet was reimbursed $60,000 – his deposit on the Raphael – on March 12, 1970. See Perry T. Rathbone to Walter Anderson, Treasurer, March 12, 1970, Documentary Archives, Museum of Fine Arts, Boston.
44. Both the Treasury and the MFA wanted to make the most of the spotlight on this historic occasion. John Connally, Secretary of the Treasury, wanted a big press conference in DC. He was discouraged by Seybolt who strove to bring the focus to Boston, but he was then defeated by the board who wanted the proceedings carried out with a minimum of press or public attention. See Rathbone to Goelet, September 3, 1971, Perry T. Rathbone Papers, Archives of American Art.

45. Jean Bergantini Grillo, "The Boston Museum's Hot Raphael," *The Boston Phœnix*, Sept. 21, 1971.

46. Seybolt, memo, May 12, 1971, James Killian Papers, Institute Archives and Special Collections, MIT.

47. Ibid. Erwin to Seybolt, September 20, 1971.

48. Ibid. Schiff to Seybolt, September 12, 1971.

49. Getty, "The Case of the Boston Raphael," 82.

50. Paul Hofmann, "Italy to Press Charges over Raphael," *The New York Times*, March 22, 1971.

51. Nelson Aldrich later said "there were periods when we felt we would be prosecuted as trustees for actual criminal negligence," Aldrich interview, Archives of American Art.

52. Trustees Helen Bernat and Frannie Hallowell were particularly vocal in their support of the director in the midst of the Raphael crisis.

53. "A Statement from the Curatorial Staff to the Trustee Officers and the Executive Committee," August 17, 1971, Perry T. Rathbone Papers, Archives of American Art.

54. Robert Moeller to the Trustees of the MFA, Perry T. Rathbone Papers, Archives of American Art.

55. "Antiquities at the Boston Museum of Fine Arts: Cornelius Vermeule," J. Paul Getty Trust, The Getty Research Institute, Los Angeles (940109).

56. Goelet, telegram to Rathbone, September 16, 1971, Perry T. Rathbone Papers, Archives of American Art.

57. Rathbone to Goelet, September 3, 1971, Perry T. Rathbone Papers, Archives of American Art.

58. Goelet did remain on the board, but his involvement with the Museum and fiscal support was greatly diminished from that point onward. At this writing, he is an honorary trustee of the MFA.

59. David Little to the Trustees of the MFA, December 15, 1971, Rathbone Papers.

60. Ibid. Thompson to Caroline Marks (Mrs. George), December 15, 1971.

61. Ibid. Babbie Smith to the Trustees of the MFA, December 1, 1971.

62. Ibid. Seybolt to Von Molkte, May 23, 1972.

63. Ibid. Rathbone to Seybolt, August 9, 1971,

64. Caron Le Brun Danikian, *The Boston Phœnix*, December 26, 1971.

65. News Release, MFA, December 16, 1971, Perry T. Rathbone Papers, Archives of American Art.

66. Ibid. Jerome Facher to Seybolt, January 3, 1972.

67. Charles Giuliano, "Goodbye Perry Rathbone, (and Good Luck)," *Boston Magazine*, August, 1972.

68. Griswold interview.

69. Ackley interview.

70. "Antiquities at the Boston Museum of Fine Arts: Cornelius Vermeule," J. Paul Getty Trust, The Getty Research Institute, Los Angeles (940109).

71. Feigen interview.
72. Robert Taylor oral history interview by Robert F. Brown, March 1980–June 1990, Archives of American Art, Smithsonian Institution.
73. William A. Coolidge to Euretta Rathbone, August 16, 1972, Perry T. Rathbone Papers, Archives of American Art.
74. The press release states that the staff doubled. In fact, it tripled.
75. News Release, MFA, December 16, 1971, Perry T. Rathbone Papers, Archives of American Art.
76. Rathbone, "On Collecting."
77. S. Lane Faison, Jr., "The Rathbone Years: An exhibition at the Museum of Fine Arts, Boston, *Art in America,* July 1972.
78. Ibid.
79. Ibid.
80. Luckey interview.
81. Bill Fripp "Medley," *The Boston Globe,* June 3, 1972
82. Bill Fripp, "Tears and mirth mark farewell to Rathbone," *The Boston Globe,* June 9, 1972.

CHRISTIE'S

1. Monty Hoyt, "Rathbone quits Boston museum," *The Christian Science Monitor,* December 18, 1971.
2. The Seattle Art Museum, The Ringling Museum in Sarasota, Washington University in Saint Louis, Tufts University.
3. Reminiscences of Perry T. Rathbone, March 31, 1982, on page 10-429, Columbia University Center for Oral History Collection.
4. Christopher Burge interview with the author, August 20, 2011.
5. Rathbone, in conversation with the author, 1970s.
6. Rathbone to J.A. Floyd, March 22, 1973, Rathbone Family Archive.
7. Reminiscences of Perry T. Rathbone, March 31, 1982, on page 10-434, Columbia University Center for Oral History Collection.
8. Pam White, "Collecting is Hot as Art Prices Soar," *Richmond News Leader,* January 29, 1980.
9. Christopher Burge was made President of Christie's, New York, in 1985 and Chairman in 1992. He is now Honorary Chairman of Christie's, New York.
10. Twenty years later, in 1994, the Bernoudys' modern art collection was sold at Christie's, New York.
11. Burge interview.
12. Ibid.
13. Ibid.
14. Reminiscences of Perry T. Rathbone, March 31, 1982, on page 10-438, Columbia University Center for Oral History Collection, New York.

15. John Canaday, "Very Quiet and Very Dangerous," *The New York Times*, February 27, 1972.

16. Hoving, *Making the Mummies Dance*, 102

17. Reminiscences of Perry T. Rathbone, March 31, 1982, on page 10-442, Columbia University Center for Oral History Collection.

18. Feigen interview.

19. Cabot interview.

20. Peter Sutton interview with the author, January 27, 2009. Greenwich, CT.

21. Ashton Hawkins interview with the author, September 13, 2011, New York.

22. Burge interview.

23. Ibid.

24. Ildiko von Berg Butler interview with the author, October 12, 2010, New York.

25. Burge interview.

26. Noel Annesley interview with the author, August 4, 2008, London.

27. Burge interview.

28. In 1979, Peter Rathbone, who had been promoted to head of American Paintings, handled the sale of Frederic Edwin Church's spectacular painting of 1861, "Icebergs," which had languished in a dark stairwell of an old country house near Manchester, England, by then a home for delinquent boys. The painting was known but had been "lost" for generations. "Icebergs" was hammered down at Sotheby's at 2.5 million, a new record for American paintings and the third highest price ever paid for any painting at auction.

29. Peter Rathbone interview with the author, January 7, 2013, telephone.

30. Peter Gomes, the African-American minister of Memorial Church at Harvard from 1970 until his death in 2011, was an admirer of Perry Rathbone from an early age. As a teenager from Plymouth he was asked to present a piece of antique silver from the Plymouth Museum into the custody of the MFA. To his surprise and delight, young Gomes found himself graciously received by the director as an equal. Years later, he enjoyed Rathbone's regular presence at the Sunday morning services at Memorial Church.

31. New York art dealer Rudolf Heinemann retracted his gift of a Correggio "Pietà," explaining to George Seybolt, "Naturally, things have changed now that my old friend Perry Rathbone was forced to resign." Rudolf Heinemann to George Seybolt, May 16, 1973, Perry T. Rathbone Papers, Archives of American Art.

32. Cabot interview.

33. Seybolt interview, Archives of Ameican Art, Tape 4, 37, April 2, 1985.

34. Clementine Brown interview.

35. Ariel Herrmann interview with the author, June 26, 2012, Cambridge, MA.

36. The Dallas Museum was at the time about the same size as the de Cordova Museum in Lincoln, MA.

37. Seybolt interview, Archives of American Art, Tape 4, 33, April 2, 1985.
38. Ibid., 36.
39. Seybolt interview, Archives of American Art, Tape 1, 35, April 2, 1985.
40. Ibid. 42.
41. Otile McManus, with Robert Taylor and Patrick McGilligan "Museum controversy rooted in style, identity, accountability," *The Boston Globe,* March 9, 1975.
42. Ibid.
43. Ibid.
44. Memorandum, ad hoc policy review committee, April 16, 1970, Erwin Canham Archive, Mary Baker Eddy Library, Boston.
45. Seybolt interview, Archives of American Art, Tape 4, 35, April 2, 1985.
46. Ackley interview.
47. Seybolt interview, Archives of American Art, Tape 4, 35, April 2, 1985.
48. Gund interview.
49. In 1974 Hilles resigned from the committee for the department of contemporary art, discouraged with its direction under curator Kenworth Moffett and trustee Lewis Cabot, and the placement of her Franz Kline "in limbo between two ventilating outlets down in the jumble room on the Fenway side!" Susan Hilles to John Coolidge, September 20, 1974, Susan (Morse) Hilles Papers, Schlesinger Library, Harvard University.
50. Nelson Aldrich, memorandum to trustees, July 31, 1975, James Killian Papers, Institute Archives and Special Collections, MIT.
51. The Metropolitan Museum was considering a similar plan at the same time, but abandoned it after a negative public response.
52. "Trustees – Staff Planning Committee," minutes of Meeting, November 19, 1973, Documentary Archives, Museum of Fine Arts, Boston.
53. Ibid.
54. Ibid. Goelet to John Coolidge, December 5, 1973.
55. Ibid. Chapman to John Coolidge, December 11, 1973.
56. Ibid. James Peabody to John Coolidge, December 17, 1973.
57. Robert Taylor, "Museum of Fine Arts reverses decision and saves grand marble staircase," *The Boston Globe*, December 14, 1973.
58. The need for climate control emerged most forcefully as attendance increased for special exhibitions. During the Andrew Wyeth exhibition in the summer of 1970 the humidity caused by the crowds had a detectable effect on some paintings. Recent studies suggest that under normal circumstances, the traditional art museum building was adequate in terms of climate control even before the trend for installing air conditioning became the norm.
59. Aldrich alluded to an incident that he claimed caused the structural damage to the floor during Rathbone's first year as director when a skating rink was installed in the rotunda for the opening of "Sport in Art," when he

invited champion figure skater Tenley Albright to perform. In the wake of that opening celebration, Aldrich threatened to resign from the board.

60. The MFA did host an earlier King Tut show in 1961, the smaller forerunner of the show circulated by the Egyptian government in the 1970s.

61. Gund interview.

62. The term "blockbuster," which originally meant an aerial bombardment capable of destroying an entire city block, was adapted by the movie industry in the 1950s, and eventually reached the art museum in the 1970s.

63. Rathbone, along with curator of contemporary art Kenworth Moffett, had already purchased the MFA's first Pollock, "Number 10," from Ossario in 1970, thus paving the way for the even greater offers to come.

64. John Coolidge to James Killian, June 1, 1975, James Killian Papers, Institute Archives and Special Collections, MIT.

65. Seybolt interview, Archives of American Art, Tape no. 5, 25, April 2, 16, 1985.

66. Charles Giuliano, "Knocking the Stuffiness Out of a Boston Stronghold," *The Boston Phœnix*, October 19, 1976.

67. Hanns Swarzenski to Rathbone, March 5, 1975, Perry T. Rathbone Papers, Archives of American Art.

68. Chapman to James Killian, June 3, 1975, James Killian Papers, Institute Archives and Special Collections, MIT.

69. Rathbone to Bartlett Hayes, March 6, 1972, Perry T. Rathbone Papers, Archives of American Art.

70. Ibid. Rathbone to Howard Johnson, September 25, 1975.

71. Seybolt interview, Archives of American Art, Tape no. 5. 11, April 2, 16, 1985.

72. Fontein interview.

73. In fact, Rathbone had approached Walsh to be curator of paintings in 1971.

74. John Walsh Jr. to the Editor of *Art News*. (typed draft), c. 1981. A hand written note at bottom states "J(an) F(ontein) asked me not to send this!" Perry T. Rathbone Papers, Archives of American Art.

75. John Coolidge to Robert Taylor of the *Boston Globe*, March 10, 1975, Documentary Archives, Museum of Fine Arts, Boston.

76. A complete transcript of this letter can be found in the Appendix: Perry T. Rathbone to John Coolidge, 307.

77. Nancy Stapen, "The Museum still adding to European Collection," *The Boston Globe*, October 24, 1993.

78. Rathbone might have taken some solace in the fact that while the MFA lost a priceless work of art, Jim Ede's sale of Brancusi's *The Fish* to the MFA created the funds necessary to realize his dream to establish a student fellowship at Kettle's Yard in Cambridge, England, which continues to this day.

79. Clementine Brown successfully guarded the Museum from the press in the face of these events.

THE BIG PICTURE

1. William Howard Adams, *The Eye of Thomas Jefferson* (Washington: National Gallery of Art, 1976), 314.

2. Rathbone told *The Boston Globe* that the MFA was offered the Euphronios Krater but he turned it down on the issue of its provenance. Robert Taylor, "Rathbone rejected Met's $1m vase on provenance grounds," *The Boston Globe*, March 10, 1973.

3. Rebecca Mead, "Den of Antiquity: The Met Defends its Treasures," *The New Yorker*, April 9, 2007.

4. Randy Kennedy and Hugh Eakin, "Met Chief, Unbowed, Defends Museum's Role," *The New York Times*, February 28, 2006.

5. Randy Kennedy and Hugh Eakin, "The Met, Ending 30-Year Stance, Is Set to Yield Prized Vase to Italy," *The New York Times*, February 3, 2006.

6. Sylvia Hochfield, "Descendant of the Pharaohs," *Art News*, May 2006.

7. Edward Rothstein, "Antiquities, The World Is Your Homeland," *The New York Times*, May 27, 2008.

8. Dows Dunham oral history interview with Robert F. Brown, October 19, 1971, Archives of American Art, Smithsonian Institution.

9. Neil MacGregor, "To Shape the Citizens of 'That Great City, The World,'" in *Whose Culture?: The Promise of Museums and the Debate Over Antiquities*, Ed. James Cuno (Princeton and Oxford: Princeton University Press, 2009), 50.

10. Today known as The Art Fund.

11. Meyer, *The Plundered Past*, 201.

12. Carol King, "Stolen Artworks and the Lawyers who Reclaim Them," *The New York Times*, March 28, 2007.

13. UNESCO, Under Article 7 (b) (i): "cultural property stolen from a museum or a religious or secular public monument or similar institution," which included objects in private hands, which are not considered property of the state.

14. Mead, "Den of Antiquity."

15. John Henry Merryman, "The Nation and The Object," In *Whose Culture?: The Promise of Museums and the Debate over Antiquities*, 183.

16. Rathbone interview, Archives of American Art., August 31, 1976, Reel 10, Side 2.

17. Reminiscences of Perry T. Rathbone, March 17, 1982, on page 9-419, Columbia University Center for Oral History Collection, New York.

18. Emily Rafferty interview with the author, October 4, 2012, New York.

19. Maureen Melton, *Invitation to Art: A History of the Museum of Fine Arts, Boston*, (Boston: MFA Publications, 2009), p. 63.

20. Kathy Halbreich, *Artforum*, (Special Museum Issue), Summer, 2010.

21. Tassel, "Reverence for the Object."

22. As far back as 1955, the Met had considered the question of whether director or chairman of the board should lead the institution, depending on their personality. See Arthur W. Page to Arthur A. Houghton, April 26, 1955, Robert Lehman Papers, Baker Library Historical Collections, Harvard Business School, Harvard University.

23. Philippe de Montebello, "Inaugural address," AFA Curator's Forum, New York, April 29, 2001.

24. Killian to Seybolt, December 26, 1973, James Killian Papers, Institute Archives and Special Collections, MIT.

25. MFA, Met, MOMA, LACMA museum directors are currently salaried at approximately one million or more. Rathbone's salary topped at $50,000 in 1972.

26. See Sebastian Smee, "Masterpieces on loan leave MFA walls lacking," *The Boston Globe*, November 25, 2012.

27. Francis Haskell, *The Ephemeral Museum: Old Master Paintings and the Rise of the Art Exhibition*, (New Haven: Yale University Press, 2000), 146.

28. Max Putzel, "Mr. Rathbone Goes to Boston," *St. Louis Post Dispatch*, September 24, 1961.

29. Nick Prior, "Having One's Tate and Eating It," in *Art and its Publics: Museum Studies at the Millennium*, Ed. Andrew McClellan, (Malden, MA: Blackwell Publishing, 2003), 56.

30. Germain Bazin, *The Museum Age* (New York: Universe Books, 1967), 267.

31. Andrew McClellan, "A Brief History of the Art Museum Public," in *Art and its Publics: Museum Studies at the Millennium*, 23.

32. Fontein interview.

33. Ibid.

34. To look up the painting go to: Polomuseale.firenze.it/catalogo/avanzata.asp. Type in NCTN, number 00194029.

35. Hasan Niyazi, "From Scandal to Obscurity – a Raphael case study," *3 Pipe Problem* (twitter), February 28, 2012, https://twitter.com/3pipenet.

36. Reminiscenses of Perry T. Rathbone, May 20th, 1982, on page11-480, Columbia University Center for Oral History Collection.

Appendix

PERRY T. RATHBONE TO JOHN COOLIDGE

Christie's USA
867 Madison Avenue
New York, N.Y. 10021

Perry T. Rathbone, Director

June 5, 1975

Mr. John Coolidge, President
Museum of Fine Arts
465 Huntington Avenue
Boston, Massachusetts 02115

Dear John,

I read with interest but not without personal concern your letter to the *Globe* of Sunday, March 9th. It has been on my mind for a matter of weeks during which, without benefit of records or other documents, I have felt compelled to compose the following letter in contradiction to one specific statement.

If I may say so, I fear that you did not think very long before you made reference to "the painting collections long so shamefully neglected" by way of referring to "the program now under way." As

I have not heard about this specific program, I am somewhat in the dark about your meaning. So, inasmuch as you refer to the neglect as "long," your public comment could only be taken by me and others similarly uninformed as a vague and rather harsh criticism of the stewardship of the collections under my directorship. I cannot believe you meant your remark this way. But now I am afraid that your comment leaves me no choice but to submit this review of the facts pertaining to the recent history of the painting collections and the department.

Upon the retirement of W. G. Constable in October, 1957, and in the absence of a successor, the collections became my responsibility. Indeed, in respect to acquisitions and exhibition the collections became so even before my arrival – by default – as W. G. Constable had exerted little or no initiative in the last years of his incumbency, a situation that irked the trustees, in particular Paul Sachs, as you will remember; we often discussed it. You will also recall the trustees out of dissatisfaction refrained from bestowing the title emeritus upon W. G. Constable at his retirement. I will not go into my efforts to find a suitable successor. Suffice it to refer to the frustration – the fiasco – of trying to engage Everett Fahy, a problem over which neither you nor I had any control but which we both hoped to solve. The last candidate I interviewed and whom I would have recommended without reserve was John Walsh and I am sure he would have come had I remained at the Museum.

Thus the years went by with the painting department first under my guidance, then under my direct supervision and finally under my acting curatorship until my retirement. In these endeavors I often sought the counsel and support of the curators; Hanns Swarzenski and Eleanor Sayre were especially influential and Cornelius Vermeule, like the others in collegial spirit, frequently contributed his critical estimate and solid support of a work under consideration. Of the accomplishments of these short years I am very proud.

By "neglect" of the collections I presume you mean the opposite of "care" which I would take to be the customary responsibilities and activities of a curator. These normally include acquisition, conservation, research, publication and interpretation, presentation and special exhibition.

May I take a moment to review these for you? First of all, acquisition. My first acquisition was the rare and wonderful Lucas van Leyden which W.G. had refused to recommend, requiring me to override his implied veto. This was after my appointment but before I took office. There followed Monet's *Japonaise*, the Hausbuch Master, the great Rembrandt pair of portraits, the Courbet *Forest Pool*, Whistler's *Symphony in Red*, John Martin's *Seventh Plague*, Tiepolo's *Time Unveiling Truth*, the Rosso *Dead Christ*, the Ruysdael *Stormy Sea* to which the Rijksmuseum aspired, the Ter Brugghen and Aert de Gelder, the St. Hippolytus triptych, the Gentile da Fabriano, the Lorenzo Lotto, the pair of Sebastien Bourdons, the Vouet, the incomparable Crespi of the *Lute Player* and the sumptuous Strozzi of *St. Sebastian* – the finest example of Venetian color in the collection. In the modern field we have not to blush at having bought an early Van Gogh, the best Munch in America, the first two Picassos (early and late) to enter the collections, a masterpiece by Nicolas de Staël and another by Feininger; capital works by Kirchner, Morandi, Okada, Nicolson and Kokoschka and the first Cubist work to enter the museum, a Metzinger. More intimate early European works and works of lesser masters were acquired as well. Among those are the pair of Mompers, the Brouwar, the pair of Bruyn the Elder portraits, the Cranach *Deposition*, the Savery, Ter Borch, and Maes, the Soreau, Lastman, and Benvenuto di Giovanni. And for the American collections, what did we purchase? The earliest American painting in the museum – portrait of the boy Robert Gibbs, 1670, Smibert's *Samuel Sewall*, Erastus S. Field's *Moore Family*, Henry Darby's great *Atwood Family Group*, both of which I brought to Karolik's attention and persuaded him to pay for (less than $5,000 for both), the Fitz Hugh Lane of *Boston Harbor* and important works by Hassam, Henri, Glackens, Marin, Maurer, Dove, and the first oils by Prendergast to be acquired.

But this recital does not take account of the gifts to the collections which do not, as you know, simply drop off the trees. Perhaps the greatest is the Manet, *The Concert*, then the Frans Hals, the Degas of the *Women in the Museum*; there is the Juan Gris, the Wyeth of *Anna Cristina*, Caleb Bingham's *The Squatters*, the Franz Kline, the Redon *Centaur*, the little Picasso of 1905, the Boudin

Plage and the Monet *Haystacks*, the Prendergast *Still Life* and the Beckmann *Tempest*. I obtained eleven paintings from the Fuller collection which, contrary to what I was told by the former curator, had not already been promised to the museum; all the pictures in the Wickes collection which included two fine Lancrets, a Boucher, a Hubert Robert and the Quentin de la Tour. I made every possible effort to obtain the Fuller late Rembrandt as a gift as members of that family will testify. Not unrelated to gifts to the collections is the fact that I pressed our treasurer to obtain the Bayley bequest for the purchase of paintings in advance while it still had buying power amidst rising prices and exerted my influence with Mrs. Russell Baker to bring her bequest of $855,000 to the museum to establish a painting curatorship. Finally, I tried my best, but without success, to persuade William Coolidge and David Bakalar to buy at auction the Erickson Rembrandt of Aristotle.

The great majority of the works named above by virtue of their quality and relative importance are on constant display in the painting galleries today. Even without consideration of the museum's very limited purchase funds, this record of acquisition would do credit to any museum. Such could not have been achieved by "neglect."

Other paintings were resurrected from storage and thanks to the conservation and re-framing program, made presentable. Among them were the best of the Millets, the *Shepherdess* acquired in 1877, Troyen's *Chien d'arret*, the Pontormo, the Vinckboons *Death Triumphant* and the Diaz *Gypsies*.

The conservation program was marked by the recruitment of new laboratory staff upon the retirement of John Finlayson, a valuable technician whom I inherited. These were three highly qualified young men trained at the Institute of Fine Arts under Modjesky and strongly recommended by him. All three have since moved to positions of higher responsibility in other museums as you no doubt know. Together with the brothers Finlayson in succession, this force, under my direction, was engaged for fifteen years in a program of cleaning that was prodigious. Scores of paintings were cleaned and relined; not a few of them for the first time, having been given only a superficial and spotty treatment by the aging Edmund Lowe whose eyesight at seventy-seven was sadly impaired when I arrived.

Certain pictures offered special problems and were long-standing operations under my personal supervision. Some of these were the panel transfer by Finlayson of the Bohemian *Dormition*, the cleaning of the Turner *Schaffhausen* and the big Rubens *Tomyris*, the Poussin *Mars and Venus*, the Fuller Romney, the Courbet *Quarry* and the Tiepolo ceiling whose remarriage with its original frame (making it truly exhibitable for the first time) and its installation was carried out under my guidance with the aid of Vincent Cerbone. Not least of Finlayson's accomplishments was the removal of mechanical fracturing of the sheet of coach varnish that overlay the Noonen Van Gogh. Among other complex problems were the cleaning of the Barberini *Birth of the Virgin*, the Bartolommeo Vivarini alterpiece, the huge retable by Martin de Soria, the Delacroix *Deposition*, the Degas *Carriage at the Races* and Degas' *Jockeys* whose entire sky had been overpainted. More routinely Finlayson cleaned the Spaulding Cézanne and Fantin-Latour, many Boudins, Renoirs and Degas and a score of Monets, Sisleys and Pissarros. He cleaned Corots and Diaz and other Barbizon works and any number of American paintings – Copleys, including *Paul Revere*, the *Royall Sisters* and *Colonel Sparhawk*, Stuarts, Karolik pictures, Eakins, Sargents, Homers, Hunts, Cassatts. How many of these were also relined I cannot remember. One wondered if there had been a conservation program before.

Special conservation problems fell also to the young recruits. Vance and Hoffman together tackled the long-neglected Tintoretto *Nativity* and faced with patience and skill subtle problems of old varnish lodged in deep impasto and of in-painting large damaged areas – problems that demanded sensitive judgment and frequent consultations with me.

The same is true of the Gauguin masterpiece (probably never really cleaned before) – joint effort, sensitive consideration of Gauguin's intention in certain equivocal areas and a brilliant result. Hoffman cleaned Gainsborough's *Lord Grey*, the Van Gogh of *Auvers*, two of the Holford-Holmes Veroneses – a ticklish task – and Norman Muller rendered a brilliant result with the Crespi *Lute Player* and Mount's *Knucklebone Player*. May I try your patience further by pointing to Vance's success with *La Japonaise* whose easily soluble background

was beyond the risk factor the elder Finlayson would assume. Vance also persuaded me that the Renoir *Bal à Bougival* needed cleaning. He was right; look at it today. Likewise, he twisted my arm to clean the Degas of the *Morbillis*, the McLeod Van Gogh, the Melendez *Still Lives* and Manet's *Victorine*. He cleaned Copley's *Mercy Otis* and the lamented Paine Rembrandt. As John Morrison will testify, we did everything the mechanical equipment of the museum would permit to control humidity and temperature. As special precautions for certain fragile panels, we constructed a plastic case for the Rosso for the dry heat months from October to May and built a permanent plastic housing for the Hippolytus triptych. I visited the conservation laboratories a minimum of twice a week and often daily. Periodic examination of all the paintings in the galleries and in storage was carried out by the conservators who made a laboratory examination of every painting that was requested for loan. Anyone who consults the conservation files will see that a scrupulous record of the condition and treatment was kept by this force and by the assistants in the department. Particular problems occasionally required the special skills and experience of non-staff technicians. Consequently, Modestini cleaned and relined the Frans Hals and Sheldon Keck brought the Ryder back to life. Shameful neglect?

So far as publication is concerned, I take pride in the departmental production under my stimulus and guidance of the two-volume catalogue of American paintings whose text had long been in preparation – an amalgam of research by many people, principally Barbara Parker who resigned a year after my directorship began. Many of the exhibitions enumerated below were accompanied by catalogues which were in whole or in part the work of the painting department under my direction, and often with text contributed by me. Two of the most welcome publications were the popular picture book published for the Centennial, 100 *Master Paintings* and the sections on painting for the museum's "coffee table" album published by Kodansha in Japan and Montedori in Italy and elsewhere. But of more profound importance are the *Bulletin* articles often written by specialists upon my invitation – Jakob Rosenberg and John Shearman to name two – pertaining to new acquisitions of the department.

During these years departmental interpretation embraced lec-

tures, gallery talks, television performances and didactic displays. I myself lectured on the collections repeatedly both in the museum and far from home and gave untold numbers of gallery talks for the public and for members. No less did Thomas Maytham perform in these ways and the conservators gave talks and demonstrations over and again. I was involved as consultant or performer or both in telecasts more times than I care to remember. It was our practice for years to prepare explanatory labels for virtually all new acquisitions in the new accessions gallery and as educational feature of special displays. Time and again we prepared theme exhibitions from the reserve collections.

A word about research. As in the case of Harold Edgell who was his own curator of paintings for six years, research in the collections was diligently pursued. Charles Cunningham, James Plaut and Barbara Parker were succeeded by Thomas Maytham, Madeleine Cavaness, Adrianwen Howard, Inge Hacker, and Angelica Rudenstine. The research on new acquisitions was uninterrupted until the departure of Mrs. Rudenstine in 1969. The catalogue therefore is basically recorded and awaits the refinements and expansion of a coordinating editor to prepare it for publication.

Presentation. The discharge of this responsibility was a Herculean task extending over several years. It was, as you will remember, part of the museum-wide program to reinvigorate a moribund institution until it throbbed with life. Not least of the innovations was the inauguration of three galleries of twentieth-century art. The program involved not only all of the staff of the painting department but many others as well. It was a renovation long overdue and a total one from skylight to floor. It began with the rescue of the skylights themselves, which were scheduled to be roofed over in 1954, as you will remember. Every aspect of the galleries was studied and with special reference to lighting – daylight and artificial. The collections were completely reorganized. The aim was to make them visible, articulate, meaningful, and beautiful. With our own staff (no costly specialists) we devised an effective lighting scheme for all the galleries and solved the special problems posed by the Catalonian chapel and for the Feranese fresco of the Crucifixion; in fact all of Gallery P3 (early Italian paintings) was ingeniously relighted. The rearrangement

of the pictures and the success of the lighting in Gallery P10 (Impressionists) specifically inspired Susan Hilles' first gift of $25,000. Like every display space in the museum, those galleries were crying for attention. I will not forget Paul Sachs' exclaiming to me as we walked through what had become a depressing hodge-podge where great pictures were often trapped amidst inimical surroundings – "You will make these galleries sing!" And I did. Not least of the elements that made for harmony and meaning were the frames. Without reference to the actual records, I should judge that some one hundred pictures were put into enhancing and worthy frames. I sent William McQuade to the Museum School night class to learn calligraphy so that for the first time the painting labels were professionally lettered – worthy of the museum.

Amidst all this activity the department was involved during those years with every special exhibition in which painting was the principle concern. Without attempting chronology or any effort to classify them as monographs, theme exhibitions or collections, may I recall the majority, though not all, of them to your mind:

Exhibitions

Sargent's Boston	*Boston's Monets*
Matisse	*European Masters of our Time*
Max Beckmann	*Andrew Wyeth*
The Age of Rembrandt	*The Block Collection*
Kirchner	*Boston Painters*
Nicolas de Staël	*Paul Klee (Galka Scheyer Collection)*
Courbet	
Morris Louis	*Selections from the Guggenheim Museum*
Barbizon Revisited	
Cézanne	*The Hilles Collection*
Surrealist Painting from the Museum of Modern Art	*Lee Gatch*
	J. S. Copley
Maurice Prendergast	*Winslow Homer*

Back Bay Boston
100 Masterpieces from the
Metropolitan Museum

Centennial Acquisitions
Lyonel Feininger
The Fuller Collection

I will not say that had I succeeded in obtaining a curator that the conduct of the department would not have been in some ways different, the acquisitions not the same. But I will defend the premise that care was lavished upon the collections – perhaps as never before – that the department could hardly have been more active and, the proverbial advantage of hindsight notwithstanding, there are few acquisitions I would discard today for others that might have been made. Through most of these years the department was fortunate to have the present office force, Miss Luckey and Mrs. Giese, to carry the daily burden and to give unstintingly of their time and talent on the many special occasions that punctuate the life of the painting department. In other words I will maintain that the collections on every count were not "shamefully neglected."

I am sending a copy of this letter which is 98% fact and perhaps 2% opinion to the Secretary of the Museum to take its place in the museum archive. I do so because your comment as President, which is now a matter of public record could, unfortunately be misinterpreted when the history of the next one hundred years of the Museum of Fine Arts comes to be written. I think the record stands to be corrected.

You as a fair minded man could not have realized that whatever the basis of your criticism, your statement was a disparagement of the self-evident accomplishment, the dedication and good faith of more than a dozen qualified and devoted members of the staff of the painting department – present and past – over many years.

Sincerely yours,
(P.T.R.)
Perry T. Rathbone
Director Emeritus
Museum of Fine Arts
Boston

Illustration Credits

Perry T. Rathbone and Jacqueline Kennedy, the White House, April 1961. Photograph: Eliza Rathbone.

THE MAKING OF A MUSEUM DIRECTOR

Howard Betts Rathbone, self-portrait, undated.

Perry, Beatrice, and Westcott Rathbone, c. 1929. Photograph: Howard Rathbone.

Edward Forbes's *Methods and Processes of Painting* class, 1933–1934. Photographs of the Harvard Art Museum (HC22), file 3.187. Harvard Art Museums Archives, Harvard University, Cambridge, MA. Left to right: James S. Plaut, Perry T. Rathbone, Henry P. McIlhenny, Katrina Van Hook, Elizabeth Dow, Charles C. Cunningham, Professor Edward W. Forbes, Mr. Depinna, John Murray. 1933–1934.

THE CENTENNIAL LOOMS

Museum of Fine Arts, Boston, Huntington Avenue façade, 1920. Photograph © 2014 Museum of Fine Arts, Boston.

Architectural rendering, George Robert White Wing, Museum of Fine Arts, Boston, 1969. Photograph © 2014 Museum of Fine Arts, Boston.

Perry T. Rathbone watches visitors' reactions to medieval limestone sculpture of the Madonna and Child in sculpture hall, City Art Museum, Saint Louis, 1952. Photograph: Jack Gould, *St. Louis Post Dispatch*.

Perry T. Rathbone escorts Eleanor Roosevelt into *Treasures from Berlin*, City Art Museum, Saint Louis, January, 1949. Photograph: Piaget Studio.

Virginia Fay, Santa Claus, Sylvia Purrins, and Perry T. Rathbone in Greek line dance, Christmas party, Museum of Fine Arts, Boston, 1960s.

THE CHANGING FACE OF THE BOARD

Rettles and Perry Rathbone, Charlotte and Ralph Lowell, receiving line, Museum of Fine Arts, Boston, 1960s.

Perry Townsend Rathbone, Director, and George Seybolt, President, Board of Trustees, 1967–1971. Photograph: © Frederick G. S. Clow, courtesy of the Museum of Fine Arts, Boston.

Tamsin McVickar, administrative assistant to the director, 1960s. Photograph: Perry T. Rathbone.

Virginia Fay, administrative assistant to the director, 1960s. Photograph: Perry T. Rathbone.

William Underwood letterhead, 1960s.

PTR'S OTHER HAT

The Beal Gallery before renovation, Museum of Fine Arts, Boston, 1961. Photograph © 2014 Museum of Fine Arts, Boston.

The Beal Gallery after renovation, Museum of Fine Arts, Boston, 1962. Photograph © 2014 Museum of Fine Arts, Boston.

New gallery for modern and contemporary art, Museum of Fine Arts, Boston, 1956.

Perry T. Rathbone (seated) and his chief curators (left to right) Larry Salmon, Jan Fontein, Hanns Swarzenski, Cornelius Vermeule, Kelly Simpson, Eleanor Sayre, c. 1970.

Laura Luckey, Perry T. Rathbone, and Angelica Rudenstine examine a painting, Museum of Fine Arts, Boston, 1960s.

THE MAN BEHIND THE MAN

Curt Valentin, cross country road trip with Rathbone, 1940. Photograph: Perry T. Rathbone.

Rathbone and Curt Valentin with Calder mobiles, Curt Valentin Gallery, 1952. Photograph: Paul Berg.

Hanns Swarzenski installing Forsyth Wickes collection, Museum of Fine Arts, Boston, 1968. Photograph: Frederick G. S. Clow.

Vincent Cerbone, head carpenter; Dows Dunham, curator of Egyptian art; Hanns Swarzenski; rotunda, Museum of Fine Arts, Boston, 1960s. Photograph: Frederick G. S. Clow.

Perry T. Rathbone and Hanns Swarzenski, Cambridge, 1960s.

Perry T. Rathbone, Hanns and Brigitte Swarzenski, Christmas at the Rathbones', 151 Coolidge Hill, Cambridge. Photograph: Peter Rathbone, c. 1963.

Perry T. Rathbone and Brigitte Swarzenski. Photograph: Peter Rathbone, c. 1963.

Unidentified artist, *Madonna and Child*, Italy, Lombardy, Second quarter of 12th century Limestone with polychromy 74 × 40 × 22 cm (29 ⅛ × 15 ¾ × 8 ¹¹⁄₁₆ in.) Museum of Fine Arts, Boston Maria Antoinette Evans Fund, 57.583 Photograph © 2014 Museum of Fine Arts, Boston.

PART II

THE PRIZE

Infant Hercules Wrestling with the Serpents, Florence, Italy, c. 1600, Metal, bronze Overall: 21.6 × 13.3 × 12.4 cm (8½ × 5¼ × 4⅞ in.) Museum of Fine Arts, Boston, The John Goelet Decorative Arts Special Fund, 68.617 Photograph © 2014 Museum of Fine Arts, Boston.

Raphael (Raffaello Sanzio or Santi), Italian, 1483–1520, *Portrait of a Young Girl*, Italy, 1505, Oil on panel, 8¹³⁄₁₆ × 10⁹⁄₁₆ in. Museum of Fine Arts, Boston, Charles H. Bayley Picture and Painting Fund, 69.1300 Ambito emiliano, *Ritratto di giovane donna*, Galleria degli Uffizi, Inv. 1890 n. 9935 Photograph © 2014 Museum of Fine Arts, Boston.

John Goelet and Hanns Swarzenski, Paris, c. 1968. Photograph: Perry T. Rathbone.

RODOLFO SIVIERO, ART SLEUTH

Portrait of a Young Girl on view at the Museum of Fine Arts, Boston, December 1969. Photograph © Frederick G. S. Clow, courtesy of Museum of Fine Arts, Boston.

Rodolfo Siviero with *Portrait of a Gentleman* by Hans Memling, 1948, courtesy Casa Siviero. Photograph: Vespasiani.

Perry T. Rathbone with the Honorable Piero Bargellini, Mayor of Florence, Italy, on a visit to Boston during a tour of American cities to report on the progress made in Florence since the flood and to thank Americans for their assistance, April 11, 1967. Photograph: Associated Press.

Mayor Kevin White, Perry T. Rathbone, and Governor Francis Sargent celebrate the MFA's 100th Birthday, week of February 4, 1970. Photograph: Ulrike Welsch.

Thomas Hoving, Sherman Lee, Perry T. Rathbone at opening reception for *Art Treasures for Tomorrow*, Museum of Fine Arts, Boston, February, 1970. Photograph: Frederick G. S. Clow.

Rathbone escorts Rose Kennedy through the galleries during centennial festivities, Museum of Fine Arts, Boston, 1970. Photograph: Frederick G. S. Clow.

BUT IS IT REALLY A RAPHAEL?

Elma Lewis, Edmund Barry Gaither, Perry T. Rathbone at press conference for *Afro-American Artists: Boston and New York*, Museum of Fine Arts, Boston, April 1970, National Center of Afro-American Artists Collection, Archives and Special Collections, Archives and Special Collections Department, Northeastern University Libraries, Boston.

William Young, head of conservation, Museum of Fine Arts, Boston, 1960s.

SEIZURE

Andrew Wyeth and Perry T. Rathbone with portrait of Betsy Wyeth, at opening reception for *Andrew Wyeth*, Museum of Fine Arts, Boston, June 1970. Photograph: Frederick G. S. Clow.

Construction of the George Robert White Wing, c. 1968, Museum of Fine Arts, Boston. Photograph © 2014 Museum of Fine Arts, Boston.

John Coolidge in the Fogg Art Museum, 1965. John Coolidge Papers (HC 15), file 133. Harvard Art Museum Archives, Harvard University, Cambridge, MA

Red Rapid Growth by Otto Piene, *Earth, Air, Fire, Water: Elements of Art* exhibition at the Museum of Fine Arts, Boston, February 4–April 11, 1971. Photograph © 2014 Museum of Fine Arts, Boston.

Listening-for-Light-Hinge (Boundaries and Constellations) by Lowry Burgess, *Earth, Air, Fire, Water: Elements of Art* exhibition at the Museum of Fine Arts, Boston, February 4–April 11, 1971. Photograph © 2014 Museum of Fine Arts, Boston.

THE RETURN OF THE RAPHAEL

At port during Greek cruise. Left to right: Lulu Pulitzer, (?), Patricia Clark, Perry T. Rathbone, Henry McIlhenny, Emlen Etting, Gloria Etting, Joseph Pulitzer, Jr., Rettles Rathbone, c. 1966. Photograph: B. Karamanolis.

Entrance to *The Rathbone Years* exhibition, June, Museum of Fine Arts, Boston, 1972.

CHRISTIE'S

Rathbone takes a break from gardening, 151 Coolidge Hill, Cambridge, MA, 1970s. Photograph: Belinda Rathbone.

Constantin Brancusi, Romanian, 1876–1957 *The Fish*, 1924, Brass and steel, Museum of Fine Arts, Boston, William Francis Warden Fund, 57.739.1 Photograph © 2014 Museum of Fine Arts, Boston.

THE BIG PICTURE

The author and her father, 1992. Photograph © 1992 Mariana Cook.

ILLUSTRATIONS FOLLOWING P. 96

Raphael (Raffaello Sanzio or Santi), Italian, 1483–1520, *Portrait of a Young Girl*, 1505 Oil on panel 20.8 × 26.8 cm (8³/₁₆ × 10⁹/₁₆ in.) Museum of Fine Arts, Boston, Charles H. Bayley Picture and Painting Fund, 69.1300 Ambito emiliano, *Ritratto di giovane donna*, Galleria degli Uffizi, Inv. 1890 n. 9935 Photograph © 2014 Museum of Fine Arts, Boston.

Rosso Fiorentino (Giovanni Battista di Jacopo), Italian (Florentine), 1494–1540 *The Dead Christ with Angels*, about 1524–27 Oil on panel 133.4 × 104.1 cm (52½ × 41 in.) Museum of Fine Arts, Boston, Charles Potter Kling Fund, 58.527 Photograph © 2014 Museum of Fine Arts, Boston.

Lorenzo Lotto, Italian (Venetian), about 1480–1556, *Virgin and Child with Saints Jerome and Nicholas of Tolentino*, 1523–24 Oil on canvas 94.3 × 77.8 cm (37⅛ × 30⅝ in.) Museum of Fine Arts, Boston, Charles Potter Kling Fund, 60.154 Photograph © 2014 Museum of Fine Arts, Boston.

Bernardo Strozzi, Italian (Genoese, active in Genoa and Venice), 1581–1644, *Three Angels* Italy, about 1631–36, Oil on canvas Overall: 85 × 121.5 cm (33⁷/₁₆ × 47¹³/₁₆ in.), Museum of Fine Arts, Boston, Henry H. and Zoe Oliver Sherman Fund, 2003.72 Photograph © 2014 Museum of Fine Arts, Boston.

Bernardo Strozzi, Italian (Genoese, active in Genoa and Venice), 1581–1644, *Saint Sebastian Tended by Saint Irene and Her Maid*, about 1631–6, Oil on canvas 166.7 × 118.7 cm (65⅝ × 46¾ in.) Museum of Fine Arts, Boston, Charles Potter Kling Fund and Francis Welch Fund, 1972.83 Photograph © 2014 Museum of Fine Arts, Boston.

Giovanni Battista Tiepolo, Italian (Venetian), 1696–1770, *Time Unveiling Truth*, about 1745–50, Oil on canvas 231.1 × 167 cm (91 × 65¾ in.) Museum of Fine Arts, Boston, Charles Potter Kling Fund, 61.1200 Photograph © 2014 Museum of Fine Arts, Boston.

Fitz Henry Lane, American, 1804–1865 *Boston Harbor*, about 1850–55, Oil on canvas 66.04 × 106.68 cm (26 × 42 in.) Museum of Fine Arts, Boston, M. and M. Karolik Collection of American Paintings, 1815–1865, by exchange, 66.339 Photograph © 2014 Museum of Fine Arts, Boston.

George Romney, English, 1734–1802 *Anne, Lady de la Pole*, about 1786, Oil on canvas 241 × 148.9 cm (94⅞ × 58⅝ in.) Museum of Fine Arts, Boston, Given in memory of Governor Alvan T. Fuller by the Fuller Foundation, 61.392 Photograph © 2014 Museum of Fine Arts, Boston.

Jacob Isaacksz. van Ruisdael, Dutch, 1628 or 1629–1682, *Rough Sea*, about 1670, Oil on canvas 107.0 × 125.8 cm (42⅛ × 49½ in.) Museum of Fine Arts, Boston, William Francis Warden Fund, 57.4 Photograph © 2014 Museum of Fine Arts, Boston.

Gerard ter Borch, Dutch, 1617–1681, *Man on Horseback*, 1634, Oil on panel 54.9 × 41.0 cm (21⅝ × 16⅛ in.) Museum of Fine Arts, Boston, Juliana Cheney Edwards Collection, 61.660 Photograph © 2014 Museum of Fine Arts, Boston.

Nicolas Lancret, French, 1690–1743 *Luncheon Party in a Park*, about 1735, Oil on canvas 54.1 × 46 cm (21⁵/₁₆ × 18⅛ in.) Museum of Fine Arts, Boston, Bequest of Forsyth Wickes—The Forsyth Wickes Collection, 65.2649 Photograph © 2014 Museum of Fine Arts, Boston.

Giuseppe Maria Crespi, Italian (Bolognese), 1665–1747, *Woman Playing a Lute*, about 1700–05, Oil on canvas 121.3 × 153 cm (47¾ × 60¼ in.) Museum of Fine Arts, Boston, Charles Potter Kling Fund, 69.958 Photograph © 2014 Museum of Fine Arts, Boston.

John Singleton Copley, American, 1738–1815 *Corkscrew Hanging on a Nail*, late 1760s Oil on panel 13.65 × 14.29 × 2.22 cm (5⅜ × 5⅝ × ⅞ in.) Museum of Fine Arts, Boston Bequest of Ogden Codman, 1970.223 Photograph © 2014 Museum of Fine Arts, Boston.

Erastus Salisbury Field, American, 1805–1900, *Joseph Moore and His Family*, about 1839, Oil on canvas 209.23 × 237.17 cm (82⅜ × 93⅜ in.) Museum of Fine Arts, Boston, Gift of Maxim Karolik for the M. and M. Karolik Collection of American Paintings, 1815–1865 58.25 Photograph © 2014 Museum of Fine Arts, Boston.

ILLUSTRATIONS FOLLOWING P. 224

Claude Monet, French, 1840–1926 *La Japonaise (Camille Monet in Japanese Costume)*, 1876, Oil on canvas 231.8 × 142.3 cm (91¼ × 56 in.) Museum of Fine Arts, Boston, 1951 Purchase Fund, 56.147 Photograph © 2014 Museum of Fine Arts, Boston.

Maurice Brazil Prendergast, American (born in Canada), 1858–1924, *Umbrellas in the Rain*, 1899, Watercolor over graphite pencil on paper; verso: pencil and watercolor sketch for arcade and lamp post. Sheet: 35.4 × 53 cm (13^{15}/₁₆ × 20⅞ in.) Museum of Fine Arts, Boston, The Hayden Collection—Charles Henry Hayden Fund, 59.57 Photograph © 2014 Museum of Fine Arts, Boston.

Edouard Manet, French, 1832–1883 *Music Lesson,* 1870, Oil on canvas 141.0 × 173.1 cm (55½ × 68⅛ in.) Museum of Fine Arts, Boston, Anonymous Centennial gift in memory of Charles Deering, 69.1123 Photograph © 2014 Museum of Fine Arts, Boston.

Edgar Degas, French, 1834–1917, *Visit to a Museum*, about 1879–90, Oil on canvas 91.8 ×

68 cm (36⅛ × 26¾ in.) Museum of Fine Arts, Boston, Gift of Mr. and Mrs. John McAndrew, 69.49 Photograph © 2014 Museum of Fine Arts, Boston.

Edvard Munch, Norwegian, 1863–1944 *Summer Night's Dream (The Voice)* 1893 Oil on canvas 87.9 × 108 cm (34⅝ × 42½ in.) Museum of Fine Arts, Boston, Ernest Wadsworth Longfellow Fund, 59.301 Photograph © 2014 Museum of Fine Arts, Boston.

Ernst Ludwig Kirchner, German, 1880–1938 *Mountain Landscape from Clavadel*, 1925–26 Oil on canvas 135 × 200.3 cm (53⅛ × 78⅞ in.) Museum of Fine Arts, Boston, Tompkins Collection – Arthur Gordon Tompkins Fund, 56.13 Photograph © 2014 Museum of Fine Arts, Boston.

Pablo Picasso, Spanish (worked in France), 1881–1973, *Standing Figure*, 1908, Oil on canvas 150.2 × 100.3 cm (59⅛ × 39½ in.) Museum of Fine Arts, Boston, Juliana Cheney Edwards Collection, 58.976 Photograph © 2014 Museum of Fine Arts, Boston.

Alexander Calder, American, 1898-1976
4 Woods (Diana), about 1934, Walnut with
steel pins, iron base Overall: 77.5 × 45.1 ×
48.9 cm (30½ × 17¾ × 19¼ in.) Museum of
Fine Arts, Boston, Frederick Brown Fund,
60.956 Photograph © 2014 Museum of Fine
Arts, Boston.

Juan Gris, Spanish (worked in France),
1887–1927, *Still Life with a Guitar*, 1925
Oil on canvas 73 × 94.6 cm (28¾ × 37¼ in.)
Museum of Fine Arts, Boston, Gift of Joseph
Pulitzer, Jr., 67.1161 Photograph © 2014
Museum of Fine Arts, Boston.

David Smith, American, 1906–1965
Cubi XVIII, 1964, Polished stainless steel
294 × 152.4 × 55.2 cm (115¾ × 60 × 21¾ in.)
Museum of Fine Arts, Boston, Gift of Susan
W. and Stephen D. Paine, 68.280 Photograph
© 2014 Museum of Fine Arts, Boston.

Nicolas de Staël, Russian (worked in France),
1914–1955, *Rue Gauguet*, 1949, Oil on ply-
wood panel 199.4 × 240.3 cm (78½ × 94⅝ in.)
Museum of Fine Arts, Boston, Tompkins
Collection – Arthur Gordon Tompkins Fund,
57.385 Photograph © 2014 Museum of Fine
Arts, Boston.

Jackson Pollock, American, 1912–1956
Number 10, 1949, Alkyd (synthethic paint)
and oil on canvas mounted on panel 46.04 ×
272.41 cm (18⅛ × 107¼ in.), Museum of
Fine Arts, Boston, Tompkins Collection –
Arthur Gordon Tompkins Fund and Sophie
M. Friedman Fund, 1971.638 Photograph
© 2014 Museum of Fine Arts, Boston.

Franz Kline, American, 1910–1962
Probst I, 1960, Oil on canvas 272.41 ×
202.56 cm (107¼ × 79¾ in.) Museum of Fine
Arts, Boston, Gift of Susan Morse Hilles,
1973.636 Photograph © 2014 Museum of
Fine Arts, Boston.

Max Beckmann, German, 1884–1950
Perry T. Rathbone, 1948, Oil on canvas
165.1 × 90.01 cm (65 × 35⁷⁄₁₆ in.)
Museum of Fine Arts, Boston, Gift of Perry T.
Rathbone, 1992.398 Photograph © 2014
Museum of Fine Arts, Boston.

Index

A NOTE ON THE TYPE

THE BOSTON RAPHAEL has been set in Walbaum 2010, a family of types created by František Štorm following the models of the German typographer Justus Erich Walbaum (1768–1837.) Derived in large part from the example of Giambattista Bodoni's types, Walbaum maintains the dramatic contrast of thick and thin strokes characteristic of so-called modern types, but is distinguished by its broader set width and taller lower-case letters. These characteristics make Walbaum a type better suited to longer texts and smaller sizes than the too-elegant Bodoni – or its dazzling French cousin, Didot. The present types, available in a standard-height version and an "XL" version with a still-higher x-height, are intended to address the defects present in the original types (and in later interpretations) and to expand the usefulness of these hardworking types. As Štorm wrote when he began digitizing the types in 2002, "The expression of the type face is robust, as if it had been seasoned with the spicy smell of the dung of Saxon cows somewhere near Weimar, where [Walbaum] had his type foundry in the years 1803–39."

DESIGN & COMPOSITION BY CARL W. SCARBROUGH